Canon® EOS 40D Digital Field Guide

Charlotte K. Lowrie

WILEY

Wiley Publishing, Inc.

Canon® EOS 40D Digital Field Guide

Published by
Wiley Publishing, Inc.
10475 Crosspoint Boulevard
Indianapolis, IN 46256
www.wiley.com

Copyright © 2008 by Wiley Publishing, Inc., Indianapolis, Indiana

Published simultaneously in Canada

ISBN: 978-0-470-26044-9

Manufactured in the United States of America

10 9 8 7 6 5 4 3 2

For general information on our other products and services or to obtain technical support, please contact our Customer Care Department within the U.S. at (800) 762-2974, outside the U.S. at (317) 572-3993 or fax (317) 572-4002.

Wiley also publishes its books in a variety of electronic formats. Some content that appears in print may not be available in electronic books.

Library of Congress Control Number: 2008922127

WILEY

About the Author

Charlotte K. Lowrie is a freelance editorial, portrait, and stock photographer and an award-winning writer based in the Seattle, Washington area. Her writing and photography have appeared in newsstand magazines including *Popular Photography & Imaging* and *PHOTOgraphic*. She is the author of eight books including the best-seller *Canon EOS Digital Rebel XTi Digital Field Guide,* the *Canon 5D Digital Field Guide,* and the *Canon 30D Digital Field Guide*, and she is co-author of *Exposure and Lighting*. Charlotte also teaches several photography classes at BetterPhoto.com. Her images have appeared on the Canon Digital Learning Center, and she is a featured photographer on www.takegreatpictures.com.

In stock and editorial assignment photography, Charlotte enjoys nature and portrait photography. Her images have been published in a variety of books, magazine articles, commercial products, and advertisements.

Credits

Acquisitions Editor
Ryan Spence

Senior Project Editor
Cricket Krengel

Technical Editor
Marianne Wallace

Copy Editor
Kim Heusel

Editorial Manager
Robyn B. Siesky

Vice President & Group Executive Publisher
Richard Swadley

Vice President & Publisher
Barry Pruett

Business Manager
Amy Knies

Senior Marketing Manager
Sandy Smith

Project Coordinator
Lynsey Stanford

Graphics and Production Specialists
Alissa D. Ellet
Jennifer Mayberry

Quality Control Technician
Caitie Kelly

Proofreading
Mildred Rosenzweig

Indexing
Johnna VanHoose

Special Help
Jama Carter
Sarah Cisco

This book is gratefully dedicated to John Isaac, www.johnisaac.com, consummate photographer, mentor, and friend. John's passion for people, his compassionate photography, his life's journey, and, most important, his faith in God changed my life forever. Thank you, John. Additionally, this book is dedicated to God and His son, Jesus Christ, through whom all things are possible.

Acknowledgments

My thanks to Peter Bryant and Rob Kline, professional photographers and dear friends, who kindly contributed their images for this book.

Introduction

Welcome to the Canon EOS 40D Digital Field Guide. With the introduction of the 40D, Canon combined the best of its recent technologies into an affordable, digital SLR that is fast, reliable, and produces stunning image quality. This book is designed to help you master using the camera and to help you get the best images possible from it. From my experience with the camera, I can safely say that this camera is an amazingly capable tool to help you express your creative vision, whether your passion is action photography, nature and landscape, documentary, news, wedding photography, or portraiture.

The 40D features the best of Canon's latest technology that gives this camera super fast response and performance, and a suite of features that has never been offered before in an EOS digital camera in this price range until now. The camera is approachable with a small and lightweight footprint, and it features Live View shooting for new creative opportunities and with the option for silent shooting, unprecedented customizability, 14-bit conversion for fine gradation and more colors, highlight tone priority, a new and improved autofocus sensor, in-camera Canon EX Speedlite control, large-text, intuitive, full-feature menus, a personalized menu, three fully customizable Camera User Settings modes, a huge, bright, wide-angle view LCD, and automatic image-sensor cleaning with the option of recording and applying Dust-Delete Data after image capture in Canon's Digital Photo Professional program.

The camera initially looks much like the other EOS digital SLRs in Canon's stable, but once you dig into the rich features, you'll soon see that the 40D represents a new breed, a new generation of cameras that opens the door to creative expression in not known before. This book is designed to help you go deep into the 40D and use its full potential.

You'll find that this book is a mix of how-to-use the camera as well as in-field experience with specific photographic subjects. Regardless of your shooting specialty preference, when the day is done, most photographers know that all of life is a photographic stage. In his book *The Mind's Eye: Writings on Photography and Photographers*, Henri Cartier-Bresson said, "There is subject in all that takes place in the world, as well as in our personal universe. We cannot negate subject. It is everywhere. So we must be lucid toward what is going on in the world, and honest about what we feel. . . . In photography, the smallest thing can be a great subject. The little human detail can become a leitmotiv. We see and show the world around us, but it is an event itself which provokes the organic rhythm of forms."

I hope that this book is a rewarding journey for you, not only in learning to use the EOS 40D, but also in exploring a universe of subjects and distilling the essence of each image with freshness and personal creative vision. And as you use this book, remember that it is the photographer who makes the picture—and having a camera like the EOS 40D is great extension of your vision and your creative insight.

Getting the Most from This Book

If you want to begin shooting right away, go first to the Quick Tour and double-check that you have setup the essential camera features and functions. This is also where you'll get a quick overview of the exposure controls used for shooting. In the Quick Tour and throughout the book, you work toward making your workflow more efficient by setting up the camera for routine shooting so that you get the highest image quality and the color settings that fit best within your workflow.

The first half of the book is devoted to not only setting the camera controls, but also on the effect of using different controls and settings during shooting. It is essential to know the camera controls well, and to set up functions so that they best suit your routine shooting preferences. The 40D is perhaps the most customizable camera that Canon has produced to this point, so you have ample opportunity to make the camera work well for you. Further, Canon provided a full complement of professional features that give you control over exposure, color, and drive modes. Knowing the extent of these features will go a long way toward making shoots efficient and successful and giving you creative control.

While you may or may not be drawn to the Picture Styles, offered on Canon EOS digital cameras, Chapter 2 explains why you need to carefully evaluate and consider modifying Picture Styles, particularly the default Standard style. The more you know about Picture Styles, the better your chances of getting the best color and quality both from the camera and subsequently from the prints you make. The 40D also offers many opportunities to customize the functions and use of the camera. Fortunately, you can save customized settings in a number of different ways, which means that you can setup specific settings for scene-specific shooting such as weddings, an indoor sports arena, and your studio. All the customization features translate into saving you time during shooting and later as you process your 40D images. This alone makes Chapter 3 a must-read if you want to get the best personalized performance from the camera.

You'll also find discussions of Canon lenses and Speedlites in Chapters 5 and 6. Chapter 5 introduces the range of lenses that Canon offers as well as providing example images taken using some of the lenses. In Chapter 6, you'll learn about both the onboard flash as well as using one and more accessory Speedlites. These chapters are designed as a quick reference, not an exhaustive compendium of lens test results and flash shooting techniques — both of which are book-length topics on their own.

The next part of the book concentrates on the photographic areas where the EOS 40D is a stand-out performer. Each section offers discussions about each photographic area; field notes on using the 40D; lenses, flash, and accessories specific to each specialty; shooting tips and experiences; and, workflow notes.

This part of the book is designed to discuss camera performance and capability in various venues and to provide suggestions and comments to make your shooting more efficient and successful. As with any area of photography, there are as many options, preferences, and opinions as there are photographers. The information provided in this part of the book reflects one photographer's experience — use it as a springboard in planning assignments and shooting them with the 40D.

Digital images aren't finished, of course, until they are edited, and, in the case of both RAW capture, until they are converted to TIFF or JEPG format. Canon provides a suite of programs that allow you to view and edit 40D images. In addition, if you are interested in getting started with RAW capture, Chapter 10 provides the basics for shooting and converting RAW images using Canon's Digital Photo Professional program. Of course, a variety of other RAW conversion programs are available, which are presented as an introduction to some of the options that you can consider.

In Chapter 10, you learn about getting and installing periodic firmware updates for the 40D that are provided by Canon. These updates are important in resolving any known bugs with the camera as well as updating menu functions to include such things as new language options.

In the Appendixes, those who are new to photography can get an overview on the basics of photographic exposure including an introduction to ISO, aperture, shutter speed, and light, and how these elements work together to create a good exposure. Appendix A offers insights into Canon's sensor technology. You may wonder why that matters, but the more you understand about the technology, the greater your understanding of the capabilities of the camera. You don't have to become a technology geek, but rather an informed photographer. Complementing the Canon sensor information, Canon's specifications for the 40D are in Appendix B. Specifications are a great when you want to quickly look up anything about the camera such as the sync speed, maximum shutter speed, frames per second, or any other fact regarding camera parameters, particularly while you're shooting or planning a shoot.

Finally, Appendix C contains a compendium of professional photography resources including organization, magazines, and Web sites. Like no other profession, photographers thrive on inspiration, ideas, and mutual support. These resources are a good starting point for finding favorite resources that provide you with not only inspiration, but also give you the latest news and views on various specialty areas.

I hope that during your journey through this book, you will be inspired and challenged to capture stunning, personal-best images. Regardless, I am confident that you will find that the EOS 40D is an exceptional tool to help you achieve your photographic vision.

The editor, the staff at Wiley, and I hope that you enjoy reading and using this book as much as we enjoyed creating it for you.

Contents

Chapter 2: Working with the Canon EOS 40D 37

Chapter 3: Color and Picture Styles 79

Chapter 4: Customizing the EOS 40D 105

Chapter 5: Using Live View Shooting 131

Part II: Getting the Most from the Canon EOS 40D 143

Chapter 6: Selecting and Using Lenses 145

Chapter 7: Working with Light 167

Chapter 8: Using Flash 179

Chapter 9: In the Field with the EOS 40D 193

Part III: Completing the Picture 253

Chapter 10: Working with RAW Capture and Updating Firmware 255

Appendix A: Image Sensors and the Canon DIGIC Processor 269

Appendix B: EOS 40D Specifications 273

Using the Canon EOS 40D

Exploring the Canon EOS 40D

Whether you are a wedding, landscape, nature, or portrait photographer, the Canon EOS 40D is a star performer in virtually all respects. In terms of image resolution and quality, the 10.1-megapixel sensor delivers 16-×-11-inch inkjet print sizes and offers the telephoto advantage of a 1.6x focal length multiplication factor. The new sensor microlens and Canon's new DIGIC III processor with four-channel reading and 14-bit analog-to-digital (AD) conversion combine to offer very fine image detail, finer gradation, far more color information than in previous 12-bit models, and noticeably faster camera performance with improved processing speed and writing to the CompactFlash card.

Standard and basic shooting modes are available on the Mode dial along with three customizable C modes so you can register your most often used modes, exposure, camera, and Custom Function settings. The 40D offers the full complement of metering and drive-mode options that are suitable for a wide range of shooting scenarios. ISO options including ISO expansion cover a broad range of lighting needs, and the noise performance is excellent even at the highest sensitivities. Depending on the ISO, the 40D's dynamic range — the range of dark-to-light values that can be captured by the camera as measured in f-stops — is approximately nine f-stops with both RAW and JPEG shooting, which represents roughly a one f-stop increase over the EOS 30D.

A new autofocus (AF) sensor provides an elliptical distribution of nine cross-type AF points across a bright, optical viewfinder that provides a 95 percent view. The 40D delivers rich, saturated color using any of the seven preset white balance options, plus custom white balance, and the ability to

set a specific color temperature. The 40D supports color-managed workflow with sRGB and Adobe RGB color space options.

This is only a small overview of the new features that the 40D offers. In this chapter, you can study in-depth the 40D functions and controls that you can use to suit your shooting needs and to complement your creative vision. Here you concentrate on the camera controls, menus, file quality, and numbering, as well as shooting modes.

Cross-Reference *Chapter 2 reviews autofocus and exposure options as well as setting ISO and viewing and playing back your images.*

Anatomy of the EOS 40D

Many of the 40D's controls are within a finger's reach for quick adjustment as you're shooting. Less frequently used functions are accessible only via the menus, and others require the simultaneous use of two controls. Regardless, adjustments are easy to master, especially if you understand Canon's functional logic and the grouping of controls.

Camera controls

The 40D groups commonly used functions in three areas on the camera:

✦ **Mode dial.** This dial enables you to switch among shooting modes by lining up the mode you want with the white mark beside the dial. Details on each shooting mode are provided later in this chapter. Setting up C1, C2, and C3 modes is detailed in Chapter 4.

✦ **LCD panel and buttons.** This panel and the buttons on the top of the camera group the most commonly used exposure and drive settings controls, including metering, white balance, focusing mode, drive mode, ISO, and flash exposure. Each button located above the LCD panel has two functions. The first function is controlled using the Main dial and the second function is controlled using the Quick Control dial. For example, if you press the Metering mode-WB button, you can select a metering mode by turning the Main dial, or you can select a white balance (WB) setting by turning the Quick Control dial. Unless you pay attention to which dial sets which function, it's easy to inadvertently set exposure compensation when you really intended to change the ISO. When changing the settings on the LCD panel, you do not need to confirm changes by pressing the Set button.

✦ **Camera menus.** These are accessed by pressing the Menu button on the back of the camera. Nine menu tabs group functions into two Shooting (color-coded red), two Playback (blue), three Set-up (yellow), one Custom Functions (orange), and one My Menu (green) menus. To move among menu tabs, press the Jump button, or tilt the Multi-controller to the left and right. To display submenus, press the Set button located in the center of the Quick Control dial. For expanding menus, use the Quick Control dial to scroll among options, and press the Set button to select and/or confirm an option. Each menu and many of the options are detailed in this chapter.

Top camera controls

The top camera controls provide ease of use so that the thumb and index finger of both the right and left hand control common adjustments quickly and without taking the camera out of shooting position as you hold it. Moving from left to right, here is a look at the top camera controls.

✦ **Mode dial.** Rotate this dial to change the Shooting modes. Shooting modes, detailed in Chapter 2, determine how much control you have over the exposure. The dial is divided between fully automatic Shooting modes such as Portrait, Landscape, and Sports modes, and semiautomatic, fully manual, and customizable modes such as Tv, Av, M, and C modes.

✦ **Hot shoe.** The hot shoe has standard dedicated flash-sync contacts for mounting a Canon EX-series Speedlite or third-party flash unit. The flash sync speed is 1/250 second or slower, or it can be fixed at 1/250 second using C.Fn I-7.

✦ **LCD Panel Illumination button.** Located at the left of the row of buttons above the LCD panel, this button turns on an amber backlight so you can see the panel options in low-light or darkness. Pressing the button once turns the LCD panel light on and pressing it again turns it off. Otherwise, the light remains illuminated for six seconds before turning off automatically. If you are using a Bulb exposure, the light turns off automatically when you press the Shutter button fully.

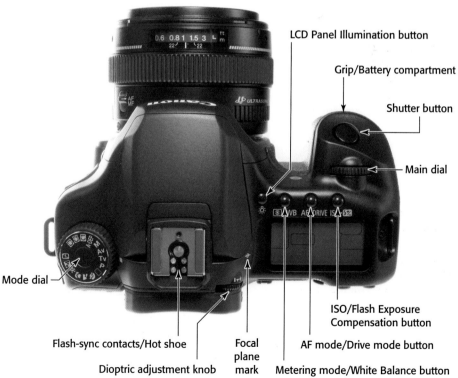

LCD Panel Illumination button

Grip/Battery compartment

Shutter button

Main dial

Mode dial

Flash-sync contacts/Hot shoe

Dioptric adjustment knob

Focal plane mark

ISO/Flash Exposure Compensation button

AF mode/Drive mode button

Metering mode/White Balance button

1.1 40D top camera controls

✦ **LCD Panel and buttons.** Located behind the Shutter button, the LCD panel buttons and the LCD panel control and display frequently used exposure and metering settings and options. Options you change on the LCD panel are displayed only on the LCD panel, except for ISO and Flash Exposure Compensation adjustments which are simultaneously displayed in the viewfinder. The settings you choose remain in effect until you change them, even after turning off the camera.

Table 1.1 shows the LCD panel buttons, options, and the dial that you use to change the settings.

 See Chapter 4 to set Custom Functions. See Chapter 3 for details on setting the white balance.

✦ **Main dial.** This dial selects a variety of settings and options. Turn the Main dial to select options after pressing an LCD panel button, to manually select an AF point after pressing the AF-point Selection/ Enlarge button, to set the aperture in Av and C modes, the shutter speed in Tv and Manual mode, and to shift the exposure program in P mode. Additionally, you can use the Main dial to scroll among Menu tabs.

✦ **Shutter button.** Pressing the Shutter button halfway sets the point of sharpest focus at the selected AF point in manual AF-point Selection mode, and it simultaneously sets the exposure based on the ISO and selected Shooting mode. Focus remains locked for approximately four seconds, after which time you have to refocus on the subject. Pressing the Shutter completely makes the exposure. In any mode except Direct Printing,

you can also half-press the Shutter button and dismiss camera menus, image playback, and recording to the CF card.

 Unless you use AutoExposure Lock or the AF-ON button in Creative Zone modes, focus and exposure are always linked to the selected AF point.

Cross-Reference See Chapter 8 for more information on using Canon Speedlites with the 40D.

Rear camera controls

The back camera controls provide quick access to the menu, various playback and image deletion controls, Picture Styles, and exposure information. They include:

✦ **Menu button.** Press the Menu button to display camera menus. To move among tabs, you can turn the Main dial or tilt the Multi-controller.

✦ **Direct Print button.** When the camera is connected with a PictBridge, Canon CP Direct, or Canon Bubble Jet Direct-enabled printer and the camera is set to Print/PTP, the Direct Print button, in conjunction with the Playback button, displays only JPEG images for cropping, layout, and direct printing.

✦ **Playback button.** Press the Playback button to display the last captured image on the LCD. The default single-image Playback display includes a ribbon of shooting information at the top of the display. Pressing the Index/Reduce button on the top-right back of the camera during playback displays a grid of images you can scroll through using the Quick Control or Main dials. Press the AF-point Selection/Enlarge button to return to single-image display.

Table 1.1
Using the Main and Quick Control Dials for LCD Panel Settings

Button	Main Dial	Quick Control Dial
Metering/WB (Metering mode/White Balance)	Metering Modes • Evaluative (35-zone TTL full-aperture metering) • Partial (9 percent at center frame) • Spot (3.8 percent at center frame) • Center-weighted Average	White Balance • Auto (3000-7000 K) • Daylight (5200 K) • Shade (7000 K) • Cloudy (6000 K) • Tungsten (3200 K) • White Fluorescent (4000 K) • Flash (6000 K) • Custom (2000-10,000 K) • K (Kelvin Temperature, 2500-10,000 K)
AF-Drive (Autofocus mode/Drive mode)	Autofocus Mode • One-shot (locks focus with a half-press of the Shutter button) • AI Focus AF (half-pressing the shutter initiates AF subject movement tracking using the center AF point) • AI Focus AF (monitors subject movement and switches to AI Servo if the camera detects subject movement)	Drive Modes • Single-shot • High-speed Continuous (6.5 fps) • Low-speed Continuous (3 fps) • Self-Timer (10 and 2 second)
ISO-Flash Exposure Compensation	ISO Options • Auto • 100 • 125 • 160 • 200 • 250 • 320 • 400 • 500 • 640 • 800 • 1000 • 1250 • 1600 • H: 3200 (with C.Fn I-3 Expansion turned on)	Flash Compensation Plus/minus 2 stops (EV) in 1/3 or 1/2-stop increments (chosen using C.Fn I-1)

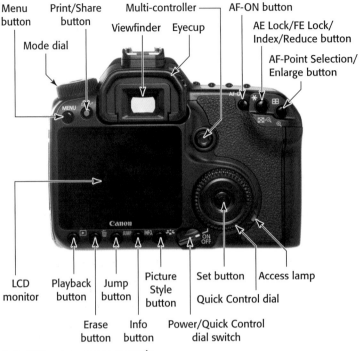

Menu button
Print/Share button
Multi-controller
AF-ON button
Viewfinder
Eyecup
AE Lock/FE Lock/ Index/Reduce button
Mode dial
AF-Point Selection/ Enlarge button

LCD monitor
Playback button
Jump button
Picture Style button
Set button
Access lamp
Quick Control dial

Erase button
Info button
Power/Quick Control dial switch

1.2 40D rear camera controls

✦ **Erase button.** Press the Erase button to display options for deleting the current or all checked images.

 Cross-Reference *Checkmarking images for batch erasure is covered in Chapter 2.*

✦ **Jump button.** When the camera menu is displayed, pressing the Jump button scrolls through menu tabs. In Playback mode, pressing this button enables jumping by 1, 10, or 100 images at a time; by screen; or by shot date. When jumping by multiple images, the camera overlays a scroll bar on the LCD image to show relative progress through the images stored on the CF card.

✦ **Info button.** Press the Info button one or more times to change the

display of images on the LCD during Playback mode. You also use the Info button to activate Picture Style parameter controls to make adjustments.

✦ **Picture Style button.** Press the Picture Style button to display the Picture Styles menu where you can change the picture style, modify the sharpness, contrast, saturation, and color tone of an existing style, or create and register up to three user-defined styles.

✦ **On/Off switch.** There are three positions on the On/Off switch. Off turns the camera off. In the first On position, the Quick Control dial has limited functionality. In the topmost On position, the Quick Control dial is fully functional.

✦ **Quick Control dial/Set button/access lamp.** Turning the Quick Control dial selects shooting-related settings on the LCD panel and scrolls among menu options. Inset within this dial is the Set button that you use to select menu options and to confirm menu selections. On the lower-right side of the Quick Control dial is an access light that glows red while images are being read to or erased from the CF card.

✦ **Multi-controller.** Above the Quick Control dial is the eight-way Multi-controller that functions as a button when pressed and as a joystick when tilted in any direction. You can use the Multi-controller to manually select an AF point after pressing the AF-point Selection/Enlarge button, select White Balance correction, scroll around an enlarged image in Playback mode, or move the trim frame when printing directly from the camera. You can use the Multi-controller to select camera menu tabs by tilting it left and right, and to move through menu options by tilting it up or down. When using the Multi-controller to manually select an AF point, you can tilt the controller in one direction and tilt again to shift to automatic AF-Point Selection mode.

✦ **AF-ON.** In Creative Zone shooting modes such as Tv, Av, and so on, pressing the AF-ON button initiates autofocusing and serves as an alternative to half-pressing the Shutter button. In Live View shooting, pressing the AF-ON button pauses Live View and drops down the reflex mirror to autofocus provided that C.Fn III-6 is enabled. Releasing the AF-ON button resumes Live View.

 Cross-Reference *C.Fn is Canon's abbreviation for Custom Functions, as detailed in Chapter 4. For details on shooting in Live View, see Chapter 5.*

✦ **AE Lock/FE Lock/Index/Reduce button.** Pressing this button sets Auto Exposure (AE) or Flash Exposure (FE) lock, display Index mode during image playback, or reduces the size of an enlarged LCD image during image playback.

✦ **AF-Point Selection/Enlarge button.** Pressing this button activates the AF points in the viewfinder and on the LCD panel so you can manually select one or all AF points. During image playback pressing this button enlarges the image. Both this button and the AE Lock button are press-and-hold buttons that are used in conjunction with the Main, Quick Control, or Multi-controller dials.

✦ **Dioptric adjustment knob.** Located beside the viewfinder, turn this knob to adjust the sharpness of the scene in the viewfinder to suit your eyesight. The range of dioptric adjustment is -3 to +1 diopters. A white mark in the center of the knob shows the movement within the range. If you wear eyeglasses when shooting, be sure to wear them when you set the dioptric adjustment. To set the dioptric adjustment, focus the lens by pressing the Shutter button halfway, and then turn the knob until the image in the viewfinder is sharp.

Front camera controls

The front of the camera is one view of the camera that photographers seldom see. But there are lamps and connections that you'll use often. The buttons and lamps, from left to right side, include the following:

Red-eye Reduction/Self-Timer lamp EF Lens mount index

Shutter button

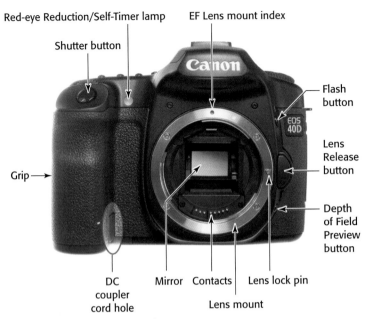

Flash
button

Lens
Release
button

Grip

Depth
of Field
Preview
button

DC Mirror Contacts Lens lock pin
coupler
cord hole Lens mount

1.3 40D front camera controls

✦ **DC coupler cord hole.** Lift up this rubber flap to access connectors including to connect the camera to household power using the optional ACK-E2 AC adapter kit, which provides a coupling unit that inserts into the battery compartment. This power option comes in handy for extended studio shooting or in the unlikely event of battery failure.

✦ **Self-Timer lamp.** This red lamp flashes to count down the seconds to shutter release when the camera is set to either of the two Self-Timer modes.

Cross-Reference *For more details on the Self-Timer modes, see Chapter 2.*

✦ **Depth of Field Preview button.** Press this button to stop down the lens diaphragm to the current aperture to preview the depth of field in the viewfinder. The larger the area of darkness in the viewfinder, the more extensive the depth of field will be. At the lens's maximum aperture, the Depth-of-Field Preview button cannot be depressed because the diaphragm is fully open. The aperture cannot be changed as long as the Depth-of-Field Preview button is depressed. You can also preview depth of field when using the Live View function.

✦ **Lens Release button.** Press this button to disengage the lens from the lens mount, and then turn the lens to the right to remove it.

Cross-Reference *The 40D uses the Canon EF lens mount and is compatible with all EF, EF-S, TS-E, and MP-E lenses. For details on Canon EF lenses, see Chapter 6.*

Camera terminals

On the side of the 40D are a set of terminals under two rubber covers. Each cover is embossed with icons that identify the terminals underneath, which include:

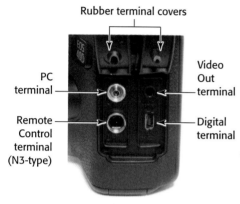

1.4 Camera terminals

✦ **PC terminal.** This threaded terminal is under the first cover closest to the front of the camera body. The terminal connects a flash unit that uses a flash sync cord. The maximum sync speed with non-Canon flash units is 1/250 second. This type of flash unit can be used in concert with a Speedlite attached to the camera's hot shoe. Use the PC Terminal to sync with a studio lighting system.

✦ **Remote Control terminal.** This N3-type terminal, also located under the first cover, connects with a remote control switch to fire the camera to avoid camera shake with long lenses or for macro shooting, or for Bulb exposures. The optional Remote Switch RS-80N3 replicates Shutter button functionality providing both half- and full depression of the shutter as well as a Shutter-release lock.

✦ **Video Out terminal.** The Video Out terminal enables you to connect the camera to a television set using the video cable supplied in the 40D box.

✦ **Digital terminal.** The Digital terminal connects the camera to a compatible printer or directly to a computer to download images. The cable for direct printing comes with the printer and must support PictBridge, PictBridge and CP Direct, PictBridge and Bubble Jet Direct, CP Direct only, or Bubble Jet Direct only.

Side and bottom camera features

On the opposite side of the terminals is the CF card slot and CF card eject button with standard insertion and ejection functionality. The bottom of the camera includes the release latch for the battery compartment, tripod socket, and the cover for the CR2016 lithium date and time battery. The estimated life of the date and time battery is five years. In addition, the bottom of the camera has an Extension system terminal used in conjunction with Canon's Wireless File Transmitter, which is sold separately.

Lens controls

All Canon lenses provide both autofocus and manual focusing functionality via the AF/MF (Autofocus/Manual Focus) switch on the side of the lens. If you choose MF, the 40D provides focus assist, shown in the viewfinder, to confirm sharp focus. When sharp focus is achieved, the Focus confirmation light in the viewfinder burns steadily and the camera emits a focus confirmation beep.

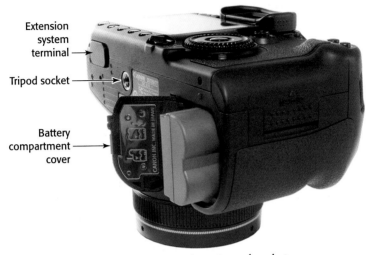

Extension system terminal

Tripod socket

Battery compartment cover

1.5 Bottom camera covers, compartments, and sockets

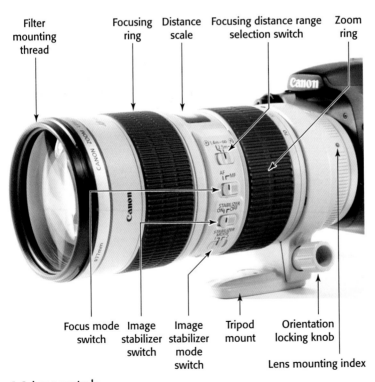

Filter mounting thread

Focusing ring

Distance scale

Focusing distance range selection switch

Zoom ring

Focus mode switch

Image stabilizer switch

Image stabilizer mode switch

Tripod mount

Orientation locking knob

Lens mounting index

1.6 Lens controls

Depending on the lens, additional controls may include the following:

✦ **Focusing distance range selection switch.** This switch determines and limits the range that the lens uses when seeking focus to speed up autofocusing. The focusing distance range options vary by lens.

✦ **Image stabilizer switch.** This switch turns optical image stabilization on or off. Optical Image Stabilization (IS) corrects vibrations at any angle when handholding the camera and lens. IS lenses typically allow sharp handheld images up to two or more f-stops over the lens's maximum aperture.

✦ **Image stabilizer mode switch.** Offered on some telephoto lenses, this switch has two modes: one mode for standard shooting and one mode for vibration correction when panning at right angles to the camera's panning movement.

✦ **Focusing ring and zoom ring.** The lens focusing ring can be used at any time regardless of focusing mode. On zoom lenses, the zoom ring zooms the lens in or out to the focal lengths marked on the ring.

✦ **Distance scale and infinity compensation mark.** This shows the lens's minimum focusing distance to infinity. The infinity compensation mark compensates for shifting the infinity focus point resulting from changes in temperature. You can set the distance scale slightly past the infinity mark to compensate.

Cross-Reference *For more detailed information on Canon lenses, see Chapter 6.*

Viewfinder display

The 40D offers an eye-level pentaprism viewfinder that displays approximately 95 percent of the vertical and horizontal coverage. Etched into the viewfinder are nine AF points. When you manually change AF points, the viewfinder highlights each AF point in red after you press the AF-point Selection/Enlarge button, and then tilt the Multi-controller or turn the Main or Quick Control dial. When you press the Shutter button halfway down to focus, the selected AF point is shown in red in the viewfinder. The spot metering circle, which is approximately 3.8 percent of the viewfinder at center, is also etched in the center of the focusing screen.

The viewfinder displays exposure information, as shown in figure 1.7. The amount of information shown in the viewfinder depends on the current camera settings. For example, if you are not using the flash, then the Flash-ready icon isn't seen in the viewfinder.

Camera menus

While the LCD panel and the controls on the body of the 40D provide much of the functionality for standard shooting, other important functions are offered in the camera menus. For quick reference, Table 1.2 shows the menus and the options for each camera menu.

The camera menus change based on the Shooting mode that you choose. In Basic Zone modes such as Portrait, Landscape, Sports, and so on, not all of the menus are available. In Creative Zone modes such as P, Tv, Av, M, and A-DEP, the full menus shown in Table 1.2 are available.

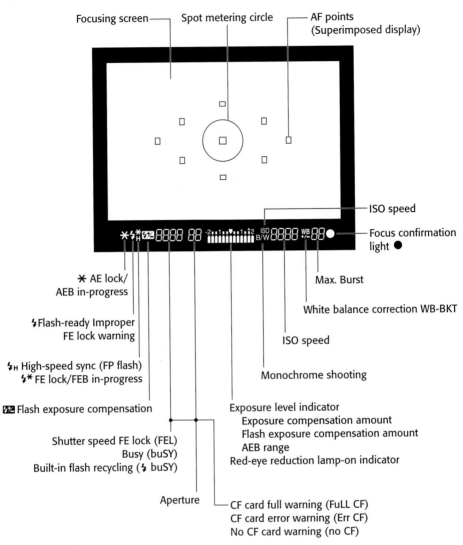

Focusing screen

Spot metering circle

AF points
(Superimposed display)

ISO speed

Focus confirmation
light ●

✱ AE lock/
AEB in-progress

Max. Burst

White balance correction WB-BKT

⚡ Flash-ready Improper
FE lock warning

ISO speed

⚡H High-speed sync (FP flash)
⚡✱ FE lock/FEB in-progress

Monochrome shooting

⚡⚹ Flash exposure compensation

Exposure level indicator
Exposure compensation amount
Flash exposure compensation amount
AEB range
Red-eye reduction lamp-on indicator

Shutter speed FE lock (FEL)
Busy (buSY)
Built-in flash recycling (⚡ buSY)

Aperture

CF card full warning (FuLL CF)
CF card error warning (Err CF)
No CF card warning (no CF)

1.7 40D viewfinder display

Tip

Become familiar with the camera menus to avoid spending time hunting for a menu option while you are shooting. I think of the Shooting 1 menu as basic camera settings; Shooting 2 as the exposure modification and color menu; and so on. You can set up My Menu to access your most frequently used menu options along with your favorite Custom Functions.

Cross-Reference

When you begin using the 40D, the camera is set to the factory default settings shown in Table 2.4 in Chapter 2. As you use and reset the camera and shooting settings, most settings are retained until you change them. If you want to quickly return to the camera defaults, you can restore settings as detailed in Chapter 2. For details on customizing the 40D, see Chapter 4.

Table 1.2
Camera Menus

Menu	Commands	Options
Shooting 1 menu (Red)	Quality	Large /Fine, Large /Normal, Medium /Fine, Medium /Normal, Small /Fine, Small /Normal, RAW, sRAW, sRAW and any of the JPEG image quality settings, or RAW + any one of the JPEG image quality settings
	Red-eye On/Off	Off/On
	Beep	On/Off
	Shoot without a card	On/Off
	Review time	Off, 2 sec., 4 sec., 8 sec., Hold
Shooting 2 menu (Red)	AEB (Auto Exposure Bracketing)	1/3-stop increments by default, up to plus/minus 2 stops
	White balance	Auto (AWB), Daylight, Shade, Cloudy, Tungsten, White Fluorescent, Flash, Custom (2000 to 10000K), Color Temperature (2500 to 10000K)
	Custom WB	Sets a manual white balance
	WB SHIFT/BKT (White Balance shift/bracketing)	White balance correction using Blue/Amber (B/A) or Magenta/Green (M/G) color bias; white-balance bracketing using B/A and M/G bias, available at plus/minus 3 levels in one-level increments
	Color space	sRGB, Adobe RGB
	Picture Style	Standard, Portrait, Landscape, Neutral, Faithful, Monochrome, User Defined 1, 2, and 3
	Dust Delete Data	Locates and records dust on the image sensor so you can use the data in Canon's Digital Photo Professional program to erase dust spots on images
Playback 1 Menu (Blue)	Protect images	Protect images from being deleted
	Rotate	Rotate vertical image from horizontal to vertical orientation only during image playback
	Erase Images	Delete images one-by-one or deletes all check-marked images as a group
	Print Order	Select images to be printed (Digital Print Order Format or DPOF)

Continued

Table 1.2 *(continued)*

Menu	Commands	Options
	Transfer order	Select images to download to a computer as a group
	External media backup	Available when the wireless transmitter accessory (WFT-E3A) Wireless Transmitter is used along with external media such as a storage device or computer. Allows images to be stored on external media
Playback 2 Menu (Blue)	Highlight alert	Disabled/Enable. When enabled, overexposed highlights blink in all image-playback displays
	AF-point disp.	Disabled/Enable. Superimposes the AF point that achieved focus on the image during playback
	Histogram	Brightness, RGB. Brightness displays a tonal distribution histogram. RGB displays separate Red, Green, and Blue color channel histograms
	Auto play	Hands-free slide-show playback of images on the LCD
Set-up 1 Menu (Yellow)	Auto power off	1, 2, 4, 8, 15, 30 minutes, Off
	File numbering	Continuous, Auto reset, Manual reset
	Auto Rotate	On for camera and computer, On for camera only, Off. Turns vertical images to upright orientation for the camera's LCD and computer display, or only for the camera's LCD display
	Info button	Normal disp., Camera set, Shoot func. Normal displays the all camera settings. Camera set. displays only exposure settings. Shoot func. enables you to press and change any of the buttons above the LCD panel and set the AF point while watching the large-text LCD
	Format	Initializes and erases images on CF card
	WFT Settings	Displays the wireless file transfer settings when an accessory Canon WFT-E3A is in use
	Recording func.+ media select	Displayed when external recording media such as a portable hard drive is used and the accessory Canon WFT-E3A attached to the camera
Set-up 2 Menu (Yellow)	LCD brightness	Seven adjustable levels of brightness
	Date/Time	Set the date (year/month/day) and time (hour/minute/second)

Menu	Commands	Options
	Language	Choose from 18 language options
	Video system	NTSC/PAL
	Sensor Cleaning	Auto cleaning, Clean now, Clean manually
	Live View function settings	[Live View shoot] Disable/Enable
		[Grid display] On, Off
		[Silent shoot.] Mode 1, Mode 2, Disable
		[Metering timer] 4, 16, 30 sec., 1, 10, 30 min.
	Flash control	Flash firing, Built-in flash func. setting, External flash func. setting, External flash C.Fn setting, Clear ext. flash C.Fn set
Set-up 3 Menu (Yellow)	Camera user setting	Save current camera settings to C1, C2, or C3, and recall them by selecting that C mode on the Mode dial
	Clear all camera settings	Restores the camera's default settings. Does not restore Custom Function to their original default settings
	Firmware Ver. (Firmware Version)	Displays the existing firmware version number, and enables you to update the firmware
Custom Functions Menu (Orange)	C.Fn I: Exposure	Displays Custom Functions related to exposure such as exposure level increments, ISO, bracketing sequence, ISO expansion to 3200, safety shift, and flash sync speed in Av mode
	C.Fn II: Image	Displays Custom Functions related to the image noise and tone including long exposure noise reduction, high ISO speed noise reduction, and highlight tone priority
	C.Fn III: Autofocus/ Drive	Displays Custom Functions related to autofocus and drive operation including lens drive when AF is impossible, lens AF Stop button function, AF-point Selection method, superimposed display, AF-assist beam, AF during Live View shooting, and mirror lockup
	C.Fn IV: Operation/ Others	Displays Custom Functions related to camera controls including Shutter button/AF-ON button, AF-ON/AE lock button switch, Set button during shooting, setting the dial direction for Tv and Av modes, changing to a different focusing screen, adding original data decision data, and Live View exposure simulation

Continued

Table 1.2 *(continued)*

Menu	Commands	Options
	Clear all Custom Func. (C.Fn)	Restores all of the camera's default Custom Function settings
My Menu (Green)	My Menu settings	Save frequently used menus and Custom Functions

Setting the Date and Time

While setting the date and time seems like a basic task that photographers would do first when setting up the 40D, I include it here for those who want to begin setting up a standard workflow. If you're new to digital photography, you may have heard the term *workflow* and wondered why it's important. As the term suggests, workflow means setting up and sequencing your work so that consistent standards are applied and so that all steps from shooting, through editing, printing, and archiving are as efficient and consistent as possible. Workflow consists of many interrelated processes and setting the date and time impacts your workflow in numerous ways. The image date and time figures into everything from file naming and file sorting on the computer, to file storage and backup schemes. Ensuring that the date and time are set correctly goes a long way toward maintaining a smooth and consistent workflow.

To set the date and time on the 40D, follow these steps:

1. **Press the Menu button on the back of the camera, and then press the Jump button until the Set-up 2 (yellow) menu appears.**

2. **Turn the Quick Control dial to highlight Date/Time, and then press the Set button.** The camera displays the date and time options with the month option highlighted.

Using Image Dates in the Workflow

When you set the date and time that data travels with each image file as part of the *metadata*. Metadata is a collection of all the information about an image that includes the filename, date created, size, resolution, color mode, camera make and model, exposure time, ISO, f-stop, shutter speed, lens data, and white balance setting. Metadata and *EXIF*, which is a particular form of metadata, are terms that are often used interchangeably.

Because you have access to the metadata in Adobe Bridge, Photoshop, Canon Digital Photo Professional, and other editing programs, you can batch rename files to include the date in the filename. File-naming strategies vary by photographer, but most strategies incorporate the date in both folder and file naming.

3. **Press the Set button, and then turn the Quick Control dial to change the month.** Turning the Quick Control dial clockwise moves to a higher number, and vice versa.

4. **Press the Set button to confirm the change.**

5. **Turn the Quick Control dial to highlight the Day option, and then press the Set button.**

6. **Turn the Quick Control dial to change the day, and then press the Set button to confirm the change.** Repeat Step 5 to change the year, minute, second, and date/time format options, and then press the Set button after each change. You can also choose to show the date as mm/dd/yy, dd/mm/yy, or yy/mm/dd by turning the Quick Control dial to select mm/dd/yy, and then pressing the Set button. Turn the Quick Control dial to scroll through the date/time options, and then press the Set button after selecting the option you want.

7. **When all options are set, turn the Quick Control dial to select OK, and press the Set button.**

 Note *If you travel to different time zones, you may want to change the date and time to reflect those of the area where you are shooting.*

Choose the File Format and Quality

The file format you choose determines whether images are stored as JPEGs, in RAW, in sRAW, in both RAW and JPEG format, or as sRAW and JPEG. And the quality

level you choose determines not only the number of images you can store on the media card but also the overall quality of the images, and the sizes at which you can enlarge and print images.

RAW versus JPEG format

If you are new to digital photography, or if you're familiar with digital photography but have always shot JPEG images, it's worthwhile to summarize the differences between JPEG and RAW capture.

Note *RAW and JPEG images are saved using the same file number in the same folder. They are distinguished by the file extension.*

JPEG capture

JPEG, which stands for Joint Photographic Experts Group, is a *lossy* file format, meaning that it discards some image data during the process of compressing image data to save space on the media card. In addition, when you edit JPEG images on the computer, each time you save the file during editing, some image data is discarded. As the compression ratio increases, more of the original image data is discarded and the image quality degrades accordingly. On the 40D, compression ratios are denoted by Fine and Normal settings. For example, Large/Fine means a low compression ratio where less data is discarded, but the file size on the CF card is larger. Large/Normal denotes a higher compression ratio where more image data is discarded, but the file size on the CF card is smaller. The difference between the Fine and Normal settings cuts the file size almost in half. The Normal option with higher compression enables you to get more images on the card, but it also means that more image data is being discarded during compression.

In addition, when you shoot in JPEG mode, images are converted from 14-bit files with 16,384 colors per channel to 8-bit files that offer a scant 256 colors per channel. Plus JPEG images are processed — essentially pre-edited — inside the camera before they are stored on the media card. As a result of the low bit depth and the preprocessing, you have far less latitude in editing JPEG images on the computer should you want to make edits. However, the JPEG format enjoys universal acceptance, which means that the images can be displayed on any computer, opened in any image-editing program, and can be printed directly from the camera or the computer.

 Note *In Basic Zone modes, only JPEG image-recording quality options are offered. RAW and sRAW image-recording options are available only in Creative Zone modes (P, Tv, Av, M, and A-DEP).*

RAW capture

RAW files are in a proprietary format that does not discard image data to save space on the CF card. Because the images are a proprietary format, they can be viewed only in programs and on operating systems that support the file format. Unlike JPEG images, RAW capture saves the data that comes off the image sensor with minimal internal camera processing. Many of the camera settings have been noted but not applied to

What Is Bit-Depth and Should You Care?

A digital picture is made up of many pixels. Each pixel is made up of a group of bits. A bit is the smallest unit of information that a computer can handle. In digital images, each bit stores information that when aggregated with other pixels and color information, provides an accurate representation of the picture.

Since digital images are based on the Red, Green, Blue (RGB) color model, an 8-bit digital image has eight bits of color information for red, eight bits for green, and eight bits for blue. This gives a total of 24 bits of data per pixel (8 bits x 3 color channels). Because each bit can be one of two values, either 0 or 1, the total number of possible values is 2 to the 8th power, or 256 per color channel.

In the RGB color model, the range of colors is represented on a continuum from 0 (black) to 255 (white). On this continuum, an area of an image that is white (with no image detail) is represented by 255R, 255G, and 255B. An area of the image that is black (with no detail) is represented by 0R, 0G, 0B.

An 8-bit file offers 256 possible colors per channel. A 14-bit file, offered with 40D RAW capture, provides 16,384 colors per channel. And then if you save the 14-bit RAW file as a 16-bit file during RAW conversion, the image provides 65,000 colors per channel.

This is important because the higher the bit depth in the file, the finer the detail, the smoother the transition between tones, and the higher the dynamic range (the ability of the camera to hold detail in both highlight and shadow areas) in the final converted and edited image. High-bit-depth images also provide much more latitude in editing images.

the data in the camera, so you have the opportunity to make changes to key settings such as exposure, white balance, contrast, and saturation after the capture is made. The only camera settings that are applied to RAW files in the camera are ISO, shutter speed, and aperture.

This means that during RAW image conversion, you can make significant adjustments to the image data. Plus, you take full advantage of the 40D's new 14-bit images by processing and saving images as 16-bit-per-channel TIFFs in conversion programs such as Canon's Digital Photo Professional or Adobe Camera Raw.

Essentially, when you choose RAW capture, you postpone the processing of image data, and you retain the ability to decide for yourself whether to preserve or discard tonal levels that may be discarded with JPEG capture.

sRAW capture

The 40D also includes an sRAW image-recording quality option. sRAW is an apt abbreviation for Small RAW. These files, which are slightly larger than half the size of a standard RAW file, are approximately 7.1 MB while a full-resolution RAW file is 12.4MB. But sRAW files offer all the conversion advantages that standard RAW files offer including the ability to change key settings such as adjusting brightness, white balance, contrast, and saturation. You can also choose to shoot sRAW along with any of the JPEG image-recording quality options.

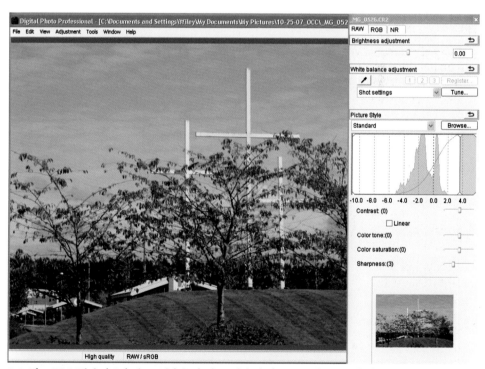

1.8 The EOS Digital Solution Disk includes Digital Photo Professional, shown here, that enables you to process RAW images and adjust brightness, contrast, saturation, and even to change the Picture Style after the image is captured.

The choice of format is yours, of course, and your decision will doubtless include factors such as convenience, image quality, the number of images you need in Burst mode, and the ability to make changes after capturing the image.

Cross-Reference *If you want to learn more about shooting and converting RAW images, read Chapter 10.*

Table 1.3 shows the file format and quality options that you can choose and the effect on images shot in Burst mode.

1.9 This and the next image show some of the differences between JPEG and RAW capture. This is a JPEG image with the camera set to Full Auto mode which uses automatic white balance (AWB). The color is characteristically cool and the image contrast is high.

1.10 By contrast, this image was taken in RAW capture. Using Canon's Digital Photo Professional, I was able to set the white balance by clicking on the white background so that the color accurately reflects the actual light in the scene and the overall image brightness.

Table 1.3
40D File Quality and Burst Rate

Image Quality	Approximate File Sizes	Approx. Number of Shots (1GB card)	Maximum Burst High-Speed	Low-Speed
L (Large/Fine)	3.5	274	75	205
L (Large/Normal)	1.8	523	171	523
M (Medium/Fine)	2.1	454	140	454
M (Medium/Normal)	1.1	854	303	854
S (Small/Fine)	1.2	779	271	779
S (Small/Normal)	0.7	1451	625	1451

Image Quality		Approximate File Sizes	Approx. Number of Shots (1GB card)	Maximum Burst	
				High-Speed	Low-Speed
RAW	**12.4**	1.1	76	17	20
RAW +	**L (Large/Fine)**	12.4+3.5=15.9	59	14	16
	L (Large/Normal)	12.4+1.8=14.2	66	14	16
	M (Medium/Fine)	12.4+2.1=14.5	65	14	16
	M (Medium/ Normal)	12.4+1.1=13.5	70	14	16
	S (Small/Fine)	12.4+1.2=13.6	69	14	16
	S (Small/Normal)	12.4+0.7=13.1	72	20	16
sRAW		7.1	135	17	34
sRAW +	**L (Large/Fine)**	7.1+3.5=10.6	90	17	21
	L (Large/Normal)	7.1+1.8=8.9	107	17	22
	M (Medium/Fine)	7.1+2.1=9.2	103	17	22
	M (Medium/ Normal)	7.1+1.1=8.2	116	17	23
	S (Small/Fine)	7.1+1.2=8.3	115	17	24
	S (Small/Normal)	7.1+0.7=7.8	124	17	25

Note *Fine and Normal denote different levels of compression for JPEG images. A lower rate of compression is applied to Fine than to Normal. The lower the compression rate, the better the image quality and also the larger the file size.*

Note *If you're shooting in Monochrome Picture Style, image file sizes are smaller than indicated in this table.*

Setting File Numbering

Many photographers use the Default option of continuous file numbering offered on the 40D. Like the date and time, continuous file numbers become an integral part of the image-naming scheme for filing, sorting, and archiving images and help prevent having duplicate filenames of the same file type on the computer. If, however, you prefer another naming scheme, the 40D enables you to reset file numbering automatically or manually.

File numbering is assigned from 0001 to 9999. File names begin with the designation IMG_ followed by the image number and file extension: .jpg for JPEG files; or _MG_ followed by the image number and file extension .CR2 for RAW and sRAW images.

Continuous numbering

With Continuous numbering, the default option on the 40D, images are numbered sequentially using a unique four-digit number from 0001 to 9999. Unique filenames make managing and organizing images on the computer easy because it ensures that images of the same file format do not have duplicate filenames.

If you insert a CF card into the camera that already has images on it taken with the 40D, then the camera usually starts numbering with the highest image number that is either stored on the card or that was captured last. To ensure that file numbering remains continuous when you insert a CF card, it's best to ensure that the CF card is empty or has been formatted.

In addition to fitting nicely with my overall file-numbering scheme, I prefer continuous file numbering for two additional reasons: the unique filenames lessen the likelihood of having duplicate filenames on the computer, which makes folder management on the computer easier; and it tracks the number of images up to 9999 per folder, provided that a clean CF card is inserted each time.

 Note *The 40D shutter is rated at approximately 100,000 actuations or cycles. This rating provided by Canon is an indication of the life expectancy of the shutter mechanism of the camera.*

Auto Reset

If you like to organize images by media card, Auto Reset may be a useful option. With Auto Reset, file numbering restarts each time you insert a newly formatted CF card. Folder numbers begin with 100, and file numbering begins with 0001, unless the CF card contains a previous image, in which case, numbering begins with the highest file number in the highest numbered folder on the CF card. However, with the Auto Reset option, multiple images will have the same filename. Because of duplicate filenames, you must use scrupulous folder management on the computer to avoid overwriting images with the same name.

Manual Reset

The third option is to manually reset file numbering. With this option, a new folder is automatically created with the next higher folder number than the last, and file numbering restarts with 0001. Subsequent images are saved in the new folder. After the manual reset, whichever file-numbering method you previously used (Continuous or Auto Reset) takes effect when begin shooting again.

Unlike other EOS cameras, the 40D does not offer a direct way to create multiple folders on the CF card. In the case of Manual Reset for file numbering, the camera automatically creates a new folder. You could use this option simply to force the creation of new folders on the CF card. If you do this, the folders are numbered sequentially with three digits beginning with 100 and continuing through 999. Otherwise, the camera uses a single folder to store images.

To change the file numbering method on the 40D, follow these steps:

The 999 and 9,999 Error Message

The maximum number for folders is 999, and the maximum number for images within a single folder is 9,999. This means that if the camera gets to folder number 999, or if image file numbers within any folder reach 9,999, you get an error message on the camera, and you cannot continue shooting.

Getting this error message may sound innocuous, but it brings shooting to a standstill. Recently, I was shooting a live event with another EOS camera. The camera reached the 9,999 image file number minutes after I had inserted an empty CF card into the camera. At image number 9,999, the camera stopped shooting. The last thing on my mind at that moment was the maximum file number. All I could think was that there was almost 2GB of space on a perfectly good CF card. As shots passed by, I finally remembered the numbering limit and replaced the card. I hope that you'll keep this experience in mind so that when you reach image number 9,999, you'll quickly remember to replace the CF card.

1. **Press the Menu button, and then press the Jump button until the Set-up 1 (yellow) menu appears.**

2. **Turn the Quick Control dial to highlight File numbering, and then press the Set button.** The camera displays the File numbering options with Continuous highlighted as the default setting.

3. **Turn the Quick Control dial to highlight the option you want.**

4. **Press the Set button.** Except for Manual Reset, the option you set remains in effect until you change it.

Shooting Modes

Central to using the 40D is understanding the shooting modes offered on the Mode dial. The 40D offers both the basic point-and-shoot modes, referred to as Basic Zone modes, as well as the traditional shooting semiautomatic and manual modes, referred

to as Creative Zone modes In addition, the 40D features three customizable Camera User setting modes, denoted as C1, C2, and C3 on the Mode dial.

 Camera User Setting modes, or C modes, are detailed in Chapter 4.

✦ **Basic Zone modes.** These modes set all exposure settings, the drive mode, the AF point(s), and the built-in flash fires automatically for quick, point-and-shoot type photography. Basic Zone modes are Full Auto, Portrait, Landscape, Close-up, Sports, Night Portrait, and Flash Off. Each mode is represented by a pictorial icon on the Mode dial except for Full Auto, which is denoted by a green rectangle.

✦ **Creative Zone modes.** These modes offer either semiautomatic or fully manual camera control so that you control one or all of the exposure settings. In these modes, you can control the drive mode,

choose either automatic AF point or manual AF point selection, and control the use of the built-in flash. The Creative Zone modes are: Program AE (P), Shutter-priority AE (Tv), Aperture-priority AE (Av), Manual exposure (M), and Automatic Depth of Field AE (A-DEP).

✦ **Camera User settings**. Camera User settings are denoted as C1, C2, and C3 on the Mode dial. In each of these Mode dial positions, you can set, register, and recall your favorite camera settings to one or more of these modes. C modes provide unprecedented ability to save camera settings for specific shooting venues such as a sports arena, a specific wedding chapel, or a studio.

 Chapter 4 details how to program the Camera User setting modes.

 Throughout the book, I refer to shooting modes using the designations Basic Zone and Creative Zone modes.

To switch to any of the shooting modes, turn the Mode dial to line up the mode you want with the white mark on the camera body next to the dial. Unless you've registered camera settings for C1, C2, and C3, these modes are programmed with the camera's default setting for image quality, metering, automatic ISO, and so on. To use these modes effectively, you must first register your favorite camera settings.

Basic Zone modes

The Basic Zone modes are designed to be quick and easy to use by choosing the type scene that you're shooting. For example, if you're photographing a landscape, the Landscape mode automatically sets classic exposure settings for this type of scene. The advantage of these modes is that you don't have to understand exposure or set any controls except the Mode dial. The downside is that the camera takes full control, which means that you can't set the focus point where you want, you cannot change any exposure settings, and the camera automatically fires the flash in some modes. These modes are a handy way to get started using the 40D and get classic photographic looks.

For example, if you want a softly blurred background for a portrait, select Portrait mode. The camera sets a wide aperture (f-stop) to blur the background, selects the Portrait Picture style to enhance skin tones, and fires the flash automatically if it detects low light, among other settings.

In all Basic Zone modes, the camera automatically sets the image quality to JPEG, although you can select the level of JPEG quality. The camera also automatically selects the following:

✦ ISO

✦ sRGB color space

✦ Automatic AF point selection

✦ White balance

✦ Evaluative metering

✦ Automatic flash depending on the ambient light

Live View shooting is not available in any of the Basic Zone modes.

 Live View shooting is detailed in Chapter 5.

Full Auto mode

In Full Auto mode, the camera automatically sets the aperture, shutter speed, ISO, drive mode, autofocus mode, white balance, and Picture Style. In short, Full Auto mode provides point-and-shoot functionality.

Because the camera sets everything, this appears to be a good mode for quick snapshots. However, the camera defaults to using the flash, even in scenes where you may not want it. In addition, the camera too often sets an unnecessarily aggressive ISO, usually starting at ISO 400, even in bright light.

1.11 This image was taken in Full Auto mode. The camera fired the flash automatically and set the AF points putting the point of sharpest focus toward the bottom of the keyboard. The camera's automatic exposure was ISO 400, f/4.0, 1/60 sec. using an EF 100mm f/2.8 USM lens.

Also in Full Auto mode, the camera automatically selects the Automatic AF point(s). It may choose a single AF point—typically set on an area of the subject that is closest to the lens and that has readable contrast. Or it may select two or more AF points. The camera displays the selected AF points in red in the viewfinder so that you can see where the camera will set the point of sharpest focus. If the subject-to-camera distance changes, the camera automatically switches to AI Servo AF mode which maintains focus by tracking subject movement.

> **Tip** *If the camera doesn't set the point of sharpest focus where you want, you can try to force it to choose a different AF point by moving the camera position slightly one or more times. If you want to control where the point of sharpest focus is set in the image, then it is better to switch to a Creative Zone mode and set the AF point manually.*

In Full Auto mode, the camera also sets Single-shot drive mode and Standard Picture Style. You can choose to use the 10-second Self-Timer drive mode.

> **Cross-Reference** *Chapter 3 details the preset Picture Styles as well as your options for customizing Picture Styles.*

Portrait mode

In Portrait mode, the 40D sets a wide aperture that makes the subject stand out against a softly blurred background. The 40D also switches to Portrait Picture Style to enhance the subject's skin tones. This mode works well for quick portraits in good light. In low-light scenes, the camera automatically fires the flash, which may or may not be the effect you want in the portrait. While flash can create an unnatural and hard look for portraits, the flash performance on the

40D is much improved over previous EOS models. The flash output typically balances nicely with the ambient light to create a fill-flash look rather than flooding the subject with too much artificial-looking light. You can optionally turn on Red-eye reduction. In Portrait mode, the camera automatically selects Low-speed continuous drive mode at 3 fps. You can choose to use the 10-second Self-Timer drive mode.

1.12 This image was taken in Portrait mode. The camera's automatic exposure was ISO 400, f/4.5, 1/750 sec.

As with other programmed modes, you can use scene modes for a variety of other types of subjects. For example, Portrait mode works well for nature and still-life photos indoors and outdoors.

In Portrait mode, the camera automatically selects the AF point(s). When the camera chooses the AF point, it looks for several things such as points where lines are well defined, the object that is closest to the lens, and the point of strongest contrast. However, the subject's eyes are where the point of sharpest focus should be in a portrait and eyes often do not fit these criteria. If you can't force the camera to refocus on the eyes, choose a Creative Zone mode instead, such as Av, set a wide aperture, and then manually select the AF point that is over the subject's eyes.

Landscape mode

In Landscape mode, the 40D chooses a narrow aperture to ensure that background and foreground elements are acceptably sharp and that the fastest shutter speed possible, depending on the amount of light in the scene, is used. This mode works well not only for landscapes but also cityscapes, and for portraits of large groups of people.

In lower light, the camera uses slower shutter speeds to maintain a narrow aperture for good depth of field and increases the ISO. As the light fades, watch the viewfinder or LCD panel to monitor the shutter speed. If the shutter speed is 1/30 second or slower, and if you're using a telephoto lens, steady the camera on a solid surface or use a tripod. In Landscape mode, the camera automatically sets One-shot autofocus with automatic autofocus point (AF) selection, Single-shot drive mode, Flash-off mode, and Landscape Picture Style. You can choose to use the 10-second Self-Timer drive mode.

1.13 This image was taken in Landscape mode using the Landscape Picture Style. The camera's automatic exposure was ISO 100, f/5.6 at 1/125 sec. using an EF 24-70mm f/2.8L USM lens.

Close-up mode

In Close-up mode, the 40D allows a close focusing distance and sets a wide aperture. It chooses One-shot drive mode and the Standard Picture Style. You can enhance the close-up effect of a close-up image further by using a macro lens. If you're using a zoom lens, zoom to the telephoto end of the lens when shooting in this mode. For the best images, focus at the lens's minimum focusing distance. The easiest way to determine the minimum focusing distance is to listen for the beep that confirms sharp focus or watch for the focus confirmation light in the viewfinder. If you don't get confirmation, move back slightly, refocus, listen for the beep and watch for the focus confirmation light. Repeat this process until the camera confirms that focus has been achieved.

In Close-up mode, the camera automatically sets One-shot autofocus with automatic autofocus point (AF) selection, Single-shot drive mode, Automatic flash with the option to turn on red-eye reduction, and Standard Picture Style and Automatic White Balance. In this mode, you can choose to use the 10-second Self-Timer drive mode.

Sports mode

In Sports mode, the 40D freezes subject motion by setting as fast a shutter speed as the ambient light allows. While this mode is designed for action and sports photography, you can use it in any scene where you want to freeze subject motion, such as the motion of a moving child or a pet. This can be a useful mode for shooting events and receptions.

1.14 This image was taken in Close-up mode with the Standard Picture Style. The camera's automatic settings were ISO 400, f/5.6 at 1/160 sec. using an EF 24-70mm f/2.8L IS USM lens.

1.15 This image was taken in Sports mode using the Standard Picture Style. The camera's automatic settings were ISO 400, f/4.0 at 1/500 sec. using an EF 24-70mm f/2.8L USM lens.

In this mode, the 40D automatically focuses on the subject and tracks the subject's movement until good focus is achieved, which is confirmed with a low beep. If you continue to hold the Shutter button down, the camera maintains focus for continuous shooting. In Sports mode, the camera automatically sets AI Servo AF mode with automatic autofocus point (AF) selection, High-speed continuous drive mode at 6.5 fps, Flash off, and Standard Picture Style. You can choose to use the 10-second Self-Timer drive mode.

Night Portrait mode

In Night Portrait mode, the 40D combines the flash to correctly expose the person with a slow sync speed to correctly expose the background. Because this mode uses a longer exposure, the subject should remain still during the entire exposure to avoid blur. Be sure to use a tripod to take night portraits.

This mode is best used when people are in the picture rather than for general night shots because the camera sets a wide aperture that softly blurs the background. In Night Portrait mode, the camera automatically sets One-shot autofocus with automatic autofocus point (AF) selection, Single-shot drive mode, automatic flash with the ability to turn on Red-eye reduction, and Standard Picture Style. You can choose to use the 10-second Self-Timer drive mode.

Flash Off mode

In Flash Off mode, the 40D does not fire the built-in flash or an external Canon Speedlite regardless of how low the scene light is. When you are using Flash-off mode in low-light scenes, be sure to use a tripod. This is the mode to use in scenes where flash is prohibited and when the subject is out of range of flash coverage. In Flash Off mode, the camera automatically sets AI Focus AF with automatic autofocus point (AF) selection, and Single-shot drive mode. You can choose to use the 10-second Self-Timer drive mode.

Creative Zone modes

Creative Zone modes offer semiautomatic or manual control over some or all exposure settings. This zone includes two modes, Program AE and A-DEP, which offer a higher degree of automation without sacrificing complete control of the camera as Basic Zone modes do. The other three Creative Zone modes, Aperture-priority AE, Tv Shutter-priority AE, and Manual exposure mode, put full or partial creative control in your hands.

Live View shooting, detailed in Chapter 5, is available in all Creative Zone modes.

Program AE

Program AE mode, denoted as P on the Mode dial, is an automatic but shiftable mode. Shifting means that you can change the aperture by turning the Main dial, and the camera automatically sets the shutter speed to an equivalent exposure. For example, if the camera initially sets the exposure at f/2.8 at 1/30 second, and you turn the Main dial one click to the left to shift the program, the exposure shifts to f/3.2 at 1/20 second. Turning the Main dial to the right results in a shift to f/4.0 at 1/15 second, and so on.

An advantage of P mode is the ability to control the depth of field and/or shutter speed with a minimum of manual exposure adjustments. When you shift the exposure and make the picture, the camera then automatically reverts back to the automatic settings for the next image. Program AE can't be used with the flash.

In Program AE mode, you can set the image quality, color space, ISO, White Balance, and the Drive, Metering, and autofocus modes.

P mode is the mode that makes sense for grab shots at a wedding, event, and for personal family snapshots. P mode offers the advantage of semi-automated shooting and/or quickly shifting to a more desirable aperture. Plus, this mode supports RAW or sRAW images, and your preferred color space.

1.16 This image was taken in P mode using a Canon EF 85mm f/1.2L II USM lens with an extension tube. I wanted to capture the cross with a gentle blur, which is relatively easy using a super-wide aperture. Exposure: ISO 100, f/1.8 at 1/160 second with one stop of exposure compensation to compensate for the extension tube.

1.17 Using P mode allowed me to quickly get an equivalent exposure at f/5.0 to increase the depth of field slightly. Exposure: ISO 100, f/5.0, 1/25 sec. with one stop of exposure compensation. This image was made using primarily north light (with a bit of east light) that provides a singular glow and clarity to the subject.

Shutter-Priority AE

Shutter-Priority AE mode, denoted as Tv on the Mode dial, is the semiautomatic mode that enables you to set the shutter speed while the camera automatically sets the aperture. And with the 40D's mechanical, focal-plane shutter and electronic shutter speed control, you can choose from 1/8000

to 30 seconds and Bulb. (Bulb keeps the shutter open as long as the Shutter button is depressed.)

In Tv mode, you set the shutter speed by turning the Main dial. When you press the Shutter button halfway, the camera calculates the required aperture based on the shutter speed, ISO, the light meter reading.

If the exposure falls outside of the 40D's exposure range, the aperture value blinks in the viewfinder and on the LCD panel letting you know to set a different shutter speed to avoid overexposure or underexposure. If the lens's maximum aperture blinks, the image will be underexposed. Set a slower shutter speed by turning the Main dial. If the lens's minimum aperture blinks, the image will be overexposed. Set a faster shutter speed. You can also set a higher or lower ISO setting, respectively. The 40D displays the shutter speed in the viewfinder and on the LCD panel.

In Shutter-Priority AE mode, you have full control over the camera's exposure controls, Picture Style, and the built-in or accessory flash use and settings.

Shutter speed increments can be changed from the default 1/3-stop to 1/2-stop increments using C.Fn I-1. Flash sync speed is 1/250 second or slower.

Cross-Reference *For details on setting Custom Functions, see Chapter 4.*

In the default 1/3-stop increments, shutter speeds are: 1/8000, 1/6400, 1/5000, 1/4000, 1/3200, 1/2500, 1/2000, 1/1600, 1/1250, 1/1000, 1/800, 1/640, 1/500, 1/400, 1/320, 1/250, 1/200, 1/160, 1/125, 1/100, 1/80, 1/60, 1/50, 1/40, 1/30, 1/25, 1/20, 1/15, 1/13, 1/10, 1/8, 1/6, 1/5, 1/4, 0.3, 0.4, 0.5, 0.6, 0.8, 1, 1.3, 1.6, 2, 2.5, 3.2, 4, 5, 6, 8, 10, 13, 15, 20, 25, 30 sec.

1.18 To show the motion of the water as a blur, I used Tv mode and set the shutter speed to 1/13 sec. Exposure: ISO 100, f/22, using a Canon EF 25-105mm, f/2.8L IS USM lens.

 Note *For both Tv and Av modes, you can set C.Fn I-6 to enable a safety shift in exposure. The shift comes into play if the lighting on the subject changes enough to make the current shutter speed or aperture unsuitable. Enabling this function causes the camera to automatically shift to a suitable exposure.*

Shutter designations in the viewfinder and LCD panel are shown with the number representing the denominator of the fractional value. For example, 8000 indicates 1/8000.

When shutter speeds are shown using a zero, a double-quote mark, and a number, the quote mark designates a decimal point. So 0"3 is 0.3 seconds while 15" indicates 15.0 seconds.

Note *You can also select Bulb, which keeps the shutter open as long as the Shutter button is depressed. While Bulb is related to shutter speed, it cannot be accessed using Tv mode. Instead you have to switch to Manual mode to select Bulb.*

Aperture-Priority AE

Aperture-Priority AE mode, denoted as Av on the Mode dial, is the semiautomatic mode that offers control over the aperture. In this mode, you control the aperture by turning the Main dial, and the camera automatically calculates the appropriate shutter speed based on the light meter reading, the metering mode, and the ISO.

If the exposure is outside the camera's exposure range, the shutter speed value blinks in the viewfinder and on the LCD panel. If "8000" blinks, the image will be overexposed. If "30" blinks, the image will be underexposed. In either case, adjust to a smaller or larger aperture, respectively, until the blinking stops or set a lower or higher ISO setting. The 40D displays the selected aperture in the viewfinder and on the LCD panel.

Note *You can preview the depth of field by pressing the Depth-of-Field Preview button on the front of the camera. When you press this button, the lens diaphragm stops down to the highlighted aperture so that you can preview the range of acceptable focus.*

The range of available apertures depends on the lens you're using. Aperture increments can be set in the default 1/3-stop or 1/2-stop values by changing the setting for C.Fn I-1.

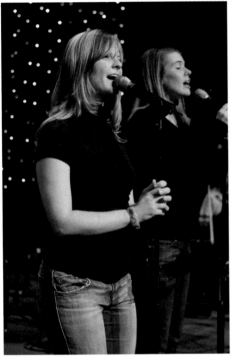

1.19 Av mode controls the rendering of the background in this Christian music concert image. I wanted the front vocalist to be in sharp focus with the other vocalist slightly blurred in the background so I chose f/2.8 to get a shallow depth of field. Exposure: ISO 400, f/2.8, 1/40 sec., using an EF 24-70mm, f/2.8L IS USM lens.

In 1/3-stop increments, and depending on the lens you use, available apertures are as follows: f/1.0, 1.1, 1.2,1.4, 1.6, 1.8, 2.0, 2.2, 2.5, 2.8, 3.2, 3.5, 4.0, 4.5, 5.0, 5.6, 6.3, 7.1, 8.0, 9.0, 10, 11, 13, 14, 16, 18, 20, 22, 25, 29, 32, 36, 40, 45, 51, 57, 64, 72, 81, and 91.

Practically speaking, however, the narrowest minimum aperture is f/45 on the Canon EF 75-300 f/4-5.6 lenses.

In Aperture-Priority AE mode, you have full control over the camera's exposure settings, Picture Style, and the built-in or accessory flash use and settings.

 For more information on Canon lenses, see Chapter 6.

Manual mode

Manual mode, denoted as M on the Mode dial, gives you full manual control. You set both the aperture and shutter speed based on the exposure level meter shown in the viewfinder and on the LCD panel. This mode is useful in a variety of shooting scenarios including shooting fireworks, astral photography, for some studio shooting, when you want to intentionally underexpose or overexpose the scene, or when you want a consistent exposure across a series of photos such as for a panoramic series.

In Manual mode, you set the exposure by turning the Main dial to select the shutter speed and the Quick Control dial to select the aperture.

Pressing the Shutter button halfway, initiates the metering. The camera's ideal exposure is indicated when the tick mark is at the center of the exposure level indicator shown in the viewfinder.

1.20 Manual mode is great for shots such as this image of the moon where I know in advance what exposure settings would work best. Exposure: ISO 100, f/3.5, 1/40 sec. using an EF 70-200mm f/2.8L IS USM lens.

The exposure level meter also displays the amount of overexposure or underexposure from the camera's ideal exposure. If the amount of under- or overexposure is +/- 2 Exposure Values (EV), the exposure level indicator bar blinks to show the amount of plus or minus EV in the viewfinder and on the LCD panel. You can then adjust either the aperture or shutter speed until the exposure level you want is displayed.

In Manual mode, you have full control over the camera's exposure controls, Picture Style, and the built-in or accessory flash use and settings.

Bulb

Bulb keeps the shutter open as long as the Shutter button is fully depressed—up to 2.5 hours on a fully charged battery. To ensure stability during Bulb exposures, you can use the Remote Switch RS-80N3 or Timer Remote Controller TC-80N3 to keep the shutter open.

Bulb is handy for low-light and night shooting, fireworks, celestial shots, and other creative long-exposure renderings. Bulb is accessible only in Manual mode. Because long exposures introduce digital noise and increase the appearance of grain, consider using the Long Exposure Noise Reduction option that is available with C.Fn II-1.

To select Bulb, follow these steps:

1. **Set the Mode dial to M (Manual).**

2. **Turn the Main dial counterclockwise to select Bulb (the setting past the 30-second option).**

3. **Turn the Quick Control dial to set the aperture.** You can use the accessory Timer Remote Switch RS-80N3 or Timer Remote Controller TC-80N3 to set the exposure time, or you can watch the elapsed time on the LCD panel for the length of exposure time that you want. In addition, you can use Mirror lockup (C.Fn III-7) to prevent vibration from the reflex mirror during long exposures.

1.21 You can use either Bulb or Manual mode for fireworks shots. Exposure: ISO 100, f/11, 1/7 sec. using an EF 70-200mm, f/2.8L IS USM lens.

Working with the Canon EOS 40D

I n this chapter, you get an overview in using the 40D on a daily basis — the most commonly used modes and functions such as autofocus, metering, exposure and exposure modifications, as well as evaluating images after capture from the core of everyday shooting tasks. This chapter not only explains how to set the camera controls, but it also provides insights into using the settings and getting the best results.

As explained in Chapter 1, mode selections are automatically made if you choose to shoot in a Basic Zone mode such as Portrait, Sports, Landscape, and so on. So to get the most from the autofocus, metering, and drive modes, it's best to use a Creative Zone mode such as Tv, Av, and so on.

Understanding and Using Autofocus

The speed and accuracy of focusing and the ease of manually selecting an Autofocus (AF) point are as critical to shooting as having a good onboard metering system. The 40D's overall autofocus performance is excellent, and the AF-point selection method is customizable. Getting tack-sharp focus, of course, depends on three factors: the resolving power of the lens (its ability to render fine details sharply), the resolution of the image sensor, and the resolution of the printer for printed images.

While the resolution of printers is beyond the scope of this book, the other two factors can be addressed. The 40D certainly has excellent image sensor resolution with fine image details and good edge performance. While the details of lenses are covered in Chapter 6, the take-away concerning image sharpness is that you can expect excellent autofocus performance from the 40D particularly with high-quality lenses.

About autofocus points and autofocus modes

The 40D sports a new autofocus (AF) sensor with nine AF points etched in the viewfinder. The selected AF point or points establish the point of sharpest focus in the image.

Canon's high-precision AF points are suited for use with fast lenses. These AF points are sensitive to vertical line detection and to horizontal line detection, which is critical to achieving sharp, accurate, fast focus. On the 40D, all nine AF points are cross-type and AF sensitivity is Exposure Value (EV) -0.5 to EV 18 at f/5.6 or better with the center AF point sensitive at f/2.8. Thus horizontal and vertical line detection is enhanced as is the ability to focus on hard-to-focus subjects. Likewise, in all autofocus modes, focus failure is reduced.

/Note/ *The AF point that establishes focus is also the point at which the camera determines the exposure for the scene. You can decouple focusing from metering using Auto Exposure Lock detailed later in this chapter.*

The 40D offers three autofocus (AF) modes that are designed for different types of subjects: still subjects, moving subjects, and subjects that start and stop moving.

The three autofocus (AF) modes that you can select in Creative Zone shooting modes are as follows:

✦ **One-Shot AF.** This mode is designed for photographing a stationary subject that is not likely to move. In this mode, pressing the Shutter button halfway establishes and locks focus. In this focus mode, you can manually select an AF point or have the camera automatically select one or more AF points.

✦ **AI Focus AF.** This mode uses One-Shot AF but automatically switches to AI Servo AF if the camera detects subject movement. A soft beep alerts you that the camera is switching to AI Servo AF, and the focus confirmation light in the viewfinder is no longer lit. Focus tracking is activated by pressing the Shutter button halfway.

✦ **AI Servo AF.** This mode is designed for photographing a moving subject. Focus is tracked regardless of changes in focusing distance from side to side or approaching or moving away from the camera. The camera sets the exposure at the moment the image is made. The camera uses either the manually selected AF point, or in automatic AF selection, it uses the center AF point and tracks movement as long as the subject is within the other eight AF points in the viewfinder. In Creative Zone modes, you can also press the AF-ON button to focus.

Tip	*Because keeping the Shutter button pressed halfway shortens battery life, anticipate the shot and press the Shutter button halfway just before making the picture to maximize battery life.*

Table 2.1 shows how autofocus and drive modes behave when used in combination.

To select an autofocus mode, follow these steps:

1. **Set the lens switch to AF, and set the camera to a Creative Zone shooting mode, P, Tv, Av, M, or A-DEP.**

2. **Press the AF-Drive button located above the LCD panel, and then turn the Main dial to select the autofocus mode you want.** Each mode is represented by text displayed to the side of the LCD panel. The selected autofocus mode remains in effect until you change it.

Table 2.1
Autofocus and Drive Modes

Drive Mode	Focus Mode One-Shot AF	AI Focus AF	AI Servo AF
One-shot shooting	In One-Shot AF mode, the camera must confirm accurate focus before you can take the picture. If you're using Evaluative metering, exposure is also locked at the selected AF point.	If the subject moves, the AF mode automatically switches from One-shot AF to AI Servo AF to track and focus on the moving subject.	The camera focuses on the subject and maintains focus during subject movement. The exposure is set at the moment the image is captured.
Continuous Shooting	Same as above during continuous shooting. In continuous shooting, focusing is not executed when shooting at 3 frames per second (fps) in Low-speed Continuous Shooting.		Same as above with autofocus continuing during continuous shooting at the maximum of 6.5 fps during High-speed Continuous shooting.

Interchangeable Focusing Screens

The 40D supports any of three focusing screens. Depending on your lenses and preference for automatic or manual focusing, swapping out the focusing screen can make focusing clearer and brighter. Alternately, you can opt for a focusing screen with a grid that helps you square up lines during composition. The Standard Precision Matte screen comes installed on the camera, but you have two additional screen options that, as of this writing, cost approximately $35 each.

The three focusing screens supported on the 40D are as follows:

✦ **Ef-A: Standard Precision Matte.** This focusing screen comes installed in the 40D. It offers good viewfinder brightness, accurate manual focusing, and it is optimized for use with EF f/5.6 and slower lenses.

✦ **Ef-D: Precision Matte with grid.** If you shoot architecture, interiors, or just want assistance keeping vertical and horizontal lines in the frame square, the matte screen with a grid is a good option. This screen features a 3-x-6-line grid to help you align horizontal and vertical lines during image composition. The grid is superimposed over the nine AF points in the viewfinder. This screen offers good viewfinder brightness and is optimized for use with EF f/5.6 or slower lenses.

✦ **Ef-S: Super Precision Matte.** This screen is optimized for manual focusing with f/2.8 or faster lenses. It offers finer microlenses than the other two screens, and it has a steeper parabola of focus to bring the image in and out of focus more vividly in the viewfinder — a benefit with very fast lenses such as the EF 85mm f/1.2 II. Because this screen is darker than the other two screens, it is not recommended for use with slower lenses or when using an extender on the lens.

If you change focusing screens, you also have to specify the screen you're using by setting C.Fn IV-5 to the proper option. The Ef-A screen is installed and set in C.Fn IV-5 as option 0. To set the camera for the Ef-D screen, set the option to 1. For the Ef-S screen, set the option to 2. For details on setting Custom Functions, see Chapter 4.

Does focus-lock and recompose work?

According to Canon's 40D manual, you can use the standard point-and-shoot technique of focus-lock and recompose. With this technique, you lock focus on the subject, and then move the camera to recompose the image. However popular the technique, in my experience, the focus shifts slightly during the recompose step regardless of which AF point is selected. As a result, focus is not tack-sharp.

Other Canon documents concede that at distances within 15 feet of the camera and when shooting with large apertures, the focus-lock-and-recompose technique increases the chances of back-focusing. Back-focusing is when the camera focuses behind where you set the AF point. Of course, the downside of not using the focus-lock-and-recompose technique is that you're restricted to composing images using the nine AF points in the viewfinder. The placement of the nine AF points isn't the most flexible arrangement nor the optimal

way to compose images. But manually selecting one of the nine AF points and not moving the camera to recompose is the way to ensure tack-sharp focus.

Selecting AF points

In most Creative Zone modes, you can either manually choose a single AF point , or you can let the camera automatically select the AF points. Each option has benefits and drawbacks.

> **Note** In A-DEP mode, the camera automatically selects the AF points to provide the optimal depth of field, and you cannot manually select an AF point.

The advantage of setting the AF point manually is getting the point of sharpest focus precisely where you want it to be in the image. Manual AF point selection takes a bit more time than letting the camera set the AF points, but you're assured of tack-sharp

focus in the appropriate spot, provided that you don't move the camera to recompose the image after setting focus.

> **Tip** You can simplify the method for changing the AF point by selecting among several alternatives offered by C.Fn III-3. For example, you can choose to use only the Quick Control dial or the Multi-controller to select an AF point, which is much faster during shooting. You can learn more about Custom Functions in Chapter 4.

If you let the camera automatically select the AF point or points, the camera focuses on the subject or the part of the subject that is closest to the lens that has readable contrast. If you're shooting a portrait, automatic AF will likely set the sharpest focus on the subject's nose rather than the subject's eyes. This method is faster in terms of shooting, but very often the point of sharpest focus is not where it should be within the subject.

2.1 In this image, I used automatic AF-point selection, and the camera set the point of sharpest focus to the right side of center instead of on the center of the flower. For this reason, I use manual AF-point selection in all of my images. Exposure: ISO 100, f/2.8, 1/250 sec. using an EF 100mm f/2.8mm Macro USM lens.

Improving Autofocus Accuracy and Performance

Autofocus speed depends on factors including the size and design of the lens, the speed of the lens-focusing motor, the speed of the autofocus sensor in the camera, the amount of light in the scene, and the level of subject contrast. Given these variables, it's helpful to know how to get the speediest and sharpest focusing. Here are some tips for improving overall autofocus performance.

✦ **Light.** In low-light scenes, the autofocus performance depends in part on the lens speed and design. In general, the faster the lens, the faster the autofocus performance. Provided that there is enough light for the lens to focus without an AF-assist beam, then lenses with a rear-focus optical design, such as the EF 85mm f/1.8 USM, will focus faster than lenses that move their entire optical system, such as the EF 85mm f/1.2L II USM. But regardless of the lens, the lower the light, the longer it takes for the system to focus.

Low-contrast subjects and/or subjects in low-light slow down focusing speed and can cause autofocus failure. With a passive autofocus sysem, autofocusing depends on the sensitivity of the AF sensor. Thus, autofocusing performance will always be faster in bright light than in low light, and this is true in both One-Shot and AI Servo AF modes. In low light, consider using the built-in flash or an accessory EX Speedlite's AF-assist beam as a focusing aid using C.Fn III-5. The AF assist beam fires twice; first, a prefire to communicate focusing distance data to the camera, then a second beam to confirm that the subject is in focus, and then the shutter fires.

✦ **Focal length.** The longer the lens, the longer the time to focus. This is true because the range of defocus is greater on telephoto lenses than on normal or wide-angle lenses. You can improve the focus time by manually setting the lens in the general focusing range, and then using autofocus to set the sharp focus. However, the 40D's new AF sensor is better able to detect extreme defocus situations and performs better than previous models.

✦ **AF-point selection.** Manually selecting a single AF point provides faster autofocus performance than using automatic AF-point selection because the camera doesn't have to determine and select the AF point(s) to use first.

✦ **Subject Contrast.** Focusing on low-contrast subjects is slower than on high-contrast subjects. If the camera can't focus, shift the camera position to an area of the subject that has higher contrast, such as a higher contrast edge.

✦ **EF Extenders.** Using an EF Extender reduces the speed of the lens-focusing drive.

✦ **Wide-angle lenses and small apertures.** Sharpness can be degraded by diffraction when you use small apertures with wide-angle or wide-angle zoom lenses. Diffraction happens when light waves pass around the edges of an object and enter the shadow area of the subject producing softening of fine detail. To avoid diffraction, avoid using apertures smaller than f/16 with wide-angle prime (single-focal length) and zoom lenses.

To manually select an AF point or to choose automatic AF, follow these steps:

1. **Set the camera to a Creative Zone mode except A-DEP, and then press the Shutter button halfway.** The currently selected AF point or points light in red in the viewfinder and are displayed on the LCD panel.

2. **Press the AF-Point Selection/Enlarge button on the back top-right side of the camera.** The selected AF point lights in red in the viewfinder and is displayed on the LCD panel.

3. **Turn the Main or Quick Control dial or tilt the Multi-controller in the direction of the AF point you want to select and select one AF point.** Or to have the camera automatically select the AF point or points, turn the Main or Quick Control dial or the Multi-controller until all the AF points are lit in red. If you're using the Multi-controller, you can also press the controller in the center to select the center AF point.

4. **Press the Shutter button halfway to focus using the selected AF point or the camera's selected AF points.** The camera beeps when accurate focus is achieved and the autofocus light in the viewfinder remains lit continuously. If you don't hear the beep, focus on a higher contrast area or use the built-in flash assist beam (C.Fn III-5).

5. **Press the Shutter button completely to make the picture.**

Tip *Manual focusing is available by sliding the switch on the side of the lens from the AF to MF position. Alternately, you can use full-time manual focusing by letting the camera automatically set the focus, and then tweaking it by manually turning the focusing ring on the lens.*

It's important to know that in normal shooting when you don't use the AF-ON button to focus, the AF point that achieves focus is also the point where exposure is set. In other words, whatever AF point you choose is also the point where the camera meters the scene light and determines the exposure settings to use.

But the AF-point location may or may not be the point of critical exposure. For example, if you're shooting a portrait and the model has a bright highlight on part of his or her face, the highlight is the point where you want to set the exposure to ensure that detail is retained in the bright highlight area. Obviously, that isn't where you want to set the point of sharpest focus. It's necessary then to decouple autofocus from metering by using Auto Exposure Lock, a technique discussed later in this chapter.

Tip *If you're shooting in a quiet venue such as a wedding ceremony, you can silence the AF confirmation beeper. Press the Menu button. On the Shooting 1 (red) menu, select Beep, and then press the Set button. Select Off, and then press the Set button. You can verify when the camera has achieved sharp focus by watching the focus confirmation light on the far-right bottom of the viewfinder.*

Verifying sharp focus

You can verify image sharpness by pressing the Playback button, and then pressing and holding the AF-Point Selection/Enlarge button on the back of the camera. Pressing the AF-Point Selection/Enlarge button multiple times progressively zooms from 1.5x to 10x on the LCD monitor. To move around the image to check the point of sharpest focus, tilt and hold the Multi-controller in the direction you want to scroll. To check the sharpness of several images, turn the Quick Control dial to move through images while maintaining the current zoom level.

To reduce the enlarged preview, press the Reduce button, or lightly press the Shutter button to dismiss image playback.

Selecting a Metering Mode

The 40D offers a full menu of metering options with new algorithms for more consistent exposure and high accuracy for highly reflective subjects. The default mode is the 35-zone through-the-lens (TTL) full-aperture reflective metering system that is linked to the selected AF point or points. Depending on your exposure needs, you can also use Partial, Spot, Center-weighted Average metering modes.

The 40D metering options, available only in Creative Zone modes, are as follows:

✦ **Evaluative.** This mode calculates exposure based on data from 35 zones throughout the viewfinder and is based on the subject position (indicated by the selected AF point), brightness, background, and back or front lighting. Evaluative metering produces excellent exposure in average scenes that include an average distribution of light, medium, and dark tones, and it functions well in back-lit scenes.

✦ **Partial.** This mode calculates exposure based on approximately 9 percent of the viewfinder at the center. This metering option weights metering data at the center of the viewfinder in slightly less than twice the size of the spot metering circle. This is a good metering option for strongly backlit or side-lit scenes where you want to ensure that the main subject is properly exposed.

✦ **Spot.** This mode calculates exposure from approximately 3.8 percent of the viewfinder at the center. Spot metering is an excellent mode when you need to meter for a critical subject-area such as skin highlights. To use Spot metering, move close and fill the frame with the subject's face, and then meter on the skin.

✦ **Center-weighted Average.** This mode weights metering for the center of the frame, and then averages for the entire scene to calculate exposure. The center area encompasses a slightly larger than the Partial metering area. Center-weighted Average metering can be useful for quickly evaluating existing light scenes.

This next series of images was taken in each of the metering modes. I set a custom white balance for all images in this series.

2.2 This image was taken using Evaluative metering. Exposure: ISO 100, f/8, 1 sec., EF 24-70mm f/2.8 Macro USM lens.

2.3 This image was taken in Partial metering mode. Exposure: ISO 100, f/8, 1 sec.

To set a metering mode, follow these steps.

1. **Set the camera to a Creative Zone shooting mode such as Tv, Av, etc.**

2. **Press the WB-Metering mode selection button above the LCD panel.** The camera activates the WB and Metering mode selections.

3. **Turn the Main dial to the right to select the Metering mode you want.** Each mode is represented by an icon: Evaluative, a black dot with an outer black circle; Partial, a white circle in a rectangle; Spot, a back dot in a rectangle, and Center-weighted Average, an empty rectangle. The mode remains selected until you change it.

2.4 This image was taken in Spot metering mode. Exposure: ISO 100, f/8, 1/3 sec.

2.5 This image was taken using Center-weighted Average metering mode. Exposure: ISO 100, f/8, 1 sec.

Evaluating the 40D's Dynamic Range

In general terms, dynamic range is the range of highlight to shadow tones as measured in f-stops in a scene. That's only one measure of dynamic range, however. In practice, you have to factor in the "usable" range by considering the effect of digital noise. If, for example, during image editing, you use a curve to bring up the details in the shadow areas, you also make digital noise (which is most prevalent in the shadows) more visible. In addition, the grain size of noise also impacts how noticeable the noise appears. So considering these factors, there is a point at which this noise becomes obnoxious and limits your ability to make high-quality enlargements from the image.

Dave Etchells of Imaging-Resource.com published dynamic range tests on the 40D at ISO 100 and reports for JPEG capture a range of 11.2 (noise level was low) to 7.72 (noise level is high) f-stops.

If you want to review the graphs and test results on the 40D's dynamic range, be sure to read Dave's excellent report at www.imaging-resource.com/PRODS/E40D/E40DIMATEST.HTM.

Evaluating Exposure

Following each exposure, you can evaluate the exposure by looking at the histogram. The histogram is a bar graph that shows the distribution of pixels in the image. The horizontal axis shows the range of values and the vertical axis displays the number of pixels at each location. The 40D offers two types of histograms, a Brightness (or luminance) histogram, and an RGB histogram.

Brightness histogram

A Brightness histogram shows grayscale brightness values in the image along the horizontal axis of the graph. The tonal values range from black (level 0 on the left of the graph) to white (level 255 on the right of the graph). This histogram shows you the exposure bias and the overall tonal reproduction of the image. If the histogram has pixels crowded against the far left or right side of the graph, then the image is underexposed

or overexposed with a subsequent loss of detail in the shadows and highlights, respectively.

Some scenes cause a weighting of tonal values more to one or the other side of the graph. For example, in scenes that have predominately light tones, the pixels are weighted toward the right side of the histogram, and vice versa. But in average scenes, good exposure is shown on the histogram with highlight pixels just touching the right side of the histogram.

The goal is to avoid exposures that have pixels stacked against the right edge of the graph. If this occurs, it means that some highlight values are beyond the limit of the sensor, and the pixels are *blown*; in other words, they are at 255, or totally white with no detail.

On the other hand, you want to avoid having pixels crowded against the left edge of the histogram because that type of exposure indicates *blocked* shadows; in other words, pixels at 0, or totally black with no detail.

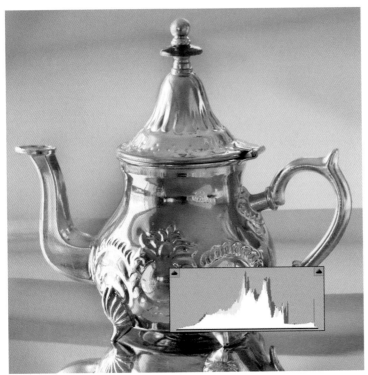

2.6 This is a combined histogram from a RAW capture image in Adobe's Camera Raw conversion program. In the camera, the histogram showed slight overexposure, but once on the computer, the highlights began just at the right side of the histogram, which is right on target for a good RAW conversion.

RGB histogram

An RGB histogram shows the distribution of brightness levels for each of the three color channels — Red, Green, and Blue. Each color channel is shown in a separate graph so you can evaluate the color channel's saturation, gradation, and color bias. The horizontal axis shows how many pixels exist for each color brightness level, while the vertical axis shows how many pixels exist at that level. More pixels to the left indicate that the color is darker and more prominent, while more pixels to the right indicate that the color is brighter and less dense. If pixels are spiked on the left or right side, then color information is either lacking or oversaturated with no detail, respectively.

Choosing the type of histogram to display depends on the shooting situation and your priority in that situation. For a fashion shoot where color reproduction is critical, the RGB histogram is likely most useful. For a wedding, outdoor shooting, and nature shooting, the Brightness histogram can be most useful for evaluating critical highlight exposure.

The histogram is a very accurate tool to use in evaluating JPEG captures because the histogram is based on the JPEG image. If,

2.7 This is a combined histogram from a RAW capture image in Adobe's Camera Raw conversion program. The graph reflects the dark shadow tones in the image but, with the pixels crowded to the left edge, also shows that shadows are blocked.

2.8 This is a Brightness histogram from a RAW capture image in Adobe's Camera Raw conversion program. This histogram reflects the white seamless background with the highlight pixels spiking on the right side of the graph showing that those pixels have no detail in them.

however, you shoot RAW or sRAW, the histogram you see is based on the JPEG conversion of the image. Due to the linear nature of RAW data, it isn't feasible to display a RAW histogram. So if you shoot RAW, remember that the histogram is showing a less robust version of the image than you'll get during image conversion. For example, there will be more data in the highlights than the JPEG-based histogram indicates. Despite the JPEG-based rendering, the histogram is still a very useful tool to gauge exposure in the field.

Tip

If you're shooting RAW capture, you can set the Picture Style setting to a lower contrast and get a better overall sense of the RAW histogram and reduce the likelihood of clipping (or discarding image pixels). Picture Styles are detailed in Chapter 3.

Histograms on the 40D are displayed during image playback. Once you set the type of histogram you prefer, it is displayed until you change it. You can set the type of histogram in all shooting modes.

To set the type of histogram displayed during image playback, follow these steps:

1. **Press the Menu button, and then press the Jump button to display the Playback 2 (blue) menu.**

2. **Turn the Quick Control dial to highlight Histogram, and then press the Set button.** The camera displays the Brightness and RGB histogram options.

3. **Turn the Quick Control dial to highlight the histogram option you want, and then press the Set button.**

To display the histogram for a captured image, follow these steps:

1. **Press the Playback button.** The camera displays the most recently captured image. If you want to check the histogram of a different image, turn the Quick Control dial to select the image.

2. **Press the Info button twice if the playback display is set to single-image display to display the histogram.** The camera displays the image thumbnail, the type of histogram you've chosen, and detailed exposure and file information for the image. You can press Info a third time to display both the Brightness and RGB histograms.

Differences in Exposing JPEG and RAW Images

For those new to digital photography or to RAW capture, it's worthwhile to point out important differences in exposure techniques for JPEG and RAW capture.

When you shoot JPEG images, you expose images as you would for slide film, by metering for the highlights. Just as you can't recover detail that isn't captured in a film image, you also can't recover highlight detail that's not recorded during a JPEG capture. To ensure that images retain detail in the brightest highlights, you can use one of the exposure techniques described later in this chapter such as Auto Exposure Lock or Exposure Compensation.

Conversely, for RAW capture, exposure is more akin to positive film in that you have a fair amount of latitude to overexpose the image and then pull back the highlight details during conversion of the RAW images in Canon's Digital Photo Professional or Adobe Camera Raw. In fact, because CMOS sensors are linear devices in which each f-stop records half the light of the previous f-stop, the lion's share of image data is recorded in the first f-stop of light. To be exact, fully half of the total image data is contained in the first f-stop in RAW capture. This fact alone underscores the importance of taking full advantage of the first f-stop by not underexposing the image. In the everyday world, that means weighting the exposure slightly toward the right side of the histogram, resulting in a histogram that has highlight pixels just touching, but not crowded against, the right edge of the histogram.

With this type of exposure, the image preview on the LCD may look a bit light, but in a RAW conversion program, you can bring the exposure back slightly So for RAW exposure, be sure to expose with a slight bias toward the right side of the histogram to get the full first f-stop of image data.

In addition to evaluating the histogram, you can also display localized areas of overexposure, or where the highlights are blown (they have no detail). The camera displays the blown highlights with a flashing display when you play back images. This is a way to quickly determine if you need to reshoot a picture because of overexposed highlights.

To turn on Highlight alert that displays overexposed areas during image playback, follow these steps:

1. **Press the Menu button, and then press the Jump button to display the Playback 2 (blue) menu.**

2. **Turn the Quick Control dial to highlight Highlight Alert, and then press the Set button.** The camera displays the Disabled and Enabled options.

3. **Turn the Quick Control dial to highlight the option you want, and then press the Set button.** If you select Enable, overexposed areas are displayed in flashing black and white on the image preview during playback. If you find the flashing display distracting, you can repeat these steps to turn off the display.

Modifying Exposure

For average scenes, using the camera's suggested exposure produces a fine exposure. However, many scenes are not average, and that's when you use any of the 40D's exposure modification options including Automated Brightness and Contrast Correction, Highlight Tone Priority, Auto Exposure Lock, Auto Exposure Bracketing, and Exposure Compensation. These options are detailed in the following sections.

Automated Brightness and Contrast Correction

While the Automated Brightness and Contrast Correction is not a setting that you can adjust manually, it's worth mentioning along with exposure modification topics. This feature comes into play only when you're shooting JPEG capture in Basic Zone modes such as Portrait, Landscape, Sports mode, and so on. The automatic correction adjusts exposure to ensure that proper dark and highlight points are maintained along with acceptable contrast.

This feature is particularly useful in challenging lighting and in scenes that might fool the camera's onboard light meter, such as snow scenes with large expanses of white where underexposure is likely. The automatic correction also kicks in when the flash fails to adequately cover the scene, and in hazy, overcast scenes with low contrast.

Highlight Tone Priority

Highlight Tone Priority is designed to improve or maintain highlight detail by extending the range between 18 percent middle gray to the maximum highlight tones, effectively increasing the dynamic range. Thus the gradation between grays and highlights is finer, and that reduces the blown highlights. This option, however, limits the ISO range from 200 to 1600 and can increase noise in the shadow areas slightly.

Highlight Tone Priority takes advantage of the higher ISO baseline so that the image sensor pixel wells do not fill, or saturate. Also with the 14-bit Analog/Digital conversion, the camera sets a tone curve that is relatively flat at the top in the highlight area to compress highlight data. The tradeoff, however, is a more abrupt move from deep

shadows to black. This increases shadow noise. The result is almost a full f-stop increase in dynamic range (the range of highlight to shadow tones as measured in f-stops in a scene), disregarding, of course, the increased shadow noise.

> **Cross-Reference** *Highlight Tone Priority is set using C.Fn II-3. See Chapter 4 for details on setting Custom Functions.*

> **Tip** *Custom Functions are not available in Basic Zone modes. To set and use Custom Functions, switch to a Creative Zone mode such as Tv or Av.*

If you turn on this option, the viewfinder and LCD panel ISO display, and the Camera Shooting Information displays 0 (zero) in the ISO setting in a smaller font size. For example, 200 displays as 2oo.

Auto Exposure Lock

As noted in earlier sections, Canon sets exposure to the AF point that you select. This approach is fine as long as the area of critical exposure falls within the point where you want sharpest focus. Often, however, that's not the case. For example, if the light falling on the model for a portrait has a bright spot

2.9 This image was taken without using AE Lock, and the brightest highlights went to white. Exposure: ISO 100, f/2.8, 1/125 sec., EF 24-70mm f/2.8L USM lens.

2.10 With AE Lock, the highlights retained much more detail in this image, but the shadows went to black quickly. I realized that this will happen and knew that I would need to bring up the shadow areas a bit during RAW image conversion, and again in Photoshop. Exposure: ISO 125, f/8, 1/50 sec., EF 24-70mm f/2.8L USM lens.

of light on the forehead (called a hot spot), then that spot of brightness is a critical area of exposure where you want to retain skin detail instead of getting blown-out highlights. The forehead, however, is not the place where you want to set the point of sharpest focus. This and other scenes are when you want to decouple the exposure from the selected AF point, and Auto Exposure Lock (AE Lock) is the way to do that.

In fact, there are many times you'll want to decouple metering from focusing. Conservatively, I'd say that I use AE Lock for 98 percent of my outdoor photography and for at least half of my on-location portraits. In practical use, I combine AE Lock with Evaluative metering and manual AF-point selection when exposing to maintain fine detail in a bride's wedding dress, to retain highlight detail in macro and nature shots (although, if you composite multiple exposures, bracketing may be a better technique), and to maintain detail in skin highlights in portraits.

If you shoot JPEG capture, then AE Lock is the best way to ensure that the brightest highlights retain detail. There is a bit more latitude in RAW capture because you can recover varying amounts of highlight detail during image conversion.

There are, however, some drawbacks for using AE Lock. First, it doesn't work in Basic Zone modes or, of course, in Manual mode. Also in Tv and Av modes, you have to use Evaluative metering, manual AF-point selection, and autofocusing rather than manual focusing (via the switch on the side of the lens).

Table 2.2 shows the relationship of AE Lock to the various metering and autofocus modes on the 40D.

Table 2.2
AE Lock Behavior with Metering and AF-Point Selection

Metering Mode	AF-Point Selection Manual AF-Point Selection	Automatic AF-Point Selection	(Lens switch is set to MF)
Evaluative	AE lock is set at the selected AF point	AE Lock is set at the AF point that achieves focus	AE Lock is set at the center AF point
Partial	AE Lock is set at the center AF point		
Spot	AE Lock is set at the center AF point		
Center-Weighted Average	AE Lock is set at the center AF point		

The following steps tell you how to set AE Lock. Before you begin, ensure that the camera is set to

✦ Av or Tv mode

✦ Evaluative metering

✦ Manual AF-point selection with the lens focusing switch set to AF.

1. **Select the AF point and point the camera to the part of the scene that you want to meter, and then press the Shutter button halfway.** For example, if you want to retain detail in the highlight area on a subject's face, point the camera so that the selected AF point is on the brightest highlight and press the Shutter button halfway.

2. **Continue to hold the Shutter button halfway as you press AE Lock button on the back right side of the camera.** The AE Lock button has an asterisk above it. When you press the button, an asterisk appears on the far left at the bottom of the viewfinder indicating the exposure is locked.

3. **Release the Shutter button and move the camera to recompose the shot.** Press the Shutter button halfway to focus, and then make the picture. As long as you continue holding the AE Lock button, you can take additional images using the locked exposure. When you release the AE Lock button, the exposure is reset when you focus again.

Auto Exposure Bracketing

Auto Exposure Bracketing (AEB) takes three exposures of the same scene: one exposure at the recommended setting, one 1/3 f-stop

above the standard exposure, and one 1/3 f-stop below the standard exposure. This is the traditional technique for ensuring an acceptable exposure in scenes that have challenging and/or high-contrast lighting and in scenes that are difficult to set up again or that can't be reproduced.

But today, AEB is also used for image compositing where you take three different exposures of a high dynamic range scene, and composite them in an image-editing program to produce a final image that offers the best of highlight detail, midtone, and shadow detail. Using this technique, photographers can produce a final image that exceeds the range of the camera's sensor. Additionally, AEB is a mainstay of High-Dynamic Range (HDR) imaging, which merges three to seven or more bracketed exposures in Photoshop to create a 32-bit image with excellent rendering throughout the tonal range.

 Note *HDR imaging brackets exposures by shutter speed rather than by aperture to avoid slight shifts in focal length rendering.*

On the 40D, the default exposure bracketing level is 1/3 stop, although you can reset the increment to 1/2 stop using C.Fn I-1. Exposure level increments AEB captures up to plus/minus 2 stops.

Here are some things that you should know about AEB:

✦ **AEB is available in all Creative Zone modes except Manual, and it cannot be used with a Bulb exposure or with the built-in or external EX Speedlight or third-party flash unit.**

✦ **AEB settings remain in effect until you turn off the camera power switch or use the flash.**

✦ **In Continuous drive modes, you must press and hold the Shutter button to make all three brack-eted exposures.**

✦ **In One-Shot AF mode, you must press the Shutter button three separate times to make the bracketed sequence.**

✦ **In the 2- or 10-second drive modes, the three bracketed shots are taken in succession after the timer interval has elapsed.**

✦ **The order of bracketed expo-sures begins with the standard exposure followed by decreased and increased exposures.** You can change the order of bracketed exposures by setting C.Fn I-5.

✦ **You can use AEB in combination with Exposure Compensation.**

✦ **If C.Fn III-7 is set for mirror lockup, and you're using AEB and Continuous drive mode, only one of the bracketed shots is taken at a time.** You press the Shutter button once to lock up the mirror and again to make the exposure. In other words, a total of six presses of the Shutter button are required to complete three bracketed exposures. The exposure level indicator in the viewfinder flashes after each Shutter click until all bracketed images have been made.

To set AEB, follow these steps:

1. **Set the Mode dial to P, Tv, or Av.**

2. **Press the Menu button, and, if necessary, press the Jump button to select the Shooting 2 (red) menu.**

 Cross-Reference *For details on setting Custom Functions, see Chapter 4.*

3. **Turn the Quick Control dial to highlight AEB, and then press the Set button.** The camera acti-vates the Exposure Level Meter display.

4. **Turn the Quick Control dial to the right to highlight the AEB amount that you want, and then press the Set button.** As you turn the Quick Control dial to the right, the tick mark on the Exposure Level Meter separates into three marks indicating the bracketing amount. You can set up to plus/minus 2 stops of bracketing. The bracketing amount is also dis-played on the LCD panel. AEB remains in effect until you turn it off. To turn off AEB, repeat Steps 1 through 4, but in Step 4, turn the Quick Control dial to the left until the three tick marks merge into a single tick mark at the center of the Exposure Level Meter.

With AEB set, when you press the Shutter button to take the exposures, the bracketing amount is displayed in the viewfinder and on the LCD panel Exposure level indicator as each shot is made.

Exposure Compensation

The third way to modify the standard expo-sure on the 40D is by using Exposure Compensation. Unlike Auto Exposure Lock and AEB, which serve well for specific shoot-ing scenarios, Exposure Compensation enables you to purposely and continuously modify the standard exposure by a specific amount up to plus/minus 2 f-stops in 1/3-stop increments or in 1/2-stop increments via C.Fn I-1.

Scenarios for using Exposure Compensation vary widely, but a common use is to override the camera's suggested ideal exposure in scenes that have large areas of white or black. In these types of scenes the camera's onboard meter averages light or dark scenes to 18 percent gray to render large expanses of whites as gray and large expanses of black as gray. For example, a snow scene requires between +1 to +2 stops of compensation to render snow as white instead of dull middle gray. A scene with predominately dark tones might require -1 to -2 stops of compensation to get true dark renderings.

I've also used Exposure Compensation in conjunction with a handheld incident meter (a meter that measures the light falling on the subject rather than reflected from the subject) to set the 40D's standard exposure to the incident meter reading when there is a difference in exposure between the 40D's onboard meter and the incident meter reading. This technique works well in scenes where the subject light remains constant over a series of images.

Occasionally, you may notice that the camera consistently overexposes or underexposes images, and in those cases, compensation enables you to modify the exposure accordingly. Exposure Compensation is useful in other scenarios as well, such as when you want to intentionally overexpose skin tones for specific rendering effects.

> **Tip** *If underexposure or overexposure is a consistent problem, it's a good idea to have the camera checked by Canon.*

Here are some things that you should know about Exposure Compensation:

2.11 Snow scenes are a good time to use Exposure Compensation. In a scene like this, Exposure Compensation of +1 helps ensure pure white snow and white in the clouds. Exposure: ISO 100, f/11, 1/350 sec., +1 Exposure Compensation with an EF 100mm f/2.8 USM lens.

✦ **Exposure Compensation works in all Creative Zone modes except in Manual mode and during Bulb exposures.** In Tv mode, setting Exposure Compensation changes the aperture by the specified amount of compensation. In Av mode, it changes the shutter speed. In P mode, compensation changes both the shutter speed and aperture by the exposure amount you set.

✦ **The amount of Exposure Compensation you set remains in effect until you reset it.** This applies whether you turn the camera off and back on, change the CF card, or change the battery.

✦ **It is annoyingly easy to inadvertently set Exposure Compensation by turning the Quick Control dial.** To avoid this, Canon recommends setting the On switch to the first On position rather than the topmost setting, but this limits the functionality of the Quick Control dial. Because I've fallen victim to this many times, I find that the best way to avoid unintentional Exposure Compensation is to keep the power switch at the topmost position and always check the Exposure level meter in the viewfinder before shooting and reset it if necessary.

To set Exposure Compensation, follow these steps:

1. **Set the On switch to the topmost position.**

2. **Set the Mode dial to a Creative Zone mode except Manual (M).**

3. **Press and hold the Shutter button halfway, and watch in the viewfinder or on the LCD panel as you turn the Quick Control dial clockwise to set a positive amount of compensation or counterclockwise to set negative compensation.** As you turn the Quick Control dial, the tick mark on the Exposure Level Meter moves to the right or left in 1/3-stop increments up to plus/minus 2 stops.

You can cancel Exposure Compensation by repeating these steps, but in Step 3, adjust the tick mark on the Exposure Level Indicator back to the center mark.

About ISO settings

In general terms, ISO is the sensitivity of the sensor to light. As the sensitivity setting increases on a digital camera (a higher ISO number), the output of the sensor is also amplified. So while you have the option of increasing the ISO sensitivity at any point in shooting, the tradeoff in increased amplification or the accumulation of an excessive charge on the pixels represents an increase in digital noise seen as multicolored flecks and grain that is similar to grain seen in film particularly in the shadow areas of an image. And the result of digital noise, depending on the appearance and severity, is an overall loss of resolution and image quality.

Improvements in the semiconductor design and fabrication process and in the sensor microlens combine to increase the light-collecting efficiency for the 40D. These, plus advanced internal noise-reduction processing, result in a camera that is a top performer at high sensitivity settings and in low-light scenes.

The 40D includes an Auto setting in both Creative and Basic Zone modes. Using this option, the camera sets and displays the ISO automatically when the exposure is determined by pressing the Shutter button halfway down. The automatic range depends on the shooting mode. Table 2.3 shows automatic ISO behavior.

Table 2.3
Set-up 2 Menu (Yellow)

Shooting Mode	Automatic ISO Speed
Full Auto, Landscape, Portrait, Night Portrait, Flash Off	ISO 100-800
Sports	ISO 400-800
Portrait	ISO 100
P, Av, A-DEP	400-800 depending on the ambient light. The speed is chosen to prevent blur from handholding the camera in low-light scenes. If ISO 400 would result in overexposure, the camera automatically lowers the setting.
Tv	Generally sets ISO 400, but the setting can range between 100-800 depending on the subject brightness.
M	ISO 400
Flash use	ISO 400 in all modes including Portrait mode unless that speed would result in overexposure. If so, a lower ISO is set.

ISO Range, Expansion, and C.Fn options

The 40D offers a default ISO range from 100 to 1600 in 1/3-stop increments. You can also adjust the ISO in 1/2-stop increments using C.Fn I-1. The ISO range can be expanded to include ISO 3200 that is displayed as "H" in the viewfinder and on the LCD panel.

 Note *Manual ISO adjustments and using Custom Functions are available only in Creative Zone shooting modes.*

With the 40D, you can choose to reduce or eliminate noise in long exposures by a *dark frame*. To totally or virtually eliminate noise, the camera takes a second picture after the first picture. The second picture, called a dark frame, is taken with the shutter closed, and it is exposed for the same amount of time as the first image. So if the initial exposure is one second, then the noise reduction exposure is also one second. The camera uses the dark frame to subtract noise from the first frame. Some noise reduction is applied at all ISO settings, but it is especially effective at high ISO settings. You can turn on this method of noise reduction by choosing the On option for C.Fn II-1: Long exp. noise reduction.

In addition, you can turn on High ISO speed noise reduction, which reduces the shadow noise in particular. This option is available using C.Fn II-2. With this option enabled, the maximum burst during continuous shooting decreases to 8 regardless of image-quality setting.

typically print, and then evaluate how far and fast you want to take the 40D's ISO settings.

Note *Noise reduction or suppression can give fine details, such as the detail in hair, a painted or water-color appearance. Details are flat, color definition becomes indistinct, and it looks as if an editing program filter has been applied to these areas.*

The 40D maintains a good level of fine detail even in areas of subtle contrast until the ISO is pushed to 1600 and 3200 (with expansion) when digital noise and suppression become visible. At these levels, fine detail tends to blur and noise becomes apparent. However, I've gotten acceptable 8-x-10-inch prints at ISO 3200.

2.12 This image was taken in theater-type light at ISO 1600. During image editing, I used Curves in Photoshop CS3 to bring up the brightness. Brightening shadow areas is a recipe for revealing ugly noise, but this ISO 1600 image made a fine 8-x-10-inch print without objectionable levels of digital noise. Exposure: ISO 1600, f/2.8, 1/100 sec. using an EF 24-70mm f/2.8L USM lens.

In practice, the most compelling benchmark in evaluating digital noise is the quality of the image at the final output size. If the digital noise is visible and objectionable in an 8-x-10-inch or 11-x-14-inch print when viewed at a standard viewing distance of a foot or more, then the digital noise degraded the quality to an unacceptable level. It is worthwhile to test the camera by using all of the ISO settings, process and print enlargements at the size as you

2.13 This is a 100 percent crop of the previous image to show the noise reduction that was applied in the 40D for this ISO 1600 exposure. You can see some munging of fine detail in the hair, but the detail remains realistic.

Types of Digital Noise

As the signal output of the image sensor increases, digital noise increases as well. Digital noise is analogous to the hiss on an audio system turned to full volume. In a digital image, the hiss translates into random flecks of color in shadow areas as well as a grainy look much like you see with film. Three types of digital noise are common in digital photography:

✦ **Random.** This noise is common with short exposures at high ISO settings. Random noise appears on different pixels and looks like a colorful grain or speckles on a smooth surface. This type of noise increases with fast signal processing. Canon's technology is designed to suppress random noise by having the sensor reset the photodiodes that store electrical charges while reading and holding the initial noise data. After the optical signal and noise data are read together, the initial noise data is used to remove the remaining noise from the photodiode and to suppress random noise.

✦ **Fixed-pattern.** This type of digital noise includes hot pixels that have an intensity beyond that of random noise fluctuations. Hot pixels, or very bright pixels, are minor manufacturing defects that result in unusually high dark-current levels. Fixed-pattern noise is caused by an uneven signal boost among different pixel amplifiers. This type of noise happens with long exposures and is worsened by high temperatures. Fixed-pattern noise gains its name because under the same exposure and temperature conditions, the noise pattern will show the same distribution. The 40D uses on-chip noise reduction technology that detects fixed-pattern noise and removes it.

✦ **Banding.** This type of noise is more camera-dependent and is introduced as the camera reads data from the image sensor. It becomes visible in the shadow areas of images made at high ISO settings. This type of noise is visible when shadow tones are lightened during image editing.

In addition, digital noise exhibits fluctuations in color and luminance. Color, or chroma, noise appears as bright speckles of unwanted color in the image shadow areas primarily. Luminance noise on the other hand takes on the appearance of film grain.

Long exposures at high ISO settings tend to reveal hot pixels in images when the long exposure noise reduction is turned off. So if your shooting scenario lends itself to using the long exposure noise reduction option, I recommend setting the Long exposure noise reduction and High ISO speed noise reduction options to On using C.Fn II-1 and C.Fn II-2.

Setting the ISO and extended range ISO

With testing of the ISO settings on the 40D, you'll find the ISO range very versatile for a wide range of shooting situations. To change the ISO setting on the 40D, follow these steps:

1. **With the camera in a Creative Zone mode, press the ISO-Flash Exposure Compensation button above the LCD panel.** The camera displays the current ISO setting on the LCD panel and in the viewfinder.

2. **Turn the Main dial clockwise to set a higher sensitivity or counterclockwise to set a lower sensitivity.** The camera displays the ISO sensitivity settings as you turn the dial. The lowest setting is Auto, which is detailed in the previous section. If you have ISO Expansion turned on using C.Fn I-3, then ISO 3200 is displayed as H. The ISO option you select remains in effect until you change it again.

To turn on expanded ISO expansion, follow these steps.

1. **Set the camera to a Creative Zone mode such as Tv, Av, or M.**

2. **Press the Menu button, and then press the Jump button until the Custom Functions (orange) tab is displayed.**

3. **Turn the Quick Control dial to highlight C.FnI: Exposure, and then press the Set button.** The C.Fn I: Exposure, Exposure level increments screen appears, and the C.Fn number control in the upper right is active.

4. **Turn the Quick Control dial clockwise to highlight the C.Fn number to 3, and then press the Set button.** The C.Fn I Exposure ISO expansion screen is displayed with two options. The C.Fn options are activated.

5. **Turn the Quick Control dial to the right to highlight On, and then press the Set button.** You can lightly press the Shutter button to dismiss the menu.

Selecting a Drive Mode

In Creative Zone modes, you can choose among three main drive-mode options on the 40D: Single, Continuous Shooting, and Self-timer modes. You can choose a drive mode in Creative Zone shooting modes.

 Note *In Basic Zone modes, the camera automatically chooses the drive mode, but in most modes, you can optionally choose the 10-second Self-timer mode.*

Here is a summary of each mode:

✦ **Single Shooting.** In this mode, one image is captured with each press of the Shutter button for up to 3 frames per second (fps).

✦ **High-speed Continuous.** In this mode, you can keep the Shutter button depressed for a conservative burst rate of approximately 75 Large/Fine JPEGs, 14 RAW+JPEG (Large/Fine), or 17 RAW files. The actual number of frames in a burst depends on the shutter speed, file size, and the space remaining on the CF card.

✦ **Low-speed Continuous.** This mode also delivers a maximum of 3 fps as you keep the Shutter button completely depressed.

✦ **Self-timer modes (10- and 2-second).** In Self-timer modes, the camera delays making the picture for 10 or 2 seconds after the Shutter button is fully depressed. In 10-second mode, the Self-timer lamp on the front blinks, a beep is emitted slowly for 8 seconds, and then the speed of the beep and the blinking increase for the final 2 seconds before the shutter releases. The camera displays the countdown to firing on the LCD panel as well. The 10-second mode is effective when you want to include yourself in a picture. This mode is useful in nature, landscape, and close-up shooting, and can be combined with Mirror Lock-up (C.Fn III-7) to prevent any vibration from the reflex mirror action and from pressing the Shutter button. You have to press the Shutter button once to lock the mirror, and again to make the exposure.

Tip	*The maximum number of images you can capture during a burst of continuous shooting depends on the image recording quality, ISO, Picture Style, and the size and speed of the CF card you use among other factors. White-balance bracketing lowers the maximum burst.*

Canon uses smart buffering to deliver large bursts of images. The images are first delivered to the camera's internal buffer. Then the camera immediately begins writing and offloading images to the CF card. The time required to empty the buffer depends on the speed of the card, the complexity of the image, and the ISO setting. JPEG images that have a lot of fine detail and digital noise tend to take more time to compress than images with less detail and low-frequency content.

But the off-loading time can seem like an eternity when the bride and groom are walking down the aisle toward you, and you

CF Card Types and Speed Ratings

Directly related to the speed of the camera is the speed of the CF card—how quickly images can be written from the camera to the card. Equally important is the speed of the card in transferring images from the card to the computer. Both factors are important to achieving a speedy and efficient workflow.

The 40D accepts CompactFlash (CF) Type I and Type II media cards as well as micro-drives. And, because the 40D supports the FAT32 file system, you can use media cards with capacities of 2GB and larger. As you evaluate cards, remember that the type and speed of media you use affect the camera's response times for tasks such as writing images to the media card and the ability to continue shooting during that process, the speed at which images are displayed on the LCD, and how long it takes to zoom images on the LCD. In addition, the file format that you choose also affects the speed of certain tasks—when writing images to the media card, for example. JPEG image files write to the card faster than RAW files or RAW+JPEG files.

If speed is your main goal, then be sure to review Rob Galbraith's test results on CF cards and microdrives. You can find the latest test results at www.robgalbraith.com. Just click the CF/SD link at the upper left of the Web site.

need buffer space to continue shooting. Thanks to smart buffering, you can continue shooting in one, two, or three-image bursts almost immediately after the buffer is filled and offloading begins making buffer space available. In Continuous Shooting mode, the viewfinder displays a Busy message when the buffer is full and the number of remaining images shown on the LCD panel blinks. You can press the Shutter button halfway and look at the bottom right of the viewfinder to see the current number of available shots in the maximum burst.

Caution

If you see Full CF displayed in the viewfinder and on the LCD panel, wait until the red access lamp next to the Quick Control dial stops blinking before opening the CF card door cover. There is a warning to let you know not to open the CF card door cover while images are being written to the card, but it is good to get in the habit of checking the red access light status before opening the CF card door. When the red lamp goes out, remove the filled card and insert an empty CF card.

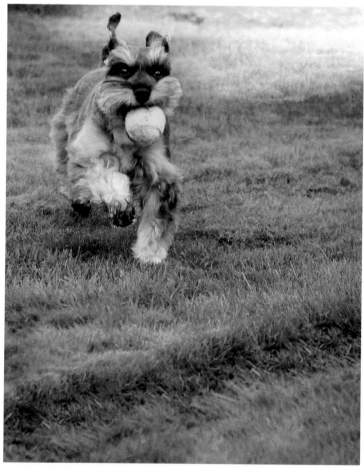

2.14 The 40D is speedy enough to capture sports and other action with no hiccups. Exposure: ISO 400, f/3.2, 1/400 sec., using an EF 24-70mm f/2.8L USM lens.

The 40D is set to Single Shot drive mode by default. To switch to a different drive mode, follow these steps:

1. **Press the AF-Drive button above the LCD panel.** The camera activates Drive mode selection in the LCD panel. The default drive mode is SingleShot. In Basic Zone modes, Self-timer options are limited to the 10-second mode.

2. **Turn the Quick Control dial to select a drive mode.** Turning the Quick Control dial clockwise, the mode sequence begins with SingleShot and sequences through High-speed continuous, Low-speed continuous, Self-timer 10 sec., and Self-timer 2-sec. The Drive mode remains in effect until you change it.

Viewing and Playing Back Images

Viewing, or playing back, images goes beyond a quick glance to see if the image exposure and composition is acceptable. Image review most often includes magnifying the LCD preview to check for sharpness, reviewing the brightness (luminance) histogram for localized areas of overexposure, and/or reviewing the color histogram to check color saturation, gradation, and white-balance bias.

And with this unprecedented ability to gauge exposure and composition on the spot, image evaluation can quickly solidify the settings for a studio shooting session or alert you to the need for a quick exposure change for other settings.

If you haven't already set the camera so that it will not shoot if a CF card isn't inserted, be sure to turn off this dubious feature. Why anyone would want to shoot without a CF card is beyond me except maybe to capture Dust Delete Data (detailed later in this chapter), but the 40D and other Canon digital SLRs continue to offer this option. To turn off the option, press the Menu button, and then press the Jump button until the Shooting 1 (red) menu is displayed. Turn the Quick Control dial to select Shoot w/o card, and then press the Set button. Select Off, and press the Set button.

In terms of image playback, one of the first things you'll want to do is to change the default display time, which is initially set to 2 seconds and is hardly enough time to move the camera from your eye to catch the image preview. The display time is intentionally set conservatively to maximize battery life, but given the excellent battery performance except when shooting in Live View mode, a display time of 4 to 8 seconds is more useful, and it doesn't significantly impact the battery performance. Also, if you're showing an image on the LCD to a subject or a client and you want the image to stay displayed, you can set the display time to Hold until you dismiss the display.

To learn more about Live View shooting, see Chapter 5.

To change the length of image playback review time, follow these steps:

1. **Press the Menu button, and then press the Jump button until the Shooting 1 (red) menu appears.**

2. Turn the Quick Control dial clockwise to highlight Review time, and then press the Set button to display the options. The camera displays the Review time options: Off, 2, 4, and 8 sec., and Hold.

3. Turn the Quick Control dial to highlight the Review time option that you want, and then press the Set button to confirm the option selection. If you select Hold, the picture is displayed until you press the Shutter button to dismiss the display. Viewing images for a long time depletes the battery faster. The option you choose remains in effect until you change it.

The 40D offers several image playback options including Single-Image playback with options for displaying or not displaying exposure information, Magnified View, Index Display, or Auto (Slideshow) playback. You also can jump among images stored on the CF card by groups.

Single-Image playback and Magnified view

As the name suggests, in Single-Image playback you see one image on the LCD at a time. This is the default playback mode on the 40D, and it's accessed by pressing the Playback (>) button on the back of the camera. One of the things you'll want to do is to verify tack-sharp focus, and with the 40D in playback mode, you can magnify the image up to 10x and scroll through the image to find the point of sharpest focus.

When you press the Playback button, the most recently captured image is displayed

with basic shooting information displayed at the top of the LCD. And if you set the options, then the display also includes flashing overexposed highlights and a superimposed AF-point display showing the AF point that achieved focus.

To cycle through multiple images on the CF card, turn the Quick Control dial counterclockwise to view the next most recent image, or clockwise to view the first image on the CF card.

For single-image playback, you can choose four display formats as follows:

✦ **Single image with basic shooting information.** This default mode displays the image at a large size with the shutter speed, aperture, folder number-file number, and media type (CF denoting CF card). This is a good display option to use when showing images to subjects because it provides a clean, uncluttered view of the image.

✦ **Single image display with basic shooting information and image recording quality.** With this option, basic shooting information appears as in the previous display, but the camera also overlays a light gray box at the bottom left of the LCD preview screen that shows the recording quality and the image number relative to the number of images captured, for example, 10/11, or image 10 of 11 stored images. This display option is useful to verify the image quality setting, or to recall exposure settings for a previous image.

✦ **Single image with shooting information and a histogram.** This is a more data-rich view that includes all the exposure and file information, flash exposure, capture time, the histogram you've selected, either brightness or RGB, and more. The image preview is necessarily reduced in size to about one-fourth of the full LCD preview size to accommodate all the information. Figure 2.15 shows this display option and identifies the data displayed. This option is invaluable for checking the histogram, exposure, color, and just about every other shooting setting that you want to verify. If you set AF points to be displayed, the AF point that achieved focus in One-Shot AF mode is also displayed on the image preview. Or for AI Servo AF mode, the AF points that achieved focus are displayed.

Note *If you want the AF point or points that achieved focus to display during image playback, press the Menu button, and then press the Jump button until the Playback (blue) menu is displayed. Select the AF-points option, press the Set button, select Display, then press the Set button. The AF point or points that achieve focus in either One-Shot AF or AI Servo AF mode are displayed as a red square on LCD preview images.*

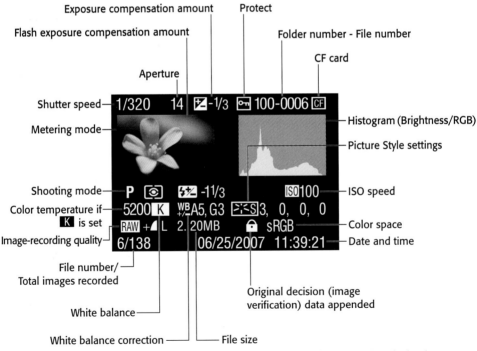

2.15 This is the single-image shooting information displayed during image playback.

✦ **Single image with shooting information and Brightness and RGB histograms.** This display option reduces the amount of shooting information to show both a Brightness histogram, and three RGB color channel histograms. In addition to the ribbon at the top that provides basic shooting information, this view includes the shooting and metering mode, white balance, file size, image recording quality, and the current image number relative to the total number of shots on the CF card.

To change the display format in Single-Image playback, follow these steps:

1. **Press the Playback button.** If you have not changed the default playback display, the most recently captured image is displayed with basic shooting information at the top of the display. This ribbon of basic shooting information is common to all Playback display options.

2. **Press the Info button once to display basic shooting information, twice to display full shooting information with a histogram, or three times to display shooting information with both RGB and Brightness histograms.** Pressing the Info button simply cycles through the various Playback display options.

To magnify an LCD preview image in any display mode, follow these steps:

1. **Press the Playback button, and then press the AF-point Selection/Enlarge button on** the top-right side of the back of the camera. The camera switches to Single image display with basic shooting information and image recording quality, and displays a square on the right to show relative magnification.

2. **Press and hold the AF-point Selection/Enlarge button to magnify the image up to 10x.**

3. **Tilt the Multi-controller to move around the image.** If you set the camera to display the AF point that achieved sharpest focus, the AF point unfortunately does not continue to display in Magnified mode. At best, you can use it as a visual point of reference before you begin magnifying and scrolling through the image.

4. **Press the AE Lock/Reduce button to zoom out the image to thumbnail display size.** When you reduce the image completely, the original playback display option is restored.

Index display

In addition to evaluating individual images, you can view multiple images on the CF card in an index display; essentially, this is a miniature, electronic version of a contact sheet. Index display shows either four or nine thumbnails of images at a time. This display is handy when you need to verify that you've captured a picture of everyone at a party or event or when you want to find a particular image quickly. You can use Index display regardless of which single-image display option you're using.

To display images as an index, follow these steps:

1. **Press the Playback button.**

2. **Press the AE Lock/Reduce/ Index button on the back of the camera once to display a four-image index page, or press it twice to display a nine-image page.** The camera displays the last images captured, and the selected image is displayed with a green border. If the Index display shows only one or a few images, turn the Main dial counterclockwise to move to the previous page of images. The Index display includes basic shooting information for the selected image on the index display.

3. **Turn the Quick Control dial to move one image at a time, or turn the Main dial to jump by one or more pages at a time.** If you selected a Jump option such as moving 100 images at a time, then turning the Main dial moves through index pages at that interval. Alternately, the Quick Control dial moves one image at a time. To display the selected image in Single-Image display, press the AF-point Selection/Enlarge button. You can press and hold this button to magnify the image. To return to Index display, press and hold the AE Lock/Reduce button until the Single-Image display is shown, and then press the AE Lock/Reduce button again to return to Index display.

4. **Press the Jump button to display a scrollbar, and then turn the Main dial to move among images in the Jump option you've set.**

5. **Press the AF-point Selection/ Enlarge button to turn off the Index display and return to the selected Single-Image display mode.**

Tip *You can also use Auto Playback to show images as a slideshow on the LCD. Just press the Menu button, and then press the Jump button until the Playback 2 (blue) menu appears. Turn the Quick Control dial to select Auto play, and then press the Set button. The images cycle through in the playback display mode you've selected. You can pause and restart the slideshow by pressing the Set button, or lightly press the Shutter button to return to shooting.*

Jump quickly among images

If you use a high-capacity CF card or simply have a lot of images on the card, it's challenging to find a single image. To make searching for a specific image or a series of images easier, you can elect to jump through images on the CF card by 1, 10, or 100 images at a time, by screen, or by shot date.

To change the jump criteria, follow these steps:

1. **Press the Playback button, and then press the Jump button.** The camera displays a scroll bar at the bottom of the LCD display and activates a control on the left for selecting jump numbers.

2. **Turn the Quick Control dial clockwise one or more clicks until the image-jump option you want is displayed.** As you turn the Quick Control dial, the option sequence is 1, 10, 100, Screen, Date.

3. **Press the Set button, and then turn the Main dial to move among images using the option you set.** As you move, the scroll bar shows the progress relative to the number of images stored on the CF card. If you choose to jump by shot date, turn the Quick Control dial to move to the previous or next date. If there are multiple images taken on the same date, the camera displays the first image taken on that date. The Jump option you choose remains in effect when you turn the Main dial to browse through images. However, if you turn the Quick Control dial, the browse method is one image at a time.

To exit Jump mode, press the Jump button.

Erasing Images

Erasing images is a fine option, but it is an option to choose only when you know without a doubt that you do not want the image you're deleting. Use it with caution. From experience, I know that some images that appear to be mediocre on the LCD often can be salvaged with judicious editing on the computer. Before you erase images, remember that you cannot recover them.

Remember also that even with the large LCD monitor, you're still looking at a tiny version of your images. I find that it's wiser to look at images on a computer monitor to better evaluate the merits or demerits of each before permanently deleting them.

Be sure to read on in this section to learn how to protect images from accidental erasure.

The 40D offers two ways to delete images: one image at a time, or by checkmarking

multiple images and deleting all marked images at once.

If you want to erase a single image forevermore, follow these steps:

1. **Press the Playback button.** Turn the Quick Control dial to navigate to the image you want to delete. Alternately, you can also use the Main dial.

2. **Press the Erase button.** Turn the Quick Control dial to highlight Erase if you want to delete the displayed image. If you change your mind, choose Cancel to not erase the image.

3. **Press the Set button to erase the image.** The camera erases the image if it does not have protection applied to it. The red access button lights while the image is being erased. Note that if a series of images shot in burst mode are being written to the CF card when you choose Erase, these images are erased as well including images that have not been processed.

Note It's a good idea to periodically format the CF card and always format it in the camera, not on the computer. Before formatting the card, be sure to download all the images from the card to the computer. To format the CF card, press the Menu button, press the Jump button until the Set-up 1 (yellow) menu is displayed. Turn the Quick Control dial to select Format, and then press the Set button. The camera displays a Format confirmation screen. Turn the Quick Control dial clockwise to highlight OK, and then press the Set button. The camera displays a progress screen as the card is formatted.

To select and erase multiple images at a time, follow these steps:

1. **Press the Menu button, and then press the Jump button until the Playback 1 (blue) menu is displayed.**

2. **Turn the Quick Control dial to highlight Erase Images, and then press the Set button.** The Erase images screen appears.

3. **Turn the Quick Control dial to highlight Select and erase images option, and press the Set button.** The 40D displays the image playback screen with options at the top left of the LCD to checkmark the current image for deletion.

4. **Press the Set button to add a check mark to the current image, or turn the Quick Control dial to move to the next image.** Continue selecting all of the images you want to mark for deletion.

5. **Press the Erase button.** The Erase images screen appears.

6. **Turn the Quick Control dial to highlight OK, and press the Set button.** The 40D erases the marked images, and the Erase images screen appears.

To replace all images on the card, follow these steps:

1. **Press the Menu button, and then press the Jump button until the Playback 1 (blue) menu is displayed.**

2. **Turn the Quick Control dial to highlight Erase Images, and then press the Set button.** The Erase images screen appears.

3. **Turn the Quick Control dial to highlight the All images on the card option, and then press the Set button.** The Erase images screen appears asking you to confirm that you want to delete all except protected images.

4. **Turn the Quick Control dial to highlight OK, and then press the Set button.** The Erase images screen appears, and images are erased.

Protecting Images

At the other end of the spectrum from erasing images is the ability to ensure that images you want to keep are not accidentally deleted. To prevent accidental erasure, you can apply protection to one or more images. Protection is much like setting a document on the computer to read-only status. When you download a protected image, you're asked to confirm that you want to move or copy one or more read-only files, which are the protected images.

Caution *Setting protection means that protected images can't be deleted using the Erase options detailed in the previous section. However, protected images are erased by formatting the CF card.*

You can apply protection to an image by following these steps:

1. **Press the Playback button.** The last image taken is displayed on the LCD.

2. **Turn the Quick Control dial to move to the image you want to protect.**

3. **Press the Menu button, and then press the Jump button to select the Playback 1 (blue) menu.**

4. **Turn the Quick Control dial to highlight Protect images, and then press the Set button.** A small key icon and "Set" appears at the top left of the display.

5. **Press the Set button again to protect the displayed image.** A key icon appears in the information bar above the image to show that it is protected. To protect additional images, turn the Quick Control dial to scroll to the image you want to protect, and then press the Set button to add protection. If you later decide that you want to erase a protected image, you must remove protection by repeating Steps 1 to 5 and pressing the Set button to remove protection for each image. When protection is removed, the key icon in the top information bar is removed.

Displaying Images on a TV

Viewing images stored on the CF card on a TV is a convenient way to look at images at a large size, particularly when traveling. The video cable to connect the camera to a TV is included in the 40D box. Before connecting the camera to the TV, you need to set the video system format using the Setup menu on the camera.

> **Note** When you display images on some TV sets, the corners may appear to be dark or part of the image may be cut off.

You can display images stored on the CF card on a TV set by following these steps:

1. **Press the Menu button, and then press the Jump button until the Set-up 2 (yellow) menu is displayed.**

2. **Turn the Quick Control dial to highlight Video system, and then press the Set button.** The camera displays the NTSC and PAL options. NTSC is the default option.

> **Note** NTSC is the analog television system in use in the United States, Canada, Japan, South Korea, the Philippines, Mexico, and some other countries, mostly in the Americas. PAL is a color encoding system used in TV systems in parts of South America, Africa, Europe, and other countries.

3. **Turn the Quick Control dial if you want to highlight PAL instead of NTSC.**

4. **Turn off the TV set and the camera.**

5. **Attach the video cable to the camera's Video Out terminal.** This terminal is under the terminal cover closest to the back of the camera and is the bottom terminal. Ensure that the cable is firmly seated in the terminal.

6. **Connect the other end of the video cable to the TV set's Video In terminal.** Ensure that the cable is fully seated in the terminal.

7. **Turn on the TV set and then switch the TV's input to Video In.**

8. **Turn the camera's power switch to the ON position.**

9. **Press the Playback button.**
 Images are displayed on the TV but not on the camera's LCD monitor. When you finish viewing images, turn off the TV and the camera before disconnecting the cables.

Restoring the Camera's Default Settings

With all of the options for different settings on the 40D, you may sometimes want to start fresh instead of backtracking to reset individual settings. The 40D offers several restore settings, including Clear all camera settings. This option is a good way to start fresh, but be aware that it resets all shooting and image quality settings back to the factory defaults.

In addition to the fresh-start advantage, I've found that resetting default settings is also a quick way to resolve unexpected problems with the camera, especially if the problems happen in the middle of a shooting session.

Table 2.4 shows the default settings for the 40D.

If you customize the 40D and want to restore the default camera settings, follow these steps:

1. **Press the Menu button, and then press the Jump button until the Set-up 3 (yellow) menu is displayed.**

2. **Turn the Quick Control dial to highlight the Clear all camera settings option, and press the Set button.** The Clear all camera settings screen appears.

Table 2.4
Clear All Camera Settings Defaults

Shooting Settings		Image Recording Settings	
AF mode	One-shot	**Quality**	Large/Fine
AF-Point Selection	Automatic	**ISO**	Auto
Metering mode	Evaluative	**Color space**	sRGB
Drive mode	Single-shooting	**White balance**	AWB
Exposure Compensation	Zero	**White-balance correction**	Off
AEB	Off	**White-balance bracketing**	Off
Flash Exposure Compensation	Zero	**Picture Style**	Standard
Custom Functions	Retains current settings		

3. **Turn the Quick Control dial to highlight OK, and then press the Set button.** A confirmation screen appears.

4. **Turn the Quick Control dial to highlight OK, and then press the Set button.** The settings are restored to the camera defaults.

Cleaning the Image Sensor

Few early digital photographers managed to escape tedious hours spent spotting images. Regardless of how careful they were when changing lenses, inevitably dust particles — some rivaling the size of digital meteors — would quickly accumulate on the sensor.

Of course, dust still accumulates on image sensors. The dust and spots come from external dust and clothing particles that fall into the chamber while changing lenses, and from dust or lubricants within the camera body that are dislodged by carrying the camera and by changes in air pressure.

Regardless of the source, the task of cleaning the image sensor is easier than ever before, particularly with the 40D, which offers four options for cleaning the sensor:

✦ **Automatic self-cleaning.** An IR-cut filter is installed in front of the CMOS sensor, and this filter has a coating to resist dust by reducing static that attracts dust. When you turn the camera on and off, the camera initiates an ultrasonic vibration to loosen and shake off dust. Then the dust is captured by material around the filter which prevents the dust from returning to the filter. The automatic cleaning process takes approximately 1 second. You can also manually run the self-cleaning element through the camera menu. Cleaning initiated via the menu takes approximately 3.5 seconds. Automatic self-cleaning is enabled by default on the 40D.

✦ **Clean now.** You can also choose to clean the sensor by way of the Clean now option on the camera menu in all shooting modes. This cleaning process is slightly longer than the cleaning that takes place when you power the camera on and off.

✦ **Dust Delete Data collection and application.** Dust Delete Data is designed to deal with larger, sticky dust particles. Capturing Dust Delete Data involves taking a picture of a piece of white paper from which the camera identifies the size and location of dust on the filter. A tiny data file is appended to the image, and then you can use it in Canon's Digital Photo Professional program to erase the spots. The Dust Delete Data option is available only in Creative Zone modes.

✦ **Clean manually.** Stubborn dust can be cleaned manually by setting an option on the camera menu to lock up the mirror and open the shutter so that you can use a blower or other cleaning method. The Clean manually option is available only in Creative Zone modes.

To clean the sensor using the camera menu command, follow these steps:

1. **In any shooting mode, press the Menu button, and then press the Jump button to display the Setup 2 (yellow) menu.**

Manual Sensor Cleaning

For manual sensor cleaning, Canon recommends using a rubber blower such as those sold at drug stores. Certainly, this is the safest approach to cleaning. But other products work very well too. I use the VisibleDust (www.visibledust.com) products, particularly the brushes that you "charge" by blowing them with air before gently swiping them across the sensor. VisibleDust offers cleaning solutions, swabs, and state-of-the-art soft brushes designed to gently clean or lift dust and spots without damaging the sensitive sensor surface. VisibleDust also offers tutorials on how to clean the sensor using its products.

But there are a variety of cleaning products available with a quick Google search. Never use canned air to clean the sensor because the force of the air on the sensor may damage it, and the gas propellant can freeze on the sensor. Also don't use a blower with a brush attached because it can scratch the sensor.

2. **Turn the Quick Control dial to highlight Sensor cleaning, and press the Set button.** The Sensor cleaning screen appears.

3. **Turn the Quick Control dial to highlight the Clean now option. and then press the Set button.** The Clean now screen appears.

4. **Turn the Quick Control dial to highlight OK if it isn't already selected, and then press the Set button.** The camera displays the cleaning symbol, and the Sensor cleaning screen appears.

Note *If for some reason you want to turn off automatic sensor cleaning, you can disable it using the Set-up 2 (yellow) menu. Just select Sensor cleaning, press the Set button, and then turn the Quick Control dial to highlight Auto cleaning. Then press the Set button. On the Auto cleaning screen, turn the Quick Control dial to highlight Disable, and then press the Set button.*

Obtaining Dust Delete Data

For larger, sticky dust particles, the camera can determine the size and location of dust when you take a picture of a white piece of paper. Although you take a picture, no image is recorded to the CF card. Using the picture of the white paper, the 40D maps the coordinates of dust particles that are stuck to the filter and creates a very small data file that is appended to images.

To erase the dust, you use Canon's Digital Photo Professional (included on the EOS Digital Solution Disk). Appending dust data does not increase the image file size, and it does not affect the continuous shooting speed or burst rate. Dust Delete Data can be applied to JPEG, RAW, and sRAW images. Also, it is a good practice to update the Dust Delete Data periodically.

Before you begin, ensure that you do the following:

✦ **Have a clean piece of white paper large enough to fill the viewfinder when positioned approximately 1 foot from the lens.** Ensure that the paper is solid white and that it is evenly lit by any light source.

✦ **Set the lens focal length to 50mm or longer.** On a zoom lens, the focal-length settings are displayed on the lens ring. Just turn the lens ring to a focal length that reads 50mm or higher.

✦ **Set the lens to manual focus by sliding the switch on the side of the lens to MF.**

✦ **With the camera facing forward, set the focus to infinity by turning the lens focusing ring all the way to the left.** On the lens distance scale, the infinity symbol looks like an "8" lying on its side.

To obtain Dust Delete Data, follow these steps:

1. **Set the camra to a Creative Zone shooting mode, press the Menu button, and then press the Jump button to select the Shooting 2 (red) tab.**

2. **Turn the Quick Control dial to highlight Dust Delete Data, and then press the Set button.** The Dust Delete Data screen appears.

3. **Turn the Quick Control dial to highlight OK, and press the Set button.** The camera raises the reflex mirror and displays a screen reminding you to completely press the Shutter button when you are ready to obtain data.

4. **With the camera approximately 1 foot from the white paper, and with the paper filling the viewfinder, press the Shutter button completely.** The camera automatically sets the exposure to f/22, 1/2 second or faster, ISO 800 in Av mode. The flash does not fire. The camera captures the data and displays a confirmation message. If the Data was obtained correctly, a confirmation screen appears.

5. **Press the Set button to select OK.** The Shooting 2 (red) menu appears.

6. **Lightly press the Shutter button to return to shooting.**

Applying Dust Delete Data

After acquiring the Dust Delete Data, you can use Canon's Digital Photo Professional program to apply the data to either JPEG or RAW images. Be sure that you've installed Digital Photo Professional from the Canon EOS Digital Solution Disk included in the camera box.

To apply Dust Delete Data in Digital Photo Professional, follow these steps.

1. **Start Digital Photo Professional, and then navigate to the folder that contains images with Dust Delete Data appended.** If you just obtained the data, then images you've taken since then will have the data file appended.

2. **Select an image with Dust Delete Data appended, and then click the Edit image window in the toolbar.** The image-editing window appears.

3. **Choose Tools ➪ Start Stamp tool.** A separate copy stamp window appears.

4. **Click Apply Dust Delete Data.** The data is applied to the image. You can check the erased dust spots individually by pressing Shift+F. To go to the previous spot, press Shift+B.

5. **Click OK.** The main Edit window appears. You can repeat these steps to apply the Dust Delete Data to remaining images in the folder.

Cleaning the sensor manually

With the self-cleaning sensor combined with Dust Delete Data, the likelihood or need to manually clean the sensor drops dramatically. Occasionally, however, you may find it necessary to clean the sensor.

Once you have the product that you'll use to clean the sensor, do the following:

✦ **Ensure that the camera battery is fully charged.** You can't use the optional battery grip with AA batteries in it to clean the sensor.

✦ **Find a place indoors away from drifting lint, dust, pets, and so on, that has bright light so that you can see the sensor as you clean it.**

✦ **Read the cleaning steps before you begin so you have a general idea of the task flow.**

✦ **Assemble the products you'll use and prepare them before you begin.**

✦ **Remove the lens and attach the body cap until you're ready to begin.**

When you're ready, follow these steps to clean the image sensor:

1. **In a Creative Zone shooting mode, press the Menu button, and then press the Jump button until the Set-up 2 (yellow) menu is displayed.**

2. **Turn the Quick Control dial to highlight Sensor cleaning, and then press the Set button.** The Sensor cleaning screen appears.

3. **Turn the Quick Control dial to highlight the Clean manually option, and then press the Set button.** The camera displays the Clean manually screen reminding you that the mirror will lock up (for cleaning) and to turn off the power switch when you finish.

4. **Turn the Quick Control dial to highlight OK, and then press the Set button.** The camera flips up and locks the mirror, and the shutter opens. Remove the body cap if you placed it on the camera during the preparation phase. "CLn" blinks in the LCD panel. Do not do anything that would disrupt power to the camera during cleaning.

5. **Use the rubber blower or a sensor brush to clean the sensor.** If you use a sensor brush specifically designed for sensor cleaning, wipe in a single down, across, and upward motion. If you use a blower brush, turn the camera so the lens mount faces down, and blow away dust.

6. **Turn the Power switch to the Off position.** The camera turns off, the shutter closes, and the reflex mirror flips back down.

To determine how well you cleaned the sensor, make and evaluate a few pictures of a blue sky at a large aperture.

In many years of digital photography, I've not found any surefire ways to avoid dust accumulating on the image sensor other than common-sense approaches that include avoiding changing lenses in windy and/or dusty outdoor areas, keeping the rear optical element of lenses scrupulously clean, changing lenses with the lens mount pointed downward, and always keeping a lens mounted or putting the body cap on the lens mount when no lens is mounted. I also carry large, unused plastic bags in my camera bag. If I'm in dusty outdoor areas, I put the camera body in the bag to change lenses. These precautions certainly help keep the sensor clean, but none is fool-proof.

Color and Picture Styles

Never has the ability to get accurate color been as accessible as it is with digital photography. Color options begin in the camera by selecting a color space that matches your workflow. In addition, Canon offers Picture Styles that determine the default tonal curve, sharpness, color rendering, and saturation of images. A variety of Picture Styles that replicate traditional film looks or render color in different ways can be applied in the camera for JPEG capture, and either in the camera or after capture for RAW capture.

In terms of color, the White Balance options on the 40D are comprehensive and dependable, whether you prefer using the preset white balance settings, setting the color temperature yourself, or setting a custom white balance. In this chapter, you learn how each option is useful in different shooting scenarios as well as some widely used techniques for ensuring accurate color.

About Color Spaces

A color space defines the range of colors that can be reproduced and the way that a device such as a digital camera, a monitor, or a printer reproduces color. Of the two color space options offered on the 40D, the Adobe RGB color space is richer because it supports a wider gamut, or range, of colors than the sRGB color space option. And in digital photography, the more data captured, or, in this case, the more colors captured by the camera, the richer and more robust the file. It follows that the richer the file, the more bits that you have to work with whether you're capturing RAW or JPEG images. And with the 40D's new 14-bit Analog/Digital conversion, you get a whopping 16,384 colors per channel when you shoot in RAW capture.

3.1 This RAW image, which was converted in Adobe Camera Raw and edited in Photoshop CS3, is the basis for the histograms in figures 3.2, 3.3, and 3.4. Exposure: ISO 250, f/8, 1/200 sec.

> **Note** *The same principle – getting the most that the 40D image sensor offers – also holds true in regard to image bit depth.*

The following histograms show the difference that choosing a large color space makes during RAW image conversion. Spikes on the left and right of the histogram indicate colors that will be clipped, or discarded, from the image.

> **Cross-Reference** *For details on evaluating histograms, see Chapter 1.*

After evaluating these histograms, you can see that much more image data is retained by using a wide color space such as ProPhoto RGB. And while the image may eventually be converted to a smaller color space such as Adobe RGB or sRGB, the goal is to keep as much image as possible during conversion and for as long as possible during Photoshop editing.

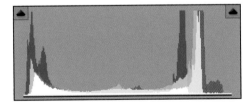

3.2 Adobe Camera Raw histogram using ProPhoto RGB. Notice the additional headroom in the highlights (shown on the right side of the histogram) that this large color space provides as well as the rich amount of color in this histogram compared to the following histograms.

What Is Bit Depth and Why Should I Care?

A digital picture is made up of many pixels that are each made up of a group of bits. A bit is the smallest unit of information that a computer can handle. In digital images, each bit stores information that when aggregated with other pixels and color information, provides an accurate representation of the picture.

Digital images are based on the Red, Green, and Blue (RGB) color space. That means that an 8-bit JPEG image has 8 bits of color information for red, 8 bits for green, and 8 bits for blue. This gives a total of 24 bits of data per pixel (8 bits x 3 color channels). Because each bit can be one of two values, either 0 or 1, the total number of possible values is 2 to the 8th power, or 256 values per color channel.

In the RGB color space, the range of colors is represented on a continuum from 0 (black) to 255 (white). On this continuum, an area of an image that is white is represented by 255R, 255G, and 255B, and an area that is black is represented by 0R, 0G, and 0B.

On the other hand, a 14-bit file, provides 16,384 colors per channel.

High bit-depth images offer not only more colors but they also offer more subtle tonal gradations and a higher dynamic range than low bit-depth images. As a result, RAW images offer much greater latitude during conversion and editing than JPEG images. If your goal is to get the highest quality from your 40D images, then RAW capture, with its higher bit depth and significantly more colors per channel, is the best option.

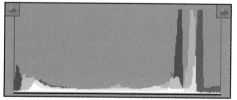

3.3 Adobe Camera Raw histogram using Adobe RGB. Both the highlights and the shadows clip as shown by the spikes on the right and left sides of the histogram, respectively.

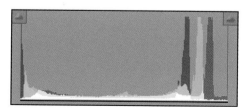

3.4 Adobe Camera Raw histogram using sRGB. Here the shadow spike increases noticeably.

Choosing a color space and keeping it consistent throughout the workflow helps to ensure that colors are accurately represented on devices including the computer monitor and the printer.

Even if you convert RAW images using ProPhoto RGB, eventually you'll want to convert the image to Adobe RGB, which is the color space of choice for printing on both inkjet and commercial printers. And for images destined for online use in e-mail or Web display, sRGB provides the best online color display. While this may sound like a conflict in choosing color spaces, for most workflows it translates into using Adobe RGB for capture, editing, and printing. When an image is needed for online display, you make a copy of the image and convert it to sRGB in an editing program such as Photoshop CS3.

Choosing a Color Space

The first step in managing color is to select a color space for shooting on the 40D. In Creative Zone shooting modes, you can choose a color space, either Adobe RGB or sRGB, and it applies to JPEG, RAW, and sRAW files. In all Basic Zone modes, the camera automatically selects sRGB and JPEG capture.

If you choose Adobe RGB for Creative Zone modes, image filenames are appended with _MG_. While the 40D does not embed the color, or ICC, profile in the file, you can embed the profile using Photoshop 6.0 or later. Then the color space information can be read by other devices such as monitors and printers that support ICC profiles.

To set the color space on the 40D, follow these steps:

1. **Set the Mode dial to a Creative Zone mode: P, Tv, Av, M, or A-DEP.**

2. **Press the Menu button.**

3. **If the Shooting 2 (red) menu isn't displayed, press the Jump button until it appears.**

4. **Turn the Quick Control dial to highlight Color space, and then press the Set button.** The camera displays the color space options.

5. **Turn the Quick Control dial to highlight the color space you want, either sRGB or Adobe RGB, and then press the Set button.** The color space remains in effect until you change it or switch to a Basic Zone mode. In Basic Zone modes, the camera automatically sets sRGB, and you don't have the option to change it.

Choosing White Balance Options

If you would rather spend your time shooting instead of sitting at the computer color-correcting images, then learning about and using the 40D's White Balance options are very important. Different shooting scenes, the type and consistency of light, the

About ICC Profiles

ICC is an abbreviation for International Color Consortium, which promotes the use and adoption of open, vendor-neutral, cross-platform color management systems. This group introduced the standard device profile format used to characterize color devices.

Photoshop and other applications that support ICC profiles, use the profiles to produce colors more accurately, so that colors look consistent when printed or viewed on different devices. Photoshop also uses profiles to convert RGB values to CMYK (a color space used in commercial printing) and CMYK to RGB, to display photo CD image color more accurately, and to soft-proof an image at different settings so that you can see how the image will look.

amount of time you have to set up the camera before and during a shoot are some of the factors that can influence which White Balance option you use.

On the 40D, White Balance options give you a variety of ways to ensure color is accurately rendered in the image. You can set the white balance by choosing one of the seven preset options, by setting a specific color temperature, or a custom white balance.

3.5 This image was captured using the Daylight White Balance setting and the Standard Picture Style. The colors are warm yet accurate. Exposure: ISO 100, f/8, 1/200 sec.

3.6 This image was captured using the Tungsten White Balance setting and the Standard Picture Style. The image has a noticeable yellow/green tint because the white balance setting did not match the light temperature in the scene.

Tip

If you shoot RAW or sRAW images, you can set or adjust the white balance in the RAW conversion program after the image is captured.

Table 3.1 provides the White Balance options, and the approximate color temperature as measured in Kelvin.

What Is White Balance?

Unlike a mechanical camera, the human eye automatically adjusts to the changing colors (temperatures) of light. For example, we see a white shirt as being white in tungsten, fluorescent, or daylight; in other words, regardless of the type of light in which we view a white object, it appears to be white. Digital image sensors are not as adaptable as the human eye, however, and sensors cannot distinguish white in different types of light unless they are told what the light temperature is. And that's what a white balance setting does – it tells the camera what the light temperature is in the scene so that the camera can accurately represent the colors in the scene in the image.

Light temperature is measured on the Kelvin scale and is expressed in Kelvin (K). Once the camera knows the light temperature, it can render white as white. On the 40D, a preset White Balance option covers a range of light temperatures, so rendering white is more approximate than specific; whereas, setting a custom white balance, or setting a specific light temperature is more specific and typically renders more neutral (or accurate) color.

Table 3.1
40D White Balance Temperature Ranges

White Balance Option	Approximate Range in Kelvin (K)	EOS 40D Setting and Corresponding Color Temperature (K)
Auto (AWB)	N/A	3000 to 7000
Daylight	5000 to 7000	5200
Shade		7000
Cloudy, twilight, sunset	6000 to 8000	6000
Tungsten	2500 to 3200	3200
White fluorescent	4300	4000
Flash	4500 to 6000	6000
Custom	NA	2000 to 10,000
Color temperature	NA	2500 to 10,000

Approaches to using various White Balance options

Because the 40D offers three basic approaches to setting white balance, you may find that you use different approaches in different shooting scenarios. Following are examples for using each.

✦ **Using preset white balance settings.** For outdoor shooting, especially during clearly defined lighting situations such as bright daylight, an overcast sky, or shooting in white fluorescent light, the preset white balance settings perform nicely. In general, the preset white balance settings have excellent color and hue accuracy and good saturation. However, be aware that the 40D tends to oversaturate color almost exclusively in the reds, which can cause a loss of shape and detail in certain subjects such as a close-up of a red flower, particularly when shooting at the default Standard Picture Style. (Picture Styles are detailed later in this chapter.)

Getting Accurate Color with RAW Images

If you are shooting RAW capture, a great way to ensure accurate color is to photograph a white or gray card that is in the same light as the subject, and then use it as a point of reference when processing the images on the computer.

For example, if you're taking a portrait, ask the subject to hold the gray card under or beside his or her face for the first shot, then continue shooting without the card in the scene. When you begin converting the RAW images on the computer, open the picture that you took with the card. Click the card with the white balance tool to correct the color and then click Done to save the corrected white balance settings. If you're using a RAW conversion program such as Adobe Camera RAW (ACR) or Canon's Digital Photo Professional, you can copy the white balance settings from the image you just color balanced, select all of the images shot under the same light, and then paste the white balance settings to them. This technique is called click-balancing. In a few seconds, you can color balance 10, 20, 50, or more images.

Shooting a white or gray card is great when shooting a wedding, for example. During the wedding, the light changes from the bride's dressing room, to the church sanctuary, and then again in the reception hall. So, instead of setting a custom white balance for each type of light, you can take a picture of a white card in each of the different areas before, during, or even after the activities. Just be sure that the light on the card isn't so bright that it registers as the brightest highlight.

There are a number of white and gray card products you can use such as the WhiBal cards from RawWorkflow.com (www.rawworkflow.com/products/whibal) or ExpoDisc from expoimaging (www.expodisc.com/index.php) to get a neutral reference point. There are also small reflectors that do double duty by having one side in 18 percent gray and the other side in white or silver. The least expensive option, and one that works nicely, is a plain, white, unlined index card.

✦ **Setting a specific color temperature.** With this option, you set the specific light temperature on the camera. This is the fastest and easiest option to use for studio shooting when you know the temperature of the strobes or continuous lights. And if you happen to have a color temperature meter, this is a great option to use in non-studio scenarios. In short, use the specific color temperature white balance setting in any scene where you know the specific light temperature.

✦ **Setting a custom white balance.** Setting a custom white balance is an option that produces very accurate color because the white balance is set precisely for the light in the scene. To use this option, you shoot a white or gray card, select the image, and the camera imports the color data and uses it to set the image color. This works great for scenes where the light doesn't change. But if the light changes, you have to repeat the process to set a new custom white balance. Certainly for JPEG capture, this is an accurate technique that I highly recommend. For RAW capture, this and other techniques work well.

Note *Gray cards are specifically designed to render accurate color by providing a neutral white balance reference point that is later used during image editing to color balance images. Once an accurate gray point is established for the image in a RAW conversion program, all other colors in the image automatically fall into place.*

Whatever your approach to White Balance options, the time you spend using and understanding them and how they can enhance your workflow is time that you'll save color-correcting images on the computer.

To change to a preset White Balance option such as Daylight, Tungsten, Shade, and so on, follow these steps:

1. **Set the Mode dial to a Creative Zone mode.** In Basic Zone modes, the 40D automatically uses AWB, and you cannot change the white balance setting.

2. **Press the Metering Mode-WB button above the LCD panel.**

3. **Turn the Quick Control dial until the White Balance option you want is displayed on the LCD panel.** The white balance settings are shown with icons that represent different types of lights. The custom white balance setting is shown with two triangles on their sides and a solid black square between them. The Kelvin temperature setting is shown as a "K" within a black background. The White Balance option you set remains in effect until you change it.

Set a custom white balance

Mixed light scenes, such as tungsten and daylight, can wreak havoc on getting accurate or visually pleasing image color. Two options work well to get neutral color quickly in mixed lighting scenes. If you're shooting RAW or sRAW capture, one option is to shoot a gray or white card as described in the earlier sidebar. The second option is to set a custom white balance. Setting a custom white balance balances colors for the specific light used when you set the custom setting. It is relatively easy to set, and it's an excellent way to ensure accurate color.

Tip *For my work, I alternate between setting a custom white balance and shooting a white card for color balancing batches of images during RAW conversion. Both techniques work in the same general way, but they differ when you set the white balance. With one, you set it on the site; with the other click-balance technique, you set it during image conversion. Both techniques involve roughly the same amount of time and effort.*

Another advantage to custom white balance is that it works whether you're shooting JPEG or RAW capture in a Creative Zone mode. Just remember that if light changes, you have to set a new custom white balance.

To set a custom white balance, follow these steps:

1. **Set the camera to a Creative Zone mode (P, Av, Tv, M, or A-DEP), and ensure that the Picture Style is not set to Monochrome.** To check the Picture Style, press the Picture Style button on the back of the camera. The Picture Style screen is displayed. To change from Monochrome (black and white), turn the Quick Control dial to select another style, and then press the Set button.

Tip *It's best to have the white balance set to anything except Custom White Balance when you begin these steps. Occasionally, I've had the 40D refuse to import data from a white card shot when the white balance was already set to Custom.*

2. **In the light that will be used for the subject, position a piece of unlined white paper so that it fills the center of the viewfinder (the spot metering circle), and take a picture.** If the camera cannot focus, switch the lens to MF (manual focusing) and focus on the paper. Also ensure that the exposure is neither underexposed nor overexposed such as by having Exposure Compensation set.

3. **Press the Menu button, and then press the Jump button until the Shooting 2 (red) menu appears.**

4. **Turn the Quick Control dial to highlight Custom WB, and then press the Set button.** The camera displays the last image captured (the white piece of paper) with a Custom White Balance icon in the upper left of the display. If the image of the white paper is not displayed, rotate the Quick Control dial until it is.

5. **Press the Set button again.** The 40D displays a confirmation screen asking if you want to use the white balance data from this image for the custom white balance.

6. **Turn the Quick Control dial to highlight OK, and then press the Set button.** A second confirmation screen appears.

7. **Press the Set button one last time.** The camera imports the white balance data from the selected image and returns to the Shooting 2 menu.

8. **Press the Shutter button to dismiss the menu.**

3.7 This shot was taken using the Shade White Balance setting. The image shows a green colorcast in the shadow areas and in the yellows of the top of the mushroom, neither of which is truly accurate to the original scene colors. Exposure: ISO 100, f/3.5, 1/50 sec.

9. **Press the Metering Mode-WB button above the LCD panel, and then turn the Quick Control dial to select Custom White Balance.** This is denoted by two triangles on their sides with a black square between them. The custom white balance remains in effect until you change it by setting another white balance. All of the images you take will be balanced for the custom setting.

3.8 This shot was taken after I set a custom white balance using a small white index card. The colors in the image reflect the colors in the scene as I recall them. Exposure is the same as the previous image.

When you finish shooting in the area for which you set the custom white balance and move to a different area or subject, remember to reset the White Balance option.

Use White Balance Auto Bracketing

Given the range of indoor tungsten, fluorescent, and other types of lights that are available, the preset White Balance options may or may not be spot-on accurate. Alternately,

you may prefer a bit more of a green or blue bias to the overall image colors. With the 40D, you can use White Balance Auto Bracketing to get a set of three images each with +/- 3 levels in 1-step increments.

White balance bracketing is handy when you don't know which bias will give the most pleasing color, or when you don't have time to set a manual white balance bias. The bracketed sequence gives you a set of three images from which to choose the most visually pleasing color. If you're shooting JPEG capture in Creative Zone modes and use the Standard, Portrait, or Landscape Picture Styles, bracketing can be a good choice to reduce color-correction time on the computer. White balance bracketing also reduces the maximum burst by one-third.

To set white balance bracketing, follow these steps:

1. **Press the Menu button, and then press the Jump button until the Shooting 2 (red) menu appears.**

2. **Turn the Quick Control dial clockwise to highlight WB SHIFT/BKT, and then press the Set button.** The WB correction/WB bracketing screen appears.

3. **Turn the Quick Control dial clockwise to set Blue/Amber bias, or counterclockwise to set a Magenta/Green bias.** As you turn the dial, three squares appear and the distance between them increases as you continue to turn the Quick Control dial. The distance between the squares sets the amount of bias. On the right side of the screen, the camera indicates the bracketing direction and level under BKT. You can set up to plus/minus three levels of bias.

3.9 This image was taken in tungsten lighting using the standard Tungsten White Balance setting. Exposure: ISO 100, f/5.6, 1/8 sec.

3.10 With the white balance bracketing, this is the blue-bias image.

3.11 With the white balance bracketing, this is the amber-bias image.

4. **Press the Set button.** The Shooting 2 (red) menu appears.

5. **Lightly press the Shutter button to dismiss the menu.**

6. **Press the Shutter button three times in One-shot drive mode to capture the bracketed images, or in Continuous drive mode, press and hold the Shutter button to capture the three bracketed images.** As you shoot, the White Balance icon on the LCD panel flashes to remind you that bracketing is in effect. With a blue/amber bias, the standard white balance is captured first, and then the bluer and more amber bias shots are captured. If magenta/green bias is set, then the image-capture sequence is the standard, then more magenta, then more green.

Note *You can combine White Balance Bracketing with Auto Exposure Bracketing. If you do this, a total of nine images are taken for each shot. Bracketing also slows the process of writing images to the CF card because three shots are being recorded.*

White balance bracketing continues in effect until it is cleared or the camera is turned off. To clear white balance bracketing, repeat Steps 1 and 2, and then press the Info button to clear the bracketing. When you clear the white balance bracketing, the White Balance icon in the LCD panel stops flashing.

Note *You can change the sequence of White Balance Auto Bracketing by setting C.Fn I-5. For details on setting Custom Functions, see Chapter 4.*

Set a White Balance Shift

Similar to white balance bracketing, you can manually set the color bias of images to a single bias setting by using White Balance Shift. The color can be biased toward blue (B), amber (A), magenta (M), or green (G) in up to nine levels measured as mireds, or densities. Each level of color correction that you set is equivalent to five mireds of a color-temperature conversion filter. When you set a color shift or bias, it is used for all images until you change the setting.

Note *On the EOS 40D, color compensation is measured in mireds, a measure of the density of a color temperature conversion filter, which is similar to densities of color-correction filters that range from 0.025 to 0.5. Shifting one level of blue/amber correction is equivalent to five mireds of a color-temperature conversion filter.*

3.12 This image was taken in tungsten light using Tungsten White Balance. Exposure: ISO 100, f/7.1, 1/2 sec.

3.13 This is the same image shifting the white balance toward magenta and blue. This shift was B5, M6 and represents much more accurate color of the scene.

Tip *The White Balance Shift technique is handy when you know that particular light needs correction such as cooling down a tungsten light source or in the same way that you would use a color-correction filter.*

Tip *Manipulating the White Balance Shift and bracketing screen on the 40D can be confusing. The main difference is when you use the Multi-controller and the Quick Control dial. To set a White Balance Shift, you use the Multi-controller to set the bias. To set white balance bracketing, you use the Quick Control dial to set the bias.*

To set White Balance Shift, follow these steps:

1. **Press the Menu button, and then press the Jump button until the Shooting 2 (red) menu appears.**

2. **Turn the Quick Control dial to highlight WB SHIFT/BKT, and then press the Set button.** The White Balance Auto Bracketing/White Balance Shift screen appears.

3. **Tilt the Multi-controller in the direction you want to set the bias; toward a blue, amber, magenta, or green shift.** On the right of the screen, the SHIFT panel shows the bias and correction amount. For example, A2, G1 shows a two-level amber correction with a one-level green correction.

4. **Press the Set button to confirm the changes.** The color shift you set remains in effect until you turn off the camera.

Note *You can set C.Fn I-4 to retain both white balance bracketing and shift settings even after the camera is turned off. See Chapter 4 for details on setting Custom Functions.*

To cancel the white balance correction, repeat Steps 1 and 2, press the Info button, and then press the Set button.

Specify a color temperature

Setting the white balance for a specific color temperature is the easiest way to get neutral color in the least amount of time. The caveat, of course, is that you must know temperature of the light to get good results. In most studios, the light temperature is known and it can be easily dialed in to the 40D. And if you're fortunate enough to have a color-temperature meter, then you can use this White Balance option with abandon.

To set a specific color temperature, follow these steps:

1. **Press the Metering Mode-WB button above the LCD panel.**

2. **Turn the Quick Control dial until the K option appears on the LCD panel.**

3. **Press the Menu button.**

4. **If the Shooting 2 (red) menu is not displayed, press the Jump button until it appears.**

5. **Turn the Quick Control dial to highlight White Balance, and then press the Set button.** The White Balance/Color Temp screen with the K option activated appears.

How Color Temperature Is Determined

Unlike air temperature that is measured in degrees Fahrenheit (or Celsius), light temperature is based on the spectrum of colors that is radiated when a black body radiator is heated. Visualize heating an iron bar. As the bar is heated, it glows red. As the heat intensifies, the metal color changes to yellow, and with even more heat, it glows blue-white. In this spectrum of light, color moves from red to blue as the temperature increases.

This concept can be confusing because "red hot" is often thought of as being significantly warmer than blue. But in the world of color temperature, blue is, in fact, a much higher temperature than red. That also means that the color temperature at noon on a clear day is higher (bluer) than the color temperature of a fiery red sunset. And the reason that you should care about this is because it affects the color accuracy of your images. So as you use color temperatures, keep this general principle in mind: The higher the color temperature is, the cooler (or bluer) the light; the lower the color temperature is, the warmer (or yellower/redder) the light.

3.14 When I work in my studio where I know that the temperature of my studio strobes is 5500K, setting a specific color temperature is the easiest option to use. Exposure: ISO 100, f/22, 1/125 sec.

6. **Turn the Main dial to set the color temperature that you want.** As you turn the Main dial, the temperature changes within the K option on the White Balance/Color Temp screen. You can set a temperature from 2500 to 10,000 Kelvin.

7. **Press the Set button.** The white balance setting and the color temperature remain in effect until you change them.

Choosing and Customizing a Picture Style

The name Picture Styles sounds like a marketing-motivated set of optional features for the 40D. Regardless of the naming, it's important to realize that the 40D attaches a Picture Style to every image that you shoot. In other words, Picture Styles form the foundation of how the camera delivers tonal

curves, color rendering, color saturation, and sharpness in the final image.

The 40D offers six Picture Styles, which are detailed in Table 3.2, and it uses the Standard Picture Style as the default style. All Picture Styles have specific settings for sharpness, contrast, color saturation, and color tone. By changing the settings, individual Picture Styles mimic the look of films such as Fuji Velvia, for rendering landscape and nature shots with vivid color saturation, or Kodak Portra, for rendering portraits with warm, soft skin tones. You can also modify

3.15 This image uses the Standard Picture Style. Exposure: ISO 100, f/22, 1/250 sec.

3.17 This image uses the Landscape Picture Style that offers an obviously modified tonal curve and saturated colors, particularly green (and blue).

3.16 This image uses the Portrait Picture Style. The color saturation and sharpness are much more subdued, but this style leaves some latitude for RAW conversion tweaks and editing in Photoshop.

3.18 This image uses the Neutral Picture Style. Color is neutral with a lower overall contrast than the Standard Picture Style. This rendering, however, provides very pleasing color.

the settings to suit your preferences, and you can create up to three User Defined Styles that are based on one of Canon's Picture Styles.

3.19 This image uses the Faithful Picture Style, which is colorimetrically adjusted to 5200K.

3.20 This is the same scene in the Monochrome Picture Style with no filter effect applied. The Monochrome option offers snappy contrast, but a nice overall tonal range.

Whether you customize an existing style or create a new style, you have lots of latitude in setting parameters. The 40D belongs to a generation of Canon digital SLRs that offer the widest range of adjustments with nine levels of adjustment for contrast, saturation, and color tone, and eight adjustment levels for sharpness.

Besides forming the basis of image rendering, Picture Styles are designed to produce classic looks that need little or no post-processing so that you can print JPEG images directly from the CF card with prints that look sharp and colorful. If you shoot RAW capture, you can't print directly from the CF card, but you can apply Picture Styles either in the camera or during conversion using Canon's Digital Photo Professional conversion program. You can also use the new Picture Style Editor to modify and save changes to Picture Styles for captured images. The Picture Style Editor is included on Canon's EOS Digital Solution Disk that comes with the camera.

Regardless of whether you use direct printing, you can and should use Picture Styles for both JPEG and RAW capture. In Basic Zone modes, the camera automatically selects the Picture Style, which you cannot change.

Choosing and customizing Picture Styles are how you get the kind of color results out of the camera that you need for your workflow, whether you prefer the contrasty, saturated-color look of the default Standard style, or the more neutral color rendition that the Neutral and Faithful styles provide. Following are parameter adjustments that you can modify for each Picture Style in Creative Zone modes.

✦ **Sharpness: 0 to 7.** Level zero applies no sharpening and renders a very soft look (due largely to the anti-aliasing filter in front of the image sensor that helps ward off various problems including moiré, spectral highlights, and chromatic aberrations). Using a high range of sharpening can introduce sharpening halos, particularly if you also sharpen after editing and sizing the image in an editing program.

✦ **Contrast: -4 to +4.** The important thing to know about contrast is that the changes you make change the tonal curve. A negative adjustment produces a flatter look but helps to maintain the dynamic range of the data coming off the sensor. A positive setting increases the contrast and can stretch the tonal range. High settings can also lead to clipping (discarding bright highlight tones or dark shadow tones).

✦ **Saturation: -4 to +4.** This setting affects the strength or intensity of the color with a negative setting producing low saturation and vice versa. The key to using this setting is to find the point at which individual color channels do not clip. A +1 or +2 setting is adequate for snappy JPEG images destined for direct printing.

✦ **Color Tone: -4 to +4.** Negative adjustments to color tone settings produce redder skin tones while positive settings produce more yellow skin tones.

With the Monochrome Picture Style, only the sharpness and contrast parameters are adjustable, but you can add toning effects, as detailed in Table 3.2. Default settings are listed in order of sharpness, contrast, color saturation, and color tone.

 Note *RAW images captured in Monochrome can be converted to color using the software bundled with the camera. However, in JPEG capture, Monochrome images cannot be converted to color.*

It seems logical that a zero setting for one Picture Style setting would directly correspond to the same setting in another style. For example, a zero Contrast setting on Standard would correspond to a zero setting on the Portrait Style. But that's not necessarily true, and the differences in the tonal curve are sometimes enough to result in clipping. You can evaluate the effect of the tonal curve on RAW images in the histogram shown in Canon's Digital Photo Professional program.

Tip *You can judge the effect of a Picture Style's tonal curve by checking the brightness histogram after making the picture on the camera's LCD. Or if you want to see if a color channel is being clipped, you can check the RGB histogram. To change histogram displays, press the Menu button, and then press the Jump button until the Playback 2 (blue) menu is displayed. Turn the Quick Control dial to select Histogram, and then press the Set button. Turn the Quick Control dial to select RGB, and then press the Set button.*

You can choose a Picture Style by following these steps:

1. **Press the Picture Styles button on the back of the camera.**

2. **Turn the Quick Control dial to highlight a Picture Style, and then press the Set button.** If you choose Monochrome, also set an

Table 3.2
EOS 40D Picture Styles

Picture Style	Description	Tonal Curve	Color Saturation	Default Settings
Standard	Vivid, sharp, crisp	Higher contrast	Medium-high saturation	3,0,0,0
Portrait	Enhanced skin tones, soft texture rendering, low sharpness	Higher contrast	Medium saturation, rosy skin tones	2,0,0,0
Landscape	Vivid blues and greens, high sharpness	Higher contrast	High saturation for greens/blues	4,0,0,0
Neutral	Allows latitude for conversion and processing with low saturation and contrast.	Low, subdued contrast	Low saturation, neutral color rendering	0,0,0,0
Faithful	True rendition of colors with no increase in specific colors. No sharpness applied.	Low, subdued contrast	Low saturation, colorimetrically accurate	0,0,0,0
Monochrome	Black-and-white or toned images with slightly high sharpness	Higher contrast	Yellow, orange, red, and green filter effects available	3,0, NA, NA

appropriate white balance setting for the best results in the black-and-white image.

After using, evaluating, and printing with different Picture Styles, you may want to change the default parameters to get the rendition that you want. Additionally, you can create up to three Picture Styles that are based on an existing style.

After much experimentation resulting from a characteristic oversaturation in the Red channel using the Standard Picture Style, I switched to a modified Neutral Picture Style that provides much better results for my work. Here are the settings I used when I modified the Neutral Picture Style settings.

✦ **Sharpness.** +3

✦ **Contrast.** +1

✦ **Saturation.** +1

✦ **Color tone.** 0

3.21 This is an image using my modified settings that are based on the Neutral Picture Style.

These settings provide excellent skin tones provided that the image isn't underexposed and the lighting isn't flat. You can try this variation and modify it to suit your work.

Tip

It's always a good idea to evaluate the image settings in Digital Photo Professional, a program that offers a great degree of control over color management settings.

To modify a Picture Style, follow these steps:

1. **Press the Picture Styles button on the back of the camera.** The Picture Style selection screen appears.

2. **Turn the Quick Control dial to highlight the Picture Style you want to modify, and then press the Info button.** The Detail Set screen for the selected style appears.

3. **Turn the Quick Control dial to highlight the parameter you want to adjust, and then press the Set button.** The camera activates the control.

Using Monochrome Filter and Toning Effects

You can customize the Monochrome Picture Style by following the previous steps, but only the Sharpness and Contrast parameters can be changed. However, you have the additional option of applying a variety of Filter and/or Toning effects.

Monochrome Filter effects. Filter effects mimic the same types of color filters that photographers use when shooting black-and-white film. The Yellow filter makes skies look natural with clear white clouds. The Orange filter darkens the sky and adds brilliance to sunsets. The Red filter further darkens a blue sky, and makes fall leaves look bright and crisp. The Green filter makes tree leaves look crisp and bright and renders skin tones realistically.

Monochrome Toning effects. You can choose to apply a creative toning effect when shooting with the Monochrome Picture Style. The Toning effect options are None, Sepia (S), Blue (B), Purple (P), and Green (G).

To apply a Filter or Toning effect, press the Picture Style button on the back of the camera. Turn the Quick Control dial to select Monochrome. Press the Info button, and then turn the Quick Control dial to highlight either Filter effect or Toning effect. Press the Set button. The camera displays options that you can choose. Turn the Quick Control dial to highlight the option you want, and then press the Set button. The effect remains in effect until you change it.

4. **Turn the Quick Control dial to change the parameter, and then press the Set button.** The camera activates the control. Negative settings decrease sharpness, contrast, and saturation, and positive settings provide higher sharpness, contrast, and saturation. Negative color tone settings provide reddish tones, and positive settings provide yellowish skin tones.

5. **Turn the Quick Control dial to highlight the next parameter, and then press the Set button.**

6. **Repeat Steps 4 and 5 to change additional settings.** The Picture Style changes remain in effect until you change them.

Registering a User Defined Picture Style

With an understanding of the settings you can change with Picture Styles, you can create a Picture Style to suit your specific preferences and workflow needs. Each style that you create is based on one of Canon's existing styles, which you choose. And because you can create three User Defined Styles, there is latitude to set up styles for different types of shooting venues.

For example, to create a set of styles for wedding shooting, one style could be a variation of the portrait parameters that you use for formal portraits. A second style, based on the Neutral or Faithful style, could provide more latitude for post-processing, and a third style, based on the Standard Picture Style, could provide a snappier, more saturated variation for the reception. And, if you first carefully evaluate the tonal curves

and color rendering that the custom style produces, then you can serve up direct-print photos during the reception with confidence that the prints will be predictable and pleasing.

To create and register a User Defined Picture Style, follow these steps:

1. **Press the Picture Style button on the back of the camera.**

2. **Turn the Quick Control dial to highlight User Def. 1, and then press the Info button.** The Detail set. User Def. 1 screen appears with the base Picture Style, Standard.

3. **Press the Set button.** The camera activates the base Picture Style control.

4. **Turn the Quick Control dial to highlight a base Picture Style, and then press the Set button.** You can select any of the preset Picture Styles such as Standard, Portrait, and so on, as the base style. Each style represents not only the parameters shown on the screen but also a unique tonal curve, which you cannot see on the screen, but that you do see in the images you take using the Picture Style.

5. **Turn the Quick Control dial to highlight a parameter, such as Sharpness, and then press the Set button.** The camera activates the parameter's control.

6. **Turn the Quick Control dial to set the level of change, and then press the Set button.**

7. **Repeat Steps 5 and 6 to change the remaining settings.** The remaining parameters are Contrast, Saturation, and Color tone.

8. **Press the Menu button to register the style.** The Picture Style selection screen appears. The base Picture Style is displayed to the right of User Def. 1. If the base Picture Style parameters were changed, then the Picture Style on the right of the screen is displayed in blue. This Picture Style remains in effect until you change it.

9. **Press the Set button.**

You can repeat these steps to set up User Def. 2 and 3 styles.

Using the Picture Style Editor

One approach to getting Picture Styles that are exactly to your liking is to set or modify one of the styles provided in the camera. But that approach is experimental: You set the style, capture the image, and then check the results on the computer until you get the results you want.

With the 40D, Canon offers a more precise and certainly more efficient approach in the new Picture Style Editor program, included on the EOS Digital Solution Disk. Using a RAW image you've captured, you can apply a Picture Style and make changes to the style while watching the effect of the changes as you work. Then you save the changes as a Picture Style file (.PF2), and use the EOS Utility to register the file in the camera and apply it to images.

The Picture Style Editor is deceptively simple, but it offers powerful and exact control over the style: for example, color specifications and minute adjustments to hue, saturation, luminosity, and gamma (tonal curve) characteristics. Up to 100 color points can be selected in the color specifications, and three color display modes—HSL (Hue, Saturation, Luminosity), Lab, and RGB—are available. You can also set the color work space display, such as Adobe RGB. A histogram display shows the distribution of luminance and color in the sample image, and the display can be switched to luminance, RGB, or R, G, and B. If you are familiar with Canon's Digital Photo Professional program, then the color tones will be familiar because the Picture Style Editor uses the same algorithms for image processing. You can set up to 10 points anywhere on the tone curve and watch the effect of the change to the sample image in the main window.

In addition, you can compare before and after adjustments in split windows with magnification from 12.5 to 200 percent.

Because the goal of working with the Picture Style Editor is to create a Picture Style file that you can register in the camera, the adjustments that you make to the sample RAW image are not applied to the image. Rather, the adjustments are saved as a file with a .PF2 extension. However, you can apply the style in Digital Photo Professional after saving the settings as a PF2 file.

While the full details of using the Picture Style Editor are beyond the scope of this book, I encourage you to read the Picture Style Editor descriptions on the Canon Web site at web.canon.jp/imaging/picture style/editor/index.html.

Be sure you've installed the EOS Digital Solution Disk programs before you begin. To start the Picture Style Editor, follow these steps.

1. **Choose Start ➪ All Programs ➪ Canon Utilities ➪ Picture Style Editor.** The Picture Style Editor main window appears.

2. **Drag a RAW, CR2 image onto the main window**. You can also choose File ➪ Open Image, and navigate to a folder that contains RAW images, double-click a RAW file, and then click Open. When the file opens, the Picture Style Editor displays the Tool palette.

3. **Click the arrow next to Base Picture Style to select a Picture Style other than Standard.**

4. **At the bottom of the main window, click one of the split screen icons to show the original image and the image with the changes you make side by side.** You can choose to split the screen horizontally or vertically. Or if you want to switch back to a single image display, click the icon at the far-left bottom of the window.

5. **Click Advanced in the Tool palette to display the parameters for Sharpness, Contrast, Color saturation, and Color tone.** These are the same settings that you can change on the camera. But with the Picture Style Editor, you can watch the effect of the changes as you apply them.

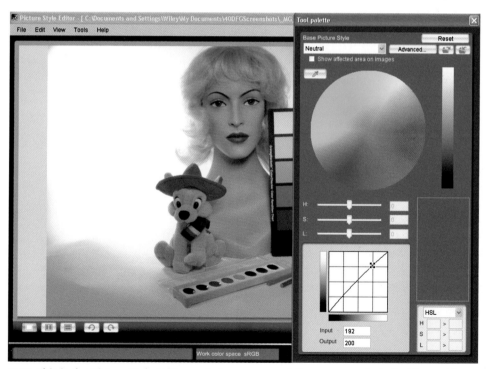

3.22 This is the Picture Style Editor and shows some of the many controls that it provides to modify a Picture Style.

6. **Make the changes you want, and then click OK.**

7. **Adjust the color, tonal range, and curve using the palette tools.** A complete description of the tools is beyond the scope of this book, but if you are familiar with image-editing programs, or with Digital Photo Professional, most of the tools will be familiar. Additionally, you can go to the Canon Web site at web.canon.jp/ imaging/picturestyle/ editor/functions.html for a detailed description of the functions.

When you modify the style to your liking, you can save it and register it to use in the 40D. However, when you save the PF2 file, I recommend saving two versions of it. During the process of saving the file, you can choose the Disable subsequent editing option, which prevents disclosing the adjustments that have been made in the Picture Style Editor as well as captions and copyright information. This is the option to turn on when you save a style for use in the 40D and in the Digital Photo Professional program. But by turning on that option, the style file no longer can be used in the Picture Style Editor.

For that reason, you likely want to save a second copy of the PF2 file without turning on the Disable subsequent editing option in the Save Picture Style File dialog box. That way, if you later decide to modify the style, you can use the Picture Style Editor to make adjustments to this copy of the PF2 file.

To save a custom Picture Style, follow these steps:

1. **Click the Save Picture Style File icon at the top far right of the Picture Style Editor tool palette.** The Save Picture Style File dialog box appears.

2. **Navigate to the folder where you want to save the file.**

3. **To save a file to use in the 40D, click the Disable subsequent editing option at the bottom of the dialog box.** To save a file that you can edit again in the Picture Style Editor, do not select this option.

4. **Type a name for the file, and then click Save.** The file is saved in the location you specified with a .PF2 file extension.

To install the custom Picture Style on the 40D, follow these steps. Before you begin, ensure that you've installed the EOS Digital Solution Disk programs on your computer and have available the USB cable that came with the camera.

1. **Connect the camera to the computer using the USB cable supplied in the 40D box.**

2. **Choose Start ⇨ All Programs ⇨ Canon Utilities ⇨ EOS Utility.** The EOS Utility screen appears.

3. **Click Camera settings/Remote shooting under the Connect Camera tab in the EOS Utility.** The capture window appears.

4. **Click the camera icon in the red tool bar, and then click Picture Style.** The Picture Style window appears.

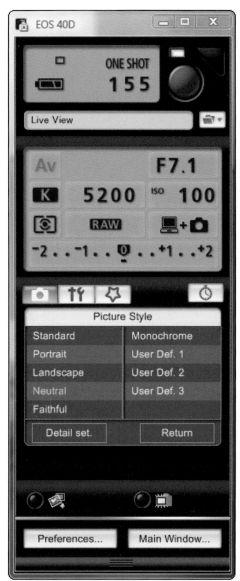

3.23 This is the EOS Utility control panel that is shown when the camera is connected to the computer.

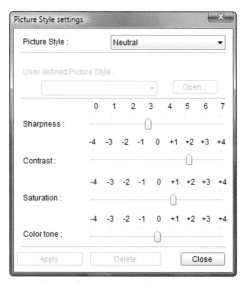

3.24 This is the Picture Style settings screen that allows you to change parameters much as you can do on the camera.

5. **Click Detail set at the bottom of the Picture Style list.** The Picture Style settings screen appears.

6. **Click the arrow next to Picture Style, and then click User Defined 1, 2, or 3 from the drop-down menu that appears.** If a Picture Style file was previously registered to this option, the new style overwrites the previous style. When you select User Defined, additional options appear.

7. **Click Open.** The Open dialog box appears.

8. **Navigate to the folder where you saved the Picture Style file that you modified in the Picture Style Editor, and click Open.** The Picture Style settings dialog box appears with the User Defined Picture Style displaying the modified style you opened. If necessary, you can make further adjustments to the file before applying it.

9. **Click Apply.** The modified style is registered in 40D. It's a good idea to verify that the style was copied by pressing the Picture Style button on the back of the 40D, and then selecting the User Defined Style you registered to see if the settings are as you adjusted them.

In addition to creating your own styles, you can download additional Picture Styles from Canon's Web site at web.canon.jp/ imaing/picturestyle/index.html. As of this writing, the site provides additional files including Nostalgia, Twilight, Autumn Hues, Clear, and Emerald. You can download these files, and then register them in the 40D using the steps detailed previously.

Customizing the EOS 40D

O ne of the first things most photographers do when
setting up a new camera is to customize it for their
personal shooting preferences. The EOS 40D offers rich
options for customizing the operation of controls and buttons
and the shooting functionality, both for everyday shooting and
for shooting specific venues.

The 40D offers three helpful features to customize the use
and operation of the camera.

✦ **Custom Functions.** These allow you to customize
 everything from how you select an autofocus point
 to increasing the chance of holding highlight detail
 in bright highlights. Grouping certain Custom
 Functions is a good way to set up the camera for
 both general and venue-specific shooting scenarios.
 Two examples of grouping are provided as a spring-
 board for using Custom Functions together.

✦ **Register Camera User Settings.** Otherwise known
 as the C1, C2, and C3 modes on the Mode dial,
 these modes enable you to save your favorite cam-
 era settings, including Custom Function settings, and
 quickly return to them by selecting the C mode to
 which you saved them.

✦ **My Menu.** This is a feature where you can place six
 of your most often used menu items in priority
 order on a single menu.

Without question, these customization features used sepa-
rately and in combination provide a great way to spend less
time tweaking camera settings and more time shooting.

Learning about Custom Functions

Custom Functions enable you to customize camera controls and operation to better suit your shooting style; as a result, they can save you significant time. For example, if you grow weary of pressing the AF-point Selection/Enlarge button before manually selecting an AF point, or using the Multi-controller to manually select an AF point, Custom Function III-3 enables you to use the Quick Control dial to select an AF point. This function has saved me more time during shooting than any other Custom Function.

Before you begin, you should know that Custom Functions can be set only in Creative Zone modes. Also, after you set a Custom Function option, it remains in effect until you change it.

Note *Canon refers to Custom Functions using the abbreviation C.Fn [group Roman numeral]-[function number]. For example, C.Fn II-3.*

The 40D offers 24 Custom Functions. Some Custom Functions are broadly useful, and others are useful for specific shooting specialties or scenes.

Caution *Be sure to remember how you have set the Custom Functions because some options change the behavior of the camera buttons and controls and, in some cases, they change the way that you control super-telephoto lenses.*

Custom Function groupings

Canon organized the 24 Custom Functions into four main groups denoted with Roman numerals, all of which are listed on the Custom Function (orange) camera menu. Most of the functions within the groupings are intuitive except for the Operation/Others group, which is a catch-all group and is less intuitive.

The following tables delineate the groupings and the C.Fn's that fall within each group. It's worthwhile to get familiar with the groupings because you must choose a group from the Custom Functions menu to find and change a specific function.

✦ **Custom Function Group I: Exposure.** This group is essentially setting any function that has to do with exposure or flash sync speed. Each bullet is the option number followed by the function name. See Table 4.1.

✦ **Custom Function Group II: Image.** I'm not sure that the group title "Image" is necessarily descriptive, but I think of this group as the NR (noise reduction) and dynamic range group. See Table 4.2.

✦ **Custom Function Group III: Autofocus/Drive.** Here the group title is more descriptive and I think of the group as AF/Drive. See Table 4.3.

✦ **Custom Function Group IV: Operation/Others.** I think of this group as "everything else." If I can't find what I want in the other groups, I choose this option on the Custom Function camera menu. See Table 4.4.

Table 4.1
Custom Function Group I: Exposure

Option Number	Function Name
1	Exposure level increments
2	ISO speed setting increments
3	ISO expansion
4	Bracketing auto cancel
5	Bracketing sequence
6	Safety shift
7	Flash synchronization speed in Av mode

Table 4.2
Custom Function Group II: Image

Option Number	Function Name
1	Long exposure noise reduction
2	High ISO speed noise reduction
3	Highlight tone priority

Table 4.3
Custom Function Group III: Autofocus/Drive

Option Number	Function Name
1	Lens drive when AF impossible
2	Lens AF stop button function
3	AF-point Selection method
4	Superimposed display
5	AF-assist beam firing
6	AF during Live View shooting
7	Mirror lockup

Table 4.4
Custom Function Group IV: Operation/Others

Option Number	Function Name
1	Shutter button/AF-ON button
2	AF-ON/AE lock button switch
3	SET button when shooting
4	Dial direction during Tv/Av
5	Focusing screen
6	Add original decision data
7	Live View exposure simulation

Custom Functions specifics

In this section, I explain each of the Custom Functions and the options that you can set. Think of Custom Functions one at a time and consider how how you could use them to simplify or customize use of the camera. You don't have to set each option, and very likely you may find only a few that are truly useful to you in the beginning.

But as you continue shooting, and as you read the examples for using Custom Functions as a set later in this chapter, you'll appreciate the power that they offer.

Keep in mind that the functions are easy to find so that you can go back and reset them if you don't like the changes that you've made. I point this out as a way to encourage you to use Custom Functions to the fullest extent. I think that you will be pleasantly surprised at how much more you'll enjoy the 40D after you customize it for your shooting needs.

 Note *If you set Custom Functions and later want to return to the camera defaults, you can do that easily by using the Clear all Custom Func. (C.Fn) option on the Custom Functions (orange) camera menu.*

C.Fn I: Exposure

All of the options for the Exposure Custom Functions are described in the following bullets. The specifics on option numbers and names along with a description can be found in Table 4.5, for your quick and easy reference.

✦ **C.Fn I-1 Exposure-level increments.** The options of this function enable you to set the amount to use for shutter speed, aperture, exposure compensation, and auto-exposure bracketing (AEB). The exposure increment you choose is displayed in the viewfinder and on the LCD as double marks at the bottom of the exposure-level indicator. If

you often shoot bracketed expo-
sures so that you can composite
multiple images in an editing pro-
gram, in my experience the half-
stop option provides a good
exposure difference among images.

✦ **C.Fn I-2 ISO speed setting incre-
ments.** The options of this function
enable you to set the amount to
use for ISO adjustments from the
default finer level of 1/3-stop to
1/2-stop.

✦ **C.Fn I-3: ISO expansion.** The
options of this function enable you
to choose an additional ISO sensi-
tivity setting of "H," which is equiva-
lent to ISO 3200. In my experience,
the 40D is trustworthy at very high
ISO settings producing above-
average image quality at 1600 and
even 3200 ISO. However, as with
any digital camera, you really must
shoot at high ISO settings, including
the expansion setting of 3200 and
examine the image to ensure that
you can get good prints with
acceptable noise levels at the size
you most often use to make prints.
And even then, to always get the
highest image quality in terms of
color, fine detail, and smooth tones,
I recommend shooting at the low-
est possible ISO setting possible
given light, lens, and other factors.

✦ **C.Fn I-4 Bracketing auto cancel.**
The options of this function enable
you to choose when Auto
Exposure Bracketing (AEB) and
White Balance Bracketing (WB-
BKT) are cancelled. Very often, AEB
and WB-BKT are specific to a
scene, and, therefore, not settings
that you want to retain. It's also
easy to forget that you've set either

bracketing option, and you end up
shooting with the bracketing inad-
vertently set. Unless you most
often shoot with AEB and WB-BKT,
then I recommend using the
default option 0. Both options are
described in the following table.

✦ **C.Fn I-5: Bracketing sequence.**
The options of this function enable
you to change the sequence of
images that are bracketed by shut-
ter speed or aperture. And it
enables you to change the
sequence for White Balance
Bracketing (WB-BKT). I find that
the Option 1 sequence makes it
much easier to identify which
image is which in a series of brack-
eted images after I download them
to the computer.

For details on the White Balance
Bracketing sequence, see Table 4.6.

✦ **C.Fn I-6: Safety shift.** With this
function enabled, the camera auto-
matically shifts the aperture or shut-
ter speed in both Shutter-priority AE
(Tv) and Aperture-priority AE (Av)
modes if there are sudden shifts in
lighting that might cause an
improper exposure. While photog-
raphers are watchful of sudden
lighting changes, this function
could be very helpful in stage and
theater lighting venues where over-
head spotlights can dramatically
shift as speakers or actors move
around the stage in and out of
spot-lit areas.

✦ **C.Fn I-7: Flash sync speed in Av
mode.** This function sets the flash
sync speed automatically or sets it
to a fixed 1/250 second in Av
mode.

Table 4.5
C.Fn 1: Exposure

Option Number	Option Name	Description
C.Fn I-1 Exposure-level increments		
0	1/3 stop	By default, the 40D uses 1/3 stop as the exposure-level increment for changes in shutter speed, aperture, exposure compensation, and auto-exposure bracketing.
1	1/2 stop	Sets 1/2 stop as the exposure-level increment for shutter speed, aperture, exposure compensation, and auto-exposure bracketing changes.
C.Fn I-2 ISO speed setting increments		
0	1/3-stop	By default, the 40D uses 1/3 stop as the ISO adjustment increment. With this option set, the ISO speeds are: Auto, 100, 125, 160, 200, 250, 320, 400, 500, 640, 800, 1000, 1250, 1600, and H (3200) with C.Fn I-3 set to On.
1	1-stop	Sets 1 f-stop as the ISO adjustment-level increment. With this option set, the ISO speeds are the traditional settings of: Auto, 100, 200, 400, 800, 1600, and H (3200) with C.Fn I-3 set to On.
C.Fn I-3 ISO expansion		
0	Off	At this default setting, you cannot choose ISO 3200 denoted as "H" in the viewfinder and LCD panel.
1	On	Allows you to select and use the expanded ISO setting of 3200 (H). With this option, you can select H as an ISO option in the same way that you select other ISO settings.
C.Fn I-4 Bracketing auto cancel		
0	On	Both AEB and WB-BKT are cancelled when you turn the camera power switch to Off, have the flash ready to fire, or if you clear camera settings.
1	Off	Choosing this option retains AEB and WB-BKT settings even after you turn off the camera. On a flash-ready, the bracketing is cancelled, but the camera remembers the AEB amount.

Option Number	Option Name	Description
C.Fn I-5 Bracketing sequence		
0	0, -, +	This is the default setting that captures bracketed images beginning with the standard exposure or white balance, then the decreased exposure or white balance, and then the increased exposure or white balance.
1	-, 0, +	This option changes the bracketed images sequence so that it begins with the decreased exposure or white balance, then the standard exposure or white balance, and then the increased exposure or white balance.
C.Fn I-6 Safety shift		
0	Disable	Maintains the set exposure you've set regardless of subject brightness changes.
1	Enable (Tv/Av)	In Shutter-priority AE (Tv) and Aperture-priority AE (Av) modes, the shutter speed or aperture automatically shifts if the subject brightness suddenly changes to provide an acceptable exposure.
C.Fn I-7 Flash sync speed in Av mode		
0	Auto	Automatically syncs Speedlites at speeds 1/250 second or slower.
1	1/250 sec. (fixed)	Automatically sets the flash sync speed to 1/250 second in Aperture-priority AE (Av) mode. If you use this sync speed against the night sky, the background goes dark.

Table 4.6
AEB, WB-BKT Bracketing Sequence

AEB	WB Bracketing	
	Blue/Amber bias	**Magenta/Green bias**
0 : Standard exposure	0 : Standard white balance	0 : Standard white balance
- : Decreased exposure	- : More blue	- : More magenta
+ : Increased exposure	+ : More amber	+ : More green

C.Fn II: Image

All of the options for the Image Custom Functions are described in the following bullets. The specifics on option numbers and names along with a description can be found in Table 4.7, for your quick and easy reference.

✦ **C.Fn II-1: Long-exposure noise reduction.** The options of this function enable you to turn noise reduction on, off, or to set it to automatic for long exposures. With noise reduction on, the reduction process takes the same amount of time as the original exposure. In other words, if the original image exposure is 1.5 seconds, then noise reduction takes an additional 1.5 seconds. This means that you cannot take another picture until the noise reduction process finishes. I keep the 40D set to Option 1 to automatically perform noise reduction if it is detected in long exposures, which I consider to be good insurance.

> **Note** If you're using Live View and you have Option 2 set, then no image displays on the LCD during the time that the camera performs the second noise-reduction exposure.

✦ **C.Fn II-2 High ISO speed noise reduction.** This option applies more aggressive noise reduction to shadow areas in particular when you're shooting at high ISO speed settings. (The camera applies some noise reduction to all images.) If you turn this option on, noise in low-ISO images is further reduced. Because Canon has a good noise reduction algorithm, this setting is less likely to munge fine details,

and reducing shadow noise is advantageous. But it pays to check your images to ensure that a watercolor effect resulting from noise reduction isn't objectionable.

✦ **C.Fn II-3 Highlight tone priority.** One of the most interesting and useful functions is Highlight Tone Priority which helps ensure good detail in bright areas such as those on a bride's gown. With the function turned on, the high range of the camera's dynamic range (the range measured in f-stops between deep shadows and highlights in a scene) is extended from 18 percent gray (middle gray) to the brightest highlights. Further, the gradation from middle gray tones to highlights is smoother with this option turned on. The downside of enabling this option is increased digital noise in shadow areas. But if you're shooting weddings or any other scene where it's critical to retain highlight detail, then the tradeoff is worthwhile. If noise in the shadow areas is objectionable, you can apply noise reduction in an editing program.

However, if you turn on Highlight Tone Priority, ISO speed settings are reduced to 200 to1600 (rather than 100 to1600 or 100 to 3200) even if you have ISO expansion (C.Fn I-3) turned on. The ISO display in the viewfinder, on the LCD panel, and in the Shooting information display uses a smaller character to indicate that this option is in effect. For example, instead of 200, the ISO will appear as 2oo.

> **Cross-Reference** For more details on digital noise, see Chapter 2.

Table 4.7
C.Fn II: Image

Option Number	Option Name	Description
C.Fn II-1: Long-exposure noise reduction		
0	Off	No noise reduction is performed.
1	Auto	The camera automatically performs noise reduction when it detects noise from 1-second or longer exposures.
2	On	The camera automatically performs noise reduction on all exposures of 1 second or longer regardless of whether the camera detects noise. Obviously, the second exposure duration reduces the continuous shooting burst rate dramatically. This is a good option for night scenes low-light still-life subjects.
C.Fn II-2 High ISO speed noise reduction		
0	Off	No noise reduction is performed.
1	On	The camera performs noise reduction on high ISO images, as well as all images.
C.Fn II-3 Highlight Tone Priority		
0	Disable	The default setting with no highlight tone expansion.
2	Enable	This option turns on highlight tone priority, improving the detail in bright highlights and in gradation of detail from middle gray to the brightest highlights. It also reduces the ISO range to 200 to 1600 regardless of the C.Fn I-3 setting.

C.Fn III: Autofocus/Drive

All of the options for the Autofocus/Drive Custom Functions are described in the following bullets. The specifics on option numbers and names along with a description can be found in Table 4.8, for your quick and easy reference.

✦ **C.Fn III-1 Lens drive when AF impossible.** This is a handy option in scenes where the lens simply cannot focus. You've likely been in situations where the lens seeks focus seemingly forever and goes far out of focus range while attempting to find focus, particularly with telephoto and super-telephoto lenses. Setting this option stops the lens from seeking to find focus and going into an extensive defocus range.

✦ **C.Fn III-2: Lens AF stop button function.** For super-telephoto lenses that offer an AF stop button, the options of this function modify the operation of the focusing, Auto

Exposure Lock, and Image Stabilization. As of this writing, lenses with the AF Stop button include the EF 300mm f/2.8L IS USM, EF 400mm f/2.8L IS USM, EF 400mm f/4 DO IS USM, EF 500mm f/4L IS USM, and EF 600mm f/4L IS USM lenses. On lenses that do not have an AF Stop button, changing the options of this function has no effect. Several of these options enable you to control different camera functions with the left and right hands.

✦ **C.Fn III-3: AF-point Selection method.** The options of this function enable you to choose which camera controls you use for selecting the AF point. For anyone who has an aching thumb from pressing the AF-point Selection/Enlarge button and rotating the Main dial or the Multi-controller to select an AF point, this Custom Function is priceless.

✦ **C.Fn III-4: Superimposed display.** The options of this function enable you to turn off the red light that flashes when an AF point is selected in the viewfinder.

✦ **C.Fn III-5: AF-assist beam firing.** This function allows you to control whether the 40D's built-in or an accessory EX Speedlite's autofocus assist light is used to help the camera establish focus. The AF-assist beam can be very helpful in speeding up and in ensuring sharp focus in scenes where you want to use the flash.

✦ **C.Fn III-6: AF during Live View shooting.** This function enables you to control whether you use autofocus or manual focus when you use Live View shooting. To use

autofocus, you focus using the AF-ON button on the back of the camera. During Live View shooting, the reflex mirror is flipped up allowing the live view of the scene. For the camera to autofocus, the mirror must come down long enough to establish focus by using the AF-ON button.

Cross-Reference *Specific techniques for both manual and autofocusing are detailed in Chapter 5.*

✦ **C.Fn III-7: Mirror lockup.** Option 1 for this function prevents blur that can be caused in close-up and telephoto shots by the camera's reflex mirror flipping up at the beginning of an exposure. This function is a point of contention among nature and landscape photographers who often use mirror lockup, because the feature is buried in Custom Functions. The easiest workaround is to add this Custom Function to My Menu for easy access particularly because there are many times when you will want to disable this option. Customizing My Menu is detailed later in this chapter.

Tip *When you use Mirror Lockup with bright subjects such as snow, bright sand, the sun, and so on, be sure to take the picture right away to prevent the camera curtains from being scorched by the bright light.*

Tip *If you use a Bulb exposure, mirror lockup, and a Self-Timer drive mode, keep pressing the Shutter button completely long enough to cover the self-timer delay and the Bulb exposure time.*

Table 4.8
C.Fn III: Autofocus/Drive

Option Number	Option Name	Description
C.Fn III-1 Lens drive when AF impossible		
0	Focus search on	The lens drive continues to function as the camera seeks focus.
1	Focus search off	Stops the lens drive from going into extreme defocus range and stops the lens from focusing.
C.Fn III-2 Lens AF stop button function		
0	AF Stop	Provides normal functioning of the AF Stop button, which stops the lens from autofocusing when the button is pressed. This is a good option for nature and wildlife shooting, and action scenes where the subject is blocked temporarily by another object.
1	AF Start	Focusing begins only while the AF stop button is pressed and AF operation with the camera is disabled.
2	AE lock	Changes the AF stop button to function as AE Lock while the AF stop button is pressed. Like traditional AE Lock (described in Chapter 2), this option decouples metering from autofocusing via the use of the AF Stop button on the lens.
3	AF point: M -> Auto/ Auto -> ctr	In Manual AF-point Selection, the camera switches to automatic AF-point Selection and selects the center AF point as long as the button remains pressed. This option is useful when you can't track a subject when you're using Manual AF-point Selection in the AI Servo AF mode.
4	One Shot <-> AI Servo	Switches from One-Shot to AI Servo AF mode when the button is held down. If you are in One-Shot AF mode, pressing and holding the button switches to AI Servo AF as long as the button is held down. If you are in AI Servo AF, pressing and holding the button switches to One-Shot AF mode as long as the button is held down. This is convenient if the subject starts and stops moving frequently.
5	IS Start	When the IS switch on the lens is turned on, IS works only while pressing the AF stop button. Autofocusing is initiated from the camera. With this option, you can use the left hand to control IS and your right hand to control AF-point Selection and releasing the Shutter button.

Continued

Table 4.8 *(continued)*

Option Number	Option Name	Description
C.Fn III-3 AF-point selection method		
0	Normal	Press the AF-point Selection/Enlarge button, and then press the Multi-controller or Main dial to select the AF-point.
1	Multi-controller direct	Multi-controller direct. Allows you to select the AF point by using only the Multi-controller. If you press the AF-point Selection/Enlarge button, the camera automatically switches to automatic AF-point Selection. This can be handy if you typically use automatic AF-point Selection for some of your routine shooting. If you don't use automatic AF-point Selection, then having it switch to automatic AF-point Selection is annoying, especially if you are already in the habit of pressing the AF-point Selection/Enlarge button to manually select an AF point (per Option 1).
2	Quick Control dial direct	Enables you to select the AF point using the Quick Control dial without first pressing the AF-point Selection/Enlarge button. From my perspective, this is by far the easiest and fastest method of selecting the AF point. Just be sure that the On switch is always set to the topmost position. If you choose this option, the Quick Control dial can't be used to set exposure compensation. To set exposure compensation, you hold down the AF-point Selection/Enlarge button and turn the Main dial to set the amount of compensation. Because I choose an AF point far more often than I set exposure compensation, I prefer this option.
C.Fn III-4 Superimposed display		
0	On	The AF point you select or that is selected by the camera in automatic AF selection or in AI Servo AF or AI Focus AF flashes with a red light in the viewfinder when the Shutter button is half-pressed.
1	Off	Turns off the red light flashing when one or more AF points are selected in any AF mode. The AF point is highlighted in red when you manually select it, but when you half-press the Shutter button, no AF point lights. I find this option annoying and akin to flying blind. I want to know as I shoot where the point of sharpest focus will be set, so I don't use this option.

Option Number	Option Name	Description

C.Fn III-5 AF-assist beam firing

0	Enable	The camera uses the built-in flash or an accessory Canon EX Speedlite's AF-assist beam to establish focus. This is especially helpful in low-light or low subject contrast situations where the AF system on the camera has difficulty establishing focus. The camera also fires the flash.
1	Disable	The AF-assist beam isn't used.
2	Only external flash emits	Only the AF-assist beam of an accessory EX Speedlite is used to help establish focus.

C.Fn III-6 AF during Live View shooting

0	Disable	This is the default setting that assumes that you will focus manually using the lens focusing ring during Live View shooting.
1	Enable	With this option, you to press the AF-ON button to autofocus during Live View shooting. When you press the AF-ON button, it temporarily suspends the Live View display and flips down the reflex mirror so that the camera can focus.

C.Fn III-7 Mirror lockup

0	Disable	Prevents the mirror from being locked up.
1	Enable	Locks up the reflex mirror for close-up and telephoto images to prevent mirror reflex vibrations that can cause blur. When this option is enabled, you press the Shutter button once to swing up the mirror, and then press it again to make the exposure. With mirror lockup, the drive mode is automatically set to Single shot. The mirror remains locked for 30 seconds, or you can press the Shutter button to flip the mirror down. If you combine Mirror Lockup with either the 10- and 2-second Self-timer modes, the optional Timer Remote Controller TC80N3, and a tripod, you can ensure rock-solid shooting.

C.Fn IV: Operation/Others

All of the options for the Operation/Others Custom Functions are described in the following bullets. The specifics on option numbers and names along with a description can be found in Table 4.9, for your quick and easy reference.

✦ **C.Fn IV-1: Shutter button/AF-ON button.** This function changes the function of the Shutter button and the AF-ON button in starting and stopping autofocus and metering.

✦ **C.Fn IV-2: AF-ON/AE lock button switch.** This function swaps the function of the AF-ON button and the AE Lock button. This may be slightly handier in terms of which button you use with the camera held to your eye.

✦ **C.Fn IV-3: SET button when shooting**. This option enables you to change the function of the Set button. Although this function's options duplicate many of the buttons that are on the back of the camera, the advantage to setting one of the options is that the Set button is larger and easier to find than the small buttons on the button bar along the bottom of the camera or on the top left of the back of the camera.

✦ **C.Fn IV-4: Dial direction during Tv/Av**. The option swaps the direction for setting shutter speed and aperture in Tv and Av modes, respectively, when using the Main dial.

✦ **C.Fn IV-5: Focusing screen.** Use this function only if you install one of the two other interchangeable focusing screens. Note that this is the only Custom Function that is not included if you Register Camera settings and recall them by switching to one of the three C modes on the Mode dial.

✦ **C.Fn IV-6: Add original decision data.** When this option is turned on, data is appended to verify that the image is original and hasn't been changed. This is useful when images are part of legal or court proceedings. The optional Data Verification Kit DVK-E2 is required.

✦ **C.Fn IV-7: Live View exposure simulation.** When this option is turned on, the aperture, shutter speed, and other exposure elements are simulated during Live View shooting to give you a realistic view at how the final image exposure will look. From my experience, turning on Option 1 is the best choice. The simulation definitely makes a difference, and it is very close to what you get in the final image. Simulation does not appear to affect the smoothness of the display.

 Note *You can also display the histogram, which updates as you move the camera during Live View shooting. Displaying the histogram is detailed in Chapter 5.*

Setting Custom Functions

Depending on your shooting preferences and needs, you may immediately recognize functions and options that would make your shooting faster or more efficient. You may also find that combinations of functions are useful for specific shooting situations. Whether used separately or together, Custom Functions can significantly enhance your use of the 40D.

Table 4.9
C.Fn IV: Operations/Others

Option Number	Option Name	Description
C.Fn IV-1 Shutter button/AF-ON button		
0	Metering + AF start	Default operation where you press the Shutter button halfway to lock focus and set exposure.
1	Metering + AF start/ AF stop	Allows you to press the AF-ON button to suspend autofocusing.
2	Metering start/ Metering + AF start	In AI Servo AF mode, pressing the AF-ON button momentarily stops autofocusing to prevent the focus from being thrown off when an object passes between the lens and the subject. Releasing the button resumes autofocusing. The camera sets exposure at the moment the shutter is released.
3	AE lock/ Metering + AF start	With this option, you can meter one part of the scene but focus on another part of the scene. You press the AF-ON button to meter and autofocus, and then press the Shutter button halfway to set AE Lock.
4	Metering + AF start/disable	Disables the use of the AF-ON button.
C.Fn IV-2 AF-ON/AE lock button switch		
0	Disable	The buttons operate normally with AF-ON setting focus and AE Lock setting exposure on the area of the scene that you meter.
1	Enable	The AF-ON button sets AE Lock on the area of the scene that you meter, and the AE Lock button initiates focusing.
C.Fn IV-3 SET button when shooting		
0	Normal (disabled)	Standard Set button function so that pressing the button confirms choices and opens submenus.
1	Change quality	Pressing the Set button while shooting displays the Image recording quality menu on the LCD. You can then change the image quality setting using the Quick Control dial. The Set button continues to perform its default functions with menus and submenus. If you often change the image quality, then this is a useful option to select.

Continued

Table 4.9 *(continued)*

Option Number	Option Name	Description
2	Change picture style	Pressing the Set button displays the Picture Style selection screen on the LCD. Then you can use the Quick Control dial to select the Picture Style and press the Set button to confirm the selection. This option is somewhat dubious given the Picture Style button on the back of the camera. Option 1 seems the most sensible use of this function to avoid redundancy with other back-of-the-camera buttons.
3	Menu display	Pressing the Set button displays the camera menu on the LCD. This option duplicates the function of the Menu button but may be handier due to the size and location of the Set button.
4	Image replay	Pressing the Set button starts image playback. This option duplicates the function of the Playback (>) button. Again, size and location of the Set button are the reasons to set this option.

C.Fn IV-4 Dial direction during Tv/Av

0	Normal	When you turn the Main dial clockwise in Tv or Av, the shutter speed or aperture increases. In Manual mode, the same changes occur using the Main and Quick Control dials for shutter speed and aperture, respectively.
1	Reverse direction	The direction is reversed so that turning the Main dial clockwise in Tv or Av modes causes the shutter speed or aperture to decrease, respectively. In Manual mode, the direction is reversed for the Main and Quick Control dials except for setting exposure compensation.

C.Fn IV-5 Focusing screen

0	Ee-A	Standard Precision Matte. The installed focusing screen that offers good viewfinder brightness and good manual focusing.
1	Ee-D	Precision Matte with grid. This screen features five vertical lines and three horizontal lines to help keep lines square during image composition.

Option Number	Option Name	Description
2	Ee-S	Super Precision Matte. Designed to make manual focusing easier with f/2.8 and faster lenses. The viewfinder is darker using this screen with slower lenses.

C.Fn IV-6 Add original decision data

0	Off	No verification data is appended.
1	On	Appends data to verify that the image is original. During image playback, a lock icon denotes verification data. To verify the image originality, the optional Original Data Security Kit OSK-E3 is required.

C.Fn IV-7 Live View exposure simulation

0	Disable (LCD auto adjust)	This view shows the image normally with no exposure simulation.
1	Enable (simulates exposure)	The Live View display on the LCD updates continuously to preview the actual exposure settings. The view is not as accurate in very bright and very low light, and it doesn't work, of course, for flash and Bulb exposures. Simulation also works if you're shooting Live View with the camera tethered (cabled) to a computer.

To set a Custom Function, follow these steps:

1. **Set the Mode dial to a Creative Zone mode.**

2. **Press the Menu button, and then press the Jump button until the Custom Functions (orange) menu is displayed.**

3. **Turn the Quick Control dial clockwise to highlight the Custom Functions (C.Fn) group you want, and then press the** Set button. The Custom Functions screen with the function group that you selected appears.

4. **Turn the Quick Control dial to highlight the Custom Function number you want, and then press the Set button.** The Custom Function number is displayed in a small box to the upper right of the screen. When you press the Set button, the Custom Function option control is activated.

5. **Turn the Quick Control dial to highlight the option you want, and then press the Set button.** You can refer to the previous tables in this section of the chapter to select the function number that you want. Repeat Steps 2 through 4 to select other Custom Function groups, functions, and options.

6. **Press the Menu button to return to the Custom Functions (orange) menu, or lightly press the Shutter button to return to shooting.**

If you want to reset one of the Custom Functions, repeat these steps to change it to another setting or the default setting.

If you want to restore the Custom Function options to the camera's default settings except C.Fn IV-5 for the focusing screen, follow these steps:

1. **Set the camera Mode dial to a Creative Zone mode such as P, Tv, Av, or M.**

2. **Press the Menu button, and then press the Jump button until the Custom Functions (orange) menu is displayed.**

3. **Turn the Quick Control dial to highlight Clear all Custom Func. (C.Fn), and then press the Set button.** The Clear all Custom Func. (C.Fn) screen appears.

4. **Turn the Quick Control dial to highlight OK, and then press the Set button.** The Custom Functions screen appears. Press the Shutter button lightly to return to shooting.

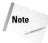 **Note** *If you change the focusing screen, be sure to set C.Fn IV-5 to match the screen that you install. The function you set remains in effect until you manually change it.*

Creating Custom Function sets

As a starting point for thinking about specific shooting situations and customizing the camera for your shooting preferences, I've provided a couple of sample Custom Function sets or combinations to show you how you can combine functions.

Unfortunately, you can't save groups of Custom Functions and recall them as a group except when they are part of registering camera settings (which is explained later in the chapter). But because setting or changing Custom Functions is relatively quick, it's worthwhile to consider creating job-specific Custom Function settings.

Wedding set

The light and location for various weddings activities change throughout the event ranging from the bridal dressing room, to the wedding location, then to the reception area. And throughout the event, the light, pace of action, and the types of shots you're making can change dramatically. Table 4.10 suggests a combination of functions and options that take these changing shooting situations into consideration.

Table 4.10
Custom Functions: Wedding Set

C.Fn Group and Number	Option Number	Rationale
I: ISO expansion	On	Because you can never predict how much light you'll have, and the option of choosing ISO 3200 may trump the option for using C.Fn II-3, Highlight Tone Priority. Alternately, you can set both functions and register them as C1 and C2, and then use the C mode that you need depending on the light. Registering settings for C modes is detailed in the next section of this chapter.
II-2: High ISO speed noise reduction	1: On	Given the rationale in the previous section, it makes sense to turn on this option as it could easily reduce post-processing time. Unless you have a favorite noise-reduction program and have time to apply it to high-ISO images, this is a good option to use.
III-3: AF-point Selection method	2: Quick Control dial direct	If you always or most often manually select the AF point, then this option saves the annoying requirement of pressing the AF-point Selection/Enlarge button to activate AF-point Selection. I prefer using the Quick Control dial because then I don't have to reposition the camera as much when I'm looking through the viewfinder and want to change the AF point. If you choose Option 2, you can set exposure compensation by pressing the AF-point Selection/Enlarge button and turning the Main dial to set the compensation amount.
IV-3: SET button when shooting	1: Change quality	When the wedding moves into the reception phase, you may want to switch from Large/Fine JPEG or RAW to perhaps sRAW+JPEG for the images that are inevitably printed at smaller sizes. This option gives you quick access to the Quality menu to make that change.

4.1 Setting up a Custom Function set for the ceremony segment of this wedding allowed me to concentrate on shooting instead of adjusting camera settings. Exposure: ISO 200, f/3.2, 1/25 sec., using an EF 24-70mm f/2.8L USM lens.

Landscape and Nature set

For full-time landscape and nature shooting, having the camera set up in advance for your favorite settings saves time and ensures that the camera is always ready for common shooting scenarios and for using bracketed images for composites, if that's your preference. Table 4.11 suggests a combination of functions and options for landscape and nature photography.

As you work with Custom Functions, you quickly learn which ones you want to set permanently for your everyday shooting, and which are useful only in certain shooting situations. When you combine Custom Function sets with the C1, C2, and C3 settings on the Mode dial, which are detailed in the next section, you can set up the camera for a variety of shooting scenarios.

Registering Camera User Settings

The Camera User Settings, denoted as C1, C2, and C3 on the Mode dial, raises the level of 40D customization one notch higher. C modes enable you to set up the camera the way you want, then register virtually all of the settings — from exposure settings and shooting mode to Custom Functions — and save them so you can use them by switching to the C1, C2, or C3 mode on the Mode dial. And you're not locked into the setting that you register, because you can still change the drive mode and menu settings. But, if you want to save the changes you make, you have to reregister the settings.

Table 4.11
Custom Functions: Landscape and Nature Set

C.Fn-number	Option	Rationale
I-1: Exposure-level increments	0 or 1	If you often bracket images to later composite different exposures, this option is handy for making multiple exposures. The increment you choose is really a matter of personal preference. Option 1 at 1/2-stop works for the composites that I make.
I-4: Bracketing auto cancel	Off	This option is purely personal preference, but if you most often use AEB, then having it remain in effect even if the camera is turned off is a good option.
I-5: bracketing sequence	1: -, 0, +	This sequence makes the bracketed images easier to identify when I download images for review on the computer.
II-1: Long exposure noise reduction	2: On	Turning on this option for a second frame to subtract digital noise from a long exposure is well worth the wait and the excellent results.
III-1: Lens drive when AF impossible	1: Focus search off	This can keep a super-telephoto lens from going too far into defocus range. Typically, you can speed up autofocus by getting the lens back in range manually, and then focusing on an area of the subject that has better contrast.
III-2: Lens AF stop button function	4: One-shot switch to AI Servo	This is also a personal preference option depending on the scene and how you want the lens to operate. Option 4 is useful when shooting an animal or bird that is stationary but is likely to begin moving.
III-3: AF-point Selection method	2: Quick Control dial direct	If you always or most often manually select the AF point, then this function and option eliminate the need to press AF-point Selection/Enlarge button to activate AF-point Selection. If you choose Option 2, then you can set exposure compensation by pressing the AF-point Selection/Enlarge button and turning the Main dial to set the compensation amount.
III-7: Mirror lockup	1: Enable	Prevents potential blur in super-telephoto, macro, and long exposure shots caused by the action of the reflex mirror flipping up. If you choose this option, you have to press the Shutter button once to flip up the mirror, and press it a second time to make the exposure.
IV-1: Shutter button/AF-ON button	2: Metering start/ Metering + AF start	This option is useful for subjects that start and stop moving. You can press the AF-ON button to control the AI Servo AF function.

4.2 Having the camera preset for my most common shooting preferences allowed me to pull the car over when I saw this sunset, and have confidence that I could capture a bracketed set of images at 1/2-stop increments in case I needed to composite them for the final image. Exposure: ISO 125, f/8, 1/15 sec., using an EF 25-105mm f/4L IS USM lens.

Tip *If you've forgotten what settings you registered for any of the C modes, just press the Info button to display the current camera settings.*

One approach to Registering Camera User Settings is to group all the modes, options, and preferences that you ordinarily use in everyday shooting and register them as one of the three C mode settings. Then you can shoot using that C mode to have all of your choices applied simultaneously and instantly.

Another approach is to use these modes for specific shooting venues such as portrait work, weddings, indoor but non-studio shooting, and so on. One of the nice aspects of the C mode is that you can plan its use for specific venues — for example, if you shoot weddings in the same church or chapel you can have a C mode set for that venue. Or you can use the mode on an ad hoc basis when you know that you will shoot a series of images using the same group of settings, such as a series of images of an interior, a series of portraits, and so on.

Whichever scenario suits your work, there is no question that being able to quickly move to a preset group of settings saves significant time.

When you register camera settings, the following settings are saved and recalled when you set the Mode dial to the C mode you registered them under.

4.3 Much of my shooting day to day is flower photography. By setting up a C mode for shooting flowers, I can begin shooting by simply switching to the C mode. Exposure: ISO 100, f/16, 1/100 sec. using an EF 24-70mm f/2.8L USM lens.

✦ **Shooting settings.** These shooting settings can be saved in a C mode.

- Shooting mode (any mode except Basic Zone modes)
- Exposure Settings: ISO, aperture, shutter speed
- AF mode
- AF-point Selection mode
- Metering mode
- Drive mode
- Exposure compensation
- Flash exposure compensation
- White Balance

✦ **Menu settings.** These menu settings can be saved in a C mode.

- Image quality
- Beep on or off
- Shoot with or without a CF card
- AEB
- White Balance Shift/Bracketing
- Custom White Balance
- Color temperature
- Color space
- Picture Style
- Review time

- AF points
- Histogram
- Auto power off
- Auto rotate
- LCD brightness
- File numbering method
- Custom Functions

To register camera user settings to C1, C2, or C3 mode, follow these steps:

1. **Set the 40D to a Creative Zone mode, and then set all of the settings that you want to register on the 40D.** In addition to shooting, exposure, and menu settings, you can set Custom Functions for specific shooting scenarios as detailed previously in this chapter.

2. **Press the Menu button, and then press the Jump button until the Set-up 3 (yellow) menu is displayed.**

3. **Turn the Quick Control dial clockwise to highlight Camera user setting, and then press the Set button.** The Camera user setting screen appears.

4. **Turn the Quick Control dial to highlight Register, and then press the Set button.** The Register screen appears.

5. **Turn the Quick Control dial to highlight the Mode dial option you want: Mode dial : C1, Mode dial : C2, or Mode dial : C3, and then press the Set button.** A second Register screen appears.

6. **Turn the Quick Control dial to highligh OK, and then press the**

Set button. The Set-up 3 (yellow) menu appears. The camera registers the settings except for the My Menu settings. Lightly press the Shutter button to dismiss the menu.

7. **Turn the Mode dial to the C1, C2, or C3 mode depending on the option you selected in Step 5 to shoot with the registered settings.** When you shoot in a C mode, the Clear all camera settings on the Set-up 3 (yellow) menu, and the Clear all custom Func. (C.Fn) option on the Custom Function menu cannot be used. To use these menu options, switch to another Creative Zone mode first.

If you want to clear the registered Camera user settings, follow these steps:

1. **Set the camera to a Creative Zone mode.**

2. **Press the Menu button, and then press the Jump button until the Set-up 3 (yellow) menu is displayed.**

3. **Turn the Quick Control dial to highlight Camera user setting, and then press the Set button.** The Camera user setting screen appears.

4. **Turn the Quick Control dial to highlight Clear settings, and then press the Set button.** The Clear settings screen appears.

5. **Turn the Quick Control dial to highlight the C mode that you want to clear, and then press the Set button.** For example, select Mode dial : C2 to clear the C2 Mode dial settings. The Clear settings screen appears.

6. Turn the Quick Control dial to highlight OK, and then press the Set button. The camera displays a wait icon, and then returns to the Set-up 3 (yellow) menu. The camera clears the registered settings for the C mode that you selected. Lightly press the Shutter button to dismiss the menu.

Customizing My Menu

Given the proliferation of menus on the 40D, and given that in an average day of shooting you may use four or five menus consistently, customizing the My Menu option is the easiest way to get to the most frequently used items quickly. Just as with the C mode registration, My Menu lets you select and register your most often used menu items and Custom Functions for easy access.

In particular, as you become a fan of Custom Functions, you can sidestep figuring out the Custom Function grouping structure on the Custom Functions menu, and just put the C.Fns that you change most often on My Menu. Again, the payoff is time savings for you.

Plus, you can add and delete items to My Menu easily and quickly, and you can change the order of items by sorting the items you register. You can also set the 40D to display My Menu first when you press the Menu button. The only drawback is that you can only register six items. So before you begin registering, evaluate the menu items and Custom Functions carefully choose your six favorite items.

To register camera Menu items and Custom Functions to My Menu, follow these steps:

1. Set the camera to a Creative Zone mode.

2. Press the Menu button, and then press the Jump button until My Menu (green) is displayed.

3. Turn the Quick Control dial to highlight My Menu settings, and then press the Set button. The My Menu settings screen appears.

4. Turn the Quick Control dial to highlight Register, and then press the Set button. The My Menu registered item screen appears. This screen is a list of all menu items available on the camera.

5. Turn the Quick Control dial to highlight the menu item you want to register, and then press the Set button.

6. Turn the Quick Control dial to highlight OK, and then press the Set button. The My Menu registered item screen reappears.

7. Repeat Step 5 until all the menu items you want are registered. To find individual Custom Functions, keep scrolling past the C.Fn group names, and you'll see the individual Custom Functions by name only (the group and option numbers are not listed).

8. When you finish registering all menu items you want to register, press the Menu button. The My Menu settings screen appears. If you want to sort your newly added items, from here jump to Step 4 in the following set of steps.

To sort your registered camera Menu items and Custom Functions, follow these steps:

1. **Set the camera to a Creative Zone mode.**

2. **Press the Menu button, and then press the Jump button until My Menu (green) is displayed.**

3. **Turn the Quick Control dial to highlight My Menu settings, and then press the Set button.** The My Menu settings screen appears.

4. **Turn the Quick Control dial to highlight Sort, and then press the Set button.** The Sort My Menu screen appears.

5. **Press the Set button if you want to move the first menu item to a different position in the list.** The camera activates the sort control represented by scroll arrow to the right side of the menu item.

6. **Turn the Quick Control dial to move the item's placement within the menu, and then press the Set button.** Turn the Quick

Control dial to the right to move the selected item down one item in the list. Or turn the Quick Control dial to the left to move the item to the end of the list.

7. **Repeat Steps 5 and 6 to move other menu items in the order that you want.**

8. **Press the Menu button twice to display your customized menu.** Or lightly press the Shutter button to dismiss the menu.

Note *The My Menu settings item always appears at the bottom of the My Menu list. Selecting it gives you access to the My Menu settings screen where you can Register, Sort, Delete, Delete all items, and disable the display of My Menu.*

Without question, the 40D offers you the maximum level of customizability. While the full complement of choices may initially seem overwhelming, I recommend taking each one in turn and building on it to set more custom settings until you get the camera set up for your shooting style.

Using Live View Shooting

For any veteran digital SLR photographer, the notion of shooting with a live view of the scene displayed on the LCD is not only foreign but also somewhat suspect. Certainly having a live view is a staple feature of point-and-shoot cameras, but on a digital SLR? The first questions an experienced photographer is likely to ask are, "Why, and when?" What advantage is there to a live view, and in what shooting scenarios would it be useful?

The answers to these questions become clearer with use. The Live View feature in the EOS 40D offers more flexibility in framing images, particularly when crouching down to examine the shot through the viewfinder requires unnatural body contortions; it offers a big view that can be magnified up to 10x to ensure tack-sharp automatic or manual focus; it offers a Silent mode that reduces shutter noise, which can spook wildlife; and it can simulate actual exposure settings on the LCD.

The Live View shooting function is useful in specific shooting situations including macro work, when shooting tethered (where the camera is connected by a cable to a computer) or wireless in the studio, and for still-life shooting. In short, it is most useful in controlled and close-up shooting scenarios.

About Live View Shooting

The concept of the camera being able to hold the shutter open to give you a real-time view of the scene and yet pause long enough to focus is impressive in terms of technology. And even more impressive is the quality of the live view that the 40D provides, which is smooth and detailed.

To create this live view, Canon engineered an electronic first-curtain shutter that enables shooting while the mechanical shutter is completely open. To give the detailed view, the camera uses a high-speed scanning and an electronic reset system that mimics the high-speed mechanical shutter operation. The system then synchronizes with the mechanical second-curtain shutter to create what Canon terms a *slit exposure*.

This technology enables some very cool side features as well. For example, because the first-curtain shutter is electronic, the shutter cocking noise can be reduced, and the 40D offers two modes for quiet or silent shooting in either Continuous or Single Shot drive modes. The caveat is that although Live View shooting has an admittedly high "coolness" factor, it comes at a price. With continual use of Live View shooting, the sensor heats up quickly, and the battery life diminishes markedly.

More specifically, here is what you can expect with Live View shooting:

✦ **Temperature affects the number of shots you can get using Live View.** With a fully charged BP-511A battery, you can expect 180 shots without flash use and approximately 170 shots with 50 percent flash use in 73-degree temperatures. In freezing temperatures, expect 140 shots without flash use and 130 shots with 50 percent flash use per charge. With a fully charged battery, you'll get approximately 30 minutes of continuous Live View shooting before the battery is exhausted.

✦ **High ambient temperatures, high ISO speeds, or long exposures can cause digital noise or irregular color in images taken using Live View.** If you see a warning icon on the LCD, discontinue shooting and let the camera's internal temperature cool down. If you disregard the warning, the camera will eventually stop shooting until the internal temperature decreases.

Live View Features and Functions

Just as real-time shooting is unusual for digital SLR photography, so are some of the functions and techniques for Live View shooting. Canon implemented some very helpful features including exposure simulation, but it's important to understand what changes during shooting.

Live View using autofocusing

With Live View shooting, you can focus either manually or by using the camera's autofocus system. With autofocus, by necessity, the reflex mirror must remain locked up

while the camera is providing a live view. When you want to focus, the mirror must go down momentarily. Autofocus is initiated by pressing the AF-ON button on the back of the camera, provided that you enable it using Custom Function (C.Fn) III-6. This suspends the live view until the AF-ON button is released. To make the picture, release the AF-ON button, wait for the Live View function to begin again, and then press the Shutter button to make the picture. You can use autofocus in Single Shot and AI Servo AF modes.

Cross-Reference *For details on focusing and drive modes, see Chapter 2.*

Another aspect that's different is that you're limited to using the center AF point for autofocusing, and no AF points are displayed during Live View shooting. If you're using a super-telephoto lens, the focus preset feature also can't be used.

Exposure simulation and metering

Canon added new Custom Functions that support Live View shooting. Among them is C.Fn IV-07, which simulates what the final image will look like at the current shutter speed, aperture, and other exposure settings on the LCD during Live View display.

Another difference is that unlike traditional shooting modes, the exposure for Live View shooting is not linked to the AF point. Instead, the camera uses focusing frame-linked evaluative metering. Another twist is that you can set the Live View Function Metering Timer from 4 seconds to 30 minutes to determine how long the camera

retains the current exposure. In controlled light scenes, a longer meter time speeds up Live View shooting operation overall.

You can also use the Depth of Field Preview button on the front of the camera. And if you are tethered to the computer, the EOS Utility Live View remote window also enables you to preview the depth of field using the computer's Live View controls.

Optionally by using the Live View function settings options on the Setup 2 (yellow) menu, you can choose to display a 3 × 3 grid in the viewfinder to help align vertical and horizontal lines, which is handy.

Using a flash

When shooting in Live View with an EX-series Speedlite using either Silent mode 1 or 2 (detailed later in this chapter), the shooting sequence after fully pressing the Shutter button is for the reflex mirror to drop to allow the camera to gather the pre-flash data, and then the mirror moves up out of the optical path for the actual exposure. As a result, you hear two shutter clicks, but only one image is taken.

Here are some things you should know about using Live View shooting with a flash unit.

✦ **With an EX-series Speedlite, FE Lock, modeling flash, and test firing cannot be used, and the Speedlite's Custom Functions cannot be set on the flash unit.**

✦ **With the 580EX II, the wireless setting cannot be changed.**

✦ **Non-Canon flash units will not fire in either Silent mode 1 or 2.** The Live View function on the Set-up 2 (yellow) menu should be set to Disable.

✦ **The LCD display may not reflect very bright or low-light conditions accurately, but the final image reflects the exposure settings.** A bright light source such as the sun may appear black on the LCD, but the final image shows the bright areas correctly.

Setting up for Live View Shooting

Before you begin using Live View shooting, decide how you want the camera to function for focusing and shooting, particularly silent shooting. The settings on the camera menus not only activate Live View shooting but also enable you to set your preferences for shooting in this mode.

It's also a good idea to spend a few minutes setting up Custom Functions, especially if you want to use autofocusing instead of focusing manually, and if you want to view the live view with simulated actual exposure settings.

Cross-Reference *For a detailed look at Custom Functions and how to set them up, see Chapter 4.*

Live View function settings

Live View function settings are available on the camera's Shooting 2 (yellow) menu. Use this menu and its options to activate

Live View shooting, display the grid in the LCD, set up silent modes, and set the metering timer.

To set up the 40D for Live View shooting and to set your preferences, follow these steps:

1. **Set the Mode dial to a Creative Zone mode such as P, Tv, Av, or M.**

2. **Press the Menu button, and then press the Jump button until the Set-up 2 (yellow) menu is displayed.**

3. **Turn the Quick Control dial to highlight Live View Function Settings, and then press the Set button.** The Live View Function Settings screen appears with the Live View shoot. option selected.

4. **With the Live View shoot. option highlighted, press the Set button.** The camera activates the Live View shoot. options.

5. **Turn the Quick Control dial to highlight Enable, and then press the Set button.** The Live View Function Settings screen is displayed.

6. **Turn the Quick Control dial to Grid display, and then press the Set button.** The Grid display options appear. Turning on the grid option displays a 3 × 3 grid on the LCD that helps you square up horizontal and vertical lines during Live View shooting.

What You Should Know about Silent Shooting Mode and Continuous Shooting

Live View shooting offers two silent shooting modes, both of which are much quieter than normal shooting. Depending on the silent shooting mode that you choose, you can either shoot in High-Speed Continuous mode at 6 fps with quieter shooting than in non-Live View shooting, or you can choose to shoot one shot at a time and delay the shutter sound. In either mode, the shutter noise is decreased by roughly 50 percent. If you're photographing birds, wildlife, or even a sleeping baby, silent shooting is far less likely to scare off the birds or animals or to wake the baby. Unfortunately, you can use the quieter modes only with Live View shooting.

Also, keep in mind that the two silent shooting modes affect only the shutter noise but not the reflex mirror noise. So in Live View shooting, if you enable C.Fn III-6 to use autofocusing via the AF-ON button on the back of the camera, when you press the AF-ON button, the sound of the mirror flipping down is just as noisy as it is in non-Live View shooting. Alternately, if you opt to focus manually (C.Fn III-6-Disable), the reflex mirror does not flip down for focusing, so mirror noise is not an issue.

Following is a summary of the two silent shooting modes and the Disable option that you can select when you set up Live View function settings.

✦ **Mode 1.** This mode enables High-speed continuous shooting at 6 fps by holding down the Shutter button completely. The shutter cocking noise is reduced by approximately half.

✦ **Mode 2.** This mode enables one-shot shooting when you fully press the Shutter button regardless of drive mode setting, and it delays the shutter noise to minimize disturbances. This mode is initially disconcerting, but it works nicely.

✦ **Disable.** If you're using a tilt-and-shift (TS-E) lens and make vertical shift movement, or if you use an extension tube, then this is the setting to choose to avoid underexposure or overexposure. With a TS-E lens, Mode 1 or 2, and a shutter speed of 1/2000 second or faster, the slit created between the first- and second-curtain shutter is in the same orientation as the optical axis causing incorrect exposures.

7. **Turn the Quick Control dial to highlight On, and then press the Set button.** The default setting is Off. If you do not want the grid displayed, leave the setting to Off, and then press the Set button without making any changes. The Live View Function Settings screen is displayed.

8. **Turn the Quick Control dial to highlight Silent shoot., and then press the Set button.** The Silent shoot. options appear.

9. **Turn the Quick Control dial to highlight the mode you want or highlight Disable, and then press the Set button.** Briefly, the Silent shooting options are:

- **Mode 1** reduces shooting noise and enables High-speed continuous shooting at 6 fps.

- **Mode 2** delays shooting noise.

- **Disable** should be used if you're using a TS-E lens or extension tubes.

The camera returns to the Live View Function Settings screen.

Note *Be sure to read the previous sidebar for more details on each silent shooting mode.*

10. **Turn the Quick Control dial to highlight Metering timer, and then press the Set button.** The Metering timer options appear. The option that you choose determines how long the camera retains the most recent metered exposure. If you're shooting in unchanging light, you can set a long metering time, but if the light changes, set it to a short duration.

11. **Turn the Quick Control dial to highlight a timer option, and then press the Set button.** The Live View Function Settings screen appears.

12. **Lightly press the Shutter button to dismiss the menu.**

Custom Functions for Live View shooting

While Chapter 4 details setting Custom Functions (C.Fn), there are one or two functions you should set before you begin using Live View shooting. For the sake of convenience, they are covered here.

Custom Function III-6

C.Fn III-6 determines whether you use autofocusing during Live View shooting. If you choose to turn on this Custom Function, then you can use the AF-ON button on the back of the camera to interrupt Live View to autofocus. The function is set to Disable by default.

To set this function so that you can autofocus during Live View shooting, follow these steps:

1. **Set the camera to a Creative Zone mode, such as P, Tv, Av, or M.**

2. **Press the Menu button, and then press the Jump button until the Custom Functions (orange) menu is displayed.**

3. **Turn the Quick Control dial to highlight C.Fn III: Auto focus/Drive, and then press the Set button.** The C.Fn III: Auto focus/Drive screen appears. The function number control located at the top right of the screen is active.

4. **Turn the Quick Control dial until the Custom Function number 6 is displayed in the control.** The AF during Live View shooting options are displayed.

5. **Press the Set button.** The camera activates the C.Fn III-6 options.

6. **Turn the Quick Control dial to highlight 1:Enable, and then press the Set button.**

7. **Lightly press the Shutter button to dismiss the screen.**

Custom Function IV-7

C.Fn IV-7, Live View Function exposure simulation, enables you to see the LCD Live View simulated to show actual exposure settings including shutter speed and aperture. Also, when you enable this function and you have the Playback option set to display the histogram, you can watch a live histogram as you move or reposition the camera during Live View shooting.

 Cross-Reference *See Chapter 2 for details on selecting the type of histogram displayed.*

To turn on Live View exposure simulation, follow these steps.

1. **Set the camera to a Creative Zone mode, such as P, Tv, Av, or M.**

2. **Press the Menu button, and then press the Jump button until the Custom Functions (orange) appears.**

3. **Turn the Quick Control dial to highlight C.FnIV: Operation/Others, and then press the Set button.** The C.FnIV: Operation/Others Shutter button/AF-ON screen appears. The function number control located at the top right of the screen is active.

4. **Turn the Quick Control dial until the Custom Function number 7 is displayed in the control.** The Live View exposure simulation options are displayed.

5. **Press the Set button.** The camera activates the C.Fn IV-7 function options.

6. **Turn the Quick Control dial to highlight 1:Enable (simulates exposure), and press the Set button.**

7. **Lightly press the Shutter button to dismiss the screen.**

Shooting in Live View

Once you have the options and functions set up for Live View, then you can begin shooting. As mentioned earlier, this Live View is best suited for macro or still-life shooting. With this type of shooting, you will likely want to use manual focusing or autofocusing with manual tweaking. During focusing, you can enlarge the view up to 10x to ensure tack-sharp focus.

The second-best option is to use Live View in a studio tethered to a computer or wirelessly with a file transmitter or wireless-enabled battery grip. With the tethered option, you connect the camera to the computer using the supplied USB cable, and you control the camera using the supplied EOS Utility program. You can view the scene on the computer monitor in real time.

Either way, just a few minutes of watching the real-time view convinces you that a tripod is necessary for Live View shooting. With any focal length approaching telephoto, Live View provides a real-time gauge of just how steady or unsteady your hands are.

Using autofocus or manual focus

The operation of the camera during Live View shooting differs from traditional still view shooting, but the following steps guide you through the controls and operation of

the camera. Before you begin, make sure that you've read the previous sections on setting up the camera Live View functions and Custom Functions so that you get the performance you want. To shoot in Live View using autofocus, follow these steps:

1. **With the camera set to a Creative Zone mode, set the ISO, aperture, and/or shutter speed.** Your settings depend on the shooting mode you chose. You can also use AEB, choose a Picture Style, set the white balance, and use AE Lock in Live View shooting. Remember that no AF points are shown in the viewfinder during Live View shooting, and focus is best established using the center AF point.

 If you are new to using Creative Zone modes, review Chapter 2.

2. **Press the Set button.** The shutter opens and the Live View display begins. A white rectangle in the center of the LCD indicates the focusing frame.

3. **Compose the image as you want by moving the camera or the subject.** Notice that as you move the camera, the exposure changes and is displayed in the bottom bar under the Live View display. This differs from standard shooting, which links exposure to the selected AF point. In Live View, however, the camera uses focusing frame-linked evaluative metering.

4. **Press the AF-point Selection/Enlarge button on the top far-right corner of the camera to magnify the view.** The first press of the button enlarges the

view to 5x, and a second press enlarges the view to 10x. The magnifications are shown on the LCD as X5 and X10.

5. **Press the AF-ON button to focus.** When you press the AF-ON button, you can hear the sound of the reflex mirror dropping down to focus. During focusing, Live View is suspended.

6. **Press the Shutter button completely to make the picture.** The shutter fires to make the picture, the image playback is displayed, and then the Live View resumes.

7. **Press the Set button to go back to standard shooting mode.** If you do not do this step, the camera automatically closes the shutter when the camera Auto Power Off (Shooting 1 menu) delay elapses.

To shoot in Live View using manual focus, follow these steps, but first ensure that C.Fn III-6 is set to 0:Disable.

1. **With the camera in a Creative Zone mode, set the ISO, aperture, and/or shutter speed.** Your settings will depend on the shooting mode you chose. You can also use AEB, choose a Picture Style, set the white balance, and use AE Lock in Live View shooting. AE Lock is applied to the full-view exposure.

2. **Press the Set button.** The shutter opens and the Live View display begins.

3. **Compose the image as you want by moving the camera.** You can press the Depth of Field Preview button on the front of the camera to gauge the depth of field.

4. **Press the Multi-controller to move the focusing frame when you are using the full LCD view.** If you want to move the focusing frame back to the center quickly, press the Multi-controller in the center.

5. **Press the AF-point Selection/ Enlarge button on the top far-right corner of the camera to magnify the view.** The first press of the button enlarges the view to 5x, and a second press enlarges the view to 10x. These magnifications are shown on the LCD as X5 and X10.

6. **Turn the lens focusing ring to focus.**

7. **Press the Shutter button completely to make the picture.** The shutter fires to make the picture, the image playback is displayed, and the Live View resumes.

Using tethered or wireless connection

One of the most useful ways to use Live View shooting is for studio work, particularly when you're shooting still-life subjects such as products, food, stock shots, and so on.

You can set up with the 40D connected to a computer using the USB cable supplied with the camera. The extra-long cord allows a decent range of movement, particularly if the computer is on a wheeled or swivel table. You can also shoot with the optional wireless file transmitter, such as the Wireless File Transmitter WFT-E3/WFT-E3A. For this section, we'll use the supplied USB cable.

Before you begin, ensure that you have installed the EOS Digital Solution Disk on

the computer to which you are connecting the camera. To shoot in Live View with the 40D tethered to the computer, follow these steps:

1. **Turn off the camera, and attach the USB cord to the Digital terminal located under the terminal covers on the side of the camera.** Be sure that the icon on the cable connector faces the front side of the camera.

2. **Connect the other end of the USB cable to a USB terminal on the computer.**

3. **Turn on the power switch on the camera.** The computer installs the device driver software and identifies the camera. If you're using Windows Vista, the AutoPlay dialog box appears. Click Downloads images from EOS camera using EOS Utility. The EOS Utility – EOS 40D dialog box appears. If a camera model selection screen appears, select the EOS 40D.

4. **Click Camera settings/Remote shooting in the EOS Utility window.** The EOS 40D control panel appears. You can use the panel to control exposure settings, set the white balance, set the Picture Style, and set White-Balance Shift in this panel. To set exposure, double-click the aperture, ISO, and so on, and use the controls to adjust the settings.

Tip *Now is a good time to click Preferences and set the options you want such as choosing the destination folder in which to save captured images, and whether to save the images both on the computer and on the CF card.*

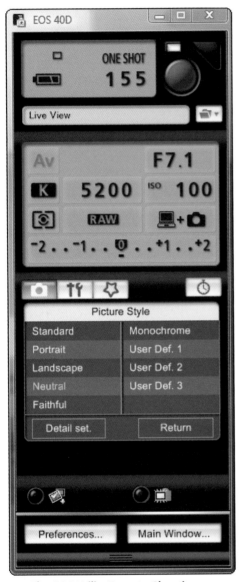

5.1 The EOS Utility Remote Shooting control panel

5. **Click the Remote Live View Shooting button at the bottom right of the Remote Shooting control panel.** The Remote Live View window appears. In this window, you can set the white point by clicking a white area or neutral gray area in the scene, use the controls to set the focus, preview the depth of field by clicking the On button, and switch between the Brightness and RGB histograms as well as monitor the histogram as the camera moves or as lighting changes.

6. **When the exposure and composition is set, you can magnify the view, and then focus using the AF-ON button on the camera or manually using the lens focusing ring, depending on your setting for C.Fn III-6.**

7. **Press the Shutter button completely to take the picture.** The Digital Photo Professional main window opens with the image selected.

5.2 The Remote Live View Shooting button, which is not labeled in the control panel but does have rollover text to identify it.

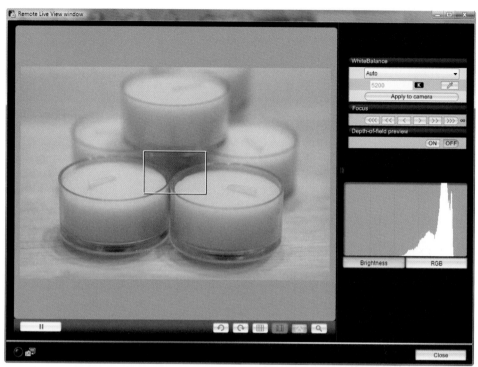

5.3 The Remote Live View window. The controls are self-explanatory and easy to use by clicking or double-clicking the option that you want to change.

8. **When you finish, turn off the camera and disconnect the USB cable from the camera.**

Tip

If you want to focus remotely from the computer in Live View, be sure to check out Breeze Systems DSLR Remote Pro V. 1.5 that offers remote-controlled autofocus for Windows systems. This program offers additional features including up to 15 bracketed shots using either aperture or shutter speed, the ability to capture time-lapse sequences, fade back for over-lays and alignment for DSLR stop-action animations or panoramic stitching, append IPTC data, and more. For more information, visit the Breeze Systems Web site at www.breezesys.com/DSLR RemotePro/index.htm.

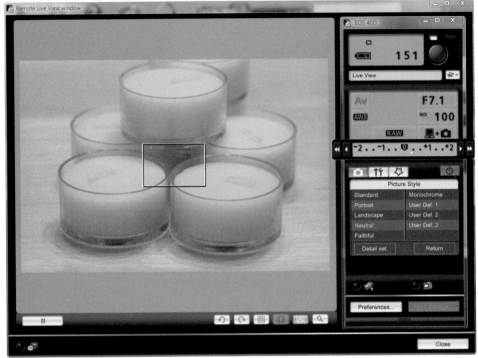

5.4 You can change exposure using the control panel, as shown here, and you can set the Picture Style, click within the real-time view to balance the color and then apply it to the picture, and much more.

5.5 The final image taken in Live View shooting. Exposure: ISO 100, f/7.1, 1/2 sec., using an EF 100mm f/2.8 Macro USM lens.

Getting the Most from the Canon EOS 40D

Selecting and Using Lenses

The lens is the eye of the camera, so don't underestimate the importance of quality lenses. With a high-quality lens, pictures have stunning detail, high resolution, and snappy contrast. Conversely, low-quality optics produce marginal picture quality. And as most photographers know, over time your investment in lenses far exceeds the money invested in the camera body. For these reasons, making studied decisions on lens purchases pays off for years to come in getting great image sharpness and quality.

This chapter looks at the lenses available to help you make decisions about lenses you can add to your system to enhance the type of photography you most enjoy.

Understanding the Focal Length Multiplication Factor

The 40D image sensor is 1.6 times smaller than a traditional 35mm film frame. It is important to know the sensor size because it not only determines the size of the image but also affects the angle of view of the lenses you use. A lens's angle of view is how much of the scene, side-to-side and top-to-bottom, that the lens includes in the image.

The angle of view for all lenses you use on the 40D is reduced by a factor of 1.6 times at any given focal length, giving an image equal to that of a lens with 1.6 times the focal length. That means that a 100mm lens on a 35mm film camera becomes the equivalent to a 160mm on the 40D. Likewise, a 50mm normal lens becomes the equivalent of an 80mm lens, which is equivalent to a short telephoto lens on a full-35mm-frame size.

EF-S lenses are usable only on the cropped-frame cameras, including the 40D, due to a redesigned rear element that protrudes back into the camera body.

This focal length multiplication factor works to your advantage with a telephoto lens because it effectively increases the lens's focal length (although technically the focal length doesn't change). And because telephoto lenses tend to be more expensive than other lenses, you can buy a shorter and less expensive telephoto lens and get 1.6 times more magnification at no extra cost.

The focal length multiplication factor works to your disadvantage with a wide-angle lens because the sensor sees less of the scene when the focal length is magnified by 1.6. But, because wide-angle lenses tend to be less expensive than telephoto lenses, you can buy an ultrawide 14mm lens to get the equivalent of an angle of view of 22mm.

Because telephoto lenses provide a shallow depth of field, it seems reasonable to assume that the conversion factor would produce the same depth-of-field results on the 40D that a longer lens gives. That isn't the case, however. Although an 85mm lens

6.1 This image shows the approximate difference in image size between a 35mm film frame and the 40D. The smaller image size represents the 40D's image size.

on a full 35mm-frame camera is equivalent to a 136mm lens on the 40D, the depth of field on the 40D matches the 85mm lens, not the 136mm lens.

This depth-of-field principle holds true for enlargements. The depth of field in the print is shallower for the longer lens on a full-frame camera than it is for the 40D.

Lens Choices

Lenses range in focal lengths (the amount of the scene included in the frame) from fisheye to super-telephoto and are generally grouped into three main categories: wide angle, normal, and telephoto. There are also macro lenses that serve double-duty as either normal or telephoto lenses and offer macro capability.

Wide angle

Wide-angle lenses offer a wide view of a scene. Lenses shorter than 50mm are commonly considered wide angle on full-frame 35mm image sensors. For example, 16mm and 24mm lenses are wide angle. A wide-angle lens also offers sharp detail from foreground to background, especially at narrow apertures such as f/22. The amount of reasonably sharp focus front to back in an image is referred to as depth of field.

6.2 As a result of the focal length multiplication factor on the 40D, less of the scene is included than would be on a full-frame camera, and the distortion of the wide-angle lens is evident. Exposure: ISO 100, f/10, 1/250 sec. using a Canon EF 16-35mm f/2.8L USM lens.

Normal

Normal lenses offer an angle of view and perspective very much as your eyes see the scene. On full 35mm-frame cameras, 50mm to 55mm lenses are considered normal lenses. Normal lenses provide extensive depth of field (particularly at narrow apertures) and are compact in size and versatile.

Telephoto

Telephoto lenses offer a narrow angle of view, enabling close-ups of distant scenes. On full 35mm-frame cameras, lenses with focal lengths longer than 50mm are considered telephoto lenses. For example, 80mm and 200mm lenses are telephoto lenses.

Telephoto lenses offer shallow depth of field and provide a softly blurred background, particularly at wide apertures, and a closer view of distant scenes and subjects.

Macro

Macro lenses are designed to provide a closer lens-to-subject focusing distance than non-macro lenses. Depending on the lens, the magnification ranges from half-life size (0.5x) to 5x magnification. Thus, objects as small as a penny or a postage stamp can fill the frame, while nature macro shots can reveal breathtaking details that are commonly overlooked or are not visible to the human eye. By contrast, non-macro lenses typically allow maximum magnifications of

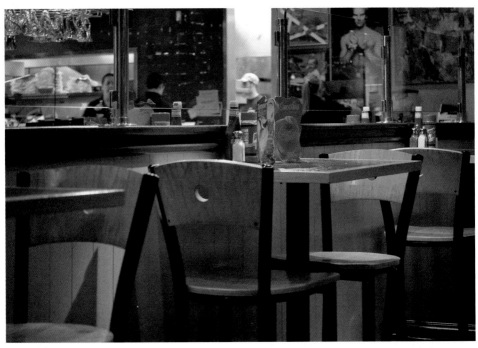

6.3 A normal lens captures the size relationships of various items in the scene much as you would see them. Exposure: ISO 1000, f/4, 1/15 sec. at 50mm.

6.4 The Canon EF 70-200mm f/2.8L IS USM telephoto zoom lens enables a close-up view of this hot-air balloon landing. Exposure: ISO 160, f/4.5, 1/80 sec.

about one-tenth life size (0.1x). Macro lenses are single focal-length lenses that come in normal and telephoto focal lengths.

Zoom Versus Prime Lenses

In addition to the basic focal-length lens categories, you can also choose between zoom and prime (also called single focal-length) lenses. The most basic difference between zoom and prime lenses is that zoom lenses offer a range of focal lengths in a single lens while prime lenses offer a fixed, or single, focal length. There are additional distinctions that come into play as you evaluate which type of lens is best for your shooting needs.

About zoom lenses

Zoom lenses, with their variable focal length, are versatile because they offer multiple and variable focal lengths in a single lens. Zoom lenses, which are available in wide-angle and telephoto ranges, are able to maintain focus during zooming. To keep the lens size compact, and to compensate for aberrations with fewer lens elements, most zoom lenses use a multi-group zoom with three or more movable lens groups.

Some zoom lenses are slower than single focal length lenses, and getting a fast zoom lens usually comes at a higher price. In addition, some zoom lenses have a variable aperture, which means that the minimum aperture changes at different zoom settings (discussed in the following sections).

Zoom lens advantages

The obvious advantage of a zoom lens is the ability to quickly change focal lengths and image composition without changing lenses. In addition, only two or three zoom lenses are needed to encompass the focal range you use most often for everyday shooting. For example, carrying a Canon EF-S 17-55mm IS USM lens and a Canon EF 55-200mm f/4.5-5.6 II USM lens, or a similar combination of L-series lenses, provides the focal range needed for most everyday shooting.

A zoom lens also offers the creative freedom of changing image composition with the turn of the zoom ring—all without changing your shooting position or changing lenses and most mid-priced and more expensive zoom lenses offer high-quality optics that produce sharp images with excellent contrast. As with all Canon lenses, full-time manual focusing is available by switching the button on the side of the lens to MF (Manual Focusing).

Zoom lens disadvantages

Although zoom lenses allow you to carry around fewer lenses, they tend to be heavier than their single focal-length counterparts. Mid-priced, fixed-aperture zoom lenses tend to be slow, meaning that with maximum apertures of only f/4.5 or f/5.6, they call for slower shutter speeds that limit your ability to get sharp images when handholding the camera.

Some zoom lenses have variable apertures. A variable-aperture lens of f/4.5 to f/5.6 means that at the widest focal length, the maximum aperture is f/4.5 and at the telephoto end of

6.5 Wide-angle zoom lenses such as the Canon EF 16-35mm f/2.8L USM lens, shown on the right, are ideal for the smaller sensor size of the 40D.

the focal range, the maximum aperture is f/5.6. In practical terms, this limits the versatility of the lens at the longest focal length for shooting in all but bright light unless you set a high ISO. And unless you use a tripod or your subject is stone still, your ability to get a crisp picture in lower light at f/5.6 will be questionable.

More expensive zoom lenses offer a fixed and fast maximum aperture, meaning that with maximum apertures of f/2.8, they allow faster shutter speeds that enhance your ability to get sharp images when handholding the camera. But the lens speed comes at a price: the faster the lens, the higher the price.

About prime lenses

Long the mainstay of photographers, prime, or single focal-length, lenses offer a fixed focal length. Prime lenses such as Canon's venerable EF 50mm f/1.4 USM lens, EF 100mm f/2.8 Macro USM are only two of a full lineup of Canon prime lenses. With a prime lens, you must move closer to or farther from your subject, or change lenses to change image composition. Single focal-length lenses generally have a brighter maximum aperture than zoom lenses which offer a broader range of creative expressiveness. Although prime lenses do not offer Image Stabilization (IS), they produce excellent sharpness and contrast.

Prime lens advantages

Unlike zoom lenses, prime lenses tend to be fast with maximum apertures of f/2.8 or wider. Wide apertures allow fast shutter speeds, and that combination allows you to handhold the camera in lower light and still get a sharp image. Compared to zoom lenses, single focal-length lenses are lighter and smaller.

In addition, many photographers believe that single focal-length lenses are sharper and provide better image quality overall than zoom lenses.

Prime lens disadvantages

Most prime lenses are lightweight, but you need more of them to cover the range of focal lengths needed for everyday photography, although some famous photographers used only one prime lens. Prime lenses also limit the options for on-the-fly composition changes that are possible with zoom lenses.

6.6 Although zoom lenses are versatile, single focal-length lenses are often smaller and lighter. The Canon EF 50mm f/1.4 lens is one of the lightest and still most versatile lenses in Canon's lineup.

Canon Lens Terminology

Canon uses several designations and lens construction technologies that are helpful to become familiar with. Understanding the terminology comes in handy when you evaluate lenses that you add to your system.

✦ **EF lens mount.** The designation EF identifies the type of mount that the lens has. The EF lens mount provides not only quick mounting and removal of lenses, but it also provides the communication channel between the lens and the camera body. The EF mount is fully electronic and resists abrasion, shock, play, and needs no lubrication of other lens mounts. The EF

system does a self-test using a built-in microcomputer so that you're alerted of possible malfunctions of the lens via the camera's LCD display. In addition, if you use lens extenders, the exposure compensation is automatically calculated.

✦ **USM.** When you see USM it indicates the lens features an ultrasonic motor. A USM lens has an ultrasonic and very quiet focusing mechanism (motor) that is built in. The motor is powered by the camera; however, because the lens has its own focusing motor you get exceptionally fast focus. USM lenses use electronic vibrations created by piezoelectric ceramic elements to provide quick and quiet focusing action with near instantaneous starts and stops.

In addition, lenses with a ring-type ultrasonic motor offer full-time manual focusing without the need to first switch the lens to manual focus. This design is offered in the large-aperture and super-telephoto lenses. A second design, the micro ultrasonic motor, provides the advantages of this technology in the less expensive EF lenses.

✦ **L-series lenses.** Canon's L-series lenses feature a distinctive red ring on the outer barrel, or in the case of telephoto and super-telephoto lenses, are distinguished by Canon's well-known white barrel. The distinguishing characteristics of L-series lenses, in addition to their sobering price tags, are a combination of technologies that provide outstanding optical performance. L-series lenses include one or more of the following technologies and features.

● **UD/Fluorite elements.** Ultralow Dispersion (UD) glass elements help minimize color fringing or chromatic aberration. This glass also provides improved contrast and sharpness. UD elements are used, for example, in the EF 70-200mm f/2.8L IS USM and EF 300mm f/4L IS USM lenses. On the other hand, Fluorite elements, which are used in super-telephoto L-series lenses, reduce chromatic aberration. Lenses with UD or Fluorite elements are designated as CaF_2, UD, and/or S-UD.

● **Aspherical elements.** This technology is designed to help counteract spherical aberration that happens when wide-angle and fast normal lenses cannot resolve light rays coming into the lens from the center with light rays coming into the lens from the edge into a sharp point of focus. The result is a blurred image. An aspherical element uses a varying curved surface to ensure that the entire image plane appears focused. These types of optics help correct curvilinear distortion in ultra-wide-angle lenses as well. Lenses with aspherical elements are designated as AL.

● **Dust, water-resistant construction.** For any photographer who shoots in inclement weather, whether it's a wedding, editorial assignment, or sports event, having a lens with adequate weather sealing is critical. The L-series EF telephoto lenses have rubber seals at the switch panels, exterior

seams, drop-in filter compartments, and lens mounts to make them both dust and water resistant. Moving parts including the focusing ring and switches are also designed to keep out environmental contaminants.

✦ **Image Stabilization.** Lenses labeled as IS lenses offer image stabilization, which is detailed later in this chapter. IS lenses allow you to handhold the camera at light levels that normally require a tripod. The amount of handholding latitude varies by lens and the photographer's ability to hold the lens steady, but you can generally count on one to four more f-stops of stability with an IS lens than with a non-IS lens.

✦ **Macro.** Macro lenses, which are covered in detail later in this chapter, enable close-up focusing with subject magnification of one-half to life-size and a maximum aperture of f/25.

✦ **Full-time manual focusing.** An advantage of Canon lenses is the ability to use autofocus, and then tweak focus manually using the lens's focusing ring without switching out of autofocus mode or changing the switch on the lens from the AF to MF setting. Full-time manual focusing comes in very handy, for example, with macro shots and when using extension tubes.

✦ **Inner and Rear Focusing.** Lenses' focusing groups can be located in front or behind the diaphragm, both of which allow for compact optical systems with fast AF. Lenses with rear optical focusing such as the

EF 85mm f/1.8 USM, focus faster than lenses that move their entire optical system, such as the EF 85mm f/1.2L II USM.

✦ **Floating System.** Canon lenses use a floating system that dynamically varies the gap between key lens elements based on the focusing distance. As a result, optical aberrations are reduced or suppressed through the entire focusing range. In comparison, optical aberrations in non-floating system lenses are corrected only at commonly used focusing distances. At other focusing distances, particularly at close focusing distances, the aberrations appear and reduce image quality.

✦ **AF Stop.** The AF Stop button allows you to temporarily suspend autofocusing of the lens. For example, you can press the AF Stop button to stop focusing when an obstruction comes between the lens and the subject to prevent the focusing from being thrown off. Once the obstruction passes by the subject, the focus remains on the subject provided that the subject hasn't moved so that you can resume shooting. The AF Stop button is available on several EF IS super-telephoto lenses.

✦ **Focus preset.** This feature lets you program a focusing distance into the camera's memory. For example, if you shoot a bicycle race near the finish line, you can preset focus on the finish line and then shoot normally as riders approach. When the racers near the finish line, you can turn a ring on the lens to instantly return to the preset focusing distance, which is on the finish line.

Evaluating Bokeh Characteristics

The quality of the out-of-focus area in a wide-aperture image is called *bokeh*, originally from the Japanese word *boke,* pronounced bo-keh, which means fuzzy. In photography, bokeh reflects the shape and number of diaphragm blades in the lens, and that determines, in part, the way that out-of-focus point of lights are rendered in the image. Bokeh is also a result of spherical aberration that affects how the light is collected.

Although subject to controversy, photographers often judge bokeh as being either good or bad. Good bokeh renders the out-of-focus areas as smooth, uniform, and generally circular shapes with nicely blurred edges. Bad bokeh, on the other hand, renders out-of-focus areas with polygonal shapes, hard edges, and with illumination that creates a brighter area at the outside of the disc shape. Also, if the disc has sharper edges, then either points of light or lines in the background become more distinct when, in fact, they are better rendered blurred.

As you are considering lenses, bokeh may be one consideration. In general, lenses with normal aperture diaphragms create polygonal shapes in the background. On the other hand, circular-aperture diaphragms optimize the shape of the blades to create circular blur because the point source is circular. Canon lenses that feature circular-aperture diaphragms use curved blades to create a rounded opening when the lens is stopped down and maintains the circular appearance even in continuous shooting burst mode.

Ken Rockwell provides an article on bokeh with excellent examples at www.ken rockwell.com/tech/bokeh.htm.

✦ **Diffractive optics.** Diffractive optics (DO) bonds diffractive coatings to the surfaces of two or more lens elements. The elements are then combined to form a single multilayer DO element designed to cancel chromatic aberrations at various wavelengths when combined with conventional glass optics. Diffractive optics result in smaller and shorter telephoto lenses without compromising image quality. For example, the EF 70-300mm f/4.5-5.6 DO IS USM lens is 28 percent shorter than the EF 70-300mm f/4.5-5.6 IS USM lens.

Using Wide-Angle Lenses

A wide-angle lens is great for capturing scenes ranging from large groups of people to sweeping landscapes and underwater subjects, as well as for taking pictures in places where space is cramped. The distinguishing characteristic of wide-angle lenses is the range of the angle of view. Within the Canon lens lineup, you can choose angles of view ranging from the fisheye lens, which offers a 180-degree angle of view, to the 35mm, which offers a 63-degree angle of view, not counting the 1.6X focal length multiplication factor.

6.7 Early-morning fog and frost were just dissipating when I captured this image with an EF 24-105mm f/4L IS USM lens. Exposure: ISO 100, f/8, 1/80 sec.

When you shoot with a wide-angle lens, keep these lens characteristics in mind:

✦ **Extensive depth of field.** Particularly at small apertures from f/11 to f/32, the entire scene, front to back, will be in acceptably sharp focus. This characteristic gives you slightly more latitude for less-than-perfectly focused pictures.

✦ **Narrow, fast apertures.** Wide-angle lenses tend to be faster (meaning they have wider apertures) than telephoto lenses. As a result, these lenses are good choices for everyday shooting when the lighting conditions are not optimal.

✦ **Distortion.** Wide-angle lenses can distort lines and objects in a scene, especially if you tilt the camera up or down when shooting. For example, if you tilt the camera up to photograph a group of skyscrapers, the lines of the buildings tend to converge and the buildings appear to fall backward (also called *keystoning*). You can use this wide-angle lens characteristic to creatively enhance a composition, or you can move back from the subject and keep the camera parallel to the main subject to help avoid the distortion.

✦ **Perspective.** Wide-angle lenses make objects close to the camera appear disproportionately large. You can use this characteristic to move the closest object farther forward in the image, or you can move back from the closest object to reduce the effect. Wide-angle lenses are popular for portraits, but if you use a wide-angle lens for close-up portraiture, keep in mind that the lens exaggerates the size of facial features closest to the lens, which is unflattering.

Tip *If you're shopping for a wide-angle lens, look for aspherical lenses. These lenses include a nonspherical element that helps reduce or eliminate optical flaws to produce better edge-to-edge sharpness and reduce distortions.*

Using Telephoto Lenses

Choose a telephoto lens to take portraits and to capture distant subjects such as birds, buildings, wildlife, and landscapes. Telephoto lenses such as 85mm and 100mm are ideal for portraits, while longer lenses (300mm to 800mm) allow you to photograph distant birds, wildlife, and athletes. When photographing wildlife, these lenses also allow you to keep a safe distance.

When you shoot with a telephoto lens, keep these lens characteristics in mind:

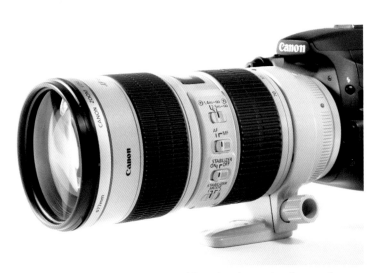

6.8 Telephoto lenses are larger and heavier than other lenses, but a sharp and versatile telephoto zoom lens is indispensable. This 70-200mm lens also features Image Stabilization, that helps counteract camera shake when handholding the camera.

✦ **Shallow depth of field.** Telephoto lenses magnify subjects and provide a limited range of sharp focus. At wide apertures, such as f/4, you can reduce the background to a soft blur. Because of the extremely shallow depth of field, it's important to get tack-sharp focus. Canon lenses include full-time manual focusing that you can use to fine-tune the camera's autofocus.

✦ **Narrow coverage of a scene.** Because the angle of view is narrow with a telephoto lens, much less of the scene is included in the image. You can use this characteristic to exclude distracting scene elements from the image.

✦ **Slow speed.** Mid-priced telephoto lenses tend to be slow; the widest aperture is often f/4.5 or f/5.6, which limits the ability to get sharp images without a tripod in all but the brightest light unless they also feature Image Stabilization And because of the magnification factor, even the slightest movement is exaggerated.

✦ **Perspective.** Telephoto lenses tend to compress perspective, making objects in the scene appear stacked together.

If you're shopping for a telephoto lens, look for those with UD glass or Fluorite elements that improve contrast and sharpness. Image Stabilization counteracts blur caused by handholding the camera.

Using Normal Lenses

A normal, or 50-55mm, lens is perhaps the most often overlooked lens in the focal range of lenses. This lens, long the primary or only lens that photography greats of past decades used, remains a classic lens that provides outstanding sharpness and contrast. On a 35mm film camera, a normal lens is 50mm, but on the 40D, a 35mm lens is closer to normal when the focal-length conversion factor is considered. Normal lenses are small, light, some are affordably priced, and offer fast and super-fast apertures such as f/1.4 and faster.

When you shoot with a normal lens, keep these lens characteristics in mind:

✦ **Natural angle of view.** A 50mm lens closely replicates the sense of distance and perspective of the human eye. This means the final image will look much as you remember seeing it when you made the picture.

✦ **Little distortion.** Given the natural angle of view, the 50mm lens retains a normal sense of distance, especially when you balance the subject distance, perspective, and aperture.

6.9 A normal lens, used for this image, is small and light, and provides an angle of view similar to that of the human eye. The Canon 50mm, f/1.4 USM lens also provides excellent contrast. Exposure: ISO 400, f/22, 1/125 sec.

✦ **Creative expression.** With planning and a good understanding of the 50mm lens, you can use it to simulate both wide-angle and medium telephoto lens effects. For example, by shooting at a narrow aperture and at a low- or high-angle shooting position, you can create the dynamic feeling of a wide-angle lens but without the distortion. On the other hand, a large aperture and a conventional shooting angle create results similar to that of a medium-telephoto lens.

Using Macro Lenses

Macro lenses open a new world of photographic possibilities by offering an extreme level of magnification. In addition, the reduced focusing distance allows beautiful, moderate close-ups as well as extreme close-ups of flowers and plants, animals, raindrops, and everyday objects. The closest focusing distance can be further reduced by using extension tubes.

Normal and telephoto lenses offer macro capability. Because these lenses can be used both at their normal focal length as well as for macro photography, they do double-duty. Macro lenses offer one-half or life-size magnification.

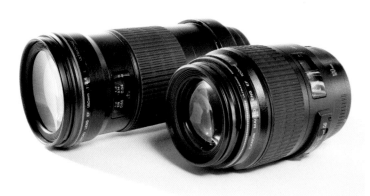

6.10 Canon offers several macro lenses including the EF 180mm f/3.5L Macro USM (left) that offers 1x (life-size) magnification and a minimum focusing distance of 0.48m/1.6 ft. Also shown here is the Canon EF 100mm f/2.8 Macro USM lens.

If you're buying a macro lens, you can choose lenses by focal length or by magnification. If you want to photograph moving subjects such as insects, choose a telephoto lens with macro capability. Moving subjects require special techniques and much practice.

Based on focal length and magnification, choose the lens that best suits the kinds of subjects you want to photograph. I find that the 100mm, f/2.8 Macro USM lens is a wonderful walk-around lens for my photography which tends to telephoto and macro work. I appreciate the ability to capture a wide variety of scenes with this lens and have the ability to do excellent macro work without changing lenses. Other photographers would never think of using a prime lens as a walk-around lens, but for me, the 100mm is ideal.

6.11 The EF 180mm f/3.5L Macro USM lens, used to make this picture of a summer rose, is very sharp with excellent contrast. Exposure: ISO 100, f/8, 1/400 sec.

Using Tilt-and-Shift Lenses

Referred to as TS-E, tilt-and-shift lenses allow you to alter the angle of the plane of focus between the lens and sensor plane to provide a broad depth of field even at wide apertures and to correct or alter perspective at almost any angle. In short, TS-E lenses allow you to correct perspective distortion and control focusing range. These types of movements were previously possible only with medium and large format cameras.

Tilt movements allow you to bring an entire scene into focus even at maximum apertures. By tilting the lens barrel, you can adjust the lens so that the plane of focus is uniform on the focal plane, thus changing the normally perpendicular relationship between the lens's optical axis and the camera's focal plane. Alternately, reversing the tilt has the opposite effect of greatly reducing the range of focusing.

Shift movements avoid the trapezoidal effect that results from using wide-angle lenses pointed up to take a picture of a building, for example. Keeping the camera so that the focal plane is parallel to the surface of a wall and then shifting the TS-E lens to raise the lens results in an image with the perpendicular lines of the structure being rendered perpendicular and with the structure being rendered with a rectangular appearance.

TS-E lenses revolve within a range of plus/minus 90 degrees making horizontal shift possible, useful in shooting a series of panoramic images. You can also use shifting to prevent having reflections of the camera or yourself in images that include reflective surfaces, such as windows, car surfaces, and other similar surfaces.

All Canon's TS-E lenses are manual focus only. These lenses, depending on the focal length, are excellent for architectural, interior, merchandise, nature, and food photography.

Using Image Stabilized Lenses

Image Stabilization (IS) is a technology that counteracts motion blur from handholding the camera. Whether IS belongs in the lens or in the camera is a matter of debate. But for Canon, the argument is that stabilization belongs in the lens because different lenses have different stabilization needs. If you've shopped for lenses lately, you know that IS comes at a premium price, but IS is often worth the extra money because in practice you gain from one to four f-stops of stability — and that means that you may be able to leave the tripod at home.

The rule of thumb for handholding the camera is 1/[focal length]. For example, the slowest shutter speed at which you can handhold a 200mm lens and avoid motion blur is 1/200 second. If the handholding limit is pushed, then shake from handholding the camera bends light rays coming from the subject into the lens relative to the optical axis, and the result is a blurry image.

With an IS lens, miniature sensors and a high-speed microcomputer built into the lens analyze vibrations and apply correction via a stabilizing lens group that shifts the image parallel to the focal plane to cancel camera shake. The lens detects camera motion via two gyro sensors — one for yaw and one for pitch. The sensors detect the angle and speed of shake. Then the lens shifts the IS lens group to suit the degree of shake to steady the light rays reaching the focal plane.

6.12 Image Stabilization provided a level of insurance for sharpness in this scene where I handheld an EF 70-200mm f/2.8L IS USM lens zoomed to 200mm. Exposure: ISO 100, f/8, 1/200 sec.

Table 6.1
Canon EF Wide, Standard, and Medium Telephoto Lenses

Ultrawide Zoom	Wide-Angle	Standard Zoom	Telephoto Zoom	Standard and Medium Telephoto
EF16-35mm f/2.8L II USM	EF 14mm f/2.8L II USM	EF-S 17-55mm f/2.8 IS USM	EF 55-200mm f/4.5-5.6 II USM	EF 50mm f/1.2L USM
EF-S 10-22mm f/3.5-4.5 USM	EF 14mm f/2.8L USM	EF-S 17-85mm f/4-5.6 IS USM	EF 70-200mm f/2.8L IS USM	EF 50mm f/1.4 USM
EF 17-40mm f/4L USM	EF 15mm f/2.8 Fisheye	EF-S 18-55mm f/3.5-5.6 USM	EF 70-200mm f/2.8L USM	EF 50mm f/1.8 II
EF 20-35mm f/3.5-4.5 USM	EF 20mm f/2.8 USM	EF-S 18-55mm f/3.5-5.6 IS	EF 70-200mm f/4L IS USM	EF 85mm f/1.2L II USM

Continued

Table 6.1 *(continued)*

Ultrawide Zoom	Wide-Angle	Standard Zoom	Telephoto Zoom	Standard and Medium Telephoto
	EF 24mm f/1.4L USM	EF 24-70mm f/2.8L USM	EF 70-200mm f/4L USM	EF 85mm f/1.8 USM
	EF 24mm f/2.8	EF 24-85mm f/3.5-4.5 USM	EF 70-300mm f/4-5.6 IS USM	EF 100mm f/2 USM
	EF 28mm f/2.8	EF 28-105mm f/3.5-4.5 II USM	EF 70-300mm f/4.5-5.6 DO IS USM	
	EF 35mm f/1.4L USM	EF 28-105mm f/4.0-5.6 USM	EF 80-200mm f/4.5-5.6 II	
	EF 35mm f/2	EF 24-105mm f/4L IS USM	EF 75-300mm f/4-5.6 III USM	
	EF 28mm f/1.8 USM	EF 28-135mm f/3.5-5.6 IS USM	EF75-300mm f/4-5.6 III	
		EF 28-200mm f/3.5-5.6 USM	EF100-300mm f/4.5-5.6 USM	
		EF 28-300mm f/3.5-5.6L IS USM	EF 100-400mm f/4.5-5.6L IS USM	
		EF 28-80mm f/3.5-5.6 II		
		EF 28-90mm f/4-5.6 II USM		

Table 6.2
Canon EF Telephoto, Super-Telephoto, Macro, and TS-E Lenses

Telephoto	SuperTelephoto	Macro	Tilt-Shift
EF 135mm f/2L USM	EF 300mm f/2.8L IS USM	EF 50mm f/2.5 Compact Macro—Life-Size Converter EF	TS-E 24mm f/3.5L

Telephoto	SuperTelephoto	Macro	Tilt-Shift
EF 135mm f/2.8 with Soft focus	EF 400mm f/2.8L IS USM	EF-S 60mm f/2.8 Macro USM	TS-E 45mm f/2.8
EF 200mm f/2L IS USM			
EF 200mm f/2.8L II USM	EF 400mm f/4 DO IS USM	MP-E 65mm f/2.8 1-5x Macro Photo	TS-E 90mm f/2.8
EF 300mm f/4L IS USM	EF 400mm f/5.6L USM	EF 100mm f/2.8 Macro USM	
	EF 500mm f/4L IS USM	EF 180mm f/3.5L Macro USM	
	EF 600mm f/4L IS USM		
	EF 800mm f/5.6L IS USM		

Stabilization is particularly important with long lenses, where the effect of shake increases as the focal length increases. As a result, the correction needed to cancel camera shake increases proportionately.

IS lenses come at a higher price, but they are very effective for close-up shots, low-light scenes, and telephoto shooting.

But what about when you want to pan or move the camera with the motion of a subject? Predictably, IS detects panning as camera shake and the stabilization then interferes with framing the subject. To correct this, Canon offers two modes on IS lenses. Mode 1 is designed for stationary subjects. Mode 2 shuts off image stabilization in the direction of movement when the lens detects large movements for a preset amount of time. So when panning horizontally, horizontal IS stops but vertical IS continues to correct any vertical shake during the panning movement.

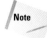 **Note** *You may wonder whether Image Stabilization is worth the premium prices for these lenses. Comparing the Canon EF 70-200mm f/2.8L USM lens and the EF 70-200mm f/2.8L IS USM, the price difference runs roughly $400 for an IS lens versus a non-IS lens. From my experience, IS is worth the price, particularly in low-light scenes such as weddings and music concerts where tripods aren't practical.*

Exploring Lens Accessories

There are a variety of ways to increase the focal range and decrease the focusing distance to provide flexibility for the lenses you already own. These accessories are not only economical, but they extend the range and

creative options of existing and new lenses. Accessories can be as simple as a lens hood to avoid flare, adding a tripod mount to quickly change between vertical and horizontal positions without changing the optical axis, or the geometrical center of the lens, or adding a drop-in or adapter-type gelatin filter holder. Other options include using extension tubes, extenders, and close-up lenses.

Lens extenders

For relatively little cost, you can increase the focal length of any lens by using an extender. An *extender* is a lens set in a small ring mounted between the camera body and a regular lens. Canon offers two extenders, a 1.4x and 2x, that are compatible only with L-series Canon lenses. Extenders can also be combined to get even greater magnification.

For example, using the Canon EF 2x II extender with a 600mm lens doubles the lens's focal length to 1200mm before applying 1.6x. Using the Canon EF 1.4x II extender increases a 600mm lens to 840mm.

Extenders generally do not change camera operation in any way, but they do reduce the light reaching the sensor. The EF 1.4x II extender decreases the light by one f-stop, and the EF 2x II extender decreases the light by two f-stops. In addition to being fairly lightweight, the obvious advantage of extenders is that they can reduce the number of telephoto lenses you carry.

6.13 Extenders, such as this Canon EF 1.4x II mounted between the camera body and the lens, extend the range of L-series lenses. They increase the focal length by a factor of 1.4x, in addition to the 1.6x focal-length conversion factor inherent in the camera.

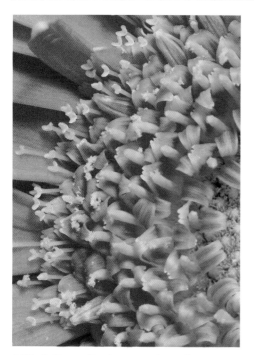

6.14 A 12mm Kenko extension tube allowed closer focusing for this image made with an EF 100mm f/2.8 Macro USM lens. Exposure: ISO 100, f/14, 1/250 sec. with +1 compensation.

The 1.4x extender can be used with fixed focal-length lenses 135mm and longer (except the 135mm f/2.8 Softfocus lens), and the 70-200mm f/2.8L, 70-200mm f/2.8L IS, 70-200mm f/4.0L, 70-200mm f/4.0L IS USM, and 100-400mm f/4.5-5.6L IS zoom lenses. With the EF 2x II, autofocus is possible if the lens has an f/2.8 or faster maximum aperture and compatible Image Stabilization lenses continue to provide stabilization.

Extension tubes and close-up lenses

Extension tubes are close-up accessories that provide magnification from approximately 0.3 to 0.7 and can be used on many EF lenses, though there are exceptions. Extension tubes are placed between the camera body and lens and connect to the camera via eight electronic contact points. The function of the camera and lens is unchanged, and extension tubes can be combined for greater magnification.

Canon offers two extension tubes, the E 12 II and the EF 25 II. Magnification differs by lens, but with the EF12 II and standard zoom lenses, it is approximately 0.3 to 0.5. With the EF 25 II, magnification is 0.7. When combining tubes, you may need to focus manually.

Extension tube EF 25 II is not compatible with the EF 15mm f/2.8 fisheye, EF 14mm f/2.8L USM, EF 20mm f/2.8 USM, EF 24mm f/1.4L USM, EF 20-35mm f/3.5-4.5 USM, EF 24-70mm f/2.8L USM, MP-E 65mm f/2.8 1-5x Macro Photo, TS-E 45mm f/2.8, and EF-S 18-55mm f/3.5-5.6 (at wide angles).

Additionally, you can use screw-in close-up lenses. Canon offers three lenses that provide enhanced close-up photography. The 250D/500D series uses a double-element design for enhanced optical performance. The 500D series features single-element construction for economy. The working distance from the end of the lens is 25cm for the 250D, and 50cm for the 500D.

Working with Light

Light has fascinated photographers since the inception of photography, and the fascination is no less compelling today than it was then. One of the key characteristics that sets images apart is the light—the quality, color, angle, and direction. Waiting for the magical light of sunrise or sunset in an outdoor scene, or setting up evocative studio lighting spells the difference between a run-of-the mill image and a spectacular image. Using the qualities of light, you can set the mood; control the viewer's emotional response to the subject; reveal or subdue the subject's shape, form, texture, and detail, and render scene colors vibrant or subdued.

To get stunningly lit images, it's important to understand the basic characteristics of light and how you can use it to your advantage. This chapter provides a basic foundation for exploring and using the characteristics of light.

Understanding Color Temperature

Few people think of light as having color until the color becomes obvious, such as at sunrise and sunset when the sun's low angle causes light to pass through more of the earth's atmosphere, creating visible and often dramatic color. However, regardless of the time of day, natural light has a color temperature, and each color, or hue, of sunlight renders subjects differently. Likewise, household bulbs, candlelight, flashlights, and electronic flashes all have distinctive color temperatures.

However, the human eye automatically adjusts to the changing colors of light so that white appears white, regardless of the type of light in which we view it. Digital image sensors are not, however, as adaptable as the human eye. For example, when the EOS 40D is set to Daylight, it renders color in a scene most accurately in the light at noon on a sunny cloudless day. But at the same setting, it does not render color as accurately at sunset or sunrise because the temperature of the light has changed.

Color temperature is important to understand because different times of day and different light sources have different color temperatures, and to get accurate color in images, the camera must be set to match the temperature of the light in the scene. Color temperature is measured on the Kelvin temperature scale and is expressed in degrees, abbreviated simply as "K." So for the camera to render color accurately, the White Balance setting must match the specific light in the scene. For example, sunlight on a clear day is considered to be between 5200 and 5500K, so the Daylight White Balance setting will render colors accurately in this light.

When learning about color temperatures, keep in mind this general principle: The higher the color temperature is, the bluer the light; the lower the color temperature is, the yellower/redder the light. However, there is a distinction between the actual color temperature and how color hues are talked about. Blue hues are referred to as being cool and red/yellow hues as being warm.

7.1 This amazing and unique sunset sets the sky ablaze with dramatic colors that run the gamut. Exposure: ISO 125, f/8, 1/15 sec. using an EF 24-105, f/4L IS USM lens.

Table 7.1 shows Kelvin scale ranges for a variety of different lights. These are, of course, general measures. The color temperature of natural light is affected by atmospheric conditions such as pollution and clouds.

 Note *If you use RAW capture, you can adjust the color temperature precisely using Canon's Digital Photo Professional RAW conversion program. See Chapter 10 for details on using this program.*

Table 7.1
Selected Artificial Light Color Temperatures

Light Source	Color Temperature (Kelvin)
Sunrise	3100 to 4300
Midday	5000 to 7000
Overcast/Cloudy sky	6000 to 8000
Sunset	2500 to 31000
Studio Strobes	4500 to 6000
Fluorescent (daylight)	6500
Fluorescent (cool white)	4300
Photoflood	3400
Tungsten-halogen	3200
Fluorescent (warm white)	3000
Household lamps	2500 to 2900
Candle flame	2000

Color Temperature Isn't Atmospheric Temperature

Unlike air temperature that is measured in degrees Fahrenheit (or Celsius), light temperature is based on the spectrum of colors that is radiated when a black body radiator is heated. Visualize heating an iron bar. As the bar is heated, it glows red. As the heat intensifies, the metal changes to yellow, and with even more heat, it glows blue-white. In this spectrum of light, color moves from red to blue as the temperature increases.

Thus color temperature becomes confusing because you likely think of "red hot" as being significantly warmer than someone who has turned "blue" by being exposed to cold temperatures. But in the world of color temperature, blue is, in fact, a much higher temperature than red. That also means that the color temperature at noon on a clear day is higher (bluer) than the color temperature during a fiery red sunset. And the reason that you care about this is because it affects the color accuracy of your pictures.

On the 40D, setting the White Balance tells the camera the general range of color temperature of the light so that it can render white as white, or neutral, in the final image. The more faithful you are in setting the correct White Balance setting or using a custom White Balance, the less color correction you have to do on the computer later.

The Colors of Light

Like an artist's palette, the color temperature of natural light changes throughout the day. By knowing the predominant color temperature shifts throughout the day, you can adjust settings to ensure accurate color, to enhance the predominant color, and, of course, to use color creatively to create striking photos. Studio and flash light also have color and are used in similar ways to natural light.

Sunrise

In predawn hours, the cobalt and purple hues of the night sky dominate. But as the sun inches over the horizon, the landscape begins to reflect the warm gold and red hues of the low-angled sunlight. During this time of day, the green color of grass, tree leaves, and other foliage is enhanced, while earth tones take on a cool hue. Landscape, fashion, and portrait photographers often use the light available during and immediately after sunrise.

7.2 Front lighting and a shaded background rendered the background as black in this image. Exposure: ISO 100, f/2.8, 1/60 sec. using an EF 100mm, f/2.8 Macro lens.

Although you can use the AWB setting, you get better color if you set a custom White Balance, which is detailed in Chapter 3. If you are shooting RAW images, you also can adjust the color temperature precisely in Canon's Digital Photo Professional RAW conversion program.

Midday

During midday hours, the warm and cool hues of light equalize to create a light the human eye sees as white or neutral. On a cloudless day, midday light often is considered too harsh and contrasty for many types of photography, such as portraiture. However, midday light is effective for photographing images of graphic shadow patterns, flower petals and plant leaves made translucent against the sun, and images of natural and man-made structures.

For midday pictures, the Daylight White Balance setting on the 40D is a reliable choice. If you take portraits during this time of day, use the built-in flash or an accessory flash to fill dark shadows. You can set flash exposure compensation in 1/3- or 1/2-stop increments to get just the right amount of fill light using either the built-in flash or an accessory Speedlite.

Cross-Reference *For more details on flash exposure compensation, see Chapter 8.*

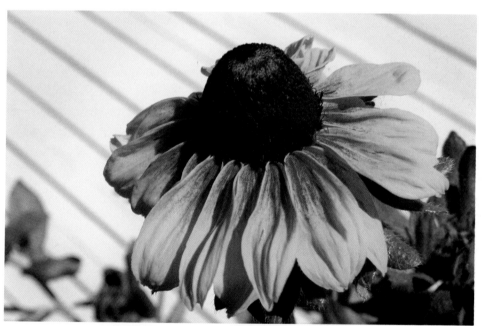

7.3 Hard midday light creates deep, sharp-edged shadows as shown in this image. Exposure: ISO 100, f/16, 1/80 sec. using an EF 24-70mm, f/2.8L USM lens.

Sunset

During the time just before, during, and just after sunset, the warmest and most intense color hues of natural light occurs. The predominantly red, yellow, and gold hues creates vibrant colors, while the low angle of the sun creates soft contrasts that define and enhance textures and shapes. Sunset colors create rich landscape, cityscape, and wildlife photographs.

For sunset pictures, the Cloudy White Balance setting is a good choice. If you are shooting RAW images, you also can adjust the color temperature precisely in Canon's Digital Photo Professional or another RAW conversion program.

 See Chapter 10 for details on using the Digital Photo Professional RAW conversion program.

Diffused light

On overcast or foggy days, the light is diffused and tends toward cool color hues. Diffusion spreads light over a larger area, making it softer and usually reducing or eliminating shadows. Light can be diffused by clouds; an overcast sky; atmospheric conditions including fog, mist, dust, pollution, and haze; or objects such as awnings or shade from trees or vegetation.

Diffused light renders colors as rich and saturated, and it creates subdued highlights and soft-edged shadows.

Because diffuse light is particularly flattering for portraits, you can create diffuse light even on a brightly lit day by using a *scrim*, a panel of cloth such as muslin or other fabric, stretched tightly across a frame. The scrim is held between the light source (the sun or a studio or household light) and the subject to diffuse the light.

Because overcast and cloudy conditions commonly are between 6000 and 8000 K, the cloudy, twilight, sunset White Balance setting on the 40D works adequately for overcast and cloudy conditions.

 To learn more about light, visit Canon's Web site at www.canon.com/technology/s_labo/light/003/01.html

Electronic flash

Most on-camera electronic flashes are balanced for the neutral color of midday light, or 5500 to 6000 K. Because the light from an electronic flash is neutral, it reproduces colors accurately.

Flash obviously is useful in low-light situations, but it is also handy outdoors where flash can be used to fill in and eliminate shadow areas caused by strong top lighting and provide detail in shadow areas for backlit subjects.

On the 40D, the Flash White Balance setting, which is set to 6000 K, is the best option because it reproduces colors accurately.

with reasonable accuracy. If you want neutral colors without the warm hue of tungsten, then set a custom White Balance. Alternately, if you know the color temperature of the bulbs, you can set the temperature using the K White Balance option.

Fluorescent and other light

Commonly found in offices and public places, fluorescent light ranges from a yellow to a blue-green hue. Fluorescent light produces a green cast in photos when the White Balance is set to Daylight or Auto.

Other types of lighting include mercury-vapor and sodium-vapor lights found in public arenas and auditoriums that have a green/yellow cast in unfiltered/uncorrected photos. You should set a custom White Balance on the 40D in this type of light or shoot a white or gray card so you can balance to neutral during RAW-image conversion.

7.4 Electronic strobes provided the light for this pet portrait. Exposure: ISO 400, f/32, 1/250 sec. using an EF 100mm. f/2.8 Macro USM lens.

 Note *You can learn more about setting custom White Balance and using white or gray cards at* www.cambridgeincolour. com/tutorials/white-balance.htm.

Tungsten light

Tungsten is the light commonly found in household lights and lamps. This light has a warmer hue than daylight and produces a yellow/orange cast in photos. In some cases, the distinct yellow hue is valued for the warm feeling it lends to images.

Setting the 40D to the Tungsten White Balance setting retains a hint of the warm hue of tungsten light while rendering colors

Under fluorescent light, set the camera to the White fluorescent light setting (4000 K). In stadiums, parking lots, and similar types of light, you may want to set a custom White Balance.

Light from fire and candles creates a red/orange/yellow color hue. In most cases, the color hue is warm and inviting and can be modified to suit your taste on the computer.

Metering Light and Reflected Light

A camera's reflective light meter sees only gray, and it measures light that is reflected back to the camera from the subject. As the meter looks at a scene, it sees tones ranging from black to white and all shades of gray between. The meter measures how much light these shades of gray, black, and white reflect back to it. Objects that are neutral gray, which is an even mix of black and white, reflect 18 percent of the light falling on them and absorb the rest of the light. In the black-and-white world of a camera's light meter, objects that are white reflect 72 to 90 percent of the light and absorb the remainder. Objects that are black absorb virtually all of the light. Since the camera's light meter sees only monotone, you may wonder how that translates to color. Simply stated, all of the colors that you see in a scene map to a percentage or shade of gray. Predictably, intermediate percentages between black and white reflect and absorb different amounts of light.

In color scenes, the light and dark values of color correspond to the swatches of gray on the grayscale. A shade of red, for example, has a corresponding shade of gray on a grayscale. The lighter the color's shade, the more light it reflects.

In addition, the camera's reflective light meter expects to see an average scene, one that contains a balance of dark and light tones that average out to 18-percent reflectance. Because the meter is calibrated for average scenes, the camera's meter produces an accurate rendition of what the human eye sees as long as the scene has average reflectance.

However, in non-average scenes with large expanses of snow, white sand, and black objects, the camera still averages the tones to 18-percent gray. That's why you get pictures with gray snow that should have been white or gray graduation gowns that should have been black. It's in scenes such as this that the 40D's exposure compensation feature comes in handy. You can use exposure compensation to fool the camera meter into correcting non-average scene exposures. For example, in a snow scene, the camera tries to make the snow an average tonality, or 18-percent gray. To render the snow as white, you set exposure compensation to a positive value, such as +1 or +2 Exposure Values (EVs) to increase the exposure and render the snow as white in the image. For scenes with large, dark expanses, you use a negative exposure compensation to get true dark tones in the image.

In addition to understanding how the camera meters light, photographers must also take into account reflected light in a scene. Given that surfaces other than pure black are reflective, they reflect their color onto the subject. For example, if you photograph a person in a grassy area, some of the green color from the grass reflects onto the subject. The closer the subject is to the grass, the more green is reflected on the subject. Similarly, photographing a subject under an awning or near a colored wall also results in color from the surface reflecting onto the subject. The amount of reflectance depends on the proximity of the subject to the colored surface, the intensity of the color, and the reflectance of the surface.

Reflected color, of course, can make getting correct color in the image difficult. To avoid or minimize corrections, you can move the subject away from the surface that is reflecting onto the subject. If you want neutral

color in the image, set a custom White Balance. Alternatively, if you're shooting RAW capture, you can shoot a gray or white card to make color correction easier during image conversion.

Additional Characteristics of Light

Photographers often describe light as hard or soft. Hard light creates shadows with well-defined edges. Soft light creates shadows

7.5 Before a music concert, I captured this image of a violin in theater-type lighting. Exposure: ISO 1600, f/2.8, 1/60 sec. using an EF 24-70mm, f/2.8L USM lens.

with soft edges. There are traditional uses for each type of light. Understanding the effect of each type of light before you begin shooting is the key to using both types of light, and variations in between, effectively.

Hard light

Hard light is created when a distant light source produces a concentrated spotlight effect—such as light from the sun in a cloudless sky at midday, an electronic flash, or a bare light bulb. Hard light creates dark, sharp-edged shadows as well as a loss of detail in highlights and shadows.

For example, portraits taken in harsh overhead light create dark, unattractive shadows under the eyes, nose, and chin. This type of light also is called *contrasty* light. Contrast is measured by the difference in exposure readings (f-stops) between highlight and shadow areas: the greater the difference, the higher the contrast. Because hard light is contrasty, it produces well-defined textures and bright colors. Hard light is best suited for subjects with simple shapes and bold colors.

To soften hard light, you can add or modify light on the subject by using a fill flash or a reflector to bounce more light into shadow areas. In addition, you can move the subject to a shady area or place a scrim (diffusion panel) between the light and the subject. For landscape photos, you can use a graduated neutral density filter to help compensate for the difference in contrast between the darker foreground and brighter sky.

Soft light

Soft light is created when a light source is diffused. In the outdoors, clouds or other atmospheric conditions diffuse a light source, such as the sun, or you can diffuse bright light to soften it by using a scrim. Diffusion not only reduces the intensity (quantity) of light, but it also spreads the light over a larger area (quality). In soft light, shadow edges soften and transition gradually, texture definition is less distinct, colors are less vibrant than in hard light, detail is apparent in both highlights and shadow areas of the picture, and overall contrast is reduced.

7.6 Mixed tungsten and diffused window light as well as backlighting all combined to softly light Chelsie for this image. Exposure: ISO 160, f/2.5,1/200 sec. using an EF 50mm, f/1.4 USM lens.

When working in soft light, consider using a telephoto lens and/or a flash to help create separation between the subject and the background. Soft light is usually well suited for portraits and macro shots, but soft light from an overcast sky is less than ideal for travel and landscape photography. In these cases, look for strong details and bold colors, and avoid including an overcast sky in the photo.

Directional light

Whether natural or artificial, the direction of light can determine the shadows in the scene. You can use both the type and direction of light to reveal or hide detail, add or reduce texture and volume, and help create the mood of the image.

✦ **Front lighting.** Front lighting is light that strikes the subject straight on. This lighting approach produces a flat effect with little texture detail and with shadows behind the subject, as seen in many snapshots taken with an on-camera flash.

✦ **Side lighting.** Side lighting places the main light to the side of and at the same height as the subject. One side of the subject is brightly lit, and the other side is in medium or deep shadow, depending on the lighting setup. This technique is often effective for portraits of men, but it is usually considered unflattering for portraits of women. However, a variation of side lighting is *high-side lighting*, a classic portrait lighting technique where a light is placed to the side of and higher than the subject.

7.7 Early sunset light with its low angle gives the balloon color a soft warm hue and soft-edged shadows on the right side of the balloon. Exposure: ISO 160, f/4.5, 1/500 sec. using an EF 70-200mm, f/2.8L IS USM lens.

✦ **Top lighting.** Top lighting, as the term implies, is light illuminating the subject from the top, such as you find at midday on a sunny, cloudless day. This lighting produces strong, deep, hard-edged shadows. This lighting direction is suitable for some subjects, but it usually is not appropriate for portraits. However, for studio portraits, a variation on top lighting is *butterfly* or *Paramount lighting*, a technique popularized by classic Hollywood starlet portraits. Butterfly lighting places the key light high, in front of, and parallel to the vertical line of the subject's nose to create a symmetrical, butterfly-like shadow under the nose.

✦ **Backlighting.** Backlighting is light that is positioned behind the subject. This technique creates a classic silhouette and, depending on the angle, also can create a thin halo of light that outlines the subject's form. Although a silhouette can be dramatic, the contrast obliterates details in both the background and subject. A fill flash can be used to show detail in the subject. In addition, backlighting often produces lens flare displayed as bright, repeating spots or shapes in the image. Flare also can show up in the image as a dull haze or unwanted rainbow-like colors. To avoid lens flare, use a lens hood to help prevent stray light from striking the lens, or change your shooting position.

Tip

Although you may not be able to control the light, especially natural outdoor light, consider these items that may improve your shot:

- *Move the subject*

- *Change your position*

- *Use a reflector or scrim*

- *Wait for better light or a light color that enhances the subject or message of the picture*

Using Flash

C ountless scenes, whether lit from the top, side, back, or barely lit at all, open the door for using flash—either the EOS 40D's onboard flash unit or one or more accessory Canon EX-series Speedlites. And on the creative front, flash offers opportunities for capturing everything from a drip of water to stroboscopic motion.

This chapter explores flash technology, details the use of the 40D's onboard flash, and the menu options for the built-in flash and for accessory EX-series Speedlites. This chapter is not an exhaustive look at all the ways in which you can use the onboard or accessory flash units. Rather, the focus of this chapter is on fundamental flash techniques and ideas for using flash for both practical situations and creative effect.

Exploring Flash Technology

Both the onboard flash and Canon's EX-series Speedlites employ E-TTL II technology. E-TTL stands for Evaluative Through-the-Lens flash exposure control. E-TTL II is a flash technology that receives information from the camera including the focal length of the lens, distance from the subject, exposure settings including aperture, and the camera's built-in evaluative metering system to balance subject exposure with the ambient light.

In more technical terms, with E-TTL II, the camera's meter reads through the lens, but not off the focal plane. After the Shutter button is fully pressed but before the reflex mirror goes up, the flash fires a preflash beam. Information from this preflash is combined with data from the evaluative metering system to analyze and compare ambient light exposure values with the amount of light needed to make a good exposure.

Then the camera calculates and stores the flash output needed to illuminate the subject while maintaining a natural-looking balance with the ambient light in the background.

In a step-by-step fashion, here is the general sequence the 40D uses when you make a flash picture.

1. Pressing the Shutter button halfway sets focus on the subject and determines the exposure needed given the amount of ambient light.

2. Pressing the Shutter button completely fires a preflash so that the amount of light reflected off the subject can be measured.

3. Very quickly, the camera compares and evaluates both the ambient and preflash readings and determines the proper subject and background exposure.

4. The reflex mirror flips up, the first shutter curtain opens and the flash fires exposing the image on the sensor, the second shutter curtain closes, and then the reflex mirror goes back down.

In addition, the flash automatically figures in the angle of view for the 40D given its cropped image sensor size. Thus, regardless of the focal length of the lens being used, the built-in and EX-series Speedlites automatically adjust the flash zoom mechanism for the best flash angle and to illuminate only key areas of the scene, which conserves power. Altogether, this technology makes the flash very handy for fill light in standard lighting and especially for backlit subjects.

With either the built-in flash or a Speedlite, you can use all of the camera's Creative Zone modes knowing that the exposure settings are taken into account during exposure given the maximum sync speed for the flash.

Why Flash Sync Speed Matters

Flash sync speed matters because if it isn't set correctly, only part of the image sensor has enough time to receive light while the shutter is open. The result is an unevenly exposed image. When using a flash, the 40D doesn't allow you to set a shutter speed faster than 1/250 second, but in some modes you can set a slower flash sync speed, as shown in Table 8.1. Using Custom Function C.Fn I-7, you can set whether the 40D sets the flash sync speed automatically (option 0) or always uses 1/250 second (option 1) when you shoot in Av mode.

8.1 This image was made with the built-in flash capturing the motion of water dripping into a water glass. A slight blur of the water droplet moving upward provided the light streaks of motion. Exposure: ISO 1000, f/2.8, 1/250 sec., using an EF 100mm, f/2.8 Macro USM lens.

Note

In Basic Zone modes except Landscape, Sports, and Flash-Off, the camera automatically fires the flash when it determines the light level is too low to produce a sharp handheld image.

E-TTL II technology also enables high-speed sync flash with accessory Speedlites that allows you to sync at a shutter speed faster than the camera's flash sync speed of 1/250 second. As a result, you can open up the lens when shooting a backlit subject to create a lovely blur to the background while shooting at faster than X-sync shutter speeds.

Tip

Normally, flash is synchronized for firing the moment when the first curtain finishes traveling but before the second curtain starts traveling. However, with high-speed sync, the flash duration is extended to make synchronization possible using fast shutter speeds by forming a slit between the first and second curtains as the curtains travel.

When shooting with accessory Speedlites, Canon's flash technology allows wireless, multiple flash photography where you can simulate studio lighting in both placement and light ratios (the relative intensity of each flash unit). You can use up to three groups of Speedlites and designate a master, or main flash, and slave units that fire in response to the master flash unit.

Tip *The Macro Ring Lite MR-14EX and Macro Twin Lite MT-24EX can also serve as master flash units.*

Note *While E-TTL II works with all lenses, some Canon lenses, such as those without full-time manual focus, art form motors, and tilt-and-shift lenses, do not properly communicate distance information.*

Using Onboard Flash

The onboard flash unit on the 40D offers a handy complement to ambient-light shooting. The unit offers flash coverage for lenses as wide as 17mm (equivalent to 27mm in full 35mm frame shooting). The flash recycles in approximately 3 seconds; however, from my experience, the unit continues to provide excellent and even illumination even when shooting in High-Speed Continuous Drive mode where the flash doesn't have a full 3 seconds to recycle.

The built-in flash guide number is 43 (feet)/13 (meters) at ISO 100. A *guide number* indicates the amount of light that the flash emits. The relationship between the aperture and the flash-to-subject distance is Guide Number ÷ Aperture = Distance for optimal exposure and Guide Number ÷ Distance = Aperture for optimal exposure.

The built-in flash offers good versatility featuring many of the same overrides that you find in EX-series Speedlites including Flash Exposure Compensation (FEC) and Flash Exposure Lock (FE Lock). In addition, flash options can be set on the camera's Flash Control menu when you shoot in Creative Zone modes.

Menu options include the ability to turn off firing of the built-in flash and an accessory flash, shutter sync with first or second curtain, Evaluative or Average metering, and Red-Eye Reduction. The 40D also allows you to set Custom Functions for an accessory EX-series Speedlite through the Set-up 2 (yellow) camera menu – a very handy feature given that the size and brightness of the camera menu is bigger and easier to read than the LCD on a Speedlite.

Table 8.1 shows the behavior of the flash in each of the Creative Zone modes. Table 8.2 and Table 8.3 show the approximate, effective range of the flash with the EF 18-55mm lenses.

Tip *When you use the built-in flash, be sure to remove the lens hood to prevent obstruction of the flash coverage. And if you use a fast, super-telephoto lens, the built-in flash coverage may also be obstructed.*

Table 8.1
Using the Built-in Flash in Creative Zone Modes

Mode	Shutter Speed	Automatic Exposure Setting
Tv	30 sec. to 1/250 sec.	You set the shutter speed, and the camera automatically sets the appropriate aperture.
Av	30 sec. to 1/250 sec.	You set the aperture, and the camera automatically sets the shutter speed.
M (Manual)	30 sec. to 1/250 sec.	You set both the aperture and the shutter speed. Flash exposure is set automatically.
A-DEP (and P)	1/60 sec. to 1/250 sec.	Both the aperture and the shutter speed are set automatically by the camera.

Table 8.2
40D Built-in Flash Range with the EF-S 18-55mm Lens

ISO	18mm	55mm
100	1 to 3.7m (3.3 to 12.1 ft.)	1 to 2.3m (3.3 to 7.5 ft.)
200	1 to 5.3m (3.3 to 17.4 ft.)	1 to 3.3m (3.3 to 10.8 ft.)
400	1 to 7.4m (3.3-24.3 ft.)	1 to 4.6m (3.3 to 15.1 ft.)
800	1 to 10.5m (3.3 to 34.4 ft.)	1 to 6.6m (3.3 to 21.7 ft.)
1600	1 to 14.9m (3.3 to 48.9 ft.)	1 to 9.3m (3.3 to 30.5 ft.)
H (3200)	1 to 21m (3.3 to 68.9 ft.)	1 to 13.1m (3.3 to 43 ft.)

Table 8.3
40D Built-in Flash Range with the EF-S 17-85mm Lens

ISO	17mm	85mm
100	1 to 3.3m (3.3 to 10.8 ft.)	1 to 2.3m (3.3 to 7.5 ft.)
200	1 to 4.6m (3.3 to 15.1 ft.)	1 to 3.3m (3.3 to 10.8 ft.)
400	1 to 6.5m (3.3-21.3 ft.)	1 to 4.6m (3.3 to 15.1 ft.)
800	1 to 9.2m (3.3 to 30.2 ft.)	1 to 6.6m (3.3 to 21.7 ft.)
1600	1 to 13m (3.3 to 42.7 ft.)	1 to 9.3m (3.3 to 30.5 ft.)
H (3200)	1 to 18.4m (3.3 to 60.4 ft.)	1 to 13.1m (3.3 to 43 ft.)

Disabling the flash but enabling the flash's autofocus assist beam

In some low-light scenes, you may want to shoot using ambient light without using the flash. However, the camera may have trouble establishing good focus due to the low light. The autofocus assist beam from the flash is invaluable in these situations to help the camera establish focus. In these kinds of scenes, you can disable the flash firing and still use the flash's autofocus assist beam to help the camera to establish focus.

To enable or disable flash firing but still allow the camera to use the flash's autofocus assist beam for focusing, follow these steps.

1. **Press the Menu button, and then press the Jump button until the Set-up 2 (yellow) menu is displayed.**

2. **Turn the Quick Control dial to highlight Flash control, and then press the Set button.** The Flash control screen appears.

3. **Turn the Quick Control dial to highlight Flash firing, and then press the Set button.** Two options appear.

4. **Turn the Quick Control dial to highlight either Enable or Disable, and then press the Set button.** If you choose Disable, neither the built-in flash nor an accessory Speedlite will fire. However,

the camera will use the flash's autofocus assist beam to establish focus in low-light scenes. For the camera to use the flash's autofocus assist beam, either pop up the built-in flash by pressing the Flash button on the front of the camera, or mount an accessory EX-series Speedlite. When you halfway press the Shutter button, the flash's autofocus assist beam fires to help the camera establish focus.

Also, with Custom Function C.Fn III-5, you can choose whether the AF-assist beam is fired by the camera's built-in flash or by an accessory Speedlite. If this function is set to Disable, the autofocus assist beam is not used. If you've set the Custom Function on the Speedlite for autofocus assist beam firing to Disable, the autofocus assist beam is not used. In short, be sure that the Custom Functions on both the 40D and on the accessory Speedlite are not in conflict with each other.

 Cross-Reference *For details on Custom Functions, see Chapter 4.*

Red-eye reduction

Certainly, a disadvantage of flash exposure in people and pet portraits is unattractive red in the subject's eyes.. There is no sure fix that prevents red eye, but a few steps help reduce it. First, before making the picture, have the subject look at the Red-Eye Reduction lamp on the front of the camera when it fires. Also have the room well lit.

Then be sure to turn on Red-Eye Reduction on the 40D. This option is set to Off by default.

Before you begin, ensure that the Flash Firing is set to Enable on the Setup 2 (yellow menu). To turn on Red-Eye Reduction, follow these steps.

1. **Press the Menu button, and then press the Jump button to select the Camera 1 (red) menu.**

2. **Turn the Quick Control dial to highlight Red-Eye On/Off, and then press the Set button.** Two options are displayed.

3. **Turn the Quick Control dial to highlight On, and then press the Set button.** The setting you choose applies to both Basic and Creative Zone modes.

4. **Press the Flash button on the front of the camera to pop up the built-in flash.**

5. **Focus on the subject by pressing the Shutter button halfway, and then watch the timer display at the bottom center of the viewfinder.** When the viewfinder timer display turns off, press the Shutter button completely to make the picture.

Modifying Flash Exposure

Regardless of the sophisticated technology behind E-TTL II, there are doubtless times when the output of the flash will not be what you envisioned. Most often, the output is stronger than desired, creating an unnaturally bright illumination on the subject. The 40D offers two options for modifying the flash output: Flash Exposure Compensation and Flash Exposure Lock for both the built-in and one or more accessory Speedlites.

Flash Exposure Compensation

Flash Exposure Compensation is much like Auto Exposure Compensation in that you can set compensation for exposure up to plus/minus two stops in 1/3-stop increments. A positive compensation increases the flash output and a negative compensation decreases the flash output. Flash Exposure Compensation can help reduce shadows in the background and balance unevenly lit scenes.

For the purpose of comparison, I have used the same simple image set up for figures 8.2 through 8.7 to illustrate how the flash and flash exposure modifications change the image. The scene is lit by a tungsten chandelier with diffuse window light coming in to camera right.

8.2 This image was taken without using a flash. Exposure: ISO 125, f/5.6, 1/3 sec., auto White Balance, using an EF 25-105mm, f/4L IS USM lens.

8.3 This image is lit by the onboard flash set to E-TTL with no exposure modification, the distracting background shadows are predictable. However, the flash cools down the strong yellow cast of the tungsten lighting.

A custom White Balance is the ticket to solve the colorcast, of course, but the combination of tungsten and flash light creates the warm appearance that I envisioned, as shown in figure 8.7 at the end of this chapter.

If you use an accessory Speedlite, you can set Flash Exposure Compensation either on the camera or on the Speedlite. However, the compensation that you set on the Speedlite overrides any compensation that you set on the 40D's Setup 2 (yellow) camera menu. If you set compensation on both the Speedlite and the camera, the Speedlite setting overrides what you set on the camera. So the take-away is to set compensation either on the Speedlite or on the camera, but not both. Unless you shoot with the Speedlite on multiple EOS camera bodies, I think setting compensation on the camera is handier simply because the camera's LCD is easier to see and change than it is on the Speedlite's display.

8.4 This image is lit with onboard flash exposure set to -1. The lowered flash exposure reduces the appearance of the background shadows, but the yellow cast of the tungsten light is evident again.

Flash Exposure Compensation can be combined with Exposure Compensation. If you're shooting a scene where one part of the scene is brightly lit and another part of the scene is much darker—for example an interior room with a view to the outdoors—then you can set Exposure Compensation to -1 and set the Flash Exposure Compensation to -1 to make the transition between the two differently lit areas more natural.

To set Flash Exposure Compensation for either the built-in flash or an accessory Speedlite, follow these steps:

1. **Set the camera to a Creative Zone mode, and then press the ISO-Flash Compensation button above the LCD panel.** The Exposure Level indicator meter is activated.

2. **Turn the Quick Control dial to the left to set negative compensation (lower flash output) or to the right to set positive flash output (increased flash output) in 1/3-stop increments.** As you turn the Quick Control dial, a tick mark under the Exposure Level meter moves to indicate the amount of Flash Exposure Compensation. The Flash Exposure Compensation is displayed in the viewfinder and on the LCD panel when you press the Shutter button halfway. The Flash Exposure Compensation you set on the camera remains in effect until you change it.

To remove Flash Exposure Compensation, repeat these steps but in Step 2, move the tick mark on the Exposure Level meter back to the center point.

Flash Exposure Lock

The second way to modify flash output is by using Flash Exposure Lock (FE Lock). Much like Auto Exposure Lock (AE Lock), FE Lock allows you to meter and set the flash output on any part, typically the point of critical exposure, of the subject. In figure 8.5, I photographed the same scene as shown in figures 8.2, 8.3, and 8.4, only here I used FE lock.

8.5 The flash exposure is locked on the highlight to the left of the bottle just under the top wrapper resulting in a darker exposure but with more detail retained in the highlights. Exposure: ISO 100, f/5.6, 1/6 sec.

One way to use FE Lock is to prevent underexposure of the highlights. With this approach, you evaluate the subject in ambient light and lock the flash exposure on a midtone area in the scene. If there are reflective surfaces in the scene such as a mirror or metal, be sure to take the flash exposure reading from an average area of the scene that doesn't include the reflective surface. Including the reflective surface can result in flash underexposure. When you press the Shutter button halfway to set the FE Lock, the camera fires a preflash that evaluates the scene. The camera calculates the exposure needed for the subject taking into account the flash meter reading.

As you evaluate the subject for flash exposure, be sure to evaluate the scene using whatever accessories you'll use for the final image. In other words, if you plan to use a reflector, evaluate the subject with the reflector in place and take the meter reading with the reflector in place as well. The more standard technique is to identify the critical midtone exposure area in the scene, and then lock the flash exposure for that area. In a food setup, the critical exposure is on the dish as opposed to the background, so FE Lock is set on the area of the food. The camera then balances the exposure with background ambient light. Regardless of the approach, FE Lock is a technique that you want to add to your arsenal for flash images.

Like AE Lock, FE Lock is one of the best features you can use for both the built-in and accessory flash.

To set FE Lock, follow these steps:

1. **Set the camera to a Creative Zone mode, and then press the Flash button to raise the built-in flash or mount the accessory Speedlite.** The flash icon appears in the viewfinder.

Note *If the flash icon in the view-finder blinks, you are too far from the subject for the flash range. Move closer to the sub-ject and repeat Step 2.*

2. **Point the selected AE point over the midtone area of the subject where you want to lock the flash exposure, press the Shutter button halfway, and then press the AE/FE Lock but-ton on the back right side of the camera.** This button has an aster-isk above it. The camera fires a preflash. FEL is displayed momen-tarily in the viewfinder, and the flash icon in the viewfinder dis-plays an asterisk beside it to indi-cate that flash exposure is locked. The camera retains the flash out-put in memory.

3. **Move the camera to compose the image, press the Shutter button halfway to focus on the subject, and then completely press the Shutter button to make the image.**

Note *You can take additional pictures at this flash output as long as you continue to hold the AE/FE Lock button.*

FE Lock is a practical technique to use when shooting individual images. But if you're shooting a series of images under unchang-ing ambient light, then Flash Exposure Compensation is more efficient and practical.

Using Flash Control Options

With the 40D, many of the onboard and accessory flash settings are available on the camera menus. The Set-up 2 (yellow) menu offers onboard flash settings including the first or second curtain shutter sync, Flash Exposure Compensation, and E-TTL II or Average exposure metering.

When an accessory Speedlite is mounted, you can use the Set-up 2 (yellow) menu to set Flash Exposure Compensation and choose between Evaluative or Average metering. In addition, you can change or clear the Custom Function (C.Fn) settings for compatible Speedlites such as the 580 EX II. If the Speedlite functions cannot be set with the camera, these options display a message notifying you that the flash is incompatible with this option. In that case, set the options you want on the Speedlite itself.

To change settings for the onboard or com-patible accessory EX-series Speedlites, fol-low these steps:

1. **Set the camera to a Creative Zone mode. If you're using an accessory Speedlite, mount it on the camera and turn it on.**

2. **Press the Menu button, and then press the Jump button until the Set-up 2 (yellow) menu is displayed.**

3. **Turn the Quick Control dial to highlight Flash Control, and then press the Set button.** The Flash Control screen appears with options for the built-in and external flash.

4. **Turn the Quick Control dial to highlight the option you want, and then press the Set button.** Choose a control option from the Flash Control menu and press the Set button. Table 8.4 lists the menu settings, options, and sub-options that you can choose from to control the flash.

8.6 For this image, using the same set up as the last few images, I set the flash metering to Average rather than Evaluative metering as used in the previous images.

8.7 Using the same set up from previous images, here I used two EX-series Speedlites, a 580 EX Speedlite mounted on the camera and bounced off the ceiling, and a 550 EX Speedlite set up on a table behind the wine and glasses. The 550 was set up as a slave and fired wirelessly from the 580. Notice how the backlight illuminates the center of the bottle and the glasses and adds depth to the scene. Exposure: ISO 100, f/5.6, 1/5 sec.

Table 8.4
Flash Control Menu Options

Setting	Option(s)	Suboptions/Notes
Built-in flash func. setting	Flash mode	(Cannot be changed from E-TTL II)
	Shutter Sync	1st curtain: Flash fires immediately after the exposure begins.
		2nd curtain: Flash fires just before the exposure ends. Can be used with slow-sync speed to create light trails behind the subject.
	Flash exp. Comp	Press the Set button to activate the Exposure Level meter, and then turn the Quick Control dial to set positive or negative compensation.
	E-TTL II	Evaluative (default) Sets exposure based on an evaluation of the entire scene. Average: Flash exposure is metered and averaged for the entire scene. Results in brighter output on the subject and less balancing of ambient background light.
External flash func. setting	Flash mode	E-TTL II
	Shutter sync	Hi-speed
		1st curtain: Flash fires immediately after the exposure begins.
		2nd curtain: Flash fires just before the exposure ends. Can be used with slow-sync speed to create light trails behind the subject.
	FEB (Flash Exposure Bracketing)	Press the Set button to activate the Exposure Level meter, and then turn the Quick Control dial to set the bracketing amount.
	Flash exp. comp	Press the Set button to activate the Exposure Level meter, and then turn the Quick Control dial to set positive or negative compensation.
	E-TTL II	Evaluative Average
External flash C.Fn setting		
Clear ext. flash C.Fn set.		

Using One or More Accessory Speedlites

With one or more accessory flash units, a new level of lighting options opens up ranging from simple techniques such as bounce flash and fill flash to controlled lighting ratios with up to three groups of accessory flash units. With E-TTL II metering, you have the option of using one or more flash units as either the main or an auxiliary light source to balance ambient light with flash to provide even and natural illumination and balance among light sources.

One or more Speedlites provide an excellent portable studio for location shooting, such as environmental portraits. And you can add light stands, light modifiers such as umbrellas and/or softboxes, and use a variety of reflectors to produce images that either replicate studio lighting results or enhance existing light.

I really encourage you to explore the options that multiple Speedlites offer. For detailed information on using Canon Speedlites, be sure to check out the *Canon Speedlite System Digital Field Guide* by J. Dennis Thomas (Wiley).

In the Field with the EOS 40D

In this chapter, we explore a wide variety of photography specialty areas with images that show EOS 40D performance in the field with each subject. In addition to the examples, I offer shooting notes based on my experience with the camera, as well as alternate shooting methods, and ideas that I hope will inspire you in thinking about photographing these subjects. After writing and shooting this chapter, I was even more impressed with the overall versatility and performance of the 40D than when I first began shooting with it. Whether you shoot all or only some of these subjects, I think that you'll gain a full appreciation of the speed and image quality that the 40D delivers.

Action and Sports Photography

Anyone who shoots action and sports events knows that a fast camera is essential for capturing the energy and critical moments of the action. With a burst rate of approximately 75 JPEG and 17 RAW frames in High-Speed Continuous Drive mode combined with smart buffering, the 40D delivers beautifully for action shooting. The focal length multiplication factor of 1.6x brings the action in close with telephoto lenses. For example, using the Canon EF 70-200mm f/2.8L IS USM lens effectively provides a 112-320mm equivalent focal length.

Canon's separate motors for shutter and mirror operation help give the 40D exceptionally speedy performance. And with shutter speeds ranging from 1/8000 to 30 sec., the camera offers ample opportunity to freeze or show action, or to create intriguing panned shots.

When you shoot action and sports scenes, the best images are those that capture the moment of peak action. That moment may be a runner crossing the finish line, a pole-vaulter at the height of a vault, or a race car getting the checkered flag. But other moments are equally compelling such as

© Rob Kleine / www.gentleye.com

9.1 Capturing images that tell a story is the goal of Rob Kleine, a seasoned soccer photographer. Exposure: ISO 400, f/4, 1/500 sec. using an EF 70-200mm f/2.8L IS USM lens with a Canon 1.4x teleconverter.

when an athlete takes a spill, the look of disappointment when an athlete comes in second, third, or last in a race — in short, moments of high emotion. As much as any other area of photography, sports and action photography offers you the opportunity to tell the rich and compelling stories of the person and event, and there are no more challenging assignments than that.

If you have a passion for sports and action shooting, one way to hone your skills and earn money is by shooting local events and posting the images on a Web site where athletes and family can purchase prints. There are a number of Web sites set up specifically for this type of business, and they offer password-protected albums and a commission from the sale of prints.

Inspiration

As you take sports and action photos, mix things up by using the techniques of freezing or showing motion as a blur to capture the emotion and give the sense of being in the moment. When shooting sports and action events, try shooting a sequence of images that tell the story of a part or all of an event or of one athlete.

One of the best example of pictorial storytelling is Brian Storm's Emmy-winning Web site at http://mediastorm.org/. Most of the stories are photojournalism-related, but they provide a look at the sense and flow of telling stories with pictures.

Tip *For ongoing inspiration, I recommend MSNBC's* The Week in Sports Pictures *at* www.msnbc.msn.com/id/3784577.

9.2 At this Christian music concert, the enthusiasm of a hand gesture is rendered as motion blur. Exposure: ISO 400, f/2.8, 1/30 sec. using an EF 70-200mm f/2.8L IS USM lens.

Action photography and the techniques used for it are by no means limited to sports. Any event that has energy and motion is an opportunity to apply sports and action shooting techniques.

Taking action and sports photographs

© Rob Kleine / www.gentleye.com

9.3 In this image, all eyes are on the ball, anticipating where the imminent kick will transport it. The EF 300/4L lens has a focal length that reaches deep onto the playing field. That reach, combined with its lightning-fast AF, is perfect for capturing midfield action like this.

Table 9.1
Action and Sports Photography

Setup	**In the Field:** The image in figure 9.3 is one of a series taken during a soccer game. The super-fast autofocus on the 40D is perfect for capturing midfield action such as this.
	Additional Considerations: At sports events, find a good shooting position with a colorful, non-distracting background. If you're shooting JPEGs and the light is bright, setting a negative exposure compensation can help avoid blowing detail from highlight areas in the image. I also recommend shooting in RAW capture mode where exposure compensation may not be necessary because you can recover one or more f-stops of highlight detail during image conversion.
Lighting	**In the Field:** To best leverage the available cloud-diffused, directional, low-angle fall sun, Rob positioned himself at the south end of the field so the players were pleasingly front-lit.
	Additional Considerations: Moderate light is ideal for showing motion blur, although motion blur can be shown in brightly lit scenes as well.
Lens	**In the Field:** Canon EF 300 f/4L IS USM lens.
	Additional Considerations: The lens you choose depends on the subject you're shooting and your shooting distance from the action. Regardless, a telephoto lens offers the advantage of blurring distracting backgrounds often found at sports events A telephoto lens also adds to the background blur if you're panning.
Camera Settings	**In the Field:** RAW capture, Aperture-priority AE mode with the White Balance set to Cloudy.
	Additional Considerations: Particularly when shooting in low light, you want to control the shutter speed, and that makes Shutter-priority AE (Tv) mode a good choice. If you want to use shutter speed to avoid blur from handholding the camera and lens, then set the shutter speed to 1/60 second or faster unless you're using a telephoto lens, in which case, use the reciprocal-of-the-focal-length rule detailed in Chapter 6. Also, in mixed-light situations, try using AWB or setting a custom White Balance for venues you shoot in frequently (such as stadiums). You can also shoot a gray card for RAW capture and balance the image series from the gray card later in the computer.
Exposure	**In the Field:** ISO 800, f/4, 1/2000 sec., Aperture-priority AE mode.
	Additional Considerations: If you want to show motion blur, you may need to experiment to get the shutter speed that shows motion blur and the f-stop that gives you the depth of field you want. You can generally show motion blur at 1/30 second and slower shutter speeds.
Accessories	At slower shutter speeds and when using a telephoto lens or zoom setting, it's really important to use a tripod or monopod to ensure you get a tack-sharp image. Rob used a monopod for this shot to ensure maximum sharpness.

Action and sports photography tips

✦ **Capture the thrill**. Regardless of the technique you choose to shoot action photos, set a goal of showing the emotion, thrill, speed, or excitement of the scene in your pictures. You want the kind of picture where people look at it and say, "Wow!"

✦ **Take a high shooting position.** Move back to the fourth or fifth row at sporting events, and use the additional height to your advantage. Leave room for your monopod or tripod. If you have a lens extender, take a few test shots with and without the extender to see whether the loss of light is worth the extended focal length (for example, a 2x extender costs you two f-stops). This loss of light may mean that you can't get a fast enough shutter speed to freeze motion.

✦ **If lighting varies dramatically across the sports field and you find it difficult to continually** change the exposure, find the best-lit spot on the playing field or court, set the exposure for that lighting, and then wait for the action to move into that area. This technique works well in a low-lit indoor stadium as well. You can also prefocus on this spot and wait for the athlete or action to move into the area.

✦ **Experiment with shutter speeds.** To obtain a variety of action pictures, vary the shutter speed for different renderings. At slower shutter speeds, part of the subject will show motion, such as a player's arm swinging, while the rest of the subject's motion will be stopped.

✦ **Shoot locally.** If you're new to shooting sports photos, consider photographing high school and local amateur events. These are good places to hone your reflexes and composition. And usually you will be under fewer restrictions, be able to get closer to the athletes, and have fewer fans to contend with.

Wide-Angle Distortion

Wide-angle lenses are a staple in architectural photography. When you use a wide-angle lens at close shooting ranges, and especially when the camera is tilted upward, the vertical lines of buildings converge toward the top of the frame. You can correct the distortion in an image-editing program, or you can use a tilt-and-shift lens, such as the Canon TS-E24mm f/3.5L, that corrects perspective distortion and controls focusing range. Shifting raises the lens parallel to its optical axis and can correct the wide-angle distortion that causes the converging lines. Tilting the lens allows greater depth of focus by changing the normally perpendicular relationship between the lens's optical axis and the camera's sensor.

To use a tilt-and-shift lens, set the camera so the focal plane is parallel to the surface of the building's wall. As the lens is shifted upward, it causes the image of the wall's surface to rise vertically, thus keeping the building's shape rectangular. For details on tilt-and-shift lenses, see Chapter 6.

Architectural and Interior Photography

Styles of architecture mirror the culture and sensibilities of each generation. New architecture reflects the hopeful aspirations of the times, while older structures reflect earlier cultural norms and sensibilities. For photographers, photographing both new and old architecture provides rich photo opportunities to document changes in culture and urban development.

Architectural photography is about capturing a sense of place and space. The challenge with the 40D, given the sensor size, is capturing the full scope of exterior and interior spaces. Canon offers a range of wide-angle lenses, including the ultrawide EF14mm f/2.8L USM lens, which gives the equivalent of approximately 22mm on the 40D, to wide-angle zoom lenses such as the EF-S 10-22mm f/3.5-4.5 USM, which is designed for the smaller sensor size, to the L-series 16-35mm f/2.8 USM, which is equivalent to 25-56mm on the 40D. Edge sharpness is important to watch for, so if you routinely frame images with extra space on the left and right edges so you can crop edges that are less than tack sharp, then the widest angle prime and zoom lenses are the best choices for architectural and interior photography.

Tip

When foreground elements mirror the architecture, be sure to include them in the composition. For example, if a nearby metal sculpture echoes the glass and steel design of the building, include all or part of the sculpture to add foreground interest and context.

9.4 The planned open spaces around modern buildings provide good foreground detail for this high-rise office building. Capturing the fall color also helps alleviate what would have been a scene with a primarily blue and white color palette. Exposure: ISO 100, f/9, 1/200 sec. using an EF 16-35mm f/2.8L USM lens.

If you're new to architectural shooting, choose a building that interests you photographically, and then study how light at different times of the day transforms the sense

High Dynamic Range Images

From shooting on assignment for real estate companies to shooting commercial assignment, the demand for and popularity of high dynamic range (HDR) images is growing. HDR images fully capture high-contrast scenes to maintain detail in the shadows and highlights. Shooting HDR images involves shooting a series of three to seven shutter-speed bracketed images. Then the images are merged Photoshop CS3, and contrast and tonal adjustments are made.

In architectural photography, HDR gives a true "view" and sense of the interior or exterior by showing fine detail in bright window views to the outside – detail that would be sacrificed as very bright or blown highlights in single-shot photographs. And the same is true for showing detail in deep shadows. Because HDR captures a full stop of information in every tonal range via the multiple exposures, HDR delivers true-to-life and almost surreal renderings that are not possible in single images, or in double-processed RAW image composites.

and character of the building. Look for structural details and visual spaces that create interesting shadow patterns as they interact with other subsections of the structure. If you're shooting on assignment, be sure to sync-up with the client's marketing and design teams so you can deliver images that visually communicate the client's message and goal about the structure or interior.

Most buildings are built for people, and people contribute to the character of the building. In a compositional sense, people provide a sense of scale in architectural photography, but more importantly, they imbue the building with a sense of life, motion, energy, and emotion.

The umbrella of architectural photography includes interior photography of both commercial and private buildings and homes. Lighting plays a crucial role in communicating the style and ambience of the space. It's certainly possible to get pleasing interior shots by using existing room lighting and window lighting, but portable strobes or multiple wireless flash units add a kiss of light and reveal details that might be lost using ambient-only light.

Inspiration

To get a true sense of the structure's character, it's important to explore the exterior and interior of the building. Look for interior design elements that echo the exterior design. As you shoot, study how the building interacts with surrounding structures. See if you can use juxtapositions for visual comparisons and contrasts. Or find old and new buildings that were designed for the same purposes – courthouses, barns, cafes and restaurants, libraries, or train stations, for example. Create a photo story that shows how design and use have changed over time.

As you consider buildings and interiors, always try to verbalize what makes the space distinctive. When you can talk about the space, then you're better able to translate your verbal description into visual terms. Many new structures include distinctive elements such as imported stone, crystal abstract displays, and so on that reflect the architect's vision for the structure. Be sure to play up the unique elements of exteriors and interiors. Very often, you can use these features as a theme that runs throughout a photo story.

9.5 A nearby symbol of a busy metro bus stop provides an easy reference point for the location of this building in a downtown area of Bellevue, Washington. The mirrored exterior also provides an opportunity to capture cloud detail. Exposure: ISO 100, f/8, 1/60 sec. using an EF 16-35mm f/2.8L USM lens.

Taking architectural and interior photographs

9.6 For this image, I wanted to capture acceptable shadow detail and maintain detail in the brighter window area, so I combined a negative exposure compensation with two EX-series Speedlite units to help balance the differences in lighting.

Table 9.2
Architectural and Interior Photography

Setup	**In the Field:** Whether you are shooting photos for a real estate company or shooting photos so you can sell your own home, it's important to plan the lighting setup carefully and present a clean, appealing shot that captures the spirit of the space. The goal in figure 9.6 was a clean shot that conveys the spaciousness of this master bedroom. Removing clutter and keeping accessories in the room to a minimum helps create a clean and spacious sense to the room. My shooting position was limited by the configuration of the entry doors to the room, but this limitation also meant that I was able to exclude an unattractive dresser on the left wall.
	Additional Considerations: Study the building or space and look for the best details. Will details be best pictured straight on or from the side? If you're shooting interiors or exteriors, can you isolate repeating patterns that define the style? Consider contrasting ultramodern buildings with older, nearby buildings. Frame architectural images carefully to include only the detail or structures that matter in the image.

Lighting

In the Field: Three types of light combined in this shot: tungsten overhead lighting, diffuse window light, and two Canon EX-series Speedlites — an EX 550 to camera left bounced off the ceiling and an EX 580 to camera right. I also used the great Canon ST-E2 Speedlite Transmitter with the light ratio set to 2:1.

Additional Considerations: If you're shooting outdoors, wait for golden late-afternoon light when photographing old structures, but with modern buildings, you can take advantage of sunny weather to show off the bold details and angular design. For mirrored buildings, reflections cast by nearby sculptures, passing clouds, and passing people can add interest.

Lens

In the Field: Canon EF 16-35mm f/2.8L USM lens set to 16mm. Here I was careful to have the camera at "eye level" with the middle of the wall and not tilt the camera up or down to help minimize wide-angle lens distortion. In this image, the frame edges maintained good detail despite the minimum zoom setting on the lens.

Additional Considerations: Zoom lenses are helpful in isolating only the architectural details you want while excluding extraneous objects such as street signs. If you use a wide-angle lens and want to avoid distortion, keep the camera on a level plane with the building and avoid tilting the camera up or down. Alternately, you can use a tilt-and-shift lens, or you can correct lens distortion in Adobe Photoshop. Very often with interior shots, you may have limited space to move back.

Camera Settings

In the Field: Aperture-priority AE (Av) mode RAW capture, with a custom white balance.

Additional Considerations: With mixed lighting, setting a custom white balance is my preference because it makes color correction during RAW image conversion easier and faster. Architectural shooting is one area where the 40D's 14-bit images deliver stunning detail with fine tonal gradation. To take full advantage of the 40Ds 14-bit images, shoot RAW images.

Exposure

In the Field: ISO 100, f/11, 1.3 sec., -1 exposure compensation, The negative exposure compensation on the camera balanced the exposure to maintain good details in the view through the window while the two Speedlites opened up shadow areas nicely.

Additional Considerations: In high-contrast range scenes, try multiple exposures using either bracketing or by metering and capturing separate exposures for highlights, midtones, and shadows, and then composite the images in Photoshop to get a greater dynamic range than the sensor can provide. If you use this technique, be sure to use a tripod and keep the camera in exactly the same position throughout the bracketed shots. Otherwise, the images will not register when you composite them in Photoshop.

Accessories

A polarizing filter is an excellent way to reduce or eliminate glare from glass and mirrored building surfaces. In addition, it also enhances color contrast.

Architectural photography tips

✦ **Emphasize color and lines.** If the building you're photographing features strong, vivid colors, emphasize the colors by shooting in bright midday sunlight. Find a shooting position that allows you to show off the dynamic lines and shapes of the building or interior.

✦ **Use surrounding elements to underscore the sense of place and space.** For example, a university building's design that incorporates gentle arches might be photographed through an archway leading up to the entrance. Or, if the area is known for something such as an abundance of dogwood trees, try including a graceful branch of blossoms at the top and side of the image to partially frame the structure. Keep surrounding elements to a minimum to avoid distracting from the subject.

✦ **Try A-DEP mode.** If your photograph shows a succession of buildings from an angle that puts them in a stair-stepped arrangement, use A-DEP mode to get the optimal depth of field.

✦ **For low-light and night exterior and interior shots, turn on Long-exposure noise reduction using C.Fn II-1.** Immediately after the initial exposure, the camera creates a dark frame to reduce noise. Using this feature slows down the shooting process, but it provides the best insurance against objectionable levels of digital noise in images. If you're shooting at a high ISO, you can also turn on High ISO speed noise reduction using C.Fn II-2.

 For details on setting Custom Functions, see Chapter 4.

✦ **Check out the American Society of Media Photographers (ASMP) Web site at** www.asmp.org. The ASMP has a special interest group for architectural photography that includes a guide for working with architectural photographers.

Business Photography

When given a choice between reading a business document that is a solid block of text or reading a business document that includes illustrative photos, most people choose the document with photos, and for good reason. Well-placed photos not only illustrate and explain the text, but they also lend credibility and interest.

Pictures also are often used for business logos which can be used in a variety of ways on business documents and carry over the business identity to Web sites and corporate publications. Photoshop offers a wide range of processing options to stylize image renderings for logo and corporate-identity images. Popular renderings include hand-coloring, sketch-type filters, and other artistic renderings.

9.7 Simple, graphic images, such as this image of colored pencils, can become the basis for logos and letterheads for designers or graphic artists. Exposure: ISO 100, f/18, 1/125 sec., using an EF 100mm f/2.8 USM lens with four Photogenic studio lights — two lighting the background, two strobes to camera left, and a large silver reflector to camera right.

Photography for businesses is not restricted to representing the company's branding, but it can also be used to communicate the personality and tenor of the business itself. With this application, the communication goals of the business or the art director must be clearly stated to produce successful images. For example, if a business prides itself on honesty and integrity, then the photography should communicate and underscore these values.

If you want to break into professional business photography, new and emerging companies offer great opportunities for paid assignments. For example, if you know a company that subcontracts to a larger, established-name company, the subcontractor may be looking for promotional images to build its own company name and brand. This is an excellent opportunity to help the company build its image and brand through imagery that you provide. Again, the key is to work with the principals in the company to clearly define the kinds of images that communicate the company's values and marketing thrust.

The area of business photography has a self-interest aspect as well. If you're just starting your photography studio or business, the images you make and choose to represent yourself are a good training ground and self-promotion for business photography.

Inspiration

If you work for a large company, then you can offer your services to photograph new employees; employee milestone events such as anniversaries and retirements; company parties and events; products or projects for internal or external newsletters; and new business or internal project proposals. You can also use pictures to illustrate employee-training materials.

If you are in sales, you can photograph customers with a product they purchased, and then use the image in thank-you promotion pieces such as calendars or cards. Small businesses can use and reuse product images for print and Web promotions, as well as for documenting processes such as product manufacturing.

Important aspects of business photography include getting clean, uncluttered images that show the subject, whether it is a person or a product, in compelling light. For small object backgrounds, you can use folding poster boards available at a craft store and set them up on a desk or conference table. For images of people and large objects, find a neutral-color wall with enough space to move the subject 5 to 6 feet away from the wall. This helps lessen dark background shadows if you use the built-in flash. Or, consider using a portable studio with multiple Canon EX-series Speedlites, light stands, and light modifiers, such as small softboxes and umbrellas.

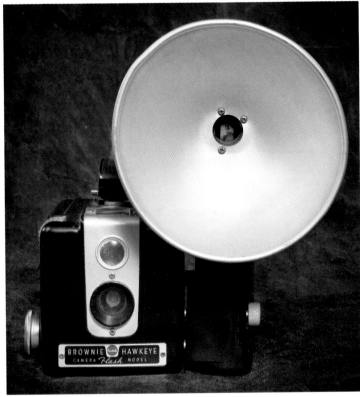

9.8 This antique camera is the cornerstone of my photography business identity. I've used a similar image with a white background on business cards, letterhead, and in my e-mail signature. Exposure: ISO 100, f/11, 1/125 sec., using an EF 24-70mm f/2.8L USM lens. Four Photogenic studio lights lit the scene with two strobes lighting the background, two strobes to camera left, and a large silver reflector to camera right.

Taking business photographs

9.9 The owner of a company that painted my home wanted new imagery for his business emphasizing clean, quality work. This is one of several conceptual images taken for the project.

Table 9.3
Business Photography

Setup	**In the Field:** When this project for a local painting company began, I researched the company's current imagery which was a stylized paint roller. Instead of replicating their existing image, I chose to use clean brushes with different bristle colors and a silver, reflective sweep for the base of the image to add reflections and depth to the image shown in figure 9.9.
	Additional Considerations: Simple setups and compositions are the best place to start with business images. You can't go wrong with white, black, silver, or gray backgrounds for small objects. Be sure to ask your clients if they need space at the top, bottom, or sides of the frame to insert text and other graphics, and then shoot accordingly.

Continued

Table 9.3 *(continued)*

Lighting	**In the Field:** Four Photogenic studio lights lit the scene with two strobes lighting the background, two strobes to camera left, and a large silver reflector to camera right. I dialed down the strobe output due to the reflective silver sweep used for the background. The silver reflective surface echoes the metallic colors of the brush wrappings. **Additional Considerations:** Watch for lighting that is contrasty and soften it by using a softbox on the main light. For a warmer effect, a gold umbrella or gold reflector on the right would be effective.
Lens	**In the Field:** Canon EF 100mm f/2.8 Macro USM lens. I started out using a 24-70mm lens, but couldn't get the composition that I wanted, particularly with reflections from the ceiling showing up on the silver background material. So I switched to the macro lens so that I could focus closely on the brushes and work around the overhead reflections. **Additional Considerations:** Your lens choice depends on the subject. For small objects, a normal lens is a good choice, such as the EF-S 60mm f/2.8 Macro USM. To control background detail, use telephoto to soften the background or a wide-angle lens for sharper details. If you photograph a group of objects or a production process, consider a medium wide-angle lens such as the Canon EF 24-70mm f/2.8L USM lens. For portraits, a short telephoto lens such as the Canon EF 100mm f/2.8 Macro USM is a good choice.
Camera Settings	**In the Field:** RAW capture, Manual mode with a custom White Balance. **Additional Considerations:** In the studio, you want to control the depth of field, so choose Aperture-priority AE mode and set the White Balance to match the temperature of the strobes.
Exposure	**In the Field:** ISO 100, f/18, 1/125 sec. **Additional Considerations:** In the studio, Manual mode and a flash meter provide the correct exposure settings, or you may already have a standard exposure for studio product shots that you can use. Outside the studio, set a narrow aperture, such as f/8 or f/16, if you want front-to-back sharpness for a scene of a manufacturing operation, for example. If the background is distracting, use a wider aperture such as f/5.6 or f/4. Given the excellent results through the ISO range on the 40D, you have flexibility in setting the ISO as the light demands.
Accessories	Silver reflectors are invaluable both in the studio and on location, especially if you have limited options for controlling existing light. Affordable silver reflectors come in a variety of sizes and fold up to fit in a small carrying pouch. My experience is that you can't have too many reflectors in the camera bag.

Business photography tips

✦ **Fill shadows.** If you're making a head-and-shoulders shot of a person, such as a new employee or a company executive, ask the subject to hold a silver reflector at waist level and tilt it to throw light upward slightly to fill in shadows created by overhead lighting. Ask the subject to adjust the reflector position slightly as you watch for the position that best fills shadow areas under the person's eyes, nose, and chin.

✦ **Adjust the setup for the photograph based on its intended use.** For example, if you're taking photos to use on a Web site, keep the composition and the background simple to create a photo that is easy to read visually when it is used in small image sizes on the Web. It's often necessary to brighten these small-size images slightly in an image-editing program for use on the Web.

✦ **Maintain the same perspective in a series.** In a series of photos, keep the perspective consistent throughout. For example, if you are photographing several products, set up the products on a long table and use the same lens and shooting position for each shot. Also keep lighting consistent through the series of shots.

✦ **Look at the colors as a group.** As you set up a photo, consider all the colors in the image. If they do not work well together, change backgrounds or locations to find a better background color scheme for the subject or use a neutral-colored background such as a white wall or a poster board.

✦ **Turn off the flash.** If you're photographing small objects, turn off the built-in flash. It is very difficult to maintain highlight detail at close working ranges using a flash. You can supplement light on the object with a desk lamp or an off-camera EX-series Speedlite, if necessary.

Editorial Photography

Many people think of editorial shooting as photojournalism and as a specialty that is reserved for working journalists. But the genre of editorial photography has been the style *du jour* for other specialties including weddings and high school senior photography for several years, although the style is evolving. The appeal lies in the documentary aspect of capturing life and events as they unfold. Editorial shooting has the essential element of the narrative — visually telling the story as it unfolds in real time with no posing, props, or fabrications.

Editorial style includes elements from other types of photography, including environmental portraiture, street, action and sports, and documentary, but with an emphasis on a visual narrative that often supports accompanying text.

Unlike with most photojournalism, editorial assignments can be planned, scouted ahead of time, and shot at a measured pace. Editorial shooting ranges from photographing

9.10 The images in figures 9.10, 9.11, and 9.12 were shot for a cover and liner for a Christian music CD featuring Jessie Butterworth and the Overlake Christian Church worship team. The goal was to capture the spirit and energy of the concert for the cover and illustrate the concert experience with images for the liner. This is an establishing shot of the overall concert stage with vocalists and musicians. Exposure: ISO 400, f/2.8, 1/20 sec., using an EF 70-200mm f/2.8L IS USM lens.

people, celebrities, concerts, and events to creating illustrative concept shots for feature articles on general interest topics, book covers, CD covers and liners, posters, and photo illustrations. The goal is to make images that define the spirit and character of the person or event — all without posing or staging the scene. To get defining shots, you need to understand the event or person, which means you need to be there, in position, and ready to shoot when each defining moment happens.

Editorial photographers may be assigned to produce the classic photo story comprised of a series of photos that tells the story of the person or event, or they may be asked to distill the essence of the story in one or two shots. Regardless of the assignment

and details, the 40D proves capable in virtually any light of giving fast response and fine image quality. If you're shooting on assignment, and if you post proofs on a Web site, then setting a RAW+JPEG capture option can save time by having ready-made JPEGs for Web posting.

Also for editorial shooting, I modify the Neutral Picture Style to parameters that I know will deliver good skin tones, a moderate tonal curve, and allow good latitude in processing RAW images and editing them in Photoshop. My settings are: +3 Sharpness; +1 Contrast, and +1 Saturation.

If you're new to editorial shooting and want to pursue this area, local newspapers and magazines are a good starting point. Also

check the *Photographer's Market*, a book published annually that lists contacts for magazines, book publishers, and stock agencies, for contact names and other editorial shooting opportunities.

Caution *The 40D is a durable camera, but it does not have the weather-sealing found in some higher-end cameras. Use caution when using the 40D repeatedly in inclement weather. However, if precautions are taken to keep it dry, the 40D will serve the editorial photographer well.*

Inspiration

Look for opportunities to hone your editorial shooting skills at local rallies, political gatherings, conventions, concerts, events, marches, protests, and elections. Often, you can find local events that allow you to polish your storytelling skills. Approach the shooting with the idea of giving viewers an inside look at the subject or event to make them feel what you felt and saw. Editorial shooting is closely related to documentary shooting, so look for subjects that reflect the times and the culture, and then tell that story.

Many photographers have broken into this field by spending hours of their personal time developing photo stories on subjects about which they are passionate with the hope they can later sell the photo story to a publication.

Tip *For the best of photographic storytelling, be sure to visit Brian Storm's Web site at* www.mediastorm.org. *Brian and his team won an Emmy for their compelling multimedia presentations of photographic storytelling.*

9.11 As with sports photography, editorial photography centers on telling a story that includes capturing the moment of high emotion, such as this moment of worship. Exposure: ISO 800, f/2.8, 1/60 sec., using an EF 70-200mm f/2.8L IS USM lens.

Taking editorial photographs

9.12 Another in the series of images with Jessie leading the music concert. Exposure: ISO 400, f/2.8, 1/50 sec., using an EF 24-70mm f/2.8L USM lens.

Table 9.4
Editorial Photography

Setup	
	In the Field: Shooting live events, such as the concert shown in figure 9.12, presents a unique set of challenges. I went to the rehearsal to make test shots and to talk to Jessie and the crew about their goals for the concert images. During the concert, access to the stage and dealing with variable stage lighting presented one set of challenges. Another challenge was working with three videographers who were shooting the live concert. I had to constantly check to see which video camera's red light was on, and then adjust my shooting positions so I wasn't featured in the video.
	Additional Considerations: For editorial shots, the goal is to accurately represent the subject and allowing enough time for subjects to overcome self-consciousness in having a camera pointed at them.

Lighting

In the Field: Stage lighting for this concert included overhead spot lights, gelled stage floor lights, and a panel of multicolored stage lights to the left and right of the stage. The twinkles in the background are the strings of twinkle lights that are the stage setup for the Illuminate service at Overlake Christian Church. The twinkle lights make a lovely backdrop and worked to my advantage.

Additional Considerations: In low-light scenes or indoors, if you're within the flash's range, you can use the built-in or an accessory flash (provided that flash photography is allowed and does not disrupt the proceedings). I've found that bounce flash with an accessory EX-series Speedlite is the most flattering light. If the ceiling is too high to produce a good exposure, you can bounce the flash off a nearby neutral-colored wall or off a silver reflector.

Lens

In the Field: Canon EF 24-70mm f/2.8L USM lens. During the concert, I alternated between this and the 70-200mm lens. No question about it, you have to take an adequate range of lenses for the assignment, so do careful advance planning and scouting.

Additional Considerations: A fast telephoto zoom lens, such as the Canon EF 70-200mm f/2.8L IS USM, is ideal for editorial shooting along with a wide-angle lens such as the EF 24-105mm f/4L IS USM or the EF 24-70mm f/2.8L USM. With a telephoto and wide-angle zoom lens, you can make portraits and get the overall context of the event or environment. For weather-related editorial pictures, a wide-angle lens is ideal so you can include the context of bad weather surrounding a person or group coping with the weather.

Camera Settings

In the Field: Aperture-priority AE (Av) using RAW capture. Because I was shooting RAW files, I could set the White Balance during RAW image conversion by clicking a white element in the photo. At concerts in particular, I find that the color of the stage lighting is best left pretty much as is; in other words, balancing the color to neutral takes away from the ambience of the event.

Additional Considerations: Always shoot at the highest resolution setting on the camera and maintain high resolution through the editing process so the image maintains maximum quality if the editor or client wants to use it in a large size.

Exposure

In the Field: ISO 100, f/2.8, 1/50 sec.

Additional Considerations: Use wide apertures of f/3.5 or f/2.8 to blur distracting backgrounds. If the background adds context to the scene, stop down to f/8 or f/11 if the ambient light levels allow. Be thankful for the 40D's outstanding performance through the range of ISO settings because in low-light venues, the only exposure options are to shoot wide open with a fast lens and crank up the ISO.

Editorial photography tips

✦ **If you're new to editorial shooting, study current feature-article images to get a feel for editorial shooting styles and flow.** Take time to carefully study photos in newspapers, news and consumer magazines, CD covers, posters, and Web photo stories to see how photographers encapsulate the defining moments details of photo stories.

✦ **Shoot for the publication's format.** Many magazines and publications run text and headlines across the image. Leave space at the top, bottom, and to one or the other side of the image so the designer can easily insert headlines, subheads, and text. If your work is for a print publication, shooting in a vertical format is a essential.

✦ **Capture the decisive and/or high-emotion moments.** Before you begin, think about what the decisive moment might be in the scene that you're shooting. Of course, as the scene develops, the decisive or iconic shot may change. Be prepared and anticipate events so you can be in a good position to capture the decisive moments.

✦ **Have plenty of power and storage.** Often, you can't tell how long an editorial shoot will last. For this reason, I recommend buying the accessory battery grip so you have battery power to last the duration and having several spare CF cards. I also have two CF card holders of different colors. As I fill cards from the green holder, I move them into a black CF card holder knowing that *black* means *exposed* in my system.

✦ **Get permission.** Be very cautious when photographing private events, and always ask the event organizers for permission to photograph the event. Never assume anything. A photographer in Seattle was arrested and detained for photographing police arresting a man on the street. Police later released him, but only after the ACLU got involved. The photographer was later awarded compensation for the wrongful arrest.

Macro Photography

Many people think about shooting flowers when they think macro photography. Certainly, few photographers can resist the temptation to photograph flowers, exotic plants, and gardens. But macro photography applications are much broader than subjects offered in nature. With any of Canon's macro lenses, you have the opportunity to make stunning close-up images of everything from

The enticements of macro subject composition include colors, the allure of symmetry and textures, intricate design variations, and descriptive details found in objects and the human form.

To explore these small worlds, a fine lineup of Canon macro lenses offer 1/2 , life-size, 5X magnifications. Each lens offers a different working distance from the subject, and with a good set of extension tubes, you can reduce the focusing distance of any lens to create dynamic close-up images. In addition, the Canon's Macro Twin Lite MT-24EX and the Macro Ring Lite MR-14EX provide versatile lighting options for small subjects.

Cross-Reference *Chapter 6 details Canon's macro lens line-up as well as extension tubes.*

9.13 The possibilities for close-up photography expand exponentially when you add an extension tube to any lens. This shot was taken in early sunset light with an 85mm f/1.2L II USM lens combined with a 12mm Kenko extension tube. Exposure: ISO 100, f/2, 1/500 sec.

stamps and water drops to jewelry and the weathered hands of a grandmother. At its best, macro photography is a journey in discovering worlds of subjects that are overlooked or invisible in non-macro photography.

Regardless of the subject, focus is critical in macro work. And at 1:1 magnification, the depth of field is very narrow. For my work, I maximize depth of field as much as possible by using a narrow aperture of f/16 to f/32, and, of course, a tripod and tripod head. In outdoor shooting, light can vary from bright to very low. This is where the Canon macro Speedlights come in handy and they also allow a low ISO which you need to get the finest detail and clarity. Macro focusing can be frustrating, so I often set the lens to the maximum focusing distance and move my position back or forward to achieve tack-sharp focus.

Inspiration

If you're shooting flowers, take the idea of anthropomorphism a step further by ascribing human characteristics to flowers, and see where it leads creatively. For example, asking questions such as how flowers handle the problem of overcrowding? For any macro subject, ask yourself how the subject relates to its surroundings, and consider how you can provide just a touch of environmental context in the shot given the very limited depth of field. Experiment with how you render the depth of field and use it in combination with subject position. For example, a picture of an insect coming straight at the lens at eye-level foreshortens the body and blurs the back of the body creating a sense of power that is disproportionate to the creature's size.

Macro lenses reveal the hidden structures and beauty of everything from flowers and insects to the wrinkles on a farmer's weathered face or hands. A single drop of water bouncing up from a pool, or the reflections of a garden in a water droplet on a flower petal, provide endless creative opportunities for macro images.

9.14 For this image, I used the power of the EF 100mm f/2.8 Macro USM lens to come in close on the ring. At this focusing level, every flaw in the subject is evident, as well as every detail. Exposure: ISO 125, f/18, 1/250 sec. A Photogenic strobe lit the background, and a second strobe placed low and to camera left lit the ring. A silver reflector to camera right provided fill light.

Taking macro photographs

9.15 This pinecone offered an opportunity to capture the repetitive patterns that occur so often in nature.

Table 9.5
Macro Photography

Setup	**In the Field:** The type of image shown in figure 9.15 works well in either an outdoor setting or in the studio. Given bad weather, this image was made in the studio with an eye toward setting the lighting to emphasize the patterns.
	Additional Considerations: Flowers, plants, insects, and other natural subject in outdoor light usually offer ready-made setup and lighting. If you don't have a garden, local nurseries and greenhouses offer plentiful subjects. Outdoors, you can take a low shooting position, and then shoot upward to use the blue sky as a beautiful backdrop. For indoor shooting of people, musical instrument details, and so on, side window light is often bright enough for shooting on a tripod. Otherwise, a Speedlite or studio system is a good option.
Lighting	**In the Field:** With small objects such as this pinecone, I used two Photogenic strobes: one to camera left, and another angled slightly behind and pointing toward the subject. My standard silver reflector filled shadows on the right.
	Additional Considerations: Outdoor light ranging from overcast conditions to bright sunshine are suitable for photos. Try using reflectors to direct light toward a small group or blossom. Macro Speedlites are a great option as well.
Lens	**In the Field:** Canon EF 100mm f/2.8 Macro USM lens.
	Additional Considerations: As detailed in Chapter 6, Canon offers excellent Macro lenses including the EF 180mm f/3.5L Macro USM, the EF-S 60mm f/2.8 Macro USM, and the venerable EF 100mm f/2.8 Macro USM.
Camera Settings	**In the Field:** Aperture-priority AE (Av) and RAW capture.
	Additional Considerations: Decide on the extent of the depth of field you want for the scene you're shooting, and then use Aperture-priority AE mode, camera-to-subject distance, and the lens choice to get the effect you envision.
Exposure	**In the Field:** ISO 100, f/14, 1/125 sec.
	Additional Considerations: Unless you want to use selective focusing, set a narrow aperture such as f/16 or f/22 to ensure maximum sharpness throughout the image when you're shooting close to the subject and use a tripod, beanbag, or mini-pod to stabilize the camera. This is also the time to use Mirror Lockup to prevent the slap of the reflex mirror from spoiling tack-sharp focus. Mirror Lockup can be used by enabling it in C.Fn III-7.
Accessories	A tripod is always a good precaution when you're taking macro shots and when using a telephoto lens. You can also buy plant holders to hold plants steady. These holders do not damage the plant and are inexpensive and small.

Macro photography tips

✦ **Enhance visual interest.** When photographing subjects with patterns, use a position that creates a strong diagonal line to create direction and motion in the composition.

✦ **Make the most of lighting.** If you want to emphasize depth in textured subjects, use strong side light that rakes across the subject. Or if you want controlled, focused light, you can fashion a modifier to reduce the breadth of light from a Speedlite. For example, one photographer fashioned a narrow "snoot" by using black electrical tape on a Speedlite to concentrate the light in a very specific, narrow beam for tiny subjects.

✦ **Maximize the area of acceptable focus.** To get the maximum acceptable sharpness throughout the frame, especially for small objects, shoot on a plane that is level with the subject. Any tilt of the lens will create blur quickly.

✦ **Watch the background.** The viewer's eye is drawn to the brightest area in the image, so it's important to avoid bright background highlights that distract from the subject. Some photographers use a handheld incident light meter to get precise exposure, although the Spot meter on the 40D is equally useful.

✦ **Take advantage of backlighting.** Many flower petals and plant leaves are transparent, and with backlighting, the delicate veins are visible. Watch for backlighting to create compelling and very graphic images of flowers and plants.

Nature and Landscape Photography

With breathtaking vistas of forests, mountains, and expanse of sky, God's handiwork remains an awesome wealth of photographic material for photographers. From dawn to dusk and sometimes beyond, nature provides an endless source of inspiration for lovely images. And you don't have to go far to find the next image. You can choose a single location and return week after week to take entirely different pictures. Seasonal changes to flora and fauna, passing wildlife, rain, sunshine, fog, and snow all contribute to nature's ever-changing canvas.

Photographing landscapes and nature requires high levels of both creative and technical skills to create compositions that are dynamic and evocative of the mood of the scene, and that adequately capture the extremes of light and shadow.

Tip *Speaking of exposure, the image histogram is a great tool for evaluating whether the camera has successfully captured detail in both light and dark areas. If the histogram shows pixels crowded against the left, right, or both sides of the histogram, the camera wasn't able to maintain detail in one or both areas. Filters, such as a graduated neutral-density (NDGrad) filter, can help balance the exposure for bright sky areas and darker foreground areas allowing the sensor to hold detail in both areas.*

9.16 From the simple to the complex, the exploration of nature is a lifelong journey of inspiration. I was struck by the simplicity and peace of this single blossom in early fall. Exposure: ISO 100, f/4, 1/1600 sec., using an EF 24-105mm f/4L IS USM lens.

9.17 Be inspired not only by the myriad of subjects in nature, but also by amazing light. Watch for the kind of light that spotlights the subject and defines highlights and shadows in a way that creates depth within the image. Exposure: ISO 160, f/5.6, 1/500 sec. using a Canon EF 24-105mm f/4L IS USM lens.

The challenge of outdoor photography is in capturing and conveying to the viewer the essence of a scene without the aid of chirping birds, the smell of clover, and the warm breeze of a late spring day. Compositional techniques including identifying a center of interest, using leading lines, framing, and other classic techniques help to convey the sense of grandeur and beauty that originally caught your eye.

The quality of light plays a starring role in nature photography. At sunrise and sunset you get singularly rich color, and the low angles of the sun create long shadows that add a sense of depth to landscapes. But also take advantage of the full range of atmospheric conditions, such as fog, which adds a sense of mystery; overcast light that enriches colors; and rain and dew that dapples foliage with fascinating patterns of water droplets.

For landscapes, you may want to try the Landscape Picture Style, which delivers vivid blues and greens and boosts image contrast and sharpness. If you're shooting JPEG images, the Picture Style is applied in the camera, but you can adjust the sharpness, contrast, color saturation, and color tone. If you're shooting RAW, you can apply the

Picture Style when you convert the image in Canon's Digital Photo Professional program. However, many photographers find that the Landscape Picture Style is over the top. I recommend using the Picture Style Editor with a sample RAW image; setting the color tone, saturation, and sharpness to your liking, and then registering the Picture Style in the camera.

Cross-Reference *For details on using and modifying Picture Styles, see Chapter 3.*

Inspiration

Choose a place that gives you a unique visual or emotional sense. For example, if you find a scene that exudes tranquility, try different positions, focal lengths, and foreground elements to help convey the sense of peace. As you take pictures, look both at the overall scene and the components that make it compelling. Isolate subscenes that make independent compositions or can be used as a center of interest for the overall scene.

As you look around, ask yourself questions such as whether including more or less of the sky will enhance the scene and the composition. Generally, a gray, cloudless sky adds no value to the image; in these conditions, including less of the sky is a better choice. Stormy skies, on the other hand, can add drama as well as beautiful color to outdoor images.

Watch for naturally occurring elements, such as an old wooden fence, a winding road, or a decaying archway to create classic compositions.

Taking nature and landscape photographs

9.18 Atmospheric conditions such as fog redefine the landscape lending a sense of both mystery and discovery.

Table 9.6
Nature and Landscape Photography

Setup	**In the Field:** In figure 9.18, patches of fog inspired me to capture this scene. I took the window screen off the window and hung out of an upstairs window to capture this foggy forest scene.
	Additional Considerations: Because such a wide variety of scenes is possible with landscapes and nature, the best advice is to trust your eye to set up and compose images. Try to exclude distracting utility wires, road signs, and trash within the scene. Shoot from a variety of low, high, and eye-level positions. For sweeping scenes, include a foreground object such as a person, a rock, or a fence to give a sense of scale. As you look through the viewfinder, consider how the elements in the frame will direct the viewer's eye in the final picture.
Lighting	**In the Field:** The late-afternoon overcast lighting reduced the dynamic range of this scene enough that the camera could capture detail in the highlights. During RAW conversion, I opened up shadows.
	Additional Considerations: A variety of lighting conditions is inherent in landscape and nature photography. Inevitably, the best light is during and just after or before sunrise and dawn when the low angle of the sun creates long shadows and enhances the colors of flora and fauna.
Lens	**In the Field:** Canon EF 70-200mm f/2.8L IS USM lens.
	Additional Considerations: Both wide-angle and telephoto zoom lenses are good choices for landscape and nature photography. For distant scenes, a wide-angle lens renders some elements too small in the frame. Use a telephoto lens to bring them closer.
Camera Settings	**In the Field:** Aperture-priority AE (Av) mode with white balance set to Cloudy, and then adjusted during RAW conversion.
	Additional Considerations: Because some landscape images look better with deeper color, you can set Exposure Compensation to -1/2 or -1/3 stop if you're shooting JPEGs. Just press the ISO-Exposure Compensation button on the LCD panel, and turn the Quick Control dial to set the amount of compensation you want.
Exposure	**In the Field:** ISO 100, f/8, 1/13 sec., using Image Stabilization on the 70-200mm lens.
	Additional Considerations: Use the lowest ISO possible to avoid digital noise. In most landscape and nature photos, extensive depth of field is the best choice. Meter for the most important element in the scene, and bracket to ensure the best overall exposure or to composite multiple images in an image-editing program.

Nature and landscape photography tips

✦ **Position yourself to take advantage of the sky as a backdrop.**
For pictures of foliage, flowers, and colorful seasonal trees, use a low shooting position and shoot upward if you have a deep blue sky as the backdrop for the subject.

✦ **Get extensive depth of field.** To get extensive depth of field, set the 40D to Aperture-priority AE mode, and choose a narrow aperture such as f/16 or narrower depending on the ambient light and whether you're using a tripod. Then focus the camera one-third of the way into the scene, lock the focus, recompose, and take the picture.

✦ **Don't always default to using a wide-angle lens.** Many people associate landscape photography with wide-angle lenses. However, telephoto lenses are indispensable in all types of outdoor photography, and they are very useful for isolating a center of interest in a wide-ranging vista.

✦ **When you shoot landscapes, include a person or a foreground object to help provide scale.** For example, to bring home the massive size of an imposing mountain range, include a hiker in the foreground or midground to give the viewer a scale.

✦ **Look for details that underscore the sense of the place.** A dilapidated fence or a rusted watering trough in a peaceful shot of a prairie helps convey how the land was used.

✦ **Look for interesting light.** For example, when you shoot in a forest or shaded area, look to include streaming shafts of light coming through the trees or illuminating a single plant.

✦ **Use Exposure compensation in scenes with large areas of light colors.** Large areas of light or white such as snow scenes or white sandy beaches can fool the camera meter into underexposing the image. To ensure that the snow or sand appears white in the final image, set Exposure compensation on the 40D to +1 or +2.

✦ **Look for different ways to frame the scene.** Try using a tree as a frame along one side of the frame or a break in the foliage that provides a natural window that reveals a longer view of the scene.

Night and Low-Light Photography

If you're ready to challenge your photography skills, shooting low-light and nighttime images is a great way to do it. Night and low-light images not only expand your

understanding of exposure, but they also open a new world of creative challenge, enjoyment, and the potential for lovely results. Some event assignments and stock photography also require you to shoot in low-light scenes and at nighttime, so having a good understanding of how to get good results without excessive digital noise is important.

Sunset and twilight are magical photography times for shooting of subjects such as city skylines, harbors, and downtown buildings. During twilight, the artificial lights in the landscape, such as street and office lights, and the light from the sky reach approximately the same intensity. This crossover lighting time offers a unique opportunity to capture detail in a landscape or city skyline, as well as the sky.

Low-light and night photos also offer a great opportunity to use Manual mode on the 40D. Sample starting exposure recommendations are provided in Table 9.7.

9.19 The great high ISO performance of the 40D opens the door to making dynamic low-light images with much less concern about obnoxious digital noise. Plus you can capture the play of light and raise the level of shadows without having to apply heavy noise reduction during image processing. Exposure: ISO 400, f/2.8, 1/45 sec., using an EF 70-200mm f/2.8L IS USM lens.

Table 9.7
Ideal Night and Low-Light Exposures

Subject	ISO	Aperture	Shutter Speed
City skylines (shortly after sunset)	100 to 400	f/4 to f/8	1/30 second
Full moon	100	f/11	1/125 second
Campfires	100	f/2.8	1/15 to 1/30 second
Fairs, amusement parks	100 to 400	f/2.8	1/8 to 1/60 second

Subject	ISO	Aperture	Shutter Speed
Lightning	100	f/5.6 to f/8	Bulb; keep shutter open for several lightning flashes
Night sports games	400 to 800	f/2.8	1/250 second
Candlelit scenes	100 to 200	f/2.8 to f/4	1/4 second
Neon signs	100 to 200	f/5.6	1/15 to 1/30 second
Freeway lights	100	f/16	1/40 second

Inspiration

Try shooting city skyline shots in stormy weather at dusk when enough light remains to capture compelling colors and the fearsome look of the sky. Busy downtown streets as people walk to restaurants, cafés, and diners; gasoline stations; widely spaced lights on a lonely stretch of an evening highway; the light of a ship coming into a harbor; or an outdoor fountain or waterfall that is lit by nearby streetlights are all potential subjects for dramatic pictures, as are indoor events such as concerts and recitals.

9.20 Sunset and sunrise qualify as low light, and certainly some of the most spectacular light of the day. This is one in a series of images made during a spectacular sunset on a Sunday evening while driving home. Exposure: ISO 125, f/4, 1/60 sec., using an EF 24-105mm f/4L IS USM lens.

Taking night and low-light photographs

9.21 The play of light across the stage spotlighted this guitar, and the background guitar repeats the theme of music.

Table 9.8
Night and Low-Light Photography

Setup	**In the Field:** The primary setup for figure 9.21 was simply to see the picture and then find a shooting position to give depth to the foreground guitar while having the background guitar at a dynamic angle to the foreground guitar.
	Additional Considerations: If you are photographing a busy outdoor area, find a location that is away from pedestrian traffic and is unaffected by the vibration of passing cars. Ensure your composition has a clear subject and isn't visually confusing by including too much in the frame. Be aware that passing cars and nearby lights can influence the camera's meter reading. You may need to wait for cars to pass, use the Spot meter, or use a handheld incident meter.
Lighting	**In the Field:** This image was taken in stage lighting with the guitar on the front edge of a spotlight. The placement of the guitar relative to the light allows light on the front of the instrument and behind to create a background spotlight.
	Additional Considerations: If you're shooting scenes with floodlit buildings, bridges, or other night scenes, begin shooting just after sunset so the buildings stand out from the surroundings. Check the image histogram on the LCD by pressing the INFO button twice or three times to display the histogram if you're in single-image playback mode.
Lens	**In the Field:** Canon EF 24-70mm f/2.8L USM lens.
	Additional Considerations: A wide-angle zoom lens set to 18mm or 24mm allows you to get a broad expanse of night and evening scenes. Telephoto lenses, of course, are great for bringing distant scenes closer, but at late sunset and at night, a tripod is a requirement especially if you use a long lens.
Camera Settings	**In the Field:** Aperture-priority AE with White Balance set to auto (AWB).
	Additional Considerations: Aperture-priority AE mode gives you control over the depth of field. If you can't stabilize the camera, you may want to use Tv mode and get a reasonable handholding shutter speed and make necessary adjustments to the ISO to achieve it. Low-light scenes are also an opportunity to use Mirror Lockup which you can enable using C.Fn III-7 and one of the Self-timer modes or a remote cable release. For outdoor low-light and night shooting, I also turn on Long Exposure Noise Reduction using C.Fn II-1.

Continued

Table 9.8 *(continued)*

Exposure	**In the Field:** ISO 400, f/2.8, 1/15 sec. (handheld)
	Additional Considerations: Just past sunset, you can usually rely on the meter to give a good exposure, but you may choose to bracket exposures at 1/2-stop intervals. However, if bright lights surround the scene, the meter can be thrown off. Use a lens hood and check the image histograms often in the LCD. To keep exposure time down, you can increase the ISO.
Accessories	A tripod or setting the camera on a solid surface is essential in low-light scenes.

Night and low-light photography tips

✦ **Be safe and use common sense.** Night shooting presents its own set of photography challenges, including maintaining your personal safety. Always follow safety precautions when shooting during nighttime. Be sure to wear reflective tape or clothing, carry a flashlight, and carry a charged cell phone with you.

✦ **Use a flashlight to focus.** If the camera has trouble focusing, train your flashlight on the subject long enough to focus manually or automatically, and then turn off the flashlight before you take the picture. You can also use the autofocus assist beam from the built-in flash without firing the flash using C.Fn III-5.

✦ **Use a level when using a tripod.** A small bubble level designed to fit on the hot shoe mount is an indispensable piece of equipment for avoiding tilted horizon shots.

✦ **Try the Self-timer mode.** You can, of course, negate the advantage of using a tripod by pressing the Shutter button with your finger causing camera shake and a noticeable loss of sharpness. A better solution is to use the Self-timer mode and Mirror Lockup.

Fireworks Photography

If you want to capture the rocket's red glare, you can use lenses in the range of 28-100mm. Choose an ISO from 200 to 400. Because the camera may have trouble focusing on distant bursts of light, you can prefocus manually on infinity and get good results. I also recommend using a tripod or setting the camera on a solid surface to ensure sharp images. If you want to keep it simple, you can set the camera to Full Auto and then just point and shoot.

If you want to have more creative control, you should know that capturing fireworks is an inexact science at best. I usually set the camera to ISO 200, use Manual mode, set the aperture to f/11 or f/16, and set the shutter on Bulb, which allows you to keep the shutter open as long as the shutter button is depressed. You can experiment to find the best time, usually between one and two seconds. Check the results on the LCD and adjust the time as necessary. The goal is to get a long enough exposure to record the full burst without washing out the brightest colors.

The different bursts of fireworks composited here were taken at ISO 200, f/11, 1/3 sec., with the Canon EF 70-200mm f/2.8L IS USM lens and a tripod. I merged them using Adobe Photoshop CS2.

Don't worry if you miss some good displays at the beginning of the fireworks show because the finale usually offers the best photo opportunities. During the early part of the display, get your timing perfected and be ready to capture the finale.

Pet and Wildlife Photography

Nothing gets an "awww" quicker than a cute pet or animal photo. Next to photographing people, pets and wildlife are some of the most appealing subjects in photography and can be a lucrative specialty area. And as with people photography, the goal is to convey the personality of the pet or animal. Of course, a major difference is that few if any pets and animals smile, so conveying the animal's mood hinges on eliciting its natural curiosity and interest, and then capturing the mood in the animal's eyes and

actions. In the wild, capturing animals interacting or in their environment going about their daily activities deliver the strongest images.

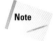

When you photograph pets and animals, keep the welfare of the animal in mind. Never put the animal in danger or expect more of the animal than it is capable of or willing to give.

If you're photographing pets, young, untrained pets and animals provide lots of appeal, but they are more challenging to work with because they don't respond to verbal commands. In these situations, give

9.22 There are few areas of photography more fun than pet photography. Photos can range from formal to comical. This is my miniature schnauzer who grew up in front of the lens and remains my best model. Exposure: ISO 100, f/11, 1/125 sec., using an EF 24-70mm f/2.8L USM lens.

9.23 Whether you're shooting birds or animals in the wild or in a more controlled setting such as this open area at a Las Vegas hotel, the 40D provides a wide dynamic range, which means there is more latitude even in contrasty light such as this to retain more highlight detail as well as good shadow detail. In addition to telephoto lens, medium-range zoom lenses such as the EF 24-70mm and the EF 24-105mm used for this image come in handy for animal and wildlife photography. Exposure: ISO 100, f/8, 1/60 sec.

the pet a large but confined area and go with the flow, using props, toys, and rewards to entice the behavior you want. Even with older pets that normally respond to verbal commands, don't be surprised if

their response is less predictable when you're photographing them. They can't see your face when it's behind the camera. Instead, establish eye contact with the pet as you set up the camera and talk to the animal, be patient, and offer rewards and verbal encouragement.

Animal preserves, zoos, and, of course, nature treks provide excellent wildlife shooting opportunities. If you go to a preserve, call the facility first because they can give useful tips on the best times to capture the animals. For example, a northwest animal preserve recommends visiting during overcast or rainy weather because the animals are out in the open more often than in sunny weather. Many preserves also have bird habitats including eagle and exotic bird areas. Resort hotels also often have animal and aquatic exhibits as well.

Inspiration

Photo opportunities with pets include any new experiences for the animal such as getting acquainted with another pet, the animal sleeping in odd positions or curled up with other pets, a pet watching out the window for kids to come home from school, racing after a ball or Frisbee, or performing in an arena. Local photo clubs and groups of photographers often organize annual trips during the best times to capture wildlife and birds such as eagles in your area. Check with a local camera store or on the Web to find upcoming treks and river trips. Also, providing plants, feeders, bird baths, and open area in your yard can attract a variety of birds for ongoing photo ops.

Taking pet and wildlife photographs

9.24 The challenge with this pet portrait was to maintain good separation between the black-and-silver miniature schnauzer and the black crinkle background.

Table 9.9
Pet and Wildlife Photography

Setup

In the Field: I set up black crinkle fabric on background stands in figure 9.24 and positioned the miniature schnauzer on the table about a foot in front of the background.

Additional Considerations: Indoor pictures are relatively easy to set up for small pets and animals. If you include a favorite toy, be sure that it doesn't obscure the pet's face. For outdoor wildlife shots, find open areas where grass or natural foliage can be the background. Be sure to focus on the animal's eyes.

Lighting

In the Field: Four studio lights were used for this image: two lights to light the background, a light in front of the schnauzer, and one to the left shooting into a silver umbrella. A large silver reflector to the right of the dog reflected light into the shadow side of the dog.

Additional Considerations: Indoors, you can use the basic lighting setup just described, or you can use the light from a nearby window. Outdoors, late-afternoon, and sunset light provide beautiful light for animal pictures.

Lens

In the Field: Canon EF 24-70mm f/2.8L USM. This lens offers excellent contrast and sharpness.

Additional Considerations: Your lens choice depends in part on whether you're taking a portrait or full-body picture and the size of the pet or animal. For large animals, the Canon EF 24-70mm f/2.8L USM or the EF 24-105mm f/4L IS USM lens is a good choice. For wildlife shooting, super-telephoto lenses are favored.

Camera Settings

In the Field: Aperture priority AE (Av), RAW capture, with a custom White Balance setting.

Additional Considerations: For outdoor pet portraits, Av mode allows you to control the depth of field, but in lower light and if the animal is fidgety, Shutter priority AE (Tv) mode may be the best choice to ensure the shutter speed is fast enough to prevent blur. If you're using a super-telephoto IS lens for bird or wildlife photography, be sure to study C.Fn III-2 options to setup the AF Stop button functions that best suit your shooting.

Exposure

In the Field: ISO 100, f/16, 1/125 sec.

Additional Considerations: If you use Aperture-priority AE (Av) mode, watch the shutter speed in the viewfinder to ensure it isn't slower than 1/30 second to avoid motion blur if the animal moves. In general, try to keep the shutter speed at 1/60 second or faster. If you fear the animal will move, increase the intensity of the lights or add more lights so you can use a faster shutter speed. Or you can increase the ISO to 200, or use a wider aperture, such as f/5.6.

Accessories

For more traditional portraits of pets indoors, use a tripod. Outdoors, a tripod may not be practical, so be sure the shutter speed is fast enough to prevent motion blur.

Pet and wildlife photography tips

✦ **In most cases, shoot from the pet's eye level.** Occasionally, a high shooting position is effective to show a young animal's small size, but generally you'll get the most expression when you are on the same eye level with the animal.

✦ **Do research.** If you're interested in photographing specific birds or wildlife, learn all you can about their habits and habitats, including feeding and mating behavior. For example, know what time of year that the birds are in breeding plumes. The more you know, the better prepared you are to capture unique shots and to maintain your safety.

✦ **Be patient.** It may take one or two days in an area to observe the habits of the indigenous wildlife.

Once you know the path they regularly take, set up the camera so that you blend with the background as much as possible, and with lighting that will fall on the animal and the background in mind. Then wait patiently for the animals to approach your area. Use a super-telephoto lens to isolate the subject while maintaining a sense of the natural context.

✦ **Use an extender.** If you don't have a super-telephoto lens, you can extend the range of your telephoto lens by adding an extender as detailed in Chapter 6 to extend the focal length of your telephoto lens by 1.4 or 2X.

✦ **Try other techniques.** Use the techniques described in the earlier sections that cover action and sports photography to photograph animals in action.

Portrait Photography

Portraiture is likely the most popular of photographic specialties, and people photography of all types can provide a steady source of revenue for professional photographers and aspiring professionals. Every photographer is ultimately drawn to a particular photographic specialty. For me, it's portraiture. Just as with the process of discovery involved in nature shooting, the process of discovering the spirit and spark of people and conveying it in images is a compelling and challenging endeavor. That doesn't mean that portraiture is easy, but it does mean that it is ultimately very rewarding.

The following sections detail some of the key considerations involved in portraiture.

Lens choices

For head and head-and-shoulders portraits, normal to medium telephoto lenses ranging from 35mm to 100mm are excellent choices. With an inherently shallow depth of field, telephoto lenses provide a lovely background blur that brings the subject forward in the image. For full-length and environmental portraits, a moderate wide-angle lens is a good choice, provided the subject is not close to the lens. Especially for environmental portraits, a wide-angle lens allows you to include the context of the environment while still making a good portrait of the subject.

9.25 This assignment image was made in an office with Phil in front of a bookcase. The lighting included diffuse window light from the front as well as an accessory 580 EX flash shooting into an umbrella to camera right. An assistant held a medium silver reflector low and to the left of the subject to lighten shadows on the left. Exposure: ISO 200, f/2.8, 1/15 sec., using a 24-70mm f/2.8L USM lens.

Backgrounds and props

In all portraits, the subject is the center of attention, and that's why a non-distracting or softly blurred background is important. Even if you have trouble finding a good background, you can de-emphasize the background by using a wide aperture such as f/4 or f/2.8 and moving the subject well away from the background. Conversely, some portraits benefit by having more background context. For example, when taking high school senior portraits, backgrounds and props that help show the student's areas of interest are especially popular. More extensive depth of field is the ticket for showing a star football player in the context of a football field.

Formal portraiture often incorporates more elaborate backgrounds and props particularly in studio settings. However, if you are just starting out, remember that a simple background and few or no props create fine portraits as well. Just remember the image is not about the background or the props. The image is first and always about the subject.

Lighting

Lighting patterns and ratios differ for portraits of men and women. For men and boys, strong, directional daylight can be used to emphasize strong masculine facial features. For women and girls, soft, diffuse light streaming from a nearby window or the light on an overcast day is flattering. To control light, you can use a variety of accessories including reflectors to bounce light into shadow areas and diffusion panels to reduce the intensity of bright sunlight. These accessories are equally handy when using the built-in or an accessory flash for portraits. For the best exposure, take a meter reading from the highlight area of the subject's face, use Exposure Lock, and then recompose and take the picture. In the studio, a flash meter serves well to determine the exposure under multiple strobes.

Flash Photography

The 40D's built-in flash offers good flash metering for both indoor and outdoor pictures particularly when set to E-TTL II with Evaluative metering. Even in backlit scenes, the FE Lock feature ensures the subject is not overexposed. The distance covered by the flash increases as the ISO increases. In other words, if you set the camera to ISO 200, the flash distance is greater than at ISO 100. Using the built-in flash is detailed in Chapter 8.

If you use an accessory flash, such as the Canon Speedlite 580EX II, buy a sync cord or flash bracket so you can position the flash unit farther away from the lens. With an accessory flash unit, you can also point the flash head toward a neutral color (or white) ceiling or wall to bounce the flash. The bounced light is diffused producing a much softer and more flattering light. You can use an accessory flash unit to fill shadows, stop action in lower-light scenes, and add a point of sharpness in panned shots.

Accessory flash

You often have more flexibility with lighting when you use an accessory flash. With accessory flash units, you can soften the light by bouncing it off a nearby wall or ceiling. You can also mount one or more accessory flash units on light stands and point the flash into an umbrella to create studio-like lighting results on location. Inexpensive flash attachments such as diffusers and softbox-like attachments are also a great option for creating nice portrait lighting.

> **Tip** *Use flash exposure compensation to dial back to the amount of light from the flash you want.*

The subject's eyes should have *catchlights*, or small, white reflections of the main light source — a 2 o'clock or 10 o'clock catchlight position is classic. Light also affects the size of the subject's pupils — the brighter the light, the smaller the pupil size. A smaller pupil size is preferable because it emphasizes the subject's irises (the color part of the eye), making the eyes more attractive.

Posing

Entire books are written on posing techniques for portraits. A quick guideline is that the best pose is the one that makes the subject look comfortable, relaxed, and natural. In practice, this means posing the subject in a comfortable position and in a way that emphasizes the attractive features while minimizing less-attractive features. Key lines are the structural lines that form the portrait. Posing the subject so that diagonal and triangular lines are formed by the legs, arms, and shoulders creates more dynamic poses. Also, placing the subject's body at an angle to the camera is more flattering and dynamic than a static pose with the head and shoulders squared off to the camera.

Rapport

Even if you light and pose the subject perfectly, a portrait can easily fail if you haven't connected with the subject. Your connection with the subject is mirrored in the subject's eyes. Every minute you spend building a good relationship with the subject pays big dividends in the final images. In short, building a relationship with the subject is the single most important step in creating meaningful portraits.

Direction

Portrait subjects are most often self-conscious in front of a camera. Even the most sparking personalities can freeze up when the lens is pointed in their direction. To ease their anxiety, you have to be a consummate director, calming them, gently guiding them into the spirit of the session, and providing positive feedback on their performance. Very often instead of describing how I want a person to sit or stand, I step onto the set and demonstrate what I have in mind. Subjects catch on immediately and add their own interpretation.

Inspiration

Before you begin, talk to the subject about his or her interests. Then see if you can create setups or poses that play off of what you learn. Consider having a prop that the subject can use for inspiration and improvisation. Alternately, play off the subject's characteristics. For example, with a very masculine subject, use angular props or a rocky natural setting that reflects masculinity.

9.26 I had a fan set to a low setting blowing toward Chelsie. The direction of her arm and hair, and the tilt of her head help to create a sense of energy. Diffuse window light lit the left side of the face. An assistant held a silver platter (a makeshift reflector) to subject right to fill shadows and add catchlights to the eyes. Exposure: ISO 160, f/2.8, 1/30 sec., using an EF 50mm f/1.4 USM lens.

When photographing younger subjects, be sure you're up on the latest fashion shooting trends and styles. For inspiration and ideas, browse the latest newsstand magazines and music CD covers.

Taking portrait photographs

9.27 Portraits such as this put the subject in the context of their environment. In this case, Chelsie is a first-year college student, so having her in the context of studying was natural.

Table 9.10
Portrait Photography

Setup	**In the Field:** For figure 9.27, Chelsie is studying for an exam in a well-lit game room of a home. The backlighting from the door glass behind the subject was problematic. I knew when I was shooting that I'd have to process the RAW image twice and composite the two to maintain detail in the bright door window glass.
	Additional Considerations: Uncluttered and simple backgrounds are effective for making the subject stand out from the background. If you don't have white paper or a large white poster board, use a plain, neutral-color wall, and move the subject four to six feet from the background. In a studio setting or with unmodified flash, moving the subject away from the background and lighting the background separately helps reduce or eliminate background shadows. Keep poses simple and straightforward; allow the subject to assume a natural position, and then tweak the pose for the best effect.
Lighting	**In the Field:** The lighting consisted of indirect light from a large window across the room and in front of the subject and backlighting from double doors behind the subject. There was also overhead tungsten light.
	Additional Considerations: If you do location shooting, you can use multiple accessory flash units and a wireless transmitter to simulate studio or natural light effects. Otherwise, you can use window light alone or in combination with a silver reflector or two; for example, use one reflector to reflect window light onto shadow areas of the background and one to fill shadows on the subject.
Lens	**In the Field:** Canon EF 24-70mm f/2.8L USM lens set to 58mm.
	Additional Considerations: Most photographers prefer a focal length of 85mm to 105mm for portraits. Canon offers a variety of zoom lenses that offer a short telephoto focal length, such as the EF 24-105mm f/4L IS USM and the EF 70-200mm f/2.8L IS USM lenses. Another lens to consider for excellent contrast in portraits is the renowned Canon EF 50mm f/1.4 USM lens (equivalent to 80mm on the EOS 40D).
Camera Settings	**In the Field:** Aperture Priority AE (Av) mode with a custom White Balance.
	Additional Considerations: In the field, you want to control depth of field for portraits, and Aperture-priority AE mode gives you the most control.

Continued

Table 9.10 *(continued)*

Exposure	**In the Field:** ISO 160, f/1.4, 1/250 sec. To recover highlight detail in the background door glass, I processed the image twice — once for the highlight detail and once for the subject. Then I composited the images in Photoshop. The super-wide aperture brings the eyes to the forefront and gives a gentle softness to the skin and hair. **Additional Considerations:** Avoid digital noise in shadow areas, particularly on portraits — choose the lowest ISO possible. To get a depth of field that ensures facial features that are reasonably sharp, set the aperture to f/5.6 or f/8, depending on your distance from the subject and the ambient light.
Accessories	A tripod is a necessity for many portraits, although it limits your ability to move around the subject quickly to get different angles. If the light permits, shooting off the tripod frees you to try more creative angles and shooting positions.

Portrait photography tips

✦ **Prepare a list of poses or setups ahead of time.** People often feel uncomfortable posing for the camera. Having a list of poses or setups minimizes setup changes, and you can move through the pose list with good speed.

✦ **Flatter the subject.** For adults, ask the subject to lift his or her head and move it forward slightly to reduce the appearance of lines and wrinkles. Watch the change to see if the wrinkles are minimized. If not, adjust the pose further.

✦ **Use natural facial expressions.** It's always nice if the subject smiles, but portraits in which the subject has a contemplative, peaceful, or pleasant look can be equally effective.

✦ **Pay attention to hands.** If the shot includes the subject's hands, you can minimize the appearance of veins by asking the subject to hold the hands with the fingers pointed up for a few minutes before you begin shooting.

✦ **Frame the subject.** As a general rule, keep the subject's head in the upper one-third of the frame.

✦ **Focus on the eyes.** Always focus on the subject's eye that is nearest to the camera.

✦ **Always be ready to take a shot.** When a good rapport is established between you and the subject, be ready to shoot spontaneously even if the setup isn't perfect. A natural, spontaneous expression from the subject is much more important than futzing to get a perfect setting.

✦ **Take several frames of key poses.** It's entirely possible that something will be amiss with one or more frames. If you take only one picture, you won't have a backup shot of important poses.

✦ **Keep up the chitchat.** Keep up a steady stream of conversation that includes friendly directions for adjusting poses. Friendly chitchat helps put the subject at ease and allows a natural way for you to provide direction during the session.

Stock Photography

At some point, almost everyone who has more than a passing interest in photography toys with the idea of making money from his or her images. And for those who do, their short list of ideas includes stock photography near the top. Stock photos fill the pages of popular newsstand magazines and brochures and grace posters in public places and billboards along the highways. Stock photography refers to existing images available for licensing by clients including advertising agencies, corporations, magazines, book publishers, and others. Stock images can be marketed by individual photographers, photographer cooperatives, or by stock photo agencies.

With more than 1,000 stock photography agencies and organizations to choose from — ranging from the leaders such as Getty and Corbis to grass-roots organizations such as Photographers Direct — it stands to reason that you can tap into additional income ranging from a few hundred or a few thousand dollars a year to a six-figure income.

Stock agencies market the work of many photographers. It negotiates with and finalizes licensing rights with clients, collects payment, and subsequently pays the photographer a percentage of the licensing price. The percentage split between the photographer and the agency varies, but a common split is 50/50: 50 percent to the photographer and 50 percent for the agency. In turn, the agency takes over marketing and licensing tasks which gives photographers

9.28 Cultural themes such as the graying of America and the lifestyle of that segment of the population are good fodder for stock images such as this couple waiting for Sunday church services to begin. Exposure: ISO 400, f/2.8, 1/20 sec., using an EF 70-200mm f/2.8L IS USM lens.

more time to make pictures. And with the potential to license a single image multiple times, a photo marketed by an agency or cooperative can provide a continuing source of income for months or even years.

Stock represents a potentially lucrative way to reuse existing imagery and a creative way to market new imagery. Currently, the hottest trends in stock photography are for lifestyle images that run the gamut of subject areas from dining to outdoor activities and sports.

Many agencies have a minimum resolution for stock images and ranges from 8" ×10" at 300 dpi to 11" × 14" at 300 dpi. Some stock agencies allow for upsampling to increase native resolution of images to larger printing sizes. If you're new to stock shooting, check the agency requirements for resolution.

Inspiration

Over the years, major stock agencies have acquired thousands of images, which means they now have more specific subject needs. For photographers shooting on assignment or for pleasure, it pays to consider potential stock use as you work. For example, if you're shooting landscape images, you may veer slightly to shoot roads leading up to the area because advertising agencies often look for scenic road shots into which they can drop the car of their client later.

Conceptual shooting is also a good area to consider. Themes such as *single, breaking up*, and the *tranquility of a spa* are examples of recent stock requests for existing imagery.

9.29 Simple, everyday subjects, such as this egg in a carton, are often overlooked as good subjects for stock photography. Exposure: ISO 100, f/2.8, 1/80 sec., using an EF 100mm f/2.8 Macro USM lens.

Taking stock photographs

9.30 Images like this one can be used to illustrate concepts such as the hurried pace of everyday life, time, speed, or a metropolitan theme.

Table 9.11
Stock Photography

Setup	**In the Field:** For the image in figure 9.30, the only setup I used was to be in place to capture the bus as it entered the scene near the clock on the building.
	Additional Considerations: For stock studio shots, white backgrounds are useful because clients often need to replace the background with a color or other background that fits their needs. Leaving space in the image composition for buyers to insert text and other graphics is also advisable.
Lighting	**In the Field:** This image was taken in late-afternoon light. The mirrored surface of the building and the shaded area combine to give the image an overall cool palette, which also fits the concept of speed and a rushed schedule.
	Additional Considerations: Bright, clean images are preferred by buyers, although stylistic variations can set your images apart from the multitudes of stock images.

Continued

Table 9.11 *(continued)*

Lens	**In the Field:** Canon EF 16-35mm f/2.8L USM lens.
	Additional Considerations: Your lens choice depends on the scene you're shooting and your distance from it. Use a telephoto zoom lens to bring distant scenes closer and a wide-angle lens to capture breathtaking sweeps of landscape.
Camera Settings	**In the Field:** Aperture Priority AE (Av) mode, RAW capture mode using Daylight White Balance.
	Additional Considerations: Control the depth of field by choosing Aperture-priority AE mode. If the light is low, switch to Shutter-priority AE (Tv) mode. Be sure to set the White Balance to match the type of light in the scene.
Exposure	**In the Field:** ISO 100, f/10, 1/20 sec. The slow shutter speed allowed me to capture the blurred motion of the bus entering the scene, which is what I wanted.
	Additional Considerations: Shoot many variations of stock images including some with extensive depth of field and some with selective focus.

Stock photography tips

✦ **Study existing styles.** The quality of stock imagery is some of the best available on the market. Minimum expectations are excellent exposure, composition, and subject matter. Agencies look for a personal style that sets imagery apart from the mass of images they have on hand. Study the images offered by top stock agencies, and determine how well you can match and do better than what's currently being offered.

✦ **Captions and keywords.** Photographers are responsible for providing clear and accurate captions. In fact, some buyers and photo researchers make go and no-go decisions based on caption accuracy and completeness.

✦ **Build a sizable portfolio.** Most stock photo agencies expect potential photographers to have a substantial body of work — images numbering in the hundreds if not thousands.

✦ **Image content and marketability.** Agencies look for a creative edge, if not creative genius, that makes images stand out. The standout quality is, of course, judged through the dispassionate eye of a photo editor — someone who reviews hundreds of images from polished photographers every day and can quickly cull pedestrian images from star performers. Make your images stand out technically and creatively.

Travel Photography

The 40D is lightweight, small, fast, and extremely versatile, making it ideal for use when traveling. With a set of compact zoom lenses and plenty of memory cards, you'll have everything you need to take high-quality shots to document your travels.

Before you begin a trip, clean your lenses, check that the image sensor is free of dust, and ensure the camera is in good working condition. Have spare batteries and memory cards. If you're traveling by air, check the carry-on guidelines on the airline's Web site and determine if you can carry the camera separately or as part of your carry-on allowance. An advantage of being a digital photographer is there's no worry about film being fogged by the X-ray machines.

Tip *Be sure to check the latest Transportation Security Administration (TSA) regulations on how many spare camera batteries that you're allowed to carry. The regulations recently changed for lithium batteries. Spare batteries must be placed in see-through, sealable bags, and carried in carry-on luggage. For more information, check the TSA Web site at* `www.tsa.gov/travelers/airtravel/assistant/batteries.shtm.`

Another pre-trip task is to research the destination by studying brochures and books to find not only the typical tourist sites, but also favorite spots of local residents. When you arrive, you can also ask the hotel concierge for directions to popular local spots. The off-the-beaten-path locations will likely be where you get some of your best pictures.

©*Peter Bryant*

9.31 Color is a primary draw for this shot of an alley in Puerto Rico, and the scene is enhanced with careful and effective composition techniques. Exposure: ISO 200, f/9, 1/125 sec., using an EF 28-300mm f/3.5-5.6L IS USM lens.

Here are some additional tips for getting great travel pictures:

✦ **Research existing photos of the area.** At your destination, check out the postcard racks to see what the often-photographed sites are. Determine how you can take shots that offer a different or unique look at the site.

✦ **Include people in your pictures.** To gain cooperation of people, always be considerate, establish a friendly rapport, and show respect for individuals and their culture. If you do not speak the language, you can often use hand gestures to indicate that you'd like to take a person's picture, and then wait for their positive or negative response.

✦ **Waiting for the best light pays big dividends.** Sometimes this means you must return to a location several times until the weather or the light is just right. Once the light is right, take many photos from various positions and angles.

Inspiration

If the area turns out to have a distinctive color in the scenery or in architecture, try using the color as a thematic element that unifies the images you take in that area. For example, the deep burnt-orange colors of the southwest U.S. can make a strong unifying color for vacation images.

Watch for details and juxtapositions of people, bicycles, and objects with backgrounds such as murals and billboards. Also watch for comical or light-hearted encounters that are effective in showing the spirit of a place.

9.32 If the weather fails to cooperate, include other elements in the image that help define the characteristics of the location. For example, Seattle is known for its abundance of large and beautiful lakes. This image shows the skyline from across Lake Washington with people enjoying a stroll across the pier with seagulls surrounding them. Exposure: ISO 100, f/8, 1/60 sec., using an EF 70-200mm f/2.8L IS USM lens.

Taking travel photographs

©Peter Bryant

9.33 Architecture is a compelling component of travel images such as the lovely tower shown here in Puerto Rico.

Table 9.12
Travel Photography

Setup	**In the Field:** For the picture shown in figure 9.33, the objective was to find a shooting position that allowed the photographer to capture the tower and the street lamps that are characteristic of the area.
	Additional Considerations: In many cases, you want to choose locations that are iconic, or classic, and try different positions, angles, or framing to show the location to give a fresh perspective on a well-photographed area. Include people in your images to provide an essence of the location. Narrow the scope of your image so that you present a clear story or message. Always ask permission to photograph local people.

Continued

Table 9.12 *(continued)*

Lighting	**In the Field:** The photographer made great use of a sparkling blue sky as the backdrop for the pastel colors in this scene showing the local architecture.
	Additional Considerations: Inherently, light for travel photos runs the full range. The trick is to know when to shoot and when not to shoot. Ask yourself if the existing light is suited for the subject. If it isn't, wait for the light to change or come back at a different time of day when the light is more appealing. If there isn't a chance of waiting for better light, then minimize the amount of sky in the frame and include iconic foreground elements that define the locale.
Lens	**In the Field:** Canon EF 28-300mm f/f/3.5-5.6L IS USM lens.
	Additional Considerations: Your lens choice depends on the scene you're shooting and your distance from it. Use a telephoto zoom lens to bring distant scenes closer and a wide-angle lens to capture large scenes such as festivals and fairs or to include environmental context for people shots.
Camera Settings	**In the Field:** Aperture-priority AE (Av) mode. The White Balance was set to Daylight.
	Additional Considerations: To control the depth of field, choose Aperture-priority AE mode and set the White Balance to the type of light in the scene.
Exposure	**In the Field:** ISO 200, f/8, 1/400 sec.
	Additional Considerations: Set the ISO as low as possible given the existing light. If you're photographing people of the area and they are the subject of the image, then use a wide aperture such as f/5.6 to blur the background without making it unreadable. Watch the shutter speed in the viewfinder to make sure it isn't so slow that subject or hand motion doesn't spoil the picture.

Travel photography tips

✦ **Guard your equipment.** Digital cameras are a target for thieves. Be sure to keep the camera strap around your neck or shoulder and never set it down and step away. This sounds like common sense, but you can quickly get caught up in activities and forget to keep an eye on the camera.

✦ **Use reflectors.** Small, collapsible reflectors come in white, silver, and gold, and they are convenient for adding light to shadow areas. Reflectors take little space and are lightweight.

✦ **Carry only the equipment you need.** You want to ensure you have the gear you need and still have your camera bag pass airline requirements for carry-on luggage. A good multipurpose lens, such as the EF 28-300mm f/3.5-5.6L IS USM lens or the EF 100-400mm f/4.5-5.6L IS USM are ideal for travel.

Wedding Photography

Today's wedding photographer is likely to be an ace at applying a photojournalistic shooting style coupled with a dash of fashion and glamour shooting — all mixed with a little traditional portraiture for good measure. For some of the top wedding photographers, the goal of every wedding is to produce fine-art imagery that will stand on their own years from now as classic photos.

Creating time-tested, artistic photos is a lofty goal for a shooting specialty that can be marked with the height of human stress compressed in a small but charged container of time and space. Wedding photography holds the potential for every

heart-stopping disaster that can happen in photography from malfunctioning gear to a missing or inebriated bride or groom.

Despite any wedding or equipment snafus, the wedding photographer has to put on a smiling face and roll with the flow. And the bulk of wedding work for the photographer happens after the couple has flown away to an exotic location for their honeymoon. It's then that the images are processed and edited, the first-cut selections are created, and the proof books are compiled. Many wedding photographers laugh when people assume they work only on weekends because they know that not only do they put in 6- to 12-hour days every weekend, but they also spend days and weeks afterward sorting and preparing images for the couple to review.

9.34 Ceremony images are often the most treasured in the wedding album. Getting a good shooting position where you can capture the emotion without disrupting the ceremony is vital. Exposure: ISO 200, f/2.8, 1/50 sec., using a Canon EF 24-70mm f/2.8L USM lens.

Inspiration

Following the advice of top wedding photographers such as Meg Smith, you want to make every wedding image strong—not just as a wedding image in the traditional sense, but as a strong photograph that can stand alone. As with other specialty areas, when it comes to wedding photography, you want to think through your photographic voice and style. You also want to come up with ways you can incorporate themes into the wedding that tie in with the decorations or the couple's interests.

9.35 Wedding post-celebration events offer the opportunity for capturing lots of candid moments, such as this couple as they relax after the ceremony and begin the reception festivities. Exposure: ISO 250, f/2.8, 1/350 sec., using an EF 70-200mm f/2.8L IS USM lens.

Taking wedding photographs

9.36 While not every wedding photographer shoots wedding formal portraits, many brides expect and want formal shots such as this one of the entire wedding party.

Table 9.13
Wedding Photography

Setup	**In the Field:** Figure 9.36 is one of the formal shots where color helps form the lines created in the image to provide good eye direction and movement through the subjects.
	Additional Considerations: Before the ceremony begins, scout out shooting positions and leave a note or object on a seat to reserve it. Some couples do not want the ceremony photographed and others want it photographed but without the use of flash. Be sure you know the couple's wishes and requirements before the ceremony begins. After the ceremony, ensure that you or the wedding coordinator rounds up the wedding party and family members for pictures before they leave for the reception.
Lighting	**In the Field:** Interior stage lighting with a variety of spotlights and floodlights provided the light for the images taken inside the church at this wedding.
	Additional Considerations: Work out in advance which areas are large enough and well-lit enough to accommodate the entire wedding party and family shots. Outdoor receptions can be a challenge, particularly with dappled light filtering through trees. Just watch the light falling on the subjects' faces and move as necessary to avoid hot spots, especially on the face.
Lens	**In the Field:** Canon EF 24-70mm f/2.8L USM.
	Additional Considerations: Your lens choice depends on the scene you're shooting and your distance from it. At a minimum, have a sharp, fast telephoto and wide-angle lens with at least two 40Ds or another backup camera body.
Camera Settings	**In the Field:** Aperture-priority AE (Av) mode using RAW capture.
	Additional Considerations: You want to control the depth of field, so choose Aperture-priority AE mode and set the White Balance to the type light in the scene.
Exposure	**In the Field:** ISO 200, f/3.5, 1/50 sec.
	Additional Considerations: In some wedding venues, sections of the wedding — such as the ceremony, the dinner, and the dance — occur in lighting that is constant for the duration of the event. As a result, you can often set the exposure and shoot with it throughout the event, unless you want to change the depth of field for specific images.
Accessories	Having a tripod handy is a good idea for wedding photos, but a tripod limits your ability to move quickly, and it requires more shooting space that may not be readily available. A monopod is another good option. And with the 40D, you can increase the ISO to 400 or higher and still get images without objectionable digital noise.

Wedding photography tips

✦ **Look at the big picture, and understand what you are getting into.** If you're new to wedding photography, it's important to understand that the wedding day requires almost constant shooting in a variety of areas and with a wide variety of people. The work continues long after the wedding is over; you spend a considerable amount of time processing and selecting images and making prints and albums. In short, wedding photography is a huge job and an equally huge responsibility.

✦ **Always have backup gear.** At a minimum, two camera bodies are necessary. Some wedding photographers also carry duplicate lenses and flash units so they can keep shooting regardless of breakdowns. Renting spare camera bodies, lenses, flash units, and tripods is often the most economical strategy for new wedding photographers.

✦ **Plan for the worst.** Ask exhaustive questions ahead of time such as whether the church or location allows flash or whether the couple wants flash for certain parts of the wedding festivities. If the wedding is outdoors, ask what alternate location the couple will use if the weather turns bad, and plan for lighting in both locations. The list of questions is almost endless, but preplanning pays big dividends on the day of the ceremony.

✦ **Hone your amateur psychologist skills.** You may need to be a good amateur psychologist as well as a good photographer, especially when dealing with disgruntled or divorced parents or an unhappy bride.

Completing
the Picture

Working with RAW Capture and Updating Firmware

Most digital photographers are familiar with RAW capture, but for those who aren't, the advantages of RAW capture can't be overstated. RAW capture is the gold standard for creating images that provide all that the 40D image sensor offers. Equally important, RAW capture is the gateway to greater creative expression and control over the final image.

Characteristics of RAW Images

RAW capture allows you to save the data that comes off the image sensor with virtually no internal camera processing. Because the camera settings have been noted but not applied in the camera, you have the opportunity to make changes to key settings such as image brightness, white balance, contrast, and saturation after the image is captured. The only camera settings that the camera applies to a RAW image are ISO, shutter speed, and aperture. During RAW image conversion, you can make significant adjustments to exposure, color, and contrast. In addition to the RAW image data, the RAW file also includes information, called *metadata*, about how the image was shot, the camera and lens used, and other description fields.

RAW capture mode offers advantages that are akin to traditional film photography. For example, in some cases, you can push digital RAW exposures during shooting with a slight overexposure, and then recover highlight detail during RAW conversion. The ability to push an exposure can, of course, make a noticeable difference in low-light shooting when you need to handhold the camera.

An important characteristic of RAW capture is that it offers more latitude and file stability in making edits than is possible with a JPEG file. With JPEG images, large amounts of image data are discarded when the images are converted to 8-bit mode, and then the image data is further reduced when JPEG algorithms compress image files to reduce the size. As a result, the image leaves precious little, if any, wiggle room to correct tonal range, white balance, contrast, and saturation during image editing. Ultimately, this means that if the highlights are blown, then they're blown for good. If the shadows are blocked up, then they will likely stay blocked up. It may be possible to make improvements in Photoshop, but the edits make the final image susceptible to posterization or banding that occurs from stretching a tonal range causing gaps between tonal levels.

Cross-Reference *See Chapter 1 for a more detailed explanation of bit depth.*

On the other hand, RAW images with rich data depth allow far more image data to work with during conversion and subsequent image editing. In addition, RAW files are more forgiving if you need to recover highlight detail. Table 10.1 illustrates the general differences in file richness between a RAW image and a JPEG image from a typical digital SLR camera. Note that Table 10.1 assumes a 5-stop dynamic range, the difference between the lightest and darkest values in an image, for an exposure.

These differences translate directly to editing leeway. And having a good amount of editing leeway is important because all image editing after RAW conversion is destructive.

Proper exposure is important with any image, and it is no less so with RAW images. With RAW images, exposure is important in part because it pertains to the distribution of brightness levels in the linear capture. Linear capture can be contrasted with how the human eye adjusts to differences in light levels. When we go from one room to another room that is twice as bright, our eyes automatically compress the differences in light so we don't perceive the difference to be twice as bright, but only brighter. The camera is linear — it makes no such distinctions and does not compress differences. Rather, the camera works in linear fashion by simply counting photons hitting the sensor. It records the tonal levels exactly according to the number of photons captured. If a camera uses 14-bits to encode the captured image to produce 16,384 tonal levels, then level 8,192 is half the total number of photons recorded. The levels correspond exactly to the number of photons captured. Stated another way, linear capture represents a one-to-one correspondence, whereas nonlinear human vision does not represent a one-to-one correspondence.

A good RAW image exposure ensures that the camera captures the maximum number of brightness levels that the 40D can deliver. During conversion, tonal mapping, or gamma encoding, assigns linear tonal levels to perceived brightness—resulting in an image that resembles what we saw with our eyes. Without going into detail of gamma encoding, it's important to know that digital capture devotes a relatively large number of image pixels to highlights and far fewer to shadows, as shown in Table 10.1. As you can see, the first f-stop of brightness accounts for half of all the tonal levels in the image.

This characteristic has implications for traditional exposure guidelines. For example exposing for the shadows sacrifices half or more of the possible levels of brightness that the camera can capture. At the same time, underexposure captures relatively few dark levels. If you subsequently brighten the image during editing, the limited number of levels must be redistributed across the tonal spectrum.

Visualize this process as a rubber band being stretched. As the band is stretched, small holes analogous to breaks between tonal levels appear. This stretching creates gaps between tonal levels that show up as posterization in the final print. In addition, underexposure magnifies noise in the shadow areas. This is shown on a histogram in Photoshop as gaps between tonal levels resembling a comb. When tonal levels are compressed, the histogram shows them as spikes.

The general rule for RAW capture is to expose for the highlights and develop for the shadows. The common technique is to expose to the right so that the highlight pixels just touch the right side of the histogram. Thus, when tonal mapping is applied during conversion, the file has significantly more bits that can be redistributed to the midtones and darker tones where the human eye is most sensitive to changes. If highlights are overexposed, programs such as Adobe Camera Raw can recover one or more f-stops of highlight detail.

Table 10.1
Comparison of Brightness Levels

F-stop	Brightness Levels Available	
	12-bit RAW file	**8-bit JPEG file**
First f-stop (brightest tones)	2048	69
Second f-stop (bright tones)	1024	50
Third f-stop (midtones)	512	37
Fourth f-stop (dark tones)	256	27
Fifth f-stop (darkest tones)	128	20

Choosing a RAW Conversion Program

RAW image data is stored in proprietary format, which means that the RAW images can be viewed and converted using the camera manufacturer's RAW conversion program, such as Canon's Digital Professional Pro conversion program, or a third-party RAW conversion program such as Adobe's Camera Raw plug-in or Adobe Lightroom, or Aperture.

Unlike TIFF and JPEG files, RAW files cannot be moved from computer to computer with the assurance that any operating system can display them. That means you must first convert RAW files to a more universal file format or verify that clients have an operating system and conversion program that allows them to display RAW images before you hand off images to clients or customers. RAW image handoff is gradually becoming a part of the handoff.

Tip *Images captured in RAW mode include unique filename extensions such as .CR2 for Canon 40D RAW files.*

10.1 This figure shows Canon's Digital Photo Professional's main window with the toolbar for quick access to commonly accessed tasks.

10.2 Adobe presents images in Bridge, and from Bridge or Photoshop you can open RAW images in Adobe Camera Raw for conversion.

Although RAW conversion programs continue to offer more image-editing tools with each new release, you won't find some familiar image-editing tools in RAW conversion programs, such as healing, history brushes, or the ability to work with layers in the traditional sense. Most conversion programs rightly focus on basic image conversion tasks, including white balance, exposure, shadow control, brightness, contrast, saturation, sharpness, noise reduction, and so on.

Choosing a RAW conversion program is a matter of personal preference in many cases. Canon's Digital Photo Professional (DPP) is included with the 40D, and

updates to it are offered free. Third-party programs, however, often have a lag time between the time the camera is available for sale and the time the program supports the new camera. For example, there was a lag time of several weeks between when the 40D was available and the time when Adobe Camera Raw was updated to support 40D files. In the interim, photographers use the Canon conversion program.

Note *Canon also includes a Picture Style Editor on the disk that comes with the camera. This program is a great way to set up a Picture Style that works well for RAW capture. For details on the Picture Style Editor, see Chapter 3.*

Arguments can be made for using either the manufacturer's or a third-party program. The most often cited argument for using Canon's program is that because Canon knows the image data best, it is most likely to provide the highest quality RAW conversion. On the other hand, many photographers have tested the conversion results from Canon's program and Adobe's Camera Raw plug-in, and they report little difference in conversion quality.

Assuming there is parity in image-conversion quality, the choice of conversion programs boils down to which program offers the ease of use and features that you want and need. Certainly Adobe has years of experience building feature-rich programs for photographers within an interface that is familiar and relatively easy to use. Canon, on the other hand, has less experience in designing features and user interfaces for software.

10.3 This figure shows the RAW image adjustment controls in Canon's Digital Photo Professional. Note that you can apply a Picture Style after capture.

Because both programs are free (provided you have Photoshop CS3), you should try both programs and any other conversion software that offers free trials. Then decide which one best suits your needs. I often switch between using Canon's DPP program and Adobe Camera Raw. When I want to apply a Picture Style from Canon to a RAW image, I use DPP. For most everyday processing, however, I use Adobe Camera Raw as a matter of personal preference.

Another consideration when you are choosing a program is which program offers the most and best batch features. Canon's DPP allows you to apply conversion settings from one photo to others in the folder, as does Adobe Camera Raw.

Whatever conversion program you choose, be sure to explore the full capabilities of the program. Remember also that one of the advantages of RAW conversion is that as the conversion programs improve, you have the opportunity to go back to previous RAW image files and reconvert them using the improved conversion program.

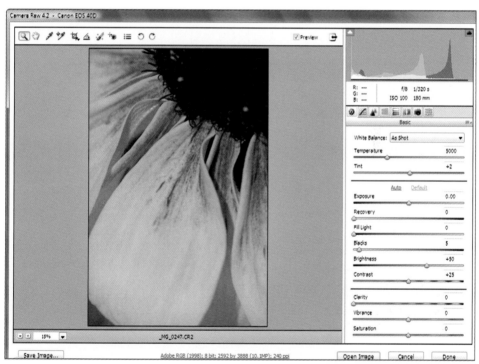

10.4 This figure shows the Adobe Camera Raw dialog box opened to the Adjust tab where color, exposure, tone, contrast, and saturation adjustments are made.

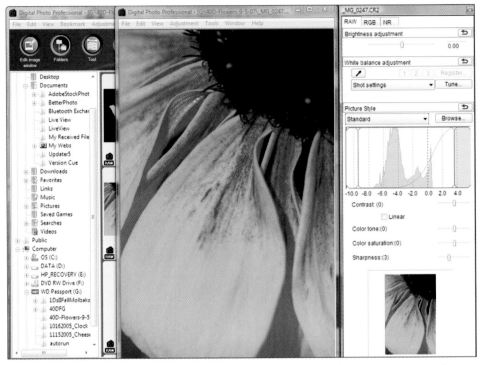

10.5 This figure shows adjusting the black point in Canon's Digital Photo Professional RAW conversion window.

Sample RAW Image Conversion

Although RAW image conversion adds a step to the processing workflow, this important step is well worth the time spent processing images. To illustrate the process, here is a high-level task flow for converting a 40D RAW image using Digital Photo Professional.

1. **Start Digital Photo Professional.** The program opens. If no images are displayed, you can select a directory and folder using the left-hand panel. RAW images are marked with a camera icon and the word RAW in the lower left of the thumbnail.

2. **Double-click the image you want to process.** The RAW image adjustment tool palette opens to the right of the image preview. In this mode, you can:

- Drag the Brightness slider to tweak the brightness to a negative or positive setting.

- Use the White Balance adjustment controls to adjust color. You can click the Eyedropper button, and then click an area that is white in the image to set White Balance, choose one of the preset White Balance settings from the Shot Setting drop-down menu, or click the Tune button to adjust the White Balance using a color wheel.

- Choose a different Picture Style by clicking the down arrow next to Standard and selecting a Picture Style from the list. The Picture Styles are the same as those offered on the menu on the 40D. When you change the Picture Style in DPP, the thumbnail updates to show the change. You can adjust the curve, color tone, saturation, and sharpness. If you don't like the results, you can click Reset to change back to the original Picture Style.

- Adjust the black and white points on the image histogram by dragging the bars at the far left and right of the histogram toward the center. By dragging the slider under the histogram, you can adjust the tonal curve.

- Adjust the Color tone, Color saturation, and Sharpness by dragging the sliders. Dragging the Color tone slider to the right increases the green tone and dragging it to the left increases the magenta tone. Dragging the Color saturation to the right increases the saturation and vice versa. Dragging the Sharpness slider to the right increases the sharpness.

3. **Click the RGB image adjustment tab.** Here you can apply a more traditional RGB curve and apply separate curves in each of the three color channels: Red, Green, and Blue. You can also adjust the following:

 - Drag the Brightness slider to the left to darken the image or to the right to brighten the image. The changes you make are shown on the RGB histogram as you make them.

 - Drag the Contrast slider to the left to decrease contrast or to the right to increase contrast.

 - Drag the Color tone, Color saturation, and Sharpness sliders to make the appropriate adjustments.

4. **In the Preview window, choose File ⇨ Convert and Save.** The Convert and Save dialog box appears. In the dialog box, you can set the bit depth at which you want to save the image, set the Output resolution, choose to embed the color profile, or resize the image. You can also click the down arrow next to Save as type and choose 16-bit TIFF or TIFF 16-bit and Exif-JPEG format, or you can choose 8-bit Exif-JPEG and TIFF formats.

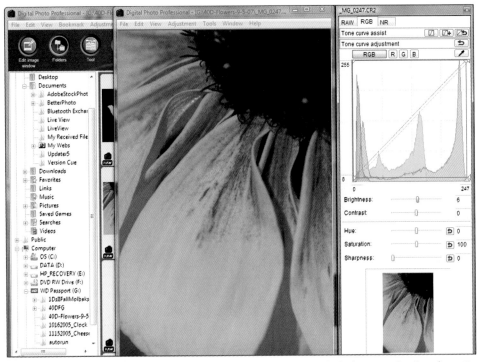

10.6 This figure shows adjusting the brightness in Canon's Digital Photo Professional RAW conversion window.

Tip *The File menu also enables you to save the current image's conversion settings as a recipe. Then you can apply the recipe to other images in the folder.*

5. **Click Save.** DPP displays the Digital Photo Professional dialog box until the file is converted. DPP saves the image in the location and format that you choose.

Creating an Efficient Workflow

When workflow became a buzzword several years ago, it typically encompassed the process of converting and editing images

one at a time or several at a time. Since then, however, the concept of workflow has expanded to include the process from image capture to client handoff, often including prepress settings, that ensures image quality and consistent settings that meet the client's needs and specifications.

While workflow varies depending on your needs or the requirements of the client, here are some general steps to consider as you create your workflow strategy.

✦ The first workflow step for many photographers is backing up original images to a separate hard drive or to a DVD. Whether you do this step now or later, it's a critical aspect of any workflow.

✦ Batch file renaming allows you to identify groups of images by subject, assignment, location, date, or all of these elements. Programs such as DPP and Adobe Bridge offer tools for batch renaming that save time in the workflow.

✦ Create a standard IPTC template that has your name, address, phone number, and other important information about the image that is appended to the image metadata. Then you can choose Tools ⇨ Append Metadata in Adobe Bridge to apply the template to all the images in a folder.

✦ Select images and name files consistently. Regardless of whether you're shooting RAW or JPEG images, programs such as Adobe Bridge and Digital Photo Professional provide tools to rate images and then sort them to display top-rated images to process.

✦ If you're processing RAW images, you can open the selected images in groups or all at once for conversion, depending on the RAW conversion program you're using. In some programs, you can select similar images, process one image, and then apply all or part of that image's conversion settings to similar images. Then you can save the images or open them in Photoshop for additional editing.

✦ If you create JPEG versions of the images for client selection on your Web site, you can use a batch action in Photoshop to make and automatically size images for the Web and save the images in a separate subfolder.

✦ If your workflow includes client selection, you can create subfolders for selected images and move unselected images to a subfolder. If you maintain a main database of your images, this is a good time to add JPEG versions of the images to the database. A good practice is to maintain tracking sheets of images that you update during each stage of the process of handing off images to clients, or for your own records for personal images.

✦ Registering images with the Copyright Office protects the copyright to your images and is an important part of the workflow. You can create a 4 × 6-inch contact sheet with approximately 12 images per sheet of the images that you want to register. Be sure to leave space on the contact sheet to add your name and contact information.

Tip *The copyright gives you the right to control use of your images for your lifetime plus 70 years. The annual fee for bulk image registration is provided on the Copyright Web site at* www.copyright.gov/register/visual.html. *For additional information on registering copyrights visit* www.editorialphoto.com/copyright/.

✦ With the final selections made, you can do the final image processing in Photoshop according to the client's specifications.

✦ When the final images are ready, you can burn a DVD or send the images by FTP to the client. Also create a DVD for your personal archives. Having a fire-safe and flood-safe place to archive hard drives and DVDs is important. Some photographers have a safety deposit box or other off-site location for storage.

The steps you incorporate into your workflow often depend on whether you're shooting for clients or for personal work, but these broad suggestions provide an overview of steps that you can consider for your workflow.

Updating the 40D Firmware

One of the greatest advantages of owning a digital camera such as the 40D is that Canon often posts updates to the firmware (the internal instructions) for the camera to its Web site. New firmware releases can add improved functionality to existing features and, in some cases, fix reported problems with the camera.

New firmware along with ever-improving software keeps your camera and your ability to process images current as technology improves. To determine if you need to update firmware, just compare the firmware version number installed on your 40D to the latest release from Canon on its Web site.

Getting the latest firmware and software

Before you begin, check the current firmware version installed on your camera and then write down the version number. To check the installed firmware version number, follow these steps:

1. **Press the Menu button.**

2. **Press the Jump button to access the Set-up 3 menu.**

3. **Rotate the Quick Control dial until you see the Firmware Ver., and then write down the number.** If the firmware installed on your camera is older than the firmware offered on the Web site, then your camera needs the firmware update.

Now you can check to see if the latest firmware version available on the Canon Web site is more current than the version installed on your 40D. To check Canon's latest firmware, go to usa.canon.com/consumer/controller?act=ModelInfoAct&tabact=DownloadDetailTabAct&fcategoryid=314&modelid=15653. Scroll down to the Firmware section and compare the version number with the version number installed on your 40D. If the Canon version number is higher than what's installed in your 40D, you need to update the firmware.

Tip Canon does not publically announce new firmware releases on its Web site. But Rob Galbraith does make announcements when new firmware is released. You can check www.robgalbraith.com periodically for the latest firmware update announcements.

Before you begin installing a firmware update, be sure that you have the following:

✦ **A fully charged camera battery installed in the camera.** Alternately, you can use the AC Adapter Kit ACK-E2 to power the camera. If the camera loses power during the firmware update, it can become inoperable.

✦ **A freshly formatted CompactFlash (CF) card on which to copy the firmware update.** Alternately, you can connect the camera to your computer with a USB cable, and then copy the firmware file onto the CF card in the camera.

To download updated firmware and install it on the 40D, follow these steps:

1. **Insert the CF card in a card reader attached to your computer.**

2. **On your computer, go to the Canon download site at** usa.canon.com/consumer/ controller?act=ModelInfoAct& tabact=DownloadDetailTabAct& fcategoryid=314&modelid= 15653.

3. **Click the arrow next to Select OS, and select your computer's operating system.**

4. **Scroll to Firmware, and then verify that the version available on the Web site is newer than the version installed on your 40D.** If the firmware version number listed on the Canon Web site is newer, continue to the next step.

5. **Click the firmware version text link.** At this writing, the text link reads, eos40d-firmware-e.html. A license agreement appears.

6. **Click I Agree – Begin Download.** The EOS 40D Digital Web site opens in a separate window with descriptions of what improvements the new firmware version includes, along with firmware installation instructions.

7. **Scroll to the bottom of the page and click the I agree and download button.**

8. **Under Files for Firmware Update, click the link that matches your computer's operating system.**

9. **Click Run if a File Security dialog box appears. If a window appears saying that Publisher cannot be verified, click Run.** A window appears notifying you that this is a self-extracting file.

10. **Click OK.** A self-extracting archive window appears.

11. **Click Browse, navigate to the CF card location, and then click OK.** The self-extracting archive window is displayed again.

12. **Click OK.** A progress window appears with the firmware file name displayed. On the CF card, the firmware appears at the top level as file with a .fir extension.

13. **Insert the CF card into the camera and close the CF card door.**

14. **Press the Menu button, and then press the Jump button until the Setup 3 (yellow) menu appears.**

15. **Turn the Quick Control dial to highlight Firmware Ver., and then press the Set button.** The Firmware update screen appears.

16. **Turn the Quick Control dial to highlight OK, and then press the Set button.** The Firmware update program screen appears. Then a Replace Firmware screen appears listing the new firmware version number.

17. **Press the Set button.** A Firmware update program confirmation screen appears. The screen displays the currently installed firmware version number and the new version number.

18. **Turn the Quick Control dial to highlight OK, and then press the Set button.** The screen updates to display a progress bar. Do not press any buttons, turn off the camera, or open the CF Card Slot door during installation. When the update is complete, a Firmware update program screen appears saying the update is complete.

19. **Press the Set button to complete the firmware update.** The LCD goes black, and the camera is ready for shooting.

Image Sensors and the Canon DIGIC Processor

A P P E N D I X

◆ ◆ ◆ ◆

In This Appendix

Sensor technology

DIGIC III image processor

◆ ◆ ◆ ◆

As Canon's ongoing research and development continues to refine camera features, Canon has progressively applied new and improved technologies throughout its camera lineup. As a result, photographers can rely on a consistently high level of quality, and this is certainly true in the EOS 40D.

An understanding of both the sensor technology and the internal processor is beneficial to better understand the camera and the image files that it produces.

Sensor Technology

The 40D features a Canon-produced CMOS (Complementary Metal Oxide Semiconductor) image sensor. While Canon isn't the only camera manufacturer that uses CMOS sensors, it is the only company, at the time of this writing, that produces and markets full-frame, 35mm-size image sensors. Canon is also one of the few companies that designs and manufactures its sensors in-house for all of its digital SLRs.

EOS 40D Specifications

Type of camera

Type: Digital AF/AE SLR

Recording media: CF Card Type I and II and external media (USB v.2.0 hard drive, via optional Wireless File Transmitter WFT-E3A)

Image sensor size: 0.87 x 0.58 in./22.2 x 14.8mm (APS-C size sensor)

Canon EF, EF-S, TS-E, and MP-E lenses

Lens mount: Canon EF mount

Lens focal length conversion factor: 1.6x

Image sensor

Type: High-sensitivity, high-resolution, single-plate CMOS sensor

Effective pixels: Approx. 10.10 megapixels

Total pixels: Approx. 10.50 megapixels

Aspect ratio: 3:2 (Horizontal : Vertical)

Color filter system: RGB primary color filters

Low-pass filter: Fixed position in front of the CMOS sensor

Dust delete feature: (1) Self-Cleaning Sensor Unit, (2) Dust Delete Data, (3) Manual Sensor Cleaning

Recording system

Recording format: DCF 2.0 (Exif 2.21): JPEG, RAW, and RAW+JPEG simultaneous recording possible. Multiple options for recording images on a memory card, and onto compatible external USB hard drives (via optional Wireless File Transmitter WFT-E3A)

File size on CF card: (1) JPEG/Large: Approx. 3.5MB (3888 x 2592), (2) JPEG/Medium: Approx. 2.1MB (2816 x 1880), (3) JPEG/Small: Approx. 1.2MB (1936 x 1288), (4) RAW: Approx. 12.4MB (3888 x 2592), (5) sRAW: Approx. 7.1MB (1936 x 1288)

File numbering: (1) Continuous numbering (2) Auto reset (3) Manual reset (the image numbering is reset to 0001, a new folder is created and selected automatically)

Color space: Selectable between sRGB and Adobe RGB

Picture Style: Six preset Picture Style settings plus three user-defined custom Picture Style settings with individual adjustments for Sharpness, Contrast, Saturation, Color tone; Filter effect, Toning effect for black and white images

White balance

Settings: Auto, Daylight, Shade, Cloudy, Tungsten Light, White Fluorescent Light, Flash, Custom WB setting, user-set Color Temperature (2500~10,000K) Auto White Balance: Auto white balance, taken from imaging sensor

Color temperature compensation: White balance bracketing: Three consecutive files written from one exposure: Up to +/- 3 levels in 1-step increments; White balance shift: blue/amber bias and/or magenta/green bias +/- 9 levels; manually set by user

Viewfinder

Type: Eye-level SLR with fixed pentaprism

Coverage: Approx. 95% horizontally and vertically

Magnification: 0.95x (-1 dpt with 50mm lens at infinity)

Eyepoint: Approx. 22mm

Dioptric adjustment correction: -3.0 to +1.0 diopter

Mirror: Quick-return half mirror (Transmission: reflection ratio of 40:60)

Viewfinder information: AF (AF points, focus confirmation light), Exposure (shutter speed, aperture, ISO speed, AE lock, exposure level, spot metering circle, exposure warning), Flash (flash ready, flash exposure

compensation, high-speed sync, FE lock, red-eye reduction light), Image (monochrome shooting, maximum burst, white balance correction, CF card information)

Depth-of-field preview: Enabled with depth-of-field preview button; possible in Live View Function

Autofocus

Type: TTL-CT-SIR AF-dedicated CMOS sensor

AF points: 9 cross-type AF points (f/2.8 at center)

AF working range: EV -1 ~18 (ISO 100 at 73°F/23°C)

Focusing modes: Autofocus (One-Shot AF, Predictive AI Servo AF, AI Focus AF), Manual Focus (MF)

AF-point selection: Automatic selection, Manual AF-point selection

AF-assist beam: Intermittent firing of built-in flash

Exposure control

Metering modes: 35-zone TTL full aperture metering: (1) Evaluative metering (linked to all AF points), (2) Partial metering (approx. 9% of viewfinder), (3) Spot metering (approx. 3.8% of viewfinder), (4) Center-weighted average metering

Metering range: EV 0–20 (ISO 100 at 73°F/23°C with EF 50mm f/1.4 USM lens, ISO 100)

Exposure control systems: Program AE (shiftable), Shutter-priority AE, Aperture-priority AE, Auto Depth-of-field AE (non-shiftable), Full auto (non-shiftable), Programmed image control modes, Manual exposure, E-TTL II autoflash program AE

ISO speed range: Equivalent to ISO 100–1600* (in 1/3-stop or whole-stop increments), ISO speed can be expanded to ISO 3200 (* Standard output sensitivity. Recommended exposure index)

Exposure compensation: Exposure Compensation (user-set): +/-3 stops in 1/3- or 1/2-stop increments
AE lock: Auto: Applied in One-Shot AF mode with evaluative metering when focus is achieved; **Manual (user-set):** By AE lock button in all metering modes

Shutter

Type: Vertical-travel, mechanical, focal-plane shutter with all speeds electronically controlled
Shutter speeds: 1/8000 to 30 sec. (1/3-stop increments), X-sync at 1/250 sec.
Shutter release: Soft-touch electromagnetic release
Self-timer: 10 sec. delay, 2 sec. delay
Remote control: Canon N3 type terminal

Built-in flash

Type: Auto pop-up, retractable, built-in flash in the pentaprism
Guide Number: 43 (feet)/13 (meters) at ISO 100
Recycling time: Approx. 3 sec.
Flash-ready indicator: Flash-ready indicator lights in viewfinder
Flash coverage: 17mm lens focal length (equivalent to 27mm in 35mm format)
Flash metering system: E-TTL II autoflash
Flash exposure compensation: +/-2 stops in 1/3- and 1/2-stop increments

Drive system

Drive modes: Single, silent, high-speed continuous (approx. 6.5 fps), low-speed continuous (approx. 3 fps), 10- or 2-sec. self-timer
Continuous shooting speed: Approx. 6.5 fps (in One-Shot AF and AI Servo AF modes)

Max. burst during continuous shooting: JPEG: approx. 75 frames (Large/Fine); RAW: approx. 17 frames (both during high-speed continuous shooting)

LCD monitor

Type: TFT color, liquid-crystal monitor
Monitor size: 3.0 in.
Pixels: Approx. 230,000 pixels
Coverage: Approx. 100%
Brightness control: 7 levels provided

Playback

Image display format: Single image, 4-image index, 9-image index, Jump, Magnified zoom (approx. 1.5x to 10x), Histogram, AF-point display, Auto rotate, Rotate
Live View function: View image before shooting on LCD monitor; live histogram and live simulation of exposure level possible with C.Fn IV-7-1
Highlight alert: In the single image display and (INFO) display, overexposed highlight areas will blink

Image protection and erase

Protection: Single image or all images in the memory card can be protected or cancel the image protection
Erase: Single image, select images, all images in a CF card or unprotected images
Direct printing from the camera: Enabled with the Print/Share button
Compatible printers: CP and SELPHY Compact Photo Printers, PIXMA Photo Printers and PictBridge compatible printers (via USB Interface Cable IFC-200U, included with camera kit)
Settings: Print quantity, style (image, paper size, paper type, printing effects, layout), trimming, tilt correction

Menus

Menu categories: (1) Shooting (2) Playback (3) Setup (4) Custom function/My Menu

LCD monitor languages: 18 (English, German, French, Dutch, Danish, Portuguese, Finnish, Italian, Norwegian, Swedish, Spanish, Greek, Russian, Polish, Simplified/Traditional Chinese, Korean, Japanese)

Power source

Battery: One dedicated Battery Pack BP-511A; AC power can be supplied via the optional AC Adapter Kit ACK-E2

Number of possible shots: Normal shooting: approx. 1,100 shots (approx. 800 shots with 50% flash use) at 73°F/23°C; Approx. 950 shots (approx. 700 shots with 50% flash use) at 32°F/0°C. Tests comply with CIPA test standards.

Battery check: Automatic

Power saving: Provided. Power turns off after 1, 2, 4, 8, 15, 30 min.

Backup battery: One CR2016 lithium battery. Battery life approx. 5 years

Dimensions and weight

Dimensions (W) × (H) × (D): 5.7 × 4.2 × 2.9 in./145.5 × 107.8 × 73.5mm

Weight (body only): 26.1 oz./740g

Operating conditions

Operating temperature range: 32–104°F/ 0–40°C

Operating humidity range: 85% or less

Professional Resources

A wealth of valuable information is available for photographers. This appendix is a handy resource to help you learn more about the EOS 40D and about photography in general.

Internet Resources

Canon Digital Learning Center

The Canon Digital Learning Center Web site (`www.usa.canon.com/dlc/controller?act=HomePageAct`) is a rich resource that includes an introduction to and information on the EOS 40D.

Canon

When you want to access the technical specifications for the camera or if you want to register your camera online, visit the Canon Web site at `www.usa.canon.com/consumer/controller?act=ModelInfoAct&fcategoryid=139&modelid=15653`.

EOS SLR

To learn more about the EOS SLR systems, visit the Canon Advantage page at `www.consumer.usa.canon.com/ir/controller?act=CanonAdvantageCatIndexAct&fcategoryid=111`.

Firmware

Visit this site to download new firmware updates for the Canon EOS 40D, and click the Drivers & Downloads tab. On the Canon site, the Download Library includes an option to download the setup guide and camera manual in English,

Spanish, French, or Chinese. You can visit the Download Library at www.usa.canon. com/consumer/controller?act=Model InfoAct&fcategoryid=139&model id=15653#DownloadDetailAct. Look at the Firmware section on this page for a link to the license agreement and latest firmware.

Accessories

When you want accessories for the 40D, the Canon Accessory Annex offers everything from AC adapters, battery grips, and battery packs to macro ring lights. You can find the Accessory Annex at www.estore.usa. canon.com/default.asp.

Lenses

You can get information on Canon lenses at www.consumer.usa.canon.com/ir/ controller?act=ProductCatIndexAct&f categoryid=111.

Photography Publications and Web Sites

Some of the popular photography Web sites and print magazines offer informative photography articles. Here are a few of the venerable photography Web sites.

Photo District News. www.pdnonline.com

Communication Arts. www.commarts. com/CA/

Digital Photo Pro. www.digitalphoto pro.com

The Digital Journalist. http://digital journalist.org

DP Review. www.dpreview.com

Imaging Resource. www.imaging-resource.com

Popular Photography & Imaging. www.popphoto.com

Shutterbug. www.shutterbug.net

Digital Image Café. www.digitalimage cafe.com/default.asp

PC Photo. www.pcphotomag.com

Digital Photographer. www.digiphoto mag.com

Outdoor Photographer. www.outdoor photographer.com

Rob Galbraith. http://robgalbraith. com/bins/index.asp

Steve's Digicams. www.steves-digicams.com

Professional Organizations

A variety of professional organizations offer support and training for photographers. Here is a selection of some of the most respected organizations by category.

Commercial

Advertising Photographers of America. www.apanational.org

Editorial/Photojournalism

American Society of Media Photographers. www.asmp.org

Editorial Photographers. www.editorial photographers.com

National Press Photographers Association. www.nppa.org

Fine art

College Art Association. www.college art.org

Photo Imaging Educators Association. www.pieapma.org

Society for Photographic Education. www.spenational.org

General

Professional Photographers of America (PPA). www.ppa.com

Association of Photographers (UK). www.the-aop.org

Professional Photographers of Canada Inc. www.ppoc.ca

The American Society of Picture Professionals. www.aspp.com

Nature and wildlife

Lepp Photo. www.georgelepp.com

Nature Photographers Network. www.naturephotographers.net

North American Nature Photography Association. www.nanpa.org

Photoshop

Adobe Design Center. www.adobe.com/designcenter/

Photoshop Support. www.photoshop support.com

The National Association of Photoshop Professionals. www.photoshopuser.com

Software Cinema. www.software-cinema.com

Portrait/Wedding

Wedding & Portrait Photographers International. www.wppionline.com

Society of Wedding & Portrait Photographers (UK). www.swpp.co.uk/

Stock

Stock Artists Alliance. www.StockArtistsAlliance.org

Workshops

Anderson Ranch Arts Center. www.andersonranch.org

Ansel Adams Gallery Workshops. www.anseladams.com

Brooks Institute Weekend Workshops. workshops.brooks.edu/

Eddie Adams Workshop. www.eddie adamsworkshop.com

The Lepp Institute. www.leppinstitute.com

The Workshops. www.theworkshops.com

Mentor Series. www.mentorseries.com

Missouri Photo Workshop. www.mophoto workshop.org

Mountain Workshops. www.mountain workshops.org

Palm Beach Photographic Centre Workshops. www.workshop.org

Photography at the Summit. www.rich clarkson.com, www.photographyatthe summit.com

Rocky Mountain Photo Adventures. www.rockymountainphotoadventures. com

Santa Fe Workshops. www.santafework shops.com

Toscana Photographic Workshop. www.tpw.it/

The Center for Photography at Woodstock. www.cpw.org

Glossary

A-DEP (Automatic Depth of Field AE) The camera mode that automatically calculates sufficient depth of field for near and far subjects within the coverage of the seven AF focusing points, such as when several people are sitting at various distances from the camera.

AE Automatic exposure.

AE lock Automatic exposure lock. A camera control that lets the photographer lock the exposure from a meter reading. After the exposure is locked, the photographer can then recompose the image.

AF lock Autofocus lock. A camera control that locks the focus on a subject and allows the photographer to recompose the image without the focus changing. Usually activated by pressing the Shutter button halfway down.

ambient light The natural or artificial light within a scene. Also called available light.

angle of view The amount or area seen by a lens or viewfinder, measured in degrees. Shorter or wide-angle lenses and zoom settings have a greater angle of view. Longer or telephoto lenses and zoom settings have a narrower angle of view.

aperture The lens opening through which light passes. Aperture size is adjusted by opening or closing the diaphragm. Aperture is expressed in f-numbers such as f/8, f/5.6, and so on.

aperture priority (Av Aperture-Priority AE) A semiautomatic camera mode in which the photographer sets the aperture (f-stop), and the camera automatically sets the shutter speed for correct exposure.

artifact An unintentional or unwanted element in an image caused by an imaging device or as a byproduct of software processing such as compression, flaws from compression, color flecks, and digital noise.

artificial light The light from an electric light or flash unit. The opposite of natural light.

autofocus A function of Basic Zone modes or a Focus mode selection where the camera automatically focuses on the subject using the autofocus point or points shown in the viewfinder, or tracks a subject in motion and creates a picture with the subject in sharp focus. Pressing the Shutter button halfway down activates autofocus.

automatic exposure A function of Basic Zone modes where the camera sets all exposure elements automatically. The camera meters the light in the scene and automatically sets the shutter speed, ISO, and aperture necessary to make a properly exposed picture.

automatic flash A function of Basic Zone modes where the camera determines that the existing light is too low to get either a good exposure or a sharp image, it automatically fires the built-in flash unit.

Av (aperture value) Indicates aperture (f-stop). Also used to indicate the Aperture-Priority shooting mode on the Mode dial.

AWB (Automatic White Balance) A white balance setting where the camera determines the color temperature of the light source automatically.

axial chromatic aberration A lens phenomenon that bends different color light rays at different angles, thereby focusing them on different planes. Axial chromatic aberration shows up as color blur or flare.

backlighting Light that is behind and pointing to the back of the subject.

barrel distortion A lens aberration resulting in a bowing of straight lines outward from the center.

bit depth The number of bits (the smallest unit of information used by computers) used to represent each pixel in an image that determines the image's color and tonal range.

blocked up Describes areas of an image lacking detail due to excess contrast.

blooming Bright edges or halos in digital images around light sources, and bright reflections caused by an oversaturation of image sensor photosites.

bokeh The shape and illumination characteristics of the out-of-focus area in an image.

bounce light Light that is directed toward an object such as a wall or ceiling so that it reflects (or bounces) light back onto the subject.

bracket To make multiple exposures, some above and some below the average exposure calculated by the light meter for the scene. Some digital cameras can also bracket white balance to produce variations from the average white balance calculated by the camera.

brightness The perception of the light reflected or emitted by a source. The lightness of an object or image. See also *luminance*.

buffer Temporary storage for data in a camera or computer.

bulb A shutter speed setting that keeps the shutter open as long as the Shutter button is fully depressed.

cable release An accessory that connects to the camera and allows you to trip the shutter using the cable instead of by pressing the Shutter button.

calibration In hardware, a method of changing the behavior of a device to match established standards, such as changing the contrast and brightness on a monitor. In software, calibration corrects the colorcast in shadows and allows adjustment of non-neutral colors that differ between an individual camera and the camera's profile used by Camera Raw.

camera profile A process of describing and saving the colors that a specific digital camera produces so that colors can be corrected by assigning the camera profile to an image. Camera profiles are especially useful for photographers who often shoot under the same lighting conditions, such as in a studio.

chroma noise Extraneous, unwanted color artifacts in an image.

chromatic aberration A lens phenomena that bends different color light rays at different angles, thereby focusing them on different planes. Two types of chromatic aberration exist. Axial chromatic aberration shows up as color blur or flare. Chromatic difference of magnification appears as color fringing along high-contrast edges.

chromatic difference of magnification Chromatic aberration that appears as color fringing where high-contrast edges show a line of color along their borders. The effect of chromatic aberration increases at longer focal lengths.

CMOS (Complementary Metal-Oxide Semiconductor) The type of imaging sensor used in 40D to record images. CMOS sensors are chips that use power more efficiently than other types of recording mediums.

color balance The color reproduction fidelity of a digital camera's image sensor and of the lens. In a digital camera, color balance is achieved by setting the white balance to match the scene's primary light source. You can adjust color balance in image-editing programs using the color Temperature and Tint controls.

colorcast The presence of one color in other colors of an image. A colorcast appears as an incorrect overall color shift often caused by an incorrect white balance setting.

color/light temperature A numerical description of the color of light measured in Kelvin. Warm, late-day light has a lower color temperature. Cool, early-day light has a higher temperature. Midday light is often considered to be white light (5000K). Flash units are often calibrated to 5000K.

color space In the spectrum of colors, a subset of colors included in the chosen space. Different color spaces include more or fewer colors.

compression A means of reducing file size. Lossy compression permanently discards information from the original file. Lossless compression does not discard information from the original file and allows you to re-create an exact copy of the original file without any data loss. See also *lossless* and *lossy*.

contrast The range of tones from light to dark in an image or scene.

contrasty A term used to describe a scene or image with great differences in brightness between light and dark areas.

cool Describes the bluish color associated with higher color temperatures. Also used to describe editing techniques that result in an overall bluish tint.

crop To trim or discard one or more edges of an image. You can crop when taking a picture by changing position (moving closer or farther away) to exclude parts of a scene, by zooming in with a zoom lens, or via an image-editing program.

daylight-balance General term used to describe the color of light at approximately 5500K — such as midday sunlight or an electronic flash.

dedicated flash An electronic flash unit that's made to be used directly with a specific make or model of camera.

depth of field The zone of acceptable sharpness in a photo extending in front of and behind the primary plane of focus.

diaphragm Adjustable blades inside the lens that determine the aperture.

diffuser Material such as fabric or paper that is placed over the light source to soften the light.

dpi (Dots Per Inch) A measure of printing resolution.

dynamic range The difference between the lightest and darkest values in an image. A camera that can hold detail in both highlight and shadow areas over a broad range of values is said to have a high dynamic range.

exposure The amount of light reaching the light-sensitive medium — the film or an image sensor. It is the result of the intensity of light multiplied by the length of time the light strikes the medium.

exposure compensation A camera control that allows the photographer to overexpose (plus setting) or underexpose (minus setting) images by a specified amount from the metered exposure.

exposure meter A built-in light meter that measures the amount of light on the subject. EOS cameras use reflective meters. The exposure is shown in the viewfinder and on the LCD panel as a scale with a tick mark under the scale that indicates ideal exposure, overexposure, and underexposure.

extender An attachment that fits between the camera body and the lens to increase the focal distance of the lens.

extension tube A hollow ring attached between the camera lens mount and the lens that increases the distance between the optical center of the lens and the sensor, and decreases the minimum focusing distance.

fast Refers to film, digital camera settings, and photographic paper that have high sensitivity to light. Also refers to lenses that offer a very wide aperture, such as f/1.4, and to a short shutter speed.

file format The form (data structure) in which digital images are stored, such as JPEG, TIFF, RAW, and so on.

filter A piece of glass or plastic that is usually attached to the front of the lens to alter

the color, intensity, or quality of the light. Filters also are used to alter the rendition of tones, reduce haze and glare, and create special effects such as soft focus and star effects.

fisheye lens A lens with a 180-degree angle of view.

flare Unwanted light reflecting and scattering inside the lens causing a loss of contrast and sharpness and/or artifacts in the image.

flat Describes a scene, light, photograph, or negative that displays little difference between dark and light tones. The opposite of contrasty.

fluorite A lens material with an extremely low index of refraction and dispersion when compared to optical glass. Fluorite features special partial dispersion characteristics that allow almost ideal correction of chromatic aberrations when combined with optical glass.

f-number A number representing the maximum light-gathering ability of a lens or the aperture setting at which a photo is taken. It is calculated by dividing the focal length of the lens by its diameter. Wide apertures are designated with small numbers, such as f/2.8. Narrow apertures are designated with large numbers, such as f/22. See also *aperture*.

focal length The distance from the optical center of the lens to the focal plane when the lens is focused on infinity. The longer the focal length is, the greater the magnification.

focal point The point on a focused image where rays of light intersect after reflecting from a single point on a subject.

focus The point at which light rays from the lens converge to form a sharp image. Also the sharpest point in an image achieved by adjusting the distance between the lens and image.

frame Used to indicate a single exposure or image. Also refers to the edges around the image.

front light Light that comes from behind or beside the camera to strike the front of the subject.

f-stop See also *f-number* and *aperture*.

ghosting A type of flare that causes clearly defined reflection to appear in the image symmetrically opposite to the light source creating a ghost-like appearance. Ghosting is caused when the sun or a strong light source is included in the scene and a complex series of reflections among the lens surfaces occur.

gigabyte The usual measure of the capacity of digital mass storage devices; slightly more than 1 billion bytes.

grain See *noise*.

gray-balanced The property of a color model or color profile where equal values of red, green, and blue correspond to a neutral gray value.

gray card A card that reflects a known percentage of the light that falls on it. Typical grayscale cards reflect 18 percent of the light. Gray cards are standard for taking accurate exposure-meter readings and for providing a consistent target for color balancing during the color-correction process using an image-editing program.

grayscale A scale that shows the progression of tones from black to white using tones of gray. Also refers to rendering a digital image in black, white, and tones of gray. Also known as monochrome.

highlight A term describing a light or bright area in a scene, or the lightest area in a scene.

histogram A graph that shows the distribution of tones or colors in an image.

hot shoe A camera mount that accommodates a separate external flash unit. Inside the mount are contacts that transmit information between the camera and the flash unit and that trigger the flash when the Shutter button is pressed.

hue The color of a pixel defined by the measure of degrees on the color wheel, starting at 0 for red depending on the color system and controls.

ICC profile A standard format data file defined by the ICC (International Color Consortium) describing the color behavior of a specific device. ICC profiles maintain consistent color throughout a color-managed workflow and across computer platforms.

image stabilization A technology that counteracts unintentional camera movement when handholding the camera at slow shutter speeds and when using long lenses.

infinity The farthest position on the distance scale of a lens (approximately 50 feet and beyond).

ISO (International Organization for Standardization) A rating that describes the sensitivity to light of film or an image sensor. ISO in digital cameras refers to the amplification of the signal at the photosites. Also commonly referred to as film speed. ISO is expressed in numbers such as ISO 125. The ISO rating doubles as the sensitivity to light doubles. ISO 200 is twice as sensitive to light as ISO 100.

JPEG (Joint Photographic Experts Group) A lossy file format that compresses data by discarding information from the original file.

Kelvin A scale for measuring temperature based around absolute zero. The scale is used in photography to quantify the color temperature of light.

LCD (Liquid Crystal Display) The image screen on digital cameras that displays menus and images during playback.

LCD panel As you're holding the camera to shoot, the LCD panel is located on the top right of the camera and displays exposure information. Above it are buttons for changing exposure, white balance, drive mode, and other camera functions.

lightness A measure of the amount of light reflected or emitted. See also *brightness* and *luminance*.

linear A relationship where doubling the intensity of light produces double the response, as in digital images. The human eye does not respond to light in a linear fashion. See also *nonlinear*.

lossless A term that refers to file compression that discards no image data. TIFF is a lossless file format.

lossy A term that refers to compression algorithms that discard image data, often in the process of compressing image data to a smaller size. The higher the compression rate, the more data that's discarded and the

lower the image quality. JPEG is a lossy file format.

luminance The light reflected or produced by an area of the subject in a specific direction and measurable by a reflected light meter.

Manual mode A camera mode in which you set both aperture and shutter speed (as well as ISO). Commonly used in scenes when you want to vary the exposure over or under the camera's ideal exposure.

megabyte Slightly more than 1 million bytes.

megapixel A measure of the capacity of a digital image sensor. One million pixels.

memory card In digital photography, removable media that stores digital images, such as the CompactFlash media used to store 40D images.

metadata Data about data, or more specifically, information about a file. Data embedded in image files by the camera includes aperture, shutter speed, ISO, focal length, date of capture, and other technical information. Photographers can add additional metadata in image-editing programs, including name, address, copyright, and so on.

middle gray A shade of gray that has 18 percent reflectance.

midtone An area of medium brightness; a medium gray tone in a photographic print. A midtone is neither a dark shadow nor a bright highlight.

Mode dial As you hold the camera to shoot, the large dial on the top left of the camera that allows you to select shooting modes such as Tv, Av, and Portrait.

moiré Bands of diagonal distortions in an image caused by interference between two geometrically regular patterns in a scene or between the pattern in a scene and the image sensor grid.

neutral density filter A filter attached to the lens or light source to reduce the required exposure.

noise Extraneous visible artifacts that degrade digital image quality. In digital images, noise appears as multicolored flecks and as grain that is similar to grain seen in film. Both types of noise are most visible in high-speed digital images captured at high ISO settings.

nonlinear A relationship where a change in stimulus does not always produce a corresponding change in response. For example, if the light in a room is doubled, the room is not perceived as being twice as bright. See also *linear*.

normal lens or zoom setting A lens or zoom setting whose focal length is approximately the same as the diagonal measurement of the film or image sensor used. In 35mm format, a 50 to 60mm lens is considered to be a normal lens. A normal lens more closely represents the perspective of normal human vision.

open up Switching to a lower f-stop, which increases the size of the diaphragm opening.

optical zoom Subject magnification that results from the lens.

overexposure Exposing film or an image sensor to more light than is required to make an acceptable exposure. The resulting picture is too light.

panning A technique of moving the camera horizontally to follow a moving subject, which keeps the subject sharp but blurs-background details.

photosite The place on the image sensor that captures and stores the brightness value for one pixel in the image.

pincushion distortion A lens aberration causing straight lines to bow inward toward the center of the image.

pixel The smallest unit of information in a digital image. Pixels contain tone and color that can be modified. The human eye merges very small pixels so they appear as continuous tones.

plane of critical focus The most sharply focused part of a scene. Also referred to as the point of sharpest focus.

polarizing filter A filter that reduces glare from reflective surfaces such as glass or water at certain angles.

ppi (Pixels Per Inch) The number of pixels per linear inch on a monitor or image file. Used to describe overall display quality or resolution.

prime lens A lens with a fixed, rather than variable, focal length.

RAM (Random Access Memory) The memory in a computer that temporarily stores information for rapid access.

RAW A proprietary file format that has little or no in-camera processing. Processing RAW files requires special image-conversion software such as Canon Digital Photo Professional or Adobe Camera Raw. Because image data has not been processed, you can change key camera settings, including exposure and white balance, in the conversion program after the picture is taken.

reflected light meter A device — usually a built-in camera meter — that measures light emitted by a photographic subject.

reflector A surface, such as white cardboard, used to redirect light into shadow areas of a scene or subject.

resampling A method of averaging surrounding pixels to add to the number of pixels in a digital image. Sometimes used to increase resolution of an image in an image-editing program to make a larger print from the image.

resolution The number of pixels in a linear inch. Resolution is the amount of data in an image to represent detail in a digital image. Also, the resolution of a lens that indicates the capacity of reproduction of a subject point of the lens. Lens resolution is expressed as a numerical value such as 50 or 100 lines, which indicates the number of lines per millimeter of the smallest black and white line pattern that can be clearly recorded.

RGB (Red, Green, Blue) A color model based on additive primary colors of red, green, and blue. This model is used to represent colors based on how much light of each color is required to produce a given color.

ring flash A flash unit with a circular light that fits around the lens or to the side and produces virtually shadowless lighting.

saturation As it pertains to color, a strong, pure hue undiluted by the presence of white, black, or other colors. The higher the color purity is, the more vibrant the color.

sharp The point in an image at which fine detail is clear and well defined.

sharpen A method in image editing of enhancing the definition of edges in an image to make it appear sharper. See also *unsharp mask*.

shutter A mechanism that regulates the amount of time during which light is let into the camera to make an exposure. Shutter time or shutter speed is expressed in seconds and fractions of seconds such as 1/30 second.

shutter priority (Tv Shutter-Priority AE) A semiautomatic camera mode allowing the photographer to set the shutter speed and the camera to automatically set the aperture (f-number) for correct exposure.

side lighting Light that strikes the subject from the side.

silhouette A scene where the background is much more brightly lit than the subject.

slave A flash unit that is synchronized to and controlled by another flash unit.

slow Refers to film, digital camera settings, and photographic paper that have low sensitivity to light, requiring relatively more light to achieve accurate exposure. Also refers to lenses that have a relatively wide aperture, such as f/3.5 or f/5.6, and to a long shutter speed.

SLR (Single Lens Reflex) A type of camera that enables the photographer to see the scene through the lens that takes the picture. A reflex mirror reflects the scene through the viewfinder. The mirror retracts when the Shutter button is pressed.

speed Refers to the relative sensitivity to light of photographic materials such as film, digital camera sensors, and photo paper. Also refers to the ISO setting, and the ability of a lens to let in more light by opening the lens to a wider aperture.

spot meter A device that measures reflected light or brightness from a small portion of a subject.

sRGB A color space that encompasses a typical computer monitor.

stop See *aperture*.

stop down To switch to a higher f-stop, thereby reducing the size of the diaphragm opening.

telephoto A lens or zoom setting with a focal length longer than 50 to 60mm in 35mm format.

telephoto effect The effect a telephoto lens creates that makes objects appear to be closer to the camera and to each other than they really are.

TIFF (Tagged Image File Format) A universal file format that most operating systems and image-editing applications can read. Commonly used for images, TIFF supports 16.8 million colors and offers lossless compression to preserve all the original file information.

tonal range The range from the lightest to the darkest tones in an image.

top lighting Light, such as sunlight at midday, that strikes a subject from above.

TTL (Through the Lens) A system that reads the light passing through a lens that will expose film or strike an image sensor.

tungsten lighting Common household lighting that uses tungsten filaments. Without filtering or adjusting to the correct white balance settings, pictures taken under tungsten light display a yellow-orange colorcast.

UD (ultralow dispersion) A lens made of special optical glass processing optical characteristics similar to fluorite. UD lenses are effective in correcting chromatic aberrations in super-telephoto lenses.

underexposure Exposing film or an image sensor to less light than required to make an accurate exposure. The picture is too dark.

unsharp mask In digital image editing, a filter that increases the apparent sharpness of the image. The unsharp mask filter cannot correct an out-of-focus image. See also *sharpen*.

value The relative lightness or darkness of an area. Dark areas have low values, and light areas have high values.

viewfinder A viewing system that allows the photographer to see all or part of the scene that will be included in the final picture. Some viewfinders show the scene as the lens sees it. Others show approximately the area that will be captured in the image.

vignetting Darkening of edges on an image that can be caused by lens distortion, using a filter, or using the wrong lens hood. Also used creatively in image editing to draw the viewer's eye toward the center of the image.

warm Reddish colors often associated with lower color temperatures. See also *Kelvin*.

white balance The relative intensity of red, green, and blue in a light source. On a digital camera, white balance compensates for light that is different from daylight to create correct color balance.

Wide angle Describes a lens with a focal length shorter than 50 to 60mm in full-frame 35mm format.

Index

Guides to go.

Colorful, portable Digital Field Guides are packed with essential tips and techniques about your camera equipment, iPod, or notebook. They go where you go; more than books—they're *gear*. Each $19.99.

978-0-470-16853-0 978-0-470-12656-1 978-0-470-04528-2

978-0-470-12051-4 978-0-470-11007-2 978-0-7645-9679-7

Also available

Canon EOS 30D Digital Field Guide • 978-0-470-05340-9
Digital Travel Photography Digital Field Guide • 978-0-471-79834-7
Nikon D200 Digital Field Guide • 978-0-470-03748-5
Nikon D50 Digital Field Guide • 978-0-471-78746-4
PowerBook and iBook Digital Field Guide • 978-0-7645-9680-3

Available wherever books are sold

WILEY
Now you know.